Eye to Eye
Twenty Years of Art Criticism

Contemporary American Art Critics, No. 4

Donald Kuspit, Series Editor
Professor of Art History
State University of New York at Stony Brook

Eye to Eye
Twenty Years of Art Criticism

by
Robert Pincus-Witten

 UMI RESEARCH PRESS
Ann Arbor, Michigan

Produced and distributed by
UMI Research Press
an imprint of
University Microfilms International
Ann Arbor, Michigan 48106

Library of Congress Cataloging in Publication Data

Pincus-Witten, Robert.
Eye to eye.

(Contemporary American art critics ; no. 4)
Includes index.
1. Art, American. 2. Art, Modern–20th century–United States. 3. Art,
Modern–20th Century. 4. Art criticism–United States–History–20th
century. I. Title. II. Series.

N6512.P49 1984 701'.1'80973 83-24121
ISBN 0-8357-1534-5

Contents

Foreword

This series offers a selection of the writings of master art critics. It does so on the basis of a proven track record. Lawrence Alloway, Joseph Masheck, and Robert Pincus-Witten are important not only for their sophisticated treatment of complex art, but for the independence of their point of view, and their self-consciousness about it. They have all thought deeply about the nature and practice of art criticism. Working within the limiting format of journalistic articles, they have all managed to expand the conception of criticism beyond that of journalistic reporting. That may have been their model, but they transcend it through their intellectuality. One cannot help thinking of Oscar Wilde's sense of the anti-intellectualism that pervades the relationship to art, and that indeed is prevalent in society. These critics have forged a solid, non-ideological, undogmatic intellectual criticism which shames conventional reporting of "newsworthy" art, promotional reporting of the artist stars of the moment. They offer us not hagiography, but analysis, functioning to sting us into consciousness. Even though they deal with the new, and can even said to be obsessed with it, they never give in to sensationalism and parochial partisanship. They are passionate, but they also have the reserve and caution of reason. They reason hard to prove their points, rather than give in to opinionation. They are the important critical minds of our day, and their work will last beyond it. Indeed, their conceptions have become the means by which art history assimilates the art they deal with, showing that art criticism at its best is the innovative cutting edge of art history. They show that art history can be a challenging intellectual adventure, as well as an account of documents and objects.

My prefaces were written without consultation with the critic in question. Each preface is my critical interpretation of his work, trying at once to give a conceptual overview of it as well as raise issues about it, continuing the dialogue it began. The only way to be in good faith with criticism is to continue to be critical. For what is finally at stake in all this writing is the survival of the critical spirit.

Donald Kuspit
New York, New York
October 1983

Preface

It has occurred to me that critics ought to pay more attention to each other than to any artist. This is because so much art is second-rate, and so much criticism is first-rate. "I am always amused," said Oscar Wilde, "by the silly vanity of those writers and artists of our day who seem to imagine that the primary function of the critic is to chatter about their second-rate work." It is hardly worth the critic's while to serve any artist by becoming the instrument of his fame and ultimately of his immortality, functioning as the passive mirror of his exaggerated self-esteem. It is not that the critic should turn the tables on the artist's narcissism by portraying him as a kind of Dorian Gray, but that the primary function of the "creative critic of art," as Wilde called him, has nothing to do with being emotionally and socially supportive of the artist. "Discovering the real intention of the artist and accepting that as final" is also unacceptable; it is simply a superior way of mirroring.

The truly creative critic does something quite different. Rather than take the work of art on its superficially most innate terms, he "lends to the beautiful thing its myriad meanings, and makes it marvellous for us, and sets it in some new relation to the age, so that it becomes a vital portion of our lives." In other words, he lends it something of his soul; in Wilde's words, his "own individuality becomes a vital part of the interpretation." This individuality consists in his conception of his age; it is his most serious duty to have one. Wilde's view can perhaps be more incisively formulated. The critic does indeed lend himself to the work of art, but as a way of interrogating—testing—it rather than endorsing it. Does it really have myriad meanings, and do they really show it in a unique relation to the age? Does it really make fresh sense of the age, unavailable elsewhere? Only if it does is it truly marvellous and vital. Whether it does or does not it is "simply...a starting-point for a new creation": the critic's marvellous and vital interpretation of it, a world-historical scrutiny to determine whether it is his equal to the age.

Robert Pincus-Witten's criticism shows the importance of the critic's growing sense of his individuality for his interpretation of his age's art. From being academically oriented, a kind of conventional art history, Pincus-Witten's criticism has become increasingly unconventional social history, because

increasingly personal. He is as interested in establishing intimacy with artists as he is in understanding their art—the one becomes the vehicle for the other——and he tends to prefer art that projects strong personal values without losing its "art properties." Though he moved in the mid-seventies to what he has called a "biographical reading" of art in which the critic exposes "covert...personal reference...in (the) machine of closed judgment," he remains aware that such a reading "tends to...hobble work in its essential condition as art." The "immediate circumstance" that art is tied to "must not be confused with the art." Yet clearly such immediate circumstance—in Keith Haring's case an "inspiring social ethos"—is for Pincus-Witten inseparable from the art which is its "cipher." One accepts his protestations that to tie art to a specific social scene is to read it "in terms far smaller than it actually is." But one notes that he regularly sees art in terms of what might be called its personal social sensibility, and that he prefers art that is subtly alienated socially—this is what makes it "personal"—and thus subtly inaccessible.

It is this recurrent dialectic between an art's social and personal properties and its strictly formal or artistic properties that makes Pincus-Witten's criticism significant. Now the balance shifts to one side, now to the other; the one side always resists the other, but never enough to dismiss it. The fruitful tension remains. Conventional art history has forgotten this tension, and tends to prefer one side to the other, giving the neglected side a nominal identity, honorable mention. But Pincus-Witten's challenge to conventional art history goes deeper, especially when it comes to understanding alienated modern art. He insists that the art be understood personally, and through a developed sense of the struggle to be personal through art in the modern period. The critic is the reminder—the symbol—of this personal factor: the intrusive interpreter of a personal dimension that has become increasingly less self evident, and perhaps deliberately neglected because it is obscure and difficult to articulate with any certainty. Above all, there is no clear method for dealing with it, and it tends to disappear in history. Pincus-Witten brings the method of personal relationship with the artist, before the art has become history. In the modern period the authentically personal may exist only through alienation, but Pincus-Witten establishes authentically personal—unexpectedly unalienated—relations with artists through his acceptance of their work as a personal production. It is that before it is historically significant or insignificant, and Pincus-Witten's ability to recover that personal sense of the work, thus communicating with both artist and art on a uniquely intimate level, is one of his major achievements.

On one level, then, being-personal pulls the art back from the brink of meaninglessness, the peculiar meaninglessness that is its fate because it is destined to be treated impersonally and impartially as another art object. But there is another kind of nothingness that being-personal resists, and that Pincus-Witten is peculiarly sensitive to. In "Random Notes on Painting from a Critic's Daybook"—the first appearance (1975) of the journal that later became

important .

"Entries"—he remarks "the ultimate *nothingness* of abstraction," *"the dialectic of abstraction* (that) *leads to nothing."* Being-personal about abstract art, and finding the eccentric personal element in it, is a way of saving it from its tendency to communicate fabled Nothingness. The critic's intrusion becomes all the more necessary as abstraction becomes all the more a matter of "nothing"—a matter simply of style, of manipulating art properties. The critic restores our sense of the biographical dimension to abstraction, and in so doing restores the credibility of abstraction, the major mode of articulating modern alienation. That is, the critic intrudes to search out the alienated element in abstraction, reminding us that it is ultimately more about alienation than pure art values. It is when *old hat* abstraction is in danger of becoming "dead perfection"—to use the expression by which Pincus-Witten characterizes one of the things in art that the Symbolist rebellion opposed—that the critic personally intrudes to remind the living artist of his personal stake in making abstract art. It is, incidentally, because of the absence of significant personal alienation that Pincus-Witten dismisses realism. (Critical intrusion is, I think, preferable to critical "intervention," the term now used for therapeutic interaction. "Intrusion" conveys a greater sense of the urgency and the unsystematic character of the therapeutic interaction between critic and artist.)

What fascinates one about Pincus-Witten, then, is the persistence of the personal intention in the critical act of engagement. It is an heroic insistence on the personalities involved, which sometimes lacks a full sense of the personality's complexity. Indeed, one sometimes detects a reluctance to dig too deeply—as if the art properties were calling us away from examining the personal properties too closely, for that would ultimately deny the art. Still, I think Pincus-Witten could go much further towards revealing the personalities of artists, critics, and dealers, without detracting from our sense of the art, especially that aspect of it which reveals and elevates personality, implying personality which reveals and elevates art. Pincus-Witten's piece on Leo Castelli (not published here) shows perhaps how far he can go towards revealing personality as such, not simply as it looks in the light of the art for which it is living. [His piece on "Lunches at Artforum" (not published here) also shows the limits of his personal thrust, in another direction.] Pincus-Witten seems to have the courtier's inherent discretion—an elegant substitute for both flattery and disdain—but, more crucially, just at the moment of psychological revelation, he pulls back towards the style of the occasion, and the art. It may simply be that he does not know how to use properly the psychological instruments he toys with; or he may fear that using them properly would be too coldblooded an affair, too psychoanalytical, or too much a case history of social psychology—vulgarly directed and pseudo-scientific rather than subtly allusive and artistic. The point is that the conflict, which is one source of Pincus-Witten's creativity, is an intellectual pleasure to watch. It is in Pincus-Witten's restless shifting of perspective between the stylistic and the social, between the formal or what he has called the "mandarin"

and the personal or (auto)biographical, that his critical strength and interest resides.

This anxious ambiguity was there from the beginning of his career, in his devotion to Symbolism, with its subjective "alienation from...positivist, empiricist, materialist and imperialist views." Pincus-Witten's writings on Symbolism are crucial to a full understanding of him. They look like conventional art history, although they are more socially sensitive than the usual art historical treatise, but in fact they set the autobiographical as well as biographical tone of the future. The dandy is mentioned in Pincus-Witten's very first publication, "Yektai and Boldini: Formal and Symbolic Interchange" (1961); it can be argued that Pincus-Witten is determined to rehabilitate him. He explicitly talks about the dandy until the role becomes implicit in his own criticism: the chronicle "Entries" show the critic as dandy. One can even argue that Pincus-Witten's intense involvement with Post-Minimalist, art which was the first new art with which he could personally as well as critically identify, has to do with its essentially dandyish character. (His recent interest in what he calls Maximalist ✗ art is cooler, for all the close attention he gives it. Perhaps this is because the dandyish balance between the personal and the stylistic is not as precise there as in Post-Minimalism. They exist in a kind of slack intimacy in Julian Schnabel and David Salle; the tension has shifted too far to the stylistic side.)

As Pincus-Witten writes in "The Iconography of Symbolist Painting," "For Baudelaire, Dandyism was a moral and heroic option taken by an intellectual alienated by bourgeois values, which expressed itself as a physical and mental preoccupation with the new." Pincus-Witten's own alienated intellectual dandyism perhaps shows itself most clearly in his sense of content, particularly as it comes into its own in his chronicle "Entries." There, he achieves, in practice, one of his and modern criticism's most significant methodological goals, the convergence of the Symbolist and formalist senses of content. As Pincus-Witten says, for the Symbolists "content" meant "literary content, the illustrative, associative story line of a work," existing like an undertow even when reduced to a Mallarmé-like set of allusions (evasive even as a set). In the 20th century "content" has come to mean "the organizational or manipulative characteristics of a work...the self-evidence of the formal problem which the artist sought out for solution." In his mature criticism—and this is its paradoxical dandyish character—Pincus-Witten tries to show how associative and organizational contents coincide in authentically new art; the immediacy of this convergence is one sign of the authentically new. Criticism aims to grasp the moment of this convergence, which is not self-evident in modern alienated art. For the divergence of the associative and organizational is one consequence of alienation. Authentically new art momentarily ends the alienation while demonstrating it, and authentically modern criticism discovers authentically new art. Its novelty consists in its creation of a moment of non-alienation which makes self-evident the inescapability of the convention of alienation—a dialectical triumph which

criticism confirms by its recognition of the personal character of the triumph. It is not a collective event for the society, but a private, utopian elimination of the modern dissociation of sensibility. It is the "moral and heroic option" of an individual, and the critic, by pentrating its novelty, achieves his own dandyish individuality.

Dandyism emerges in another way in Pincus-Witten's criticism, in a way that shows criticism to be a kind of triumphant dandyism. Pincus-Witten is acutely aware of the increasingly rapid pace of "the *embourgeoisement* of art... from the Renaissance to the present" ("Improbable Furniture"). This conventionalization and neutralization of new art by making it an imperialist possession positivistically conceived can be resisted by a dandyish insistence on its essentially personal—intransigently alien—character. This means that by nature it is inappropriable, or that something serious—in fact the most significant aspect of the work—is lost in the appropriation. This nags at the bourgeois, and undermines *embourgeoisement,* keeping the work unexpectedly open to a personal approach; that becomes the "open sesame" to its riches. The bourgeois is forced to become something, as modern psychologists tell us, almost impossible for him to become: authentically personal. He has even lost the meaning of the personal, for it means enduring alienation—terminating the make-believe, staged reconciliation with the world that is the meaning of being-bourgeois. New art renews his inner alienation, externalizes and symbolizes his repressed "difference." Dandyist criticism makes the bourgeois aware that he must contradict himself to reach art—to be as new as new art. The dandy's revenge is to cause an identity-crisis in the bourgeois art-lover. It is to show him, really, that the art does not need his love, but he needs its lesson in being-personal.

Pincus-Witten's pursuit of the authentically new is a way of acknowledging his alienation, and his conversion of it into a dandyish attitude. He has been accused of being flighty and gossipy, but the new and the personal are constantly being conventionalized into the bourgeois and the social: flightiness and gossip interfere with that process, cocoon the new and the personal in protective camouflage. They seem to blend in to the bourgeois social world without really doing so. Also, they signify that one must move on to keep one's sense of the new personal; they are paradoxical signs of integrity and individuality. Just as the work of art is marvellous and vital and full of myriad meanings only when it is new, so the critic is perceptive only when he is on the move, the secret of being eternally new. Pincus-Witten's restlessness continues the peripatetic tradition of the modern critic, implicit in the "Vernet Promenade" of Diderot's "Salon of 1767" and overt in Baudelaire's description of his visit to the "Salon of 1859" as a "rapid, philosophical walk." Such rapidity of movement and trendiness are paradoxical ways of being a symbolist-style critic, which the dandy inevitably is. Pincus-Witten's turn to the journal, an intimate, rapidly moving medium, shows his symbolist dimension explicitly, for a journal does not pretend to be the

unvarnished empirical truth. It is not " 'straight' reporting of sensory-input"—
matter-of-fact description—but a system of allusions in which impulse and
turmoil have their place, as "Mel and Dorothea" makes clear.

Acknowledgments

The chapters in this book appeared originally as articles in the publications listed below. For permission to reprint these articles in this collection, I want to thank the following publications:

Chapter	Publication
1.	*Ring des Arts*, Automne/Autumn 1961, No. 2, pp. 40-42.
2.	*Artforum*, October 1969, pp. 71-73.
3.	*Artforum*, January 1970, pp. 56-62.
4.	*Arts Magazine*, April 1976, pp. 84-91.
5.	*White on White: The White Monochrome in the 20th Century*, Chicago, The Museum of Contemporary Art, December 18, 1972.
6.	*Improbable Furniture*, Philadelphia, Institute of Contemporary Art, University of Pennsylvania, March 10-April 10, 1977, pp. 8-16.
7.	*Against Order, Chance, Art*, Philadelphia, Institute of Contemporary Art, University of Pennsylvania, November 14-December 22, 1970.
8.	*Artforum*, April 1975, pp. 54-59.
9.	*Cy Twombly, Paintings and Drawings*, (Reprinted by permission of the Milwaukee Art Museum, Milwaukee, Wisconsin).
10.	*Artforum*, April 1974, pp. 60-64.
11.	*Artforum*, June 1972, pp. 50-53.
12.	*Artforum*, June 1970, pp. 47-49.
13.	Reprinted with permission from *Michael Hall: Three Installations*, The Detroit Institute of Arts, 1977.
14.	From the catalogue for "Materials and Methods: A New View," Katonah, New York, Katonah Gallery, March 21-May 2, 1971.
15.	From "A View of a Decade," essays by Martin Friedman, Robert Pincus-Witten, and Peter Gay. Chicago, Museum of Contemporary Art, September 10-November 11, 1977, pp. 19-25.
16.	From the catalogue for "Neustein," The Tel-Aviv Museum, Zacks Hall, Summer 1977.

17. From *John Baldessari,* essays by Marcia Tucker, Robert Pincus-Witten, and an interview with Nancy Drew. New York, The New Museum of Contemporary Art, and Dayton: University Art Galleries, 1891, pp. 51-61.

18. New York, Shafrazi Gallery, 1982, pp. 9-14.

19. The Robert Miller Gallery, New York, New York.

20. *Art-Rite,* Painting Issue, No. 9, Spring 1975, pp. 10-11.

21. *Arts Magazine,* March 1976, pp. 9-11.

22. *Arts Magazine,* February 1983, pp. 70-75.

23. *Arts Magazine,* June 1979, pp. 105–109.

24. *Arts Magazine,* November 1978, pp. 121-129.

Symbol

1

Yektai and Boldini: Formal and Symbolic Interchange

«Quant au peintre Yektai, c'est un Boldini qui peint à la manière des informels.»

Michel Ragon, *Arts,* 8 mars 1961

The non-commitment does disservice to the justice of the perception; Ragon succinctly states the grounds on which the committed abstract painter—and public—can reassess the work of the long-discredited school of late 19th century portraitists, can admire anew the eclipsed prestige of Boldini, Sargent, Helleu, Jacques-Emile Blanche, even Whistler, etc.

A half-century and more has ignored these once lionized painters and their equally celebrated sitters. Marxist disdain has rendered suspect the bravura style by which the latter were typified. Socialist republics and two world wars diverges our world of manners from theirs. Our fundamental assimilation of the aesthetic dictates of the Divisionist schools, of Pont-Aven, of Cubism and its myriad splinter groups further separates them from us.

Admittedly, nostalgic Proust-cultism still bridges the gap between a lost and living dandyism, but the Surrealistically bestirred reestimation of the symbol and the Symbolist Period can only explain a part of the revival. A no longer exclusive identification of the Society Painter with his dumb adoration of the leisured, the socially fluent, the conspicuously consuming, also explains much of the reappreciation.

Just as the stuffs of Hals and Velasquez were cited to be Proto-Impressionist by enlightened criticism, today the late 19th century portraitist can be correctly labelled as Proto-Expressionist. His favored jabots and décolletés inform us of painting-painting, of "pure" painting, in an era supposedly sworn to a Salon machine which had deteriorated by the end of the century to little more than meticulous anecdotalism and "erotic mysticism," as Gustave Geffroy called it.

Forget about the Impressionists, the Neo-Impressionists, the School of Pont-Aven—*they counted for nothing in their period!* Indeed, among the first glimmerings of Impressionist appreciation was that coming from the circle of Society Painters out of certain resemblances between their painting and that of

the Divisionist school, caused in part by a common inspiration in Manet and Couture. In this connection, recall that Boldini was one of the rare friends of Degas, that Whistler's enormous prestige in the end of the century was enhanced by his early flirtation with Impressionist precepts, that Zorn in Sweden and Kroyer in Denmark were considered in their native countries to be daring Impressionist exponents—an Impressionism equal to that of the celebrated Salon dilutions of Besnard and Chabas in France. If one faction of the Salon of the 1890s can still be spoken of as progressive it would be precisely these portrait painters who although chroniclers of fashion were also the purveyors of light-loaded, atmospheric canvasses, whose rules of painting hold consistent in great part with the "luminism" of Impressionism and the spontaneity of today's Expressionism.

Firstly, theirs was an art of *gesture,* which in their epoch served the dual-function of expressing motion and identifying objects. Gesture painting today, limited to calligraphy and graphism, unless practised by an artist of considerable means such as Degottex or Mathieu, is only a trite and widespread phenomenon. But consider the effect and importance of an art of gesture—however trivial the subject—in a period fundamentally devoted to an obsessive placement of color in painstakingly predrawn contours. Detaille, Meissonier, Bonnat, from the lions of the Salon to the meekest practitioners, at best were "attentive" or "industrious"; by comparison, even a pedestrian Society Painter was "intuitive."

Secondly, theirs was an art of *Rapidity.* Virtuosity came to mean under their aegis, the ability, the facility even, to represent with *speed,* thereby seriously undermining Ruskin's notion that virtuosity resided in verisimilitude. The contemporary précis is witnessed by the all too familiar slander of Ruskin against Whistler and the oft-quoted bons-mots of the subsequent trial. The whole notion of speed particularly associated with post-World War II painting is presaged for the first time in Western Art in the virtuosity of the later 19th century portrait. Thirdly, and most importantly, they rejected the academic conception of space-painting. Bloodlessly revolutionary, they refused the ossified and pronounced classicism of the Salon stemming from David's rituals and their monopolization at the hands of the dynasty of Ingres. The reforms of Delacroix, Courbet and their circles, were to remain even to the late 19th century as somehow stigmatized. The Society Portraitist rejected a slowly built-up canvas of *uniform surface* of *uniform depth,* and of *uniform finish.* That is, he anticipated the 20th century exploitation of *total surface-space consciousness.* By this I mean a heightened awareness of the total work so that to speak of only a portion and its manner of being worked is a falsification of the actual procedure; I mean a stroke as meaningful as a non-stroke; I mean a recognition of the function of "emptiness" and its immense artistic utility. For the first time in post-Renaissance Western art—despite token nods to Orientalism made by certain Impressionists and Post-Impressionists—the empty really functions; the uncovered is as intense as the

covered; the hasty is as meaningful as the labored and is considered possible to the same image. That is, *arrangement*—an informalist idea—as distinguished from *composition*—an academic idea—comes to the fore. In a living, modern sense, the Society Painter was painting abstractly. Lastly, on a psychological plane, the Society Painter frequently succeeds where the committed Symbolist of the 19th century fails out of over self-consciousness. For example, heads and hands of somewhat tight painting, when played against broad areas of informal painting, or vice-versa—Society Portrait clichés—clearly make statements about the femininity or refinement of the sitter and the uselessness of his class. Women particularly suffer. A constant refusal to delineate their hands enlarges our conception of the changing position of women in the day, a problem which the still academic canvases of the Salon Symbolists could only abstrusely hint at by re-investigating the literary themes of Judith, Salomé, Delilah, and very tellingly, for the first time, late-Orphic imagery.

The portrait, quid pro quo, has had prior to our century a very limited iconography—one could say, even a fixed iconography so that any invention within its boundaries is of significance and commands our attention. In this respect, it is far more than praiseworthy, it is remarkable, that Yektai could determine a new figuration of the face—a new constellation of that expressive and closely grouped landscape in a century in which the head, above all, has endured infinitely many plastic translations.

As early as 1953, Yektai had created a head image of considerable interest. In two studies, *Head I* and *Head II,* for example, the head has been arranged out of two more-or-less interlocking trowel-formed planes. The structure is simple, powerful, at once anonymous and particular. Curious, though unintentional parallels occur between these heads and certain researches of artists as disparate as Paul Klee, Alfred Maurer and the late Jawlensky in his head abbreviations, not to mention the inspirational germ found in Cézanne and the Cubist schools. The portrait, *Monir* (1953), is of particular interest because it is one of the first manifestations of the head of destroyed or "erased" feature since the initial and abandoned researches along these lines made by pre-World War I Arnold Schoenberg, painter: a somewhat triangular dark patch, eye-like at two extremities, the nose and the mouth of which has been "gouged out" and left unidentified in the central dark.

After 1953, Yektai resumed his abstract painting and gained in the succeeding years an estimable and serious reputation as a member of the New York School.

Four years later, feeling that the abstract path which he had been following was in some way too facile, Yektai adopted a rigorously figurative painting—"studio nudes"—working with all the naif ardor of a beginning art student.

About 1958, this representationalism was abandoned and Yektai entered his present phase, a period of immense bravura, lyricism, power, directness and

of a determined abstract commitment in which the appearance of such ostensible representationalism as found in a portrait presents important interpretive problems.

The two earlier representational periods, 1953 and 1958, grew out of simple painterly expansion—a youthful need to evolve a "new" image and the maturer need to channel, to husband, to analyse. Inherent in this understanding resided the present, bolder, still-unfettered vision.

These portraits—figuration-in-abstraction—their head-bisection descending the forehead, laterally channeling the nose and seaming the face[1] are at last symbolizations of enormous power which but faintly echo the structural research of the bi-planed heads of 1953. Through this cruel organization, Yektai underscores a most important feature of today's portraiture—its schizophrenia.

Because Yektai is a committed abstract painter—the point cannot be over-emphasized—he feels in his portraiture the need to "kill the sitter". He must exorcize the human figuration by which he is haunted and about which he still retains categorical classifications of excellence above the abstract art by which he is engaged. In short, a disquieting atavism is gnawing at the fundamental pride of the abstract commitment.

The cloven face employed by Yektai, to cite only one element, demonstrates this even if it always has an organizational raison d'être. Other features, such as the retained "erasures" of the arms in the portrait, *Pat* (1960), or of the retained "erasures" of large expanses of clothing or of bare flesh, also attest to this. Generally speaking, most of the important mid-century figure-painting demonstrates a similar appalled-reattraction. Of the first two elements of the preoccupations of the Society Painter listed earlier, very little need be said with regard to Yektai. In his work, *gesture* and *rapidity* are the fundamental aesthetic appeals most easily apprehended.

"A Rembrandt", Thomas Bouchard, art film maker, once remarked to Yektai, "can be copied, but not you because it is impossible to reproduce your negative space." The observation clearly illuminates the third element which Yektai shares in common with the late 19th century Society Painter. Study practically any of Yektai's recent paintings. The enormous density of unpainted canvas is really like so many blocks or channels of turgid space. By contrast, the painted atmosphere is at once thick and diaphanous—like so many material but atomized veils or screens. In *Concierge,* for example, it is this dense but unpainted channel which unites the two blocks of dark space and body to form one abstract shape—the artistic chemistry is anti-human.

Furthermore, Yektai paints in an *unconfined* way. Although one portion of the canvas is being attacked, his vision and instinct is divided between the area of touch and the total world screen of the canvas. He is as conscious of the effect of a stroke in other parts of the canvas as he is to its immediately adjacent color relation.

The arch-awareness may in some measure account for the impenetrability of space and the impalpability of matter in Yektai's paintings. Space has been molecularized by the encroachments of stroke and color.

The fourth element has already been alluded to by the identification of the psychological position in which today's portraitist finds himself. Of its nature, any human figuration makes a symbolic statement. One such—underscored femininity—has already been mentioned with regard to the late 19th century portrait. Furthermore, a symbolic statement is made by the very flamboyance of its style.

The bravura style was in its epoch a symbol alluding to rank. Public and artistic consciousness admitted it only to the Society Portrait. There are no genre pieces to speak of painted in the style; neither military nor cabinet anecdotes.

The anterior style of the 19th century to which the bravura style is readily related is that expended for vast public decorations such as Baudry and Clairin effected for the Opéra. Normally their subject matter was a diluted and ambiguous classicism. This florid style, called Neo-Baroque, traces its inspiration to the Baroque ceiling decoration of the Counter-Reformation, for which the hierarchic deportments of Christianity and classical mythology provided the subject. It is not unlikely that a broad style originally called for by architectural decoration, in which the elevated personages ranged from God Himself to Parnassan revellers, could become the secularized symbolization by which the celebrities of the late 19th century could be further glamorized, and thought properly so, by a beguiled middle-class.

Intense contrast: today, the bravura style—epitomized in the work of Yektai—reveals the deep antagonism toward figuration born of the painter's life-long parti-pris towards abstraction. The portrait figure is no longer a symbolic statement of caste, but rather a declaration of frustrated love-hate. It is a kind of bitter self-flagellation born of regret and scorn for that figuration, a cruel image of the sitter being a small unit of a large and misanthropic world view.

The proud intellectual recognition that the abstract researches of the 20th century far exceed in quality that of contemporary figurative research is undermined by a jealously of the achievements and joy nonetheless open to that figuration. However, to cite Picasso, Bonnard, Matisse, Rouault, etc., as great researches of 20th century figuration is to some measure a falsification because their world views were all essentially formed in the late 19th century and spurred a production which was for a long while in no way inimical to their academic heritage.

Yektai—to focus the bitter message implicit in the bravura deformation of his portraiture—quite rightly places himself in a tradition stemming from late-Goya. In its day, this temperament was called "Gothic". Today, that temperament flashingly lashed onto a formal pattern coming from a largely misunderstood group of late 19th century progressives, more rightfully can lay claim to this attenuating appellation.

Note

1. See the portraits, *Concierge* (1960) and *Paul Jenkins* (1960–61).

Henry Tanner

The sources of Henry Tanner's art are often not obvious, but they are permeating—pre-Raphaelitism, a hard factual strain developed under Eakins, an early predilection for genre, begun in Philadelphia and intensified in the studio of Benjamin-Constant, a mystical and Symbolist propensity that tells of the influence of Ryder, Redon and Whistler, a passionate attachment to Rembrandt. Yet for all this absorption, Henry Tanner cannot be dismissed as a turn of the century *pasticheur*. Indeed, several of his works equal the achievements of many of the masters I have mentioned and, in the case of Benjamin-Constant at least, unquestionably surpasses them.

For the major portion of his career, Tanner was in the awkward position of having been displaced by modernist art, as was often the lot of the Symbolist artist in the early 20th century—think of Maurice Denis, for example. The inevitable happened. Tanner first fell from favor and then from time. After his death in 1937 he succumbed to an oblivion which the continued exposure of his astonishing *Annunciation* (of the Wilstach Collection in Philadelphia) could but little brighten. And then, too, Tanner was a Negro. While this fact inevitably altered the ways in which Tanner's art was viewed and is presently viewed, as well as having deeply affected Tanner's own aspirations and how to realize them, Tanner is, for all that, an artist of unquestionable rank. (My eyes alone convince me of this in ways which no amount of topical rhetoric can even remotely touch.)

Henry Ossawa Tanner was born to a third generation Pittsburgher, Benjamin Tucker Tanner, later Bishop of the African Methodist Episcopal Church, and his wife Sarah. Benjamin Tanner was proud of his family heritage, which also included an Indian strain. His family enjoyed a respected position in Pittsburgh and then Philadelphia. Henry Tanner began life, then, in unusual circumstances, about which there is scant documentation—a black bourgeois of social and religious rank. (His white counterparts populate the novels of Henry James and Booth Tarkington.) It has been suggested that Tanner's resolve to be a religious artist responded not only to his own mystical nature but to the express wishes of the Bishop himself. But this is an imponderable.

When Henry was seven the large Tanner family moved to Philadelphia. Walking in Fairmount Park one day with his father, Henry, then about twelve,

encountered an artist painting. "... after seeing this artist at work for an hour, it was decided on the spot, by me at least, that I would be one, and I assure you it was no ordinary one I had in mind." His obituary in the Paris Herald Tribune (May 25, 1937) reported that the child "... cut up a kitchen awning for a canvas and converted the back of his geography textbook into a palette, while his father contributed fifteen cents for colors." The tale elaborates Tanner's own recollections which were printed in *The World's Work* of June 1909, selections from which are reprinted in the catalog of the present exhibition.

A period of study, strayed enterprises and poor health followed. In 1880 Tanner was accepted as a student at the Pennsylvania Academy of Fine Arts, which had then only begun a short tenure of direction under Thomas Eakins. From Eakins (and therefore, ultimately, from Couture and Gérôme), Tanner received his earliest coaching in unflinching draftsmanship—as well as the oblique and understated genre picture of a kind which fills Eakins' first period. Though the only Negro, Tanner was a popular student. That Eakins held Tanner especially dear is testified to in the fine and intellectual portrait of Tanner which Eakins painted in 1900 (at the time that Tanner was beginning to enjoy his widest acclaim and prestige)—one of only three portraits Eakins ever painted of his students. Tanner left the Academy at the end of two years and turned his attention to photography. Can one still discern an influence of Eakins in this decision? Eakins, it will be remembered, was one of the pioneering photographers of the late 19th century, whose work with Muybridge opened the way toward cinematography. As a modest portrait photographer, Tanner hoped to earn enough to be able to support himself as well as to find sufficient time for his painting. He began a portrait gallery in Atlanta. The business failed, as did his fragile health. He survived by teaching drawing at Clark University in Atlanta. At length, through the intercession of a rare early patron, Tanner was able to embark for Europe in 1891. Through the early 1890s, Tanner was to be found in the Académie Julian, working under Benjamin-Constant and Laurens.

In 1894, *The Banjo Lesson*, a genre painting done after studies made in the South, was accepted at the Official Salon—the first sign that an artist, in the terms of that day, hopefully was going to arrive. *The Banjo Lesson* is a great American painting. Its anecdotal narrative is subdued. An old Negro field hand, his fingers forming the chords, teaches a young boy to pick at a banjo. The boy leans into the old man. As an academic *tour de force* it is a realized example of crossed-light. The heads of the figures are *contra-soleil* while the legs move into shifting areas of greater illumination. But apart from such petty considerations, few paintings so convincingly convey the rapt concentration of musical teaching and performance. Certainly Eakins' musical pictures must be taken into consideration here, as well as those of William Sidney Mount. But even more than these anticipated American sources I feel the influence of Degas: I am thinking of the portrait of Degas' *Father Listening to the Guitarist Pagans*. Not only is Degas evident in the expressions of concentration but also in the contrast

between anatomical forms and areas of flattened space. The room horizon cuts across the waists of the figures and the lower right-hand still life is seen in typical Degas bird's-flight entry. The work, then, is a remarkable fusion of the conventional and the radical.

Black intellectuals and reformers, on the testimony of *The Banjo Lesson,* began to hope that the American Negro would at last find his great artist. W.S. Scarborough, the Vice President of Wilberforce University wrote: "When *The Banjo Lesson* appeared many of the friends of the race sincerely hoped that a portrayer of Negro life by a Negro artist had arisen indeed. They hoped, too, that the treatment of race subjects by him would serve to counterbalance so much that has made the race only a laughing-stock subject for those artists who see nothing in it but the most extravagantly absurd and grotesque. But this was not to be."[1] The fact that Tanner showed another genre subject on a French theme, *The Young Sabot Maker,* at the Salon of 1896 would bear out Scarborough's sense of disappointment. Although the theme still deals with age instructing youth, there are indications in the painting that Tanner had been studying the work of the academician Bastien-Lepage who had died young and who was extravagantly mourned. But Scarborough was wrong in imagining that in abandoning the Negro genre subject, Tanner had abandoned the race; instead Tanner was trying to become a first-rank artist in terms of accredited 19th-century goals and his own religious scruples. To succeed in art meant to succeed in all.

In 1896 *Daniel in the Lion's Den* received an honorable mention at the Salon. In 1897, *The Raising of Lazarus* (the motif comes from Rembrandt), exhibited at the Salon, was awarded a third-class medal and purchased by the French government for the Luxembourg gallery. At the time the "Luxembourg" (it no longer exists) served the function of allowing the French nation to acquire works of contemporary art by living artists—admittedly on the dubious advice of the Salon jury. After the death of an artist his work would be transferred from the "Luxembourg" to the Louvre. (The latter institution was crippled by the regulation that no work by a living artist could enter its collections. There is no need to dwell on the blunders which resulted from this system. America is especially rich in Impressionist works because of it.) With the "Luxembourg" acquisition Tanner had become a recognized artist. He could not fail to have identified with the first American artist to have enjoyed the same privilege— James McNeil Whistler.

The portrait of his mother, painted by Tanner in 1897, the year of his great success, bears out this assertion. The composition is an adaptation of Whistler's celebrated canvas of his mother, painted in 1872, which had been, in its day, the work acquired by the Luxembourg. Tanner presents his mother, laterally, as Whistler did, and likewise sets her upon a planar surface divided into three rectangles. The work is tenebrous, in a Rembrandt-like way. The deep browns and blue-blacks are relieved by the highlighted, tannish colors of the face of the artist's mother and a broad swathe of cloth which falls from her chair to the floor.

The work was originally known as *An Artist's Mother,* inferring by the title that though the sitter be black she too could be the mother of an artist.

The next year's production is dominated by *The Annunciation.* Although still viewed through the amber hazes of Rembrandt, *The Annunciation* is a miraculous achievement of late 19th-century American painting—although deeply foreign to our own taste. Tanner had fallen in love with a singer from San Francisco, Jessie Macauley Olssen, a white woman, and was shortly to marry her. He employed her as the model for Mary, projecting into his conception both an anguish and a modesty which are remarkable for all that one may regard as posed or artificial by today's standards—the innocent gaze, the distressed wringing of the hands, the huddled withdrawal of Mary's body. In the representation of the angel, Tanner, however, achieved something for which there is virtually no model in official art. Luke and Matthew, the two gospel writers who record the event, respectively describe Gabriel as an "Angel of God" and an "Angel of the Lord." Yet Tanner shows him as a radiation of light, a flare. I believe that Tanner's vision of New Testament events is deeply marked by an attachment to the Old Testament. Gabriel is seen in terms of a divine apparition like that of the burning bush, for example. In this sense, we have another means of identifying the strong undercurrent of Rembrandt in Tanner's work.

The garments of Mary and the bedclothes are perhaps overly turbulent—and in this disarray may be marked the Art Nouveau then emerging into full bloom. The disposition of the figures are again made against broad rectangles. The model for the work comes from Dante Gabriel Rossetti whose version of the subject is one of the major canvases of the Pre-Raphaelite movement. Rossetti solved the textual problem by depicting the annunciatory angel as miraculously supported upon toes of flame. Yet Rossetti's rugger-playing angel cannot compare to the iconographic power of Tanner's incandescent torch. I can think of only one period parallel for an iconographic alteration of equal power—the glowing spermatozoa surrounding several of Edvard Munch's versions of the Madonna. By this I do not wish to imply that Tanner was even aware of Munch's work. If he were, I am sure the Norwegian's religious imagery would have struck the American as uncouth and sacrilegious.

Other Pre-Raphaelite clues continue throughout Tanner's life. At the end of the century Tanner made the first of several pilgrimages to the Holy Land—imitating Holman Hunt in his desire to find the *factual* as well as the *emotional* verisimilitude of Palestine. The empathic portraits of Jews painted there inevitably must be compared to those Rembrandt painted in Leyden and Amsterdam.

At the beginning of the century Tanner's style altered. Compositions grew broader, less filled with data, less incidented with anecdotal material. The pictures grew more improvisational and committed to the manipulative possibilities of pure pigment. Glazes grew deeper, more resonating. Scourings appear. Crusts and chiaroscuro contrasts are more striking. Space is altered and

stretched and surfaces crack into long, crazed apertures in ways resembling Ryder's impastoes which had been built in a similar way. The themes remain religious. Even when one encounters what one imagines a "straight" portrait such as the one of Mr. and Mrs. Atherton Curtis, the intense gazes of the figures assume greater import when one learns that they were originally destined to be shown in conversation with Jesus, who was omitted from the canvas because of the possibility that it might be considered irreverent.

Even though these pictures were being painted at the same moment that Picasso and Braque were opening new worlds of form, I still rank them as among the most subtle and exquisite of the moment. They are deeply similar to those of Redon at the same time—not only in terms of an oil practice that is in constant self-elaboration but also because of the overall simplicity of the compositional patterns. Among the intensely realized (though perhaps unfinished) is the *Salomé with the Head of John the Baptist*. Without question, the most perversely sexual of Tanner's works—a rare nude body appears under Salomé's clinging garments—the canvas is washed in a glowing cool blue. Under this glaze one barely distinguishes the grinning death's head of Salomé, who, for the Symbolists, had come to represent overweening vanity, death and sterility. Salomé affects a mannered pose as she extends her elegant fingers toward the head of John the Baptist (hidden under bold yellow cloths). Although the works are separated by perhaps as much as twenty years, I suspect that Tanner's version of Salomé in part is based on Redon's lithograph, *La Mort* (Plate III of the album dedicated *A Gustave Flaubert*, 1889). It is of great importance that Redon himself went back to this work for his later painting, *La Mort*, which is roughly contemporaneous with Tanner's *Salomé*. In both cases the dating of the painting is problematical—1905 or thereabouts. It is also possible that Tanner, in selecting this theme, was recalling some forgotten version by his former teacher Benjamin-Constant who was celebrated for such morbidly erotic and exotic subjects. And certainly popular imagery which fused vanity and death (the woman before a skull-faced mirror) must also have added its modish note.

Tanner spent the remainder of his life in France. He settled in Etaples, playing the honored and gregarious host to an art colony which sprang up around him. He was made a *Chevalier de la Légion d'Honneur*, a gold medal laureate of the Panama-Pacific Exposition and, at length, a full academician in the American National Academy of Design. These are honors Tanner fully merited and which had never before been bestowed upon a Negro. The reasons why always bear rehearsing. Early in Tanner's career Booker T. Washingon had written a passionate article on the artist: "I believe and know that my race is thoroughly capable of assimilating the higher instruction, and is, when permitted to receive the training, fitted to enter upon any of the pursuits, esthetics or otherwise, as other men and women are ... to entertain any belief to the contrary ... could be considered a virtual indictment of the mental capacity of my race."[2] That Washington needed at all to make this painful statement of axiomatic human

principles on behalf of Tanner illuminates his achievements as much, though in a different light, as this long overdue retrospective.

Notes

1. "Henry Ossian (sic) Tanner," *Southern Workman,* December, 1902, pp. 661-70.

2. "Henry O. Tanner, Artist." *The Congregationalist and Christian World,* November 2, 1901, pp. 678-79.

The Iconography of Symbolist Painting

I

There never has been a successful direct overview of Symbolist painting and sculpture. It seems to be impossible since each of its requisite elements is locked into a network of cross-references and apparently evanescent data. This results from at least two reasons. The first is apparent. When Symbolism is treated in a straightforward, horizontal way it is made to appear superficial, which it is not. The second reason is not so apparent. There is no dross in Symbolism, no grain and chaff. Everything is equally important (and therefore, possibly, equally minor). Symbolism lacks monolithic figures (with the possible exceptions of Gauguin and Klimt). There is no great man in Symbolism—at least not in the way that Rembrandt is great, or Goya, or Michelangelo, or even Ingres. This owes partly to the fact that Symbolism is a style which has not lent itself to monumental art. It emphasizes easel painting and cabinet curios, and a scale allied to intimate self-referential concerns—to mystify, to intrigue, to suggest. It is not a grand style but a devious one.

There are, however, major figures: Moreau, Redon, Gauguin, Bernard, Khnopff, Mallarmé, Baudelaire and Poe. The last, while ignored at home, was piously translated by both Baudelaire and Mallarmé. The latter taught English to girl seminarians and wrote fashion copy all the while that he was developing the quintessential Symbolist archetypes and archetypal fragments: Salomé or her alter egos, Hérodiade and Judith (symbols of sterile overelaboration, dead perfection and wily triumph over the male); the Faun, drowsy of a day's heat, who hesitates between human *sapienza* and his pre-conscious animalism; the broken fan, the blue feather wing, the cult of the mind and the dream; the ever-tossed dice that never succeed in cancelling out mere chance.

Such considerations are pertinent to the mammoth and impressive exhibition, "The Sacred and Profane In Symbolist Art," held at the Art Gallery of Toronto. Not only does it present a heavy sampling of more familiar Nabis and Pont-Aven production, it also emphasizes Rosicrucian work, Italian Symbolism (as a basis for Futurism, especially the Boccioni of 1910-11), German production (Klinger and his imitator, Otto Greiner), later Pre-Raphaelite sensibility as it

was absorbed into English Academic practice (Albert Moore and Lord Leighton) and Belgian Idealist efforts (Khnopff and Delville). The selection begins early in the century, with a few isolated precursors such as the Englishmen Danby, Blake and Fuseli (by adoption), as well as the notorious Belgian, Wiertz, whose *Belle Rosine* examines her skeleton to be, a lurid *memento mori* dating from 1829.

The current exhibition had been originally organized by Luigi Carluccio for the *Galleria Civica d'Arte Moderna* of Turin (July and August of 1969). Mario Amaya, newly appointed Curator of the Art Gallery of Toronto, made a generous selection of the Italian enterprise and brought the exhibition to Canada. Carluccio's original catalog essay has been translated; and another, by Simon Watson-Taylor has been added. Watson-Taylor correctly stresses the influence of Symbolist literature, which preceded by some years the flowering in the visual arts. Since his essay covers so much ground, his remarks range and are brief— although he adumbrates the possibility that a second school of Symbolist authors appeared by the end of the 1880s and early 1890s which, in its turn, was able to benefit from the activities of the first generation of Symbolist painters and sculptors.

"The Sacred and Profane" is a loosely used catchphrase intended to cover the general trends of a vast body of artists who were united in this at least—their alienation from the positivist, empiricist, materialist and imperialist views which had come to dominate European society in the later 19th century. Such social predicates need not in themselves lead to artistic decline. Impressionism and Neo-Impressionism are two kinds of art built on a "straight" reporting of sensory-input. In fact, Impressionism and Neo-Impressionism provided the Symbolist with a technique (Gauguin matures under Pissarro, Osbert and Segantini are unthinkable without Seurat), as well as a challenge. They were obliged to equal the Impressionists' achievements, if they, too, were seriously to be regarded as artists of rank. It was, of course, the apparent absence of "content" (by which was meant subject matter in the empirically-based Impressionist style) that was being reacted against. From a Symbolist viewpoint, there can be few paintings dumber than Monet's haystacks except perhaps Cézanne's apples.

In the '80s, "content" was still understood to mean literary content, the illustrative, associative story line of a work. This is entirely different from the modern view of artistic content which may be taken to refer to the organizational or manipulative characteristics of a work. For us the meaning of content may relate to the self-evidence of the formal problem which the artist sought out for solution. In the Symbolist Period, artists in rebellion against the apparent lack of content of Impressionism were attracted by systems and devices of literary allusion as the means of subjugating the token enemy, Impressionism. In this attempt they were unsuccessful—for the formalist refinement of empiricist data remains central to the post-Symbolist arts of Cubism and Futurism. Nevertheless, the Symbolist did create an alternative to sensationist-derived styles, an alternative which in its time shared domination with Neo-

Impressionism over the later years of the 1880s through the first years of the 20th century. While we imagine that Seurat and Cézanne were the chief figures of this same period, Seurat was dead in 1891 and Cézanne was an all but forgotten recluse in Aix-en-Provence, far from the turbulence of the Paris scene. By contrast, it was the Symbolist Redon who agreed to become the Vice President of the *Salon des Indépendants* in 1884, which in its early years was the Neo-Impressionist Salon *par excellence*. And it was Bernard who imposed upon Gauguin his convictions about the excellence of Cézanne's work, just as he had earlier transferred the secrets of Synthetism to him. It was also Bernard who recorded, perhaps with errors, the celebrated aphorisms of the stolid, embittered Cézanne, and introduced the intellectuals of Paris to the Dutch painter Vincent, whose illustrated letters to Bernard were published in the period's central review, the *Mercure de France,* after the painter himself had been indifferently tossed into a pauper's grave. In Bernard's case, it is these gifts to the literature of art that must be recalled after the fulminations against Gauguin (who had usurped his role as the seminal painter of Pont-Aven) have palled.

I take the "Sacred" and "Profane" of the exhibition title to mean the polarizations of an idealistic elite set against bourgeois philistinism. "Sacred" and "Profane," then, are terms by which the religious and sexual turmoil (brought about by the scientific and materialistic emphasis of the Second Empire and of the Third Republic) are known. The following notes attempt to supply a partial insight into the complexities of Symbolist religious impulse and sexuality.

II

> Whatever is sacred, whatever is to remain sacred,
> must be clothed in mystery. All religions take
> shelter behind arcana which they unveil only to
> the predestined. Art has its own mysteries.
>
> —Mallarmé

In the Symbolist heyday the primitive Christian communism of Maurice Denis, the syncretic pietism of Gauguin and a wide body of occult revivalists, Theosophists, Anthroposophists, Rosicrucians under Peladan and Stanislas de Guaïta, a nostalgia for lost mysteries induced by Edouard Schuré and a drift toward Eastern arcana among the lesser figures of the Nabis circle (whose very name is Old Testament Hebrew for prophet)—all these attitudes elbowed and overlapped one another. Since much of my work on the *Salon de la Rose+Croix* has assisted in its gaining currency, I will not dwell on Peladan's enterprise except to note that between 1892 and 1897 more than 230 artists of varying merit received a forum in which to promote their esthetic views. Such manifestations were followed by exhibitions of *Les Artistes de l'Ame.* The *Indépendants*

included a broad front of Symbolists in their exhibitions. In Belgium, the schism in *les* XX separated the more doctrinaire impressionists from the Belgian Symbolists who founded, in turn, the idealist *Pour l'Art* and took part in Jean Delville's Ideal exhibitions of a Rosicrucian imitativeness. It may be added that the two Official Salons, the *Société Nationale des Beaux-Arts* and the *Société des Artistes Français*, provided the central arenas in which an immense amount of academic work of more or less religious impulse was disseminated. One need only think of Luc-Olivier Merson, or Dagnan-Bouveret or even Bouguereau to note to what degree talent could be abused within the nepotic academic system. It was here too that Gustave Moreau and Puvis de Chavannes exhibited.

Easily, the most convincing Catholic of major Symbolist rank—attested to by his magnificent journal—is Maurice Denis. Denis was introduced to Synthetic practice by Sérusier, who in October, 1888, had carried back from Pont-Aven a tiny landscape painted under the supervision of Gauguin, which because of its anticipatory decorative flatness and abstractness was immediately called the "Talisman." The current exhibition is placed under the protection of *The Muses* or *The Sacred Wood*, of 1893, by Denis. The Muses, all bearing likeness to Denis's young and adored wife (she was known as the Muse of the Nabis), sit under the chestnut trees very much like the figures in Manet's canvas *Musique aux Tuilleries* of 1862, which it still echoes. But the Gardens of the Louvre are now the Sacred Grove Dear to the Muses, a transparent homage to Puvis de Chavannes, who, even though an academician, had achieved the Nabis flatness of shape and firmness of contour prior to Bernard and Gauguin.

In another Sacred Grove-like canvas by Denis, the smaller *Green Trees* of 1893 (which echoes his lithograph for *La Revue Blanche*, the *Young Women at the Tomb*), he depicts a procession of postulant or communicant-like figures who encounter a winged angel beneath the flat green ribbons of trees. By allusion then, the composition superimposes the Christian iconography of the Maries at the Tomb, and the virginal conception of the female, one of the chief resolutions to the problem of the feminine in the period. I suspect too, that such processions of virgins—a dim memory of a vestal frieze—were given tangibility and actuality through their depictions as the women of Brittany. The *Bretonne,* in her nun-like, folkloric coif, appears not only in the work of Denis, but in Gauguin, Sérusier, Antoine de la Rochefoucauld, Emile Bernard and Henry Van de Velde, to name but a few figures of the Pont-Aven circle. In Denis's canvas the procession encounters an angel (of the Resurrection?). In Gauguin's *The Vision After The Sermon,* the file of Breton women encounter (or imagine) the vision of Jacob wrestling with the angel. It was on the basis of such painting, his own and that of his comrades of the School of Pont-Aven, that Denis could broadcast in *Du Symbolisme et de Gauguin* that a "picture before anything else, is a surface covered in beautiful colors ordered within rhythmical forms...," a piece of dogmatic rhetoric taken up by Albert Aurier, chief Symbolist critic of the

Mercure de France. After 1900 Denis himself came to seriously doubt the exclusively abstract imputations of his celebrated dictum.

An unswerving Catholic sentiment and delight in historical issues led Denis, even as late as 1939, to publish a history of religious architecture. As testimony to the religious consciousness of the late 19th century, Denis indicates the raising of the younger Abadie's designs for the *Sacré Coeur* on the heights of Montmartre. He saw this as a rededication of French national consciousness to the motherland after her "humiliation" by the Prussians in 1870—and more—as a Catholic antidote to the revulsion and moral despair caused, in part, by the Communard sacking of Paris in 1870-71, and the savage reprisals taken against the Left by General MacMahon supported by the bourgeois chauvinists of the newly instituted Third Republic. In this atmosphere, the still unsanctified Joan of Arc (she would be made a saint in the 20th century), *La Pucelle,* the historical ultra-virgin, could emerge as an heroic figure under whose beatific guidance the nation would once again prosper. To a lesser degree the cult of Sainte Geneviève, the patroness saint of Paris, gained prominence too. With a nation consecrated to militant Christian heroines, Bastien-Lepage would paint the *Maid of Orléans Hearing The Voices,* and Fremiet's Joan glittered gold on the *Place des Pyramides.* Joan and Virginity were everywhere.

Certainly Denis's *Théories* of 1912 (a republication of the Nabis writing of the 1890s), remains one of the monuments of modern criticism, although his own painting by this time had declined. He was then at work on the decoration of the major architectural edifice of Paris—*Le Théâtre des Champs-Elysées:* Perret's architecture, Bourdelle's reliefs and Denis's murals. Denis perhaps required the trials of great national turmoil to fulfill his Christian ambitions. In 1919, once again demoralized by the human and cultural losses of the First World War, Denis founded the *Atelier d'Art Sacré,* with a former student of Gustave Moreau, Georges Desvallières, which, it was hoped, would be an anodyne to the crippled spirit of the French nation.

Early on, Denis had written of the German Benedictine Brotherhood at Beuron. Were it not for Denis's close friendship with the chief Beuron talent, Dom Willibrord Verkade, we would be considerably less informed about Beuronic aspirations. Verkade's conversion (he was born a Dutch Protestant) to Catholicism had been brought about, it appears, through the constant ministrations of Denis—a role similar to the one he played in bringing the Danish Jew, Ballin (one of the shadowiest figures of the Nabis) to Catholicism. What is most striking about the art theories of the Beuron Brotherhood is their Pre-Raphaelite and Byzantine enthusiasm. A propensity for a diagrammatic and copybook art is echoed by, and may well have been directly influential on, the Byzantine schemata of the reclusive and Catholic artist Filiger. After a painful episode in Paris (there are two threads, one records a lack of money, the other speaks of pederasty, neither of which are mutually exclusive), Filiger sequestered

himself in Brittany where, in the early 1890s, he produced the finest religious painting of the late 19th century—*The Virgin and Child* of 1892 and the *Child Jesus Standing* (probably of the same year). A recipient of a stipend from Count Antoine de La Rochefoucauld, Filiger was the chief figure shown at the first *Salon de la Rose+Croix,* an organization in which La Rochefoucauld played *Archonte* to Peladan's Sâr.[1]

The Pre-Raphaelite stream in French Symbolist art, especially the Rosicrucian faction, was admitted from the outset. All of the major English exponents represented in the Toronto exhibition were passionately admired by Peladan. In the so-called *Rose+Croix* Manifesto of 1891, Peladan flatly stated that "we will go to London to invite Burne-Jones, Watts and the five other Pre-Raphaelites." Evidence has yet to come to light to indicate that this trip was ever made. If it were taken, then I suspect that it would have been made by La Rochefoucauld, who had already traveled to Switzerland to see to it that Hodler's collaboration with the Rosicrucians would be ensured. Peladan did not speak English. It is likely that his views on English artistic matters were dependent upon the writings of Robert de la Sizeranne, a French historian of the Pre-Raphaelite movement, and Gabriel Mourey, who, as French Editor of *The London Studio,* assisted in disseminating a thirst for things English to that segment of Symbolists who had been following with great interest the envoys of Burne-Jones to the official French Salons. In fact, much of the Symbolist style, particularly of the so-called "Idealistic" sector is exceptionally Anglo-centric. I think immediately of the Belgian Fernand Khnopff in this respect, although he descends from an English family and spent long sojourns in London. The "five other pre-Raphaelites" Peladan refers to were probably to be found among the following: Dante Gabriel Rossetti, who in the 1880s had altered his initially revolutionary style to conform to a vision that he now shared commonly (because they had been affected by his work) with Lord Leighton and Albert Moore; John Millais and Ford Madox Brown, who had been in the initial skirmishes of Pre-Raphaelitism; Walter Crane and William Morris, the later Pre-Raphaelite figures who fused an Anglo-Gothic style with Socialist precepts. It is interesting that Peladan recognized the importance of George Frederic Watts' intellectually abstract art, particularly since he is so neglected today. Current evaluation of Watts has still to emerge from that of the Manet critic, George Moore, who, in a famous passage, likened Watts' color to that of the rind of ripe Stilton cheese.

III

What is odd and endearing about the Nabis was their affectation of addressing each other as "Dear" or "Brother" Nabi—as we see in the Denis-Sérusier correspondence. This tiny philo-Semitism was daring in the face of the monumental anti-Semitism of the later 19th century. While it is true that one is hard put to find overt Hebrew themes in Nabis painting, they are present

through allusion, such as when, in a self-portrait, the Rosicrucian Sérusier represents himself in the patriarchal lineaments of the Prophet Ezekiel; he had seen the vision and the vision was Synthetism.

There is a curious side to the endemic anti-Semitism of the late 19th century—the degree to which it is marked by earlier poetical theory, most particularly Baudelaire's conception of the Dandy. For Baudelaire, Dandyism was a moral and heroic option taken by an individual alienated by bourgeois values, which expressed itself as a physical and mental preoccupation with the new. Baudelaire saw this concern as primarily played out in the sphere of moral choice. Many avenues lead away from this view. Because of it, Baudelaire is able to negotiate a horror and revulsion of women, who are repellent to him because they are "natural" (that is, not like art) and "abominable." Woman, for Baudelaire, "is always vulgar, that is to say, the opposite of the dandy." These lifelong views received circulation in *Mon Coeur mis à nu* (1862-64). In them two streams of the later Symbolist phase have been articulated and conjoined, the moral superiority of the dandy and his sexual neuroses.

By the time of the Third Republic, anti-Semitism provided an almost universally acceptable arena in which a certain kind of artistic sensibility could parade and congratulate itself upon a specious moral superiority. Peladan's reactionary ultramontanism is a prime example. Edouard Drumont's newspaper *La Libre parole* gained currency as did his book, *La France juive,* which armed him sufficiently to campaign politically in 1892-93 on an exclusively anti-Semitic platform. Between 1894-97, the continent was torn by *l'affaire Dreyfus.* The effects of this crisis were inestimable. Zola's *J'Accuse* came from it, as did Proust's *A la Recherche du temps perdu,* a sensitivity doubtless heightened by his Jewish maternal line. One has to admit the adoption of the anti-Dreyfusard views by many Symbolist figures. The Impressionists had been on the political left and their attachment to tangible and immediately felt sensations is supported by this. (Degas, of course, is the monumental exception.) The Impressionists and Neo-Impressionists supported the laborer, the factory worker, the *Communard* and the Anarchist. They were Dreyfusards. They were on the side of all who were the "natural" enemy of the dandy. They were on the side of the Jew. The Symbolist—at least of the Rosicrucian type—felt an almost "moral" duty to be an anti-Semite.[2]

IV

> Yes, I am traveling, but in unknown lands; and if
> I have fled from the fierce heat of reality and
> taken pleasure in cold imagery, it is because...
> I have been on the purest glaciers of Esthetics;
> because, after I had found Nothingness, I found
> Beauty. You cannot imagine the lucid heights that

I have dared to climb. Out of this will come a
splendid poem that I am working on now: and
this winter (or next) will come Hérodiade.

—Mallarmé

By the end of the 19th century we find a compartmentalization of the female into
distinct roles: Baudelaire's "natural, abominable and vulgar" female would be
counterbalanced by ideal creatures, demoiselles élues, blessed damosels—
princesses of the lands of porcelain, impressed upon the public's consciousness
by Rossetti, Swinburne, Burne-Jones, Whistler and Armand Point. For the
Symbolist, these roles had become clear and standardized. In Toorop's The Three
Brides of 1893, we find the Nun bride of Christ on the left, the Satanic bride of
Lucifer on the right and, in the center, the Virgin bride of Man. Compare
Toorop's Nun bride of Christ with Johan Thorn Prikker's The Bride of 1892, for
a similar conception. Edvard Munch's The Dance of Life also deals with such
Ibsen-like role playing. Among the brides of Satan are the ubiquitous
emasculators and decapitators such as Moreau's and Klimt's Salomés and Judiths
and the erethistic and sapphic heroines of Mallarmé, Moreau and Khnopff. To
Klimt's Judith must be added her pendant, Hope, in which one fears that the
child of Satan's plaything will be stillborn. (What a remarkable counterpart to
Watts' Blind Hope, who yet has one last string on her lyre; or Puvis de
Chavannes' Hope, who like the spring, once more brings life back to fields
strewn with the French dead of 1870.)

What are the implications of these femmes fatales? On a blunt level they
epitomize a sexualized triumph (often in pact with the devil) over the male.
From Peladan, to Rops, to Pierre Louÿs, the period slogan is "Man, plaything of
Woman; Woman, plaything of the devil." The last decade of the 19th century saw
the emergence of women as political and professional competitors with men, a
change which opened earlier standards of female subjugation and dependency to
examination. Women's altering and ascending position began to provoke the
several unhealthy tendencies of the period, such as the dandified estheticism
which isolated a Symbolist elite from the lives of the field and factory laborer as
well as from the bourgeois moneygrubber. Woman's incipient struggle aided in
transforming dandified estheticism into mere foppishness and latent or
participatory homosexuality. Proust's clincal transformation of Count Robert de
Montesquiou-Fesensac, a real poet of hothouse imagery, into the immortal
Baron Charlus is one well-known chronicling of this change. Peladan exalted the
androgynous perfection of the boy John-the-Baptist, and his theories were
absorbed into the work of Filiger, Point and Delville.

Perverse dandyism, not to say perversion, came to be regarded as a standard
of refinement. Des Esseintes, the hero of Huysmans' A Rebours (Robert Baldick
recently translated the title as "Against Nature"), was also in part modelled on

Montesquiou-Fesenzac. The novel rapidly became a guidebook, a *cicerone* of Symbolist taste. Des Esseintes' household pet, his bejeweled turtle (compare this to the conceits of Felicien Rops's beribboned turtles) dies for want of air. In such a detail, Huysmans, who originally had been a Naturalist author, may be exteriorizing his own revulsion against attenuated Symbolism, to which he contributed so largely. That he attempted to overcome the spiritual inertia and deadness central to Symbolist feeling on a private level is expressed in several retreats as an *oblate* in a *Trappist* monastery, throughout the '90s.

The degree to which sexuality had itself become the object of rarefied tastefulness is endemic in the period. It is particularly measurable in Max Klinger's *Fantasies Upon the Finding of a Glove,* a suite of etchings noteworthy for an acutely neurotic effect. Subsequent works by Klinger such as the *Brahmsphantasie,* tend to border on deep-dyed gush, quite German in effect. Still the iconographic Teutonic muse, the raven-tressed fulsome nude bearing an outscale lyre (stolen perhaps from a vanquished Orpheus as we shall momentarily see) is largely a popularization of Klinger's, with a nod to the earlier Roman types of Anselm Feuerbach.

Klinger's suite is a veritable scenario of an object fetishist. Klinger himself may have been afflicted with such an object fixation. The Suite treats of a young man who finds a long six-buttoned glove dropped by an unknown woman at a Berlin skating rink. Obsessed with her, he dreams of her glove in violently sexualized situations of adoration, love and loss. In the Symbolist Period, Baudelaire's *Artist of Modern Life* had been demoted into a therapeutic self-analyst. It was in this atmosphere that Sacher-Masoch was preparing *Venus in Furs.*

The emergence of sterile *demoiselles élues,* castrating princesses and evanescent virgins was accompanied by a new heroic type—the poet-hero. Classical mythology indicated the figure, Orpheus, the lovelorn companion of Eurydice, who, unable to withstand the test of faith, cannot refrain from looking back upon Eurydice and loses her forever to the underworld. Wandering and singing lamentations of his lost love, Orpheus became the poetic hero. His very depiction came to mean The Poet or Poetic Inspiration. What appears so peculiar to us is the constant refocusing of this heroic legend in feminine terms. The Rosicrucians, notably the Belgian Delville, but Point and Khnopff too, were drawn by the new poetical conception. In depicting the decapitated head of the poet floating upon a lyre (possibly to Lesbos) Delville is at a single stroke answering high Rosicrucian presuppositions (God viewed as the fusion of opposites) and honoring Gustave Moreau, who had established the poet-hero model for the Symbolists. Moreau's conception is aided by the Orphic myth itself. In his wanderings, Orpheus at length appears on the Isle of the Thracian Women (again, some say, the Isle of the Lesbians) and rejects their attentions on the grounds of his grief for Eurydice. Angered by Orpheus's spurning, the Thracian women set upon him and murder him, purportedly by decapitation. Delville's

work refers back to Moreau's masterpiece of the Salon of 1866, *The Thracian Girl Mourning Over The Head of Orpheus*. The decapitated head, to become Redon's theme *par excellence,* must be viewed in the light of this work too. That Orpheus's spurning of the Thracian Women should have been the part of the Orphic myth which most appealed to Symbolist sensibility is among the surest indications of sexual ambiguity in the period.

What I have been attempting to draw together is that the Judith-Salomé syndrome must be allied to its pendant theme, the androgynous poet-hero, if one is ever to approach a comprehension of Symbolist art. In 1903, Otto Weininger's *Geschlecht und Charakter* was published in Vienna. He posited a philosophical counterpart to Franz von Stuck and Gustav Klimt: Man represents the virtuous, the positive, the creative; woman the evil, the negative, the destructive. All human condition results from man's bisexual character in consequence of the interior struggle between his natures.

The highly conceptualized form of the Nun bride of Christ, the ultra-Virgin, counterbalances the destructress and castrator Salomé. The third option, The Virgin Bride of Man, links the extremes: destruction of the male and attenuated mystical detachment. The Virgin Bride is Genetrix, our most important heroine, although the least compelling achievement of the feverish Symbolist imagination. Through her the race is perpetuated. Such a confrontation is too direct, too tangible and too threatening to be easily absorbed into a style which is dedicated to the evasive, the evocative and the furtive. In front of the dynamos of the new industrial society ushered in at the Paris World's Fair of 1900, Henry Adams, scion of two American presidents, pondered the conception of the Virgin Bride of Man, and saw a refreshed future for her quite as the Symbolists shrank from her. The dynamo, "a symbol of infinity," was only equalled by the sexual power of the Virgin. "Everyone," he wrote, "even among Puritans, knew that neither Diana of the Ephesians nor any of the Oriental goddesses was worshipped for her beauty. She was goddess because of her force; she was the animated dynamo; she was reproduction—the greatest and most mysterious of all energies; all she needed was to be fecund." Had Gaston Lachaise been reading the autobiography of Henry Adams when he created the generatively explosive *Dynamo Mother* in 1933?

Notes

1. At the turn of the century Filiger turned from his extraordinary Catholic art to a Chromatic Notation—mosaic-like, geometrical surrogates for human anatomy. This Byzantinism is, it seems to me, marked by the Beuron adventure as well as (and here I am speculating) the numinous theories of the Anthroposophist, Rudolph Steiner. I submit this theory on analogical evidence. Lensbaron Arild Rosenkrantz (the lineal descendant of Hamlet's friend) whom I believe was the last surviving exhibitor of the *Salons de la Rose+Croix* when I interviewed him in the early 1960s at his Danish Barony, Rosenholm, also underwent a change from a Pre-Raphaelitic focus to that of a Chromatic Notationist expressly on the personal advice of Steiner.

The similarities of Rosenkrantz's later pictures to those of the Byzantinizing patterns of Filiger are vivid to say the very least.

2. Max Nordau, later the Zionist, was particularly sensitive to this strain of anti-Semitism in Symbolism and it impelled him to collate a huge mass of what he thought to be condemnatory evidence against the Symbolist movment, which he called *Degeneration*. This work, sectarian and narrow, ridiculed even by Shaw, nonetheless gives one of the fullest pictures of the neurotic underside of the Symbolist movement.

4

On Target: Symbolist Roots of American Abstraction

The American-ness of American art remains a nagging area of speculation. Some authors stress a hard-nosed empiricism and idealized provincialism; others note a transcendental strain on the one hand, or, on the other, an attraction to practical considerations rather than to a grand manner. Transposing this speculation to modernist issues, what has been seen recently as the best of reductivist abstraction—Andre, Judd, LeWitt, Rockburne, Bochner, et al.—actually maintains in part an American fascination with an iconography of intelligence rooted in Symbolism and running across the work of Jasper Johns (although this was not his conscious intention) to our own day. In short, American reductivist abstraction is in certain aspects rooted in Symbolism.

While hardly its inaugurators, Americans in the late 19th century shared with Europeans a fascination with Symbolism. True, we have no Symbolists of the stature, say, of Gauguin, Redon, or Moreau, although American artists working in Europe contributed in small ways to the larger Symbolist movement—figures such as Pinky Marcius-Simmons, a favorite painter of Theodore Roosevelt,[1] or Augustus Vincent Tack whose later abstract landscapes (as distinct from his commercial portraiture) suggest a strong understanding of the synthetist principles of Gauguin and his followers, specifically an awareness of the landscapes of the Rosicrucian painter Maurice Chabas.[2] Then, too, Elihu Vedder's work was highly regarded in the 19th century, especially the "visionary" and "idealistic" paintings, works we are beginning to re-esteem although many are more than a century old.[3] But if we have a Symbolist artist of the highest caliber, then surely it is Albert Pinkham Ryder.

Ryder's work, apart from a manifestly gratifying painterly achievement, reveals an iconography specifically paralleled in the Symbolist movement in Europe. Ryder, for example, was attracted to literature, Shakespeare especially, and more important for us to Edgar Allen Poe, the American writer rendered legendary in European Symbolism, owing, in part, to Baudelaire's and Mallarmé's translations of his stories. Moreover like many of his French counterparts, the imagery found in Richard Wagner's music-dramas is a preferred theme of Ryder's work as well.

Less obvious than these literary (and musical) concerns is Ryder's attraction to small formats, a concentrated scale (I take to be a function of the mental intentions of his paintings) primarily focused on the evocativeness of the sea. (Again, European Symbolist counterparts to this latter fascination are legion, and, like Ryder, may derive somewhat from the 17th-century little Dutch masters of the seascape.) As a function of the poetics of the sea, Ryder's blunt and abstractly silhouetted boats, a theme paralleled in Winslow Homer and continuing into Marsden Hartley, must be understood as symbolic of the Journey of Life. The American tradition takes Thomas Cole's transcendental narrative *The Voyage of Life* (1839; Munson Williams Proctor Institute, Utica, N.Y.) as its standard; The French tradition, Rimbaud's *Bateau Ivre* (ca. 1872), literally a "drunken boat," with roots in the medieval Ship of Fools, as its model. Like Cole and Rimbaud, Ryder conceives of the boat as both world observer and victim of the elements—that is, as a surrogate for the human being or a proxy for the artist—a subjugation underscored by Ryder's generalizing night, fog, or dusk effects.

Still, for all that, Ryder's sources remain a puzzle. Lloyd Goodrich has the most expert word. After a sifting of the available material, Goodrich sums up: "Thus the direct influences on Ryder, except for Corot, [Matthias] Maris, the Barbizon school, and probably Monticelli, are matters of conjecture—sometimes intriguing conjectures." I add the likelihood of influence stemming from the wide dispersal of Henri Fantin-Latour's lithographs based on Wagnerian themes, although as yet no one-to-one connection between figures in Fantin-Latour's Wagnerian work and Ryder's has been observed. Goodrich sharply disassociates Ryder from Blakelock, although many stylistic affinities "would lead anyone to assume a close personal and artistic relationship; but no evidence has been found." Goodrich notes that "Coincidence and parallel development are factors as real as influence."[4]

As our surpassing Symbolist, Ryder—for all his purely painterly issues—is also concerned with the central general postulate of Symbolism, the superiority of the mental over the physical. The chief indication of this is embodied in Ryder's boats expressing, I believe, the free-floating action of an unanchored course. In this Redon and Ryder are exactly parallel; Redon's pastels on the theme of boats adrift are intended to evoke unanchored travel through a dense medium. (Redon was also fascinated by balloons that drift through air, the least dense medium of all.) Drifting is for Redon a symbol for an activity of the mind complemented in his work by Gustave Moreau's numerous *Salomés* in terms of a contemporary imagery of the decapitated or disembodied head.

So too does an allusive imagery of the mental preoccupy Ryder. In *The Temple of the Mind* (Albright-Knox Museum) dated before 1885, a painting that Ryder acknowledged as one of "the two chief efforts of my ambition,"[5] a moonlit architectural landscape is depicted. To the left stands a columned temple portico; to the right, a splashing fountain surrounded by vague figures; in the

center, silhouetted by moonlight, a group of three women (Graces akin to Fates), and more difficult to distinguish, a dancing satyr and cupid.

The theme of the painting is taken from "The Haunted Palace," Poe's poem first published in *The Baltimore Museum* of 1839, and subsequently incorporated into his horror tale "The Fall of the House of Usher."[6] In a 1907 letter, Ryder noted: "The finer attributes of the mind are pictured by three Graces who stand in the center of the picture: where their shadows from the moonlight fall toward the spectator. They are waiting for a weeping love to join them. On the left is a Temple where a cloven-footed faun dances up the steps snapping his fingers in fiendish glee at having dethroned the erstwhile ruling Graces; on the right a splashing fountain."[7] Poe makes no reference to the satyr, the cupid, or the fountain, and Ryder's Graces were to Poe a troupe of Echoes.

The conjunction of cupid, satyr, and female figures derives from a general array of classical models ranging, say, from *The Three Graces* (Urbino), draped *Tanagra* figurines, the so-called *Fates* of the Elgin marbles, and later, to Antonio Canova's *The Three Graces* (1817), all of which knew hosts of popular copies and dilutions. Ryder's Graces equally suggest models derived from celebrated versions of the Muses, particularly Polyhymnia, the muse of sacred song. Her characteristic pensive pose, chin on hand, established the musing prototype of 19th-century portraiture, the most famous variation of which is, as Robert Rosenblum pointed out, Ingres' portrait of the *Countess d'Haussonville* (1845; Frick Collection).[8] This amazing portrait is dissimilar from the larger run of Ingres' great body of portraits because in it (and The National Gallery, London, *Mme. Ines Moitessier,* 1856) the sitter's image is reflected in a mantelpiece mirror. This prominent and startling device may indicate that Ingres was playing with the idea of reflection both as a physical effect and as an orchestration of the figure's pensive or musing role. In this sense, "reflection" corresponds to a manner of thought. That musing is itself a free-floating process of thought (the unanchored boat of rudderless indirection) cannot be underestimated in drawing the connection between classical memory and Symbolist actuality.

Ryder's *The Temple of the Mind* seems to have no other specific Symbolist manifestation as a theme in itself, although it has a curious parallel in the work of Rodin. Surface distinctions in Rodin's sculpture manifest pervasive philosophical attitudes: spiritual and material duality is expressed as a contrast between rusticated surfaces and smooth ones. Among his many incarnations of the dualistic notion of the mind conquering brute matter is a head of Athena, *Pallas au Parthenon* (Musée Rodin), crowned with a classical temple—in this sense literally a "temple of the mind."[9] Rodin may be playing with the conceit between the notion of pedimented temple elevation—in French, *le fronton*— and the human brow—*le front,* the "temple," so to speak, of the mind, hence of thought and thinking.

Many works reveal the primacy of thought as a Symbolist theme, for example, Redon's repertory of disembodied heads. In this imagery closed eyes

and inward glances speak of insight rather than sight, clairvoyance rather than sensation; with eyes closed or lips sealed with hushing gestures (finger to the lips), Redon's heads infer a blocking of sensory input that heightens a supposed second sight.

Such are the strains of meaning that Brancusi will derive, say, from Rodin's *Thought,* a disembodied head—a portrait of his mistress and student, the sculptor Camille Claudel—set upon a block of rusticated stone. For Rodin, thinking tends to be a masculine function, musing is feminine. *Thought* restates the theme of the mental conquest of physical matter, or the more Rodin-like variation of female spirituality conquering male materiality. A similar dualism preoccupies George Gray Barnard, the chief Rodinist in this country. His monumental marble *I Feel Two Natures Within Me* (1896; Metropolitan Museum), while ostensibly a wrestling scene, actually depicts the struggle between antagonistic halves within the same being—perhaps between anima and animus, female spirituality and male materiality.

While surely the meanings attributable to Brancusi's various muses and sleeping muses derive from such a Symbolist pool of meaning, his formal principles and his carving is purposefully anti-Rodinist. Brancusi's *Sleeping Muse* of 1910 and his *Muse* of 1912 are prototypes for the multiple versions of the *Mlle. Pogany* portraits that will occupy Brancusi from 1912 through the 1930s. In developing her blank inward stare, Brancusi had recourse to an abstraction that, in its "art-deco" way, at length was reduced to arc-segments akin to target sections. This is a modernist consequence drawn from the postulates of the decapitated head theme central to Symbolist taste from the 1860s on.

Across this preoccupation with the mental, the target became the desacralized abstraction of the apparition of the head of John the Baptist to the crazed Salomé, the Biblical dualistic confrontation between a presumed male good and a female evil. With his targets, then, Johns becomes the natural grandchild of Symbolism, sired as he was by the immediate concerns of Duchamp (himself a scion of Symbolism)—or, as Picabia might have said of Johns, could he have known him (instead, he was titling a Dada picture), a child "....born without a mother."

In "The Theater of the Conceptual: Autobiography and Myth,"[10] I noted a tight relationship between the target imagery of Jasper Johns and the three erotic objects of Marcel Duchamp, that is, between paintings of 1955 and small talismanic sculptures of 1951. "The sheer perversity of Duchamp's *objet dard,* shockingly unclassifiable as art to an Abstract Expressionist taste, is even more paradoxical when the question 'what is the object of a dart?' is answered by Johns' *Targets*—an oddly specific response to a hypothetical query."

This was hardly intended to be a preemptive interpretation. There are many putative reasons why Johns and, to a lesser degree, Rauschenberg[11] were drawn to a multivalent conceptual iconography that, compared to the expressionist norm of high art in the mid-'50s, seemed inert and emotionally depleted; prime among them is that the target—and its adjunct, concentricity—is liable to be seen

as a prime icon of the mental in 20th-century abstraction.[12] This motif, while it may engage the emotions or the passions depending upon its depiction, addresses the mental almost as a separate entity. Its use is a clue to strong intellectual ambitions rather than as an exclusive appeal to taste or feelings. In the case of Johns the target is so important a motif that one may regard it as a kind of abstract self portrait quite as the circle subdivided into pie-shaped sectors may be thought of as a similar kind of self portrait in the work of Rauschenberg.

Because of its primary gestalt, fixed symmetry, and repetitive character, the incidence of the target in painting grabs the eye and the mind. Since it is such a powerful die tending to overwhelm compositional ordinance, its depiction is infrequent. The target is related to other closed figures (and conceptual sets): squares, concentric squares, triangles (though these are rare, and rarer still, concentric triangles)—not to mention these flat figures projected into space: circle/sphere, square/cube, triangle/pyramid. Of course, "concentric circles" is not quite the same as "target"; one generates the image of an abstract and ideal class; the other is more specific if only because it conjures up a utilitarian image, a usefulness that may in some sense be athletic (archery, darts, shooting range) or metaphorical, such as a goal, an aim, an ambition.

In the inert iconography of proto-Pop imaged as targets—or numerical sequences zero to nine, or alphabetical sequences A to Z,[13] and in coloristic schema derived not from sensory data but from the chromatic analysis of white (the sequence of color in spectrum)—Johns recognized an imagery that was not exclusively corroborated in nature, but in abstract laws derived from nature. In this sense, it is not that circles, squares, and triangles are interesting if they occur in nature (they don't except as crystals), but that they are compelling insofar as these forms together make up simple, logical primary sets.[14] To speak of a "pictorial logic" is to speak metaphorically. The language we use to talk about the visual is largely derived from other disciplines—mathematics, biology, philosophy. Circle, triangle, square form a "logical set" in that they may be seen as the basic configurations of all potential visual organization (although for Paul Klee the smallest visual particle was the dot; for Mondrian the vertical and horizontal were the primordial components).[15] The system is the means whereby the art is corroborated; in representational art, the "art," i.e., illusion, is corroborated through an on-going comparison with nature. An unitary and holistic visual apprehension, the cardinal feature of the Minimal style, may still be open to further analysis. For example, a nine-cube square by, say, LeWitt (or earlier, a Reinhardt) can be apprehended as either whole in itself or as comprised of nine separate units of smaller components. The latter view engages time— indeed, the temporal increment is itself a function of the analytic procedure, an accruing awareness that serves to tip Minimalism into a newer post-Minimal style much involved with additive or subtractive procedures.

The desire to reduce larger wholes into their elemental constituents found echo in the strides taking place in linguistic studies during the '60s, so that, say, Noam Chomsky's reduction of language to primary phonemes was viewed as a

confirmation of Minimalism by another discipline. Similarly, Wittgenstein's desire to determine language's fundamental components of sense or meaning was viewed as a telling philosophical prefiguration of then-current visual concerns. Most important, the simple figures of Minimalism were almost interchangeable with their works: "square" as a word conjures up an image little different from a depicted square. Similarly, the procedures of earlier sensibility-oriented painting and sculpture were so complex that the language used to describe them was rich, varied, and elaborate. But in Minimalism the executive procedures were so spare and lean as to find linguistic parallel in simple prepositions: at/in/upon/out/into.

Surely in 1955 such a view of the corroborative nature of an external system was only intuitively applied. The advent of the Minimal style and its relationship to various linguistic analyses renders Johns' hunch that such a problem might even exist that much more prescient. Insofar as the target is concerned, Johns so isolated this motif that what was earlier seen as a compositional relative is in his work promoted to a near-exclusive element. Through all of this, the target remains inextricably linked to popular American imagery and amusements—the shooting gallery, the turkey shoot, pitching games of all kinds. In this sense, the target is an isolated aspect of larger illusionistic scenes in the American genre and illustrative tradition, of which, say, George Caleb Bingham's *Shooting for the Beef* (Brooklyn Museum; 1850) is representative. Still, more modern prototypes for Johns' concerns are telling.

In Francis Picabia's *Andalusian Blood (Spanish Night)* of 1922, for example, the targets are used in conjunction with simple binary contrasts; black and white, male and female, activity and passivity. The black figure dressed as an Andalusian gypsy points to the white female nude; upon her body are two targets indicating areas of erotic interest—one the breast, the other the abdomen (and by analogy the genitals). The aggressive nature of Spanish machismo—Picabia's Cuban heritage and sexual prowess cannot be discounted here—is underscored by the scatter-shot marks upon the painting as if the targets had in fact been shot at. As does much else in Picabia's work, these trompe-l'oeil holes derive from Duchamp's literally real holes shot upon *The Bride Stripped Bare by Her Bachelors, Even, i.e. The Large Glass.* Sexual aggression is surely embedded in such a direct functional connection as the one Picabia makes between target and sexuality.[16]

This connection is maintained in the Surrealist work of Joseph Cornell, one of the few Americans to have direct experience of Surrealism in Paris prior to World War II. There are a good number of implicit or explicit target images—in Cornell's boxes the format alone reveals Cornell's relationship to Duchamp (whose works often are completed only when "boxed"). Among the best known is *Habitat* of 1943. As if in a shooting gallery, a number of cut-outs, parrots, cockatoos, birds of elaborate plumage, are installed at varying heights in the box. The glass over the box has been smashed—another reference to Duchamp most

of whose glasses have been broken—as if by a shot. There is a blood smear; a bird has been wounded or killed. In general usage, the exotic bird infers male sexuality (the brilliant cock, the dun-colored hen). It is largely the strutting bird that is alluded to in Romantic erotic imagery as, for example, in Courbet's *Woman with a Parrot*. However, the brilliant plumage need not always signify male sexuality. Ever since the Art Nouveau, the connection between female vanity and the splendid mindlessness of the peacock—the avian Salomé—has been maintained. Thus for Cornell, deeply familiar with French Symbolist imagery, these rare birds cut from handbooks and children's Lotto games were partly appreciated doubtless for their implications of multivalent sexuality.

For Picabia as for Duchamp, the sexuality lent itself not only to images of specific aggression, but to a more general sexual metaphysics. The abstruse character of their preoccupation is perhaps clearest in the "L.H.O.O.Q." exchange, a private joke between the two artists. Duchamp's L.H.O.O.Q. captions the first epiphany of Rrose Selavy as the Mona Lisa, Duchamp's female alter-ego (and as photographed by Man Ray in 1921, the artist himself in drag). The 1919 work, punning on the French pronunciation of the letters—hence, *"elle a chaud au cul"* or, colloquially, "she's got a hot ass"—displays the Mona Lisa with a moustache, that is, the female with male attributes.

That Duchamp should have made this celebrated gesture upon a capital symbol of Western culture is not so obvious as it at first might seem. Duchamp took the Mona Lisa as his object of male aggression not only because of the fame of the work—hence as an "anti-art" gesture, which it is not—but because Mona Lisa herself had clearly been understood to be the object of an androgynizing process. Joséphin Peladan, a now-ignored historian and critic, was throughout Duchamp's youth the central propagandist for the idealized androgyny of Leonardo's subjects: the enigmatic heroines, Virgins, page-like angels, John the Baptist, and Leonardo's mysterious sitters, most notably La Gioconda. On the simplest level, androgyny reconciles two opposing symbologies, one male and one female. This fusion leads to stasis, inertness, and, by extension, to a nirvana-like desirelessness, a satori-like immobility. This is paralleled in the Western tradition by the vision of God as a reconciliation of opposites which we take to be if not the best, then the least imperfect conception of deity. Duchamp's choice of the Mona Lisa as an incarnation of his female alter-ego was ratified in the period by the notoriety that Peladan's heady androgynous if not bi-sexual identification of the Mona Lisa already enjoyed.[17]

Picabia's riposte to Duchamp's "L.H.O.O.Q." inscription on the Mona Lisa was double-barreled. Incorrectly remembering the Duchamp original with its van Dyke beard and moustache, Picabia, in publishing an authorized reproduction of it in *391* (No. XII, Paris, March 1920) left off the beard. The drawing *Le double monde* (1919; former coll. André Breton) is a more involuted reply in which the letters "L.H.O.O.Q." form a vertical spine lassoed by two interlocking double loops. The drawing incorporates verbal directives as if

depicting a parcel of great fragility: *"fragile/ haut/ bas/ a domicile/ m'amenez'y*—such delivery instructions are dispersed upon the drawing. The "up" part of the drawing parcel *("haut")* is in the wrong place, as is the bottom *("bas")*. The capstone of Picabia's L.H.O.O.Q. is the phrase *"le double monde"* or "the double world," a clue as well to the androgynous attributes of the Mona Lisa. It was Picabia who, in concert with Duchamp, established the mechanomorph as the central iconography of New York Dada; and the important captions connoting specific private information in his work (for example, "Udnie" or "Edtaonisl") coincides with such practice by Duchamp.

The connection between Johns' targets and Duchamp's work is taken for granted. Certainly a specific source for the targets themselves, apart from the unexpected reply to *objet dard,* is the number of target and target-like formations that occur in Duchamp, the most famous being the *Precision Optics* (1920, with Man Ray), which presents a mechanized image of concentric circles when its propeller-like glass blades are set in motion. [It prefigures of the Picabia *Optophone I*—hence, that it is a step toward *Spanish Night* is equally assumed.] *Rotary Demisphere* of 1925, also motorized, is the companion work. In the functioning of this machine, the illusion is not that of expanding concentricity, but of black lines spiraling out infinitely from a center to an absorbing black ground. While linked—the spiral is a visual consequence of the circle—they differ as to meaning.

Precision Optics of 1920 derives from studies for *Oculist Witnesses* of 1920 which determined the voyeuristic elements of *The Large Glass.* Such an image presents centered, infinite repetition, unchanging holistic information. In this sense, its concentric circles may be compared to the holistic unitary elements of Minimalism—squares, checkerboards, cubes, circles. By contrast, other Minimal structures, either of lateral or vertical increments, differ in meaning. The vertical or lateral orientation is implicitly infinite, as Brancusi definitively showed in numerous variant *Endless Columns.* This kind of information—say, in a Judd, Andre, Hesse, or early Serra—is open and endless. In terms of their openness and (potential) endlessness, such stacks or alignments correspond to the infinite spiral of the turning *Rotary Demisphere,* and differ from the target-like formation of *Precision Optics.*

While verticals and horizontals postulate icons of infinity, infinity is even more explicit in the spiral itself, of which for us the cardinal example is Robert Smithson's *Spiral Jetty.* The iconic content of the spiral is meaningful insofar as it traces the path between closed worlds of abstract meaning—circles, squares, and triangles—and the open ones of infinite latitudes and longitudes. The negotiation of these symbolic worlds is a function of the eccentric value of pi(π), a ratio regulating, among other structures, the golden mean rectangle, the Fibonacci series, and the entire range of artistic composition when its value was obsessively noted by Jay Hambridge in his famous study, Dynamic Symmetry (1923). Pi was accorded sacred status precisely because the value allowed one

kind of symbolic meaning—closed—to become another kind—open. The legendary magician/mathematician is Hermes Trismegistus, the ancient Egyptian who, it was thought, discovered the ratio in the first place and who became the central hero of the entire hermetic tradition named for him. This kind of symbology is paralleled by the male/female exchange in androgyny.

Duchamp, presumably the figure most central to the maintenance of an esoteric intellectual tradition in 20th-century art (though this hegemony is really shared by Picabia, especially in his New York Dada phase), has been accorded a degree of unparalleled study since his work not only tantalizes formal analysis (and in the end defeats it). What intrigues in Duchamp is the attempt at reconstituting his hermetic thought processes. Through various clues, several critics have pointed to the pun—the sybilline thrifty utterances attributed to Rrose Selavy—as the central organizing principle of Duchamp's art. A recent study went further, attempting to structure Duchamp's (that is, Rrose Selavy's) puns systematically according to an informal linguistic examination.[18] There are apparently two kinds of puns in Duchamp. The first is one in which the homonymic elements replace and mirror one another in parity relationships; syllables and syllable sections account for one another and all components are exhausted. I associate the target, the closed world of primordial geometric shapes, with this kind of pun (e.g., *l'aspirant habite Javel et moi j'avais l'habite en spirale*). The other type of pun in Duchamp does not see-saw equal numbers of elements upon a fulcrum, but continues linguistically substituting homonyms across two or three fulcra—e.g., *esquivons les echymoses des esquimaux aux mots exquis*—suggesting by this structure an infinite number of increments. Such puns might reasonably be associated with the model of an open world of verticals, horizontals, and spirals.

The sexual metaphysic that underlies the Duchamp-Picabia "L.H.O.O.Q." exchange may have been further cued by a rather unexpected source. Arthur B. Davies remains problematic in the history of American modernism. His presence in The Eight exhibition of 1908 is still perplexing insofar as his work rejects the Ashcan principles of Robert Henri and his followers. Instead of a Hals-Manet-Munch and anti-National Academy of Design position, or even a quasi-Impressionist stance—all of which are shared by the Henricists (Glackens, Sloan, Luks, Shinn, and to a lesser degree, the Impressionists Prendergast and Lawson)—Davies' work reveals a nostalgia for the Symbolist proclivities associated with other models—Gustave Moreau, Odilon Redon, and Ferdinand Hodler, who, like Davies, were attracted to esoteric religious doctrine. The inclusion of many Symbolists in the Armory Show was surely a reflection of Davies' Symbolist predisposition. Davies' painting of the first decade of the century reveals not only a fascination with a broadly painted here-and-now, but with intimately scaled escapist subjects dealing with reverie, such as *Sleep* ... (ca. 1905; Worcester Art Museum), with its references to Hodler and Redon—the artist most heavily shown at the Armory Show, or the even more enigmatic *A*

Double Realm (ca. 1906; Brooklyn Museum). The title of this work is intriguing—it is the alternate title of Picabia's L.H.O.O.Q. interlace—since Davies' connection with the esoteric revival of the latter 19th century has tended to be ignored. It appeared he was a Theosophist, and drawn to yoga breathing exercises in all likelihood because of their place in Eurythmy as taught by Rudolf Steiner.[19] *A Double Realm* appears to be a straightforward grand landscape despite its small format, one that celebrates the external world. Yet its title implies a rent between the empiricist externals and its Symbolist implications. I believe "the double realm" here refers to a Theosophical inner truth before a material vision. As such, the American antebellum Transcendental landscape—Cole and the Hudson River School—remains a source.

Davies' paintings, difficult to square with an Ashcan ethos, grew even more perplexing when he encountered Cubist and Futurist developments. His later work tends to be patronized for only superficially grasping the fractured and prismatic possibilities of these styles. Yet, when the Armory Show of 1913 was being prepared by the Association of American Painters and Sculptors, it was Davies who led this association to the European practitioners. He brought a real awareness of modernist issues to the organizers, one coeval with those of Steiglitz and the 291 circle (that is, the core of the New York Dadaists) who, indifferent to Ashcan painterly realism, shied away from this group.

Dadaist activism and Metaphysical painting in Italy were parallel reactions to the Cubo-Futurist mode that cleaved to the metaphysical rather than the physical side of 20th-century experience. Both modes challenge concepts of what is real. As Davies' *A Double Realm* may reflect symbolist doctrines underlying the physical world, so too does de Chirico's *The Double Dream of Spring* (1915; Museum of Modern Art) bring into play a reality beyond that of the merely sensory. The central image of this early Metaphysical work is a painting upon an easel, a painting-within-a-painting, a depiction that casts doubt upon the "normal" sequence of representationalism. For if what is depicted on the painting is an illusion, then that surrounding the easel must be real. But this is a paradox, as the raw material of de Chirico's representationalism is itself "painted," hence not "real" (a conceit surely not lost on Johns and Rauschenberg).

Among the illusionistic appurtenances of de Chirico's Metaphysical painting is a deep perspectival arcaded space, little figures casting long shadows, sexually-metaphorical onrushing steam engines, Renaissance towers, and, not the least, evocations of Classical statuary. The Hellenistic *Sleeping Ariadne* is partially diagramed in the painting-within-a-painting of *The Double Dream of Spring,* for it is in sleep that the mind may reconcile the duality of nature as itself and as a symbolic veil.

In the *Amusements of a Young Girl* of 1916, de Chirico alludes to domestic skills such as sewing (spools of thread and binding tape), while the glove may infer masturbation. The sexual symbolism inherent to Metaphysical painting

enabled de Chirico to transmit insight concerning a female psyche. Similarly, in *Song of Love* (1914), a glove is centrally contrasted with the classical head of the *Apollo Belvedere*. This rubber glove is quite different from the leather or cloth glove in *Amusements*. While inferring domesticity or domestic chores, it is more immediately allied to surgical or medical imagery. Since the central ambition of Metaphysical painting was, as it would be for Surrealism, the illumination of paranoia or schizophrenia through the use of sexual symbols, it may be that the rubber glove connotes an illegal surgical intervention such as an abortion. Obviously, this cannot be definitively shown to be the case, but it is interesting that these Metaphysical still lifes attempt to enter a young girl's fantasy although they remain male (hence sexist?) fantasies about female thinking.

But who can be the male who is the female? The seer, or shaman, traditionally cast in a bisexual role. The seer is a favorite personage in Metaphysical painting, and it is hardly surprising that Apollinaire's play *The Breasts of Tiresias* (1917) is accounted the first Surrealist drama.

De Chirico's symbolic androgyny adumbrates Duchamp's similar achievement when, in conceiving the function of the elements in *The Large Glass*, he separated out the male and female parts of his name (the MAR of *mariee* [bride] and the CEL of *celibataires* [bachelors]), perhaps as early as 1912 but surely by 1919 when the Rrose Selavy material began to appear.

By 1917, the metaphysical concerns developed by de Chirico in Ferrara during the First World War would be powerful enough to staunch the by then dated modernism of Futurism. The 1915-17 phase of de Chirico's activities, however, remain sufficiently unclear for his major convert from Futurism, Carlo Carrà, also to claim authorship for the shift in Italian sensibility towards Metaphysical painting and the subsequent nationally oriented work of the *Novecentisti*.

Still, circumstantial conjectures may be made about de Chirico's Italian episode during the war. Unlike most artists associated with the heroic years of early modern art, de Chirico trained not in France or Italy but in Germany, in Munich, where he studied with the Swiss painter Arnold Böcklin until 1910 when he then left for Paris. Böcklin's paintings afford specific iconographic sources for de Chirico's earliest "enigmatic" style. More important to our concerns, de Chirico's long German sojourn primed him not to French but to German culture; the esoteric literature he came to know was not, like Duchamp or Picabia, French Symbolist literature, but the traditions of German Romantic poetry—say, Novalis and Kleist—and, more important, early psychological writings such as those by Otto Weininger (his bisexually obsessed *Kunst und Geschlect,* for example) and Sigmund Freud. In this he was greatly in advance of his French colleagues who had to await the French translations of the '20s, as the English-speaking world had to await the Leonard Woolf editions of the late '30s and '40s. This knowledge put him at distinct advantage in Paris prior to World War I, and helps explain de Chirico's close friendship with Guillaume

Apollinaire who, despite close association with Cubism, was perhaps more attracted by Symbolism, poetics, and proto-Surrealism.

I propose the following scenario: Ferrara served as the central Italian hospital city of the First World War, and it appears that it was a seat of Italian military intelligence as well. De Chirico's stationing there may have been caused by a nervous or mental breakdown, or by general ill health, unlike Carlo Carrá, who arrived there a wounded soldier. De Chirico's probable awareness of Freud's theories may have stood him well in Ferrara. It is even possible that he intermittently acted as a lay analyst to Italian soldiers brought there for rest and recreation. Mostly however, de Chirico's presence in Ferrara tied him to a desk job, the specifics of which have yet to come to light; it may even be that he served in some capacity in the intelligence corps.

Even were these conjectures—some or all—to prove untrue, the fact that Metaphysical painting reveals specific Freudian concerns as well as an imagery related to military intelligence or strategy—Mediterranean topographical maps, Italian regions symbolized in local breads, bomb targets, or military insignias—is irrefutable on the evidence of the pictures themselves.

Though the general motival and formal properties of Metaphysical painting had been developing in de Chirico's work from 1910 on, and were already exemplary in his 1912-14 phase in Paris, perhaps the clearest link to the iconography of the mental is to be found in Carrá's *The Metaphysical Muse* (1917; Museum of Modern Art). The mannequin tennis player on the left in this work[20] is an updated image of the early Renaissance undersculpture upon which painted gesso drapery was subsequently affixed. A topographical map of the Mediterranean is abutted to a powerful target image suggesting the craft of war, airplane insignias on wings and tails or specific bombsites. This abutment of map to symbol had occurred in de Chirico's evangelical and metaphysical still lifes of the previous year. In these still lifes, the maps are placed beside local breads, suggesting both the native foods of Italian regions and the eucharistic symbol.

The relationship of target symbol to the military is not only found throughout Metaphysical painting, but in the work of Marsden Hartley from 1913 on. Hartley worked in Munich prior to World War I, shortly after de Chirico and at the same time as Duchamp, and like them, had been attracted by the art activity of Munich and Berlin, centers of the Expressionist movement. While in Germany, Hartley developed a characteristic use of target images which he brought back to the United States during the war. In his works, the target (or a semi-target) is located in the center bottom of an often square canvas format.[21] Equally striking is the fact that, like Picabia and Duchamp, Hartley made inscriptions upon his pictures. The 1916 target/inscription painting *Trixie* (probably a depiction of a sail boat, as are many of these early "abstractions") suggests an American version of Picabia's *Udnie* (i.e., "nudie"), the multiple adventures of Duchamp's nudes, imbued with the memory of Ryder's Boats. Ryder, not incidentally, was a hero to Hartley—he knew Ryder as an old man,

revered him as a kind of sage, and even wrote an essay to honor the American Symbolist. Hartley's Expressionist use of a target motif (although through the 'teens he passed as a Dadaist), while it suggests a transposition of Delaunay's Orphist rainbow compositions, is probably linked to a vestigal military iconography connoting perhaps a certain common interest with Metaphysical painting as well. This is exemplified in, say, the 1914 *Portrait of a German Officer* in which a target image is centered within a wide array of abstract decorative motifs such as crosses and checkerboard fields.

These many examples show that the commitment to intelligence marks a broad range of American art from the late 19th century on—and that the target is a sign of that fascination. The image has proliferated from the '60s on so that perhaps a final word is called for, if only to dissociate this symbol from our often more sensibility-aimed manifestations. Much has been made of the connection between Frank Stella's *Sinjerli III* (1968) and its model in Robert Delaunay's Orphist tondo, *Disk* (1912). Without wishing to minimize the nature of this homage to Delaunay nor the questioning, intellectual character of Stella's painting throughout his career, Stella's scaling up from Delaunay's intimist image to the public one of the protractor variations—of which *Sinjerli III* is an eccentric variation—is keyed into Stella's admiration of Matisse's later style of public decoration marked in his work from the Barnes Foundation Murals on (1931). While Stella's target is clearly a very intelligent painting, its meaning both formally and iconographically is less about intelligence and more about sensibility. I would make the same assertions about Noland's *Targets*. In this aspect both Noland and Stella may be responding, in varying degrees of intensity, to the models of a more mystically linked painterliness found in Barnett Newman's images of the *Void* of the mid-1940s.

Notes

1. Joseph Mascheck, "Teddy's Taste: Theodore Roosevelt and the Armory Show," *Artforum,* Nov. 1970, vol. IX, no. 3, pp. 70-74. Roosevelt reasonably regretted the absence of Marcius-Simmons, considering the high incidence of Symbolist art included in the exhibition.

2. Eleanor Green, in her essay for the catalogue *Augustus Vincent Tack, 1870-1949* (University Art Museum, University of Texas at Austin, Aug-Oct. 1972; University of Maryland Art Gallery, Oct-Nov. 1972), surmises this possibility but makes no specific connection of Tack's to so reasonable a Rosicrucian model (p. 8).

3. Regina Soria, *Elihu Vedder, American Visionary Artist in Italy* (Cranbury, N.J., 1970).

4. Lloyd Goodrich, "New Light on the Mystery of Ryder's Background," *Art News,* vol. 60, no. 1, March 1961, pp. 39-41, 51.

5. From a letter to Thomas B. Clark (typed copy in the possession of Mrs. T.B. Clark, Jr.). Information supplied by Professor H. Barbara Weinberg, whose study, "Thomas B. Clark: Foremost Patron of American Art from 1872 to 1899" appears in the *American Art Journal. VIII,* no. 1, May 1976, pp. 52-82.

6. The poem is reproduced in *Albert Pinkham Ryder* (Corcoran Gallery of Art, April-May, 1961, with an essay on Ryder by L. Goodrich) on page 24, facing an illustration of *The Temple of the Mind.*

7. In 1907, Dr. John Pickard, professor of classical archaeology and the history of art at the University of Missouri, in organizing a pioneering course in the history of American painting, solicited information from distinguished artists of a disparate range of interests: academicians, Impressionists, Symbolists—among them George DeForrest Brush, Robert Henri, Dwight W. Tryon, Childe Hassam. Thomas Eakins, and still others. Allen Weller, who brought this information to light, notes in "An Unpublished letter by Albert P. Ryder" (*Art in America,* April 1939, Vol. 27, no. 2, pp. 101-2) that Ryder's reply was the most interesting.

8. Robert Rosenblum, *Ingres* (Abrams, New York, 1967), p. 148.

9. Number 285 in the 1944 catalogue of the Rodin Museum, Paris, dressed by George Grappe. Professor Kirk Varnedoe, Columbia University, supplied me with the catalogue number, and Professor Albert Elsen made the Rodin Archives, Stanford University photograph available to me.

10. R. Pincus-Witten, "Theater of the Conceptual: Autobiography and Myth," in *Marcel Duchamp in Perspective,* edited by J. Masheck (Prentice-Hall, New York, 1975); first published, *Artforum* (October 1973).

11. If concentricity is seen as an adjunct to target imagery, then perhaps radiation ought to as well. This premise granted, the sectioned umbrella collaged as a circle upon Rauschenberg's *Charlene* (1954) would become a natural parallel to Johns' *Targets.* To dwell upon this analogue an instant more: the other symbolic icon to emerge from Johns' *Targets* are the *Flags.* The *Flags* and Rauschenberg's *Bed* are roughly comparable; beyond so simple an issue as rectangular format, they both elaborate paradoxes dealing with cloth. The Rauschenberg is literally a picture painted on a pillow, sheet, and quilt, while Johns' work is a flag, an illusionistic piece of cloth. Similarly, both artists attack pictorial conventions by pressing their paintings in the direction of objects. Rejecting conventional figure-ground relationships as the basis of their painting, they both postulate work in which the figure and the ground coincide to produce a new, ambiguous species, that of the object. This reinforces the sense that the primary intentions of such work are not representational or illusionistic but rather the actual, literal object. *The Bed* is largely an Abstract-Expressionist alteration of an American quilt. It is unlikely that there is any more American domestic skill than quilting. This subject appears early on, for example, in John Louis Krimmel's *Quilting Party* (Winterhur; 1813).

 Putting aside the question of historical precedents, there is the whole matter of autobiographical referents in Rauschenberg's (and Johns') work. It well may be that the close friendship between the artists, dating to that moment, is memorialized in *Bed.* Enlarging on the non-formal, associative side of *Bed,* a story presently circulates that its quilt belonged originally to Dorothea Rockburne, who in the '50s was, with Rauchenberg, a student at Black Mountain College. The quilt was used, it is said, to wrap her then-infant daughter. Last, that *Bed* is, after all, a painting may play with the Dada conceit between "making a bed" and "making (i.e., painting) a picture"—an extremely Johns-like notion in the work of an artist who otherwise derives so much from an Expressionism and the Picasso collage tradition. There is scarcely a more Johns-like work than *Bed* in Rauschenberg's oeuvre.

12. Reasoning from numerous clues starting with Chagall's paintings of his first Paris days, around 1911, I noted that the target "is the icon par excellence of explosive energy, of new beginnings in the 20th century" ("Sons of Light: An Observer's Notes in Israel," *Arts Magazine,* September 1975). Typical of the major canvases of that date is a target formation, such as the one in the self-portrait souvenir, *I and My Village,* a painting which recapitulates the psychological and

religious issues pertinent to an orthodox Eastern European Jew drawn into the Cubist and Futurist melée. The structural referents—concentric circles (a target?) coinciding with corner-to-corner diagonals—signifies, it would seem, the new identity, the free artist, fortified by the recognition that bohemian Paris represents the secular paradise, the new Eden. Such an indication is borne out by Chagall's *Homage to Apollinaire,* a pendant painting of 1911-12, in which the target is given a specific identity as the face of a clock. Adam and Eve, conjoined as a single figure, function not only as the insignias of primordial parents, but as the hands of this chronometer of new time. It is likely that Chagall's *Homage* (one made as well to Cendrars, Camondo, and Walden) is related to a painting by another emigré Russian in Paris, Natalia Goncharova's *Clock,* with Futurist face that corresponds to Chagall's clock. Jacques Lipschitz' sculpture *The Meeting* (1911-12), which duplicates the primitivizing confrontation of the Adam and Eve figures in Chagall's *Homage,* enlarges this iconography among Eastern Europeans in Paris, that is, nationals extremely sensitive to the retrograde pull of a provincial art, but themselves now liberated in the center of modernism. Like Chagall, Lipschitz' Lithuanian Jewish orthodoxy made him that much more susceptible to the meaning of new time symbolized by Paris. Lastly, the male-female confrontation in several versions of Brancusi's *Kiss* (1908 on) more starkly renders the sense of the new beginning of modernist time that Paris represented for the Eastern Europeans.

13. There is also an "active iconography," recognizable imagery of the real world, e.g., wire clothes hangers. Flags, though "real," perhaps stand in a middle ground between the abstract or inert iconography of letters and the active iconography of clothes hangers.

14. Kandinsky established the preeminence of this set by including a primary colored plate of circle, square, and triangle in the first Russian edition of *Concerning the Spiritual in Art* (1914).

15. Compare these early modern examples with a typical late-modern statement: "Pure paper addresses itself articulately to the problem of painting. . . . It was a ground itself. I simply called the paper "ground" and considered it a position upon which I could build. It became a zero point for the reductionist tendency I was involved in. . . ." Joel Fisher, *Ein Unwiderruflicher Schritt,* exhibition catalogue (Stadisches Museum, Mönchengladbach, Sept.-Oct., 1975).

16. A pendant work to the *Spanish Night* would be *Optophone I* (c. 1922), a work which depicts a reclining female nude centered on a field of rings of a black and white target. William Camfield, who has worked most extensively on the meaning of the Machinist style of Picabia, noted that *Optophone* "seems to be . . . an instrument that 'converts' electrical energy into sexual energy." This conclusion is drawn from the fact that a real optophone "is an instrument which converts light variations"—the black-white interchange?—"into sound variations so that a blind person may estimate varying degrees of light through the ear and actually 'read' printed matter." (William Camfield, *Francis Picabia,* Solomon R. Guggenheim Museum, 1970, p. 119.)

 Even earlier, *Voila elle,* a mecanomorphic drawing by Picabia reproduced in the *291* of November 1915 (facing, significantly, Marius de Zayas' futuristic poem *Femme!*) prominently depicts a pistol and a target. Of this major example of New York Dada, Camfield notes: "De Zayas' poem denounces the woman as an unintelligent creature consumed by carnal desires—an opinion echoed in Picabia's drawing of a pistol and a target with connecting mechanical linkage. The pistol and target, forms repeatedly employed by Picabia as male and female sexual symbols . . . , are aligned with the clear implication that a target hit would cause the revolver to be re-cocked and discharged again in a repetitive, mechanical action. *Voilla elle* thereby becomes an automatic love machine akin in theme and spirit to Duchamp's . . . *The Large Glass.*" (William Camfield, *Ibid.,* pp. 37-38).

 In this purview with *Lampe Cristal* (Weston Collection, Cincinnati; 1922) is telling. Here the enemy motif begins as a black and white centered target, at length radiating the colored energy of the spectrum across the concentric striped field; black lines suggesting a filament to this

crystal lamp abstractly enact the sprawled configuration of the nude at the center of *Optophone I.* I suppose that the *Lampe Cristal,* like so many creations of Picabia's Machinist style, or of the Duchamp/Picabia mechanomorphs, is a portrait-evocation, but of whom? The drawing is dedicated to Madame Dalmau, wife of the celebrated art dealer in Barcelona which, at its heyday, was a center of Spanish Dadaist and Surrealist activity. But it seems unlikely that she is depicted, if the drawing is, as I suspect, a crypto-portrait. These kinds of questions are illuminated by Camfield's "The Machinist Style of Francis Picabia," *The Art Bulletin,* 48 (1966), pp. 309-22, William Innes Homer, "Picabia's *Jeune fille americaine dans l'état de nudité* and *Her Friends, The Art Bulletin,* 57 (1975), pp. 110-115, and Dickran Tashjian, *Skyscraper Primitives: Dada and the American Avant-Garde, 1910-1925* (Wesleyan University Press, 1975).

17. Joséphin Peladan, *De l'Androgyne,* théorie plastique (Sansot, Paris, 1910). Peladan's work is marked by the sinological studies of the Lyons scholar Charles de Paravey (1787-1871), an intimate of Peladan's family. See de Paravey, *de la Creation de l'homme comme androgyne et de la femme* (Paris, 1864). The questions of androgyny preoccupied Peladan as a novelist, too. His two novels, *l'Androgyne* and *Gynandre,* were brought out in Paris in 1891. Peladan's fascination with the Mona Lisa led to his article "la Joconde: histoire d'un tableau," *Les Arts,* Janvier 1912, pp. 1-9.

18. Katrina Martin, "Anemic-Cinéma," *Studio International* (Jan.-Feb. 1975). Vol. 189, no. 973, pp. 53-60.

19. Royal Cortissoz, *Arthur B. Davies* (Whitney Museum of Art, 1931), part of a series of popular introductions to the work of American artists, was once the only reference work on Davies' career. Cortissoz brushes past this material with this intriguing remark: "...Davies became interested in a relationship which he...discovered, between the art of the Greeks and inhalation. As a result of this he made researches in the processes of inhalation, the results of which he applied in his subsequent work." Cortissoz, the leading critical proponent of American academics of his period, notes that Davies investigated these exercises with a Dr. Gustavus A. Eisen, and that he embarked on them on the last years of his career, after 1922. My feeling is that Davies was intrigued by such questions long before the 1920s. Cortissoz appears to be basing his observation on an essay by Eisen called "Davies Recovers the Inhalation of the Greeks," *Arthur B. Davies, Essays on the Man and His Art* (Philips Publication, No. 3, 1924), pp. 69-78.

20. The subject may allude to Nijinsky's choreography and dancing for *Jeux,* premiered for Diaghilev's ballet company in 1913. This is the first ballet to use modern athletic dress—tennis flannels—as costume. It was equally shocking for both Nijinsky's use of athletic movements as the basis of his choreography, and the innuendoes of lesbian interplay between the two female roles. The libretto invokes Nijinsky's choreography of 1912 for *l'Apres-midi d'un faun* (based on Mallarmé's epic poem) in which a faun may or may not have had sexual relations with the nymphs who danced with him. The scores for both *Jeux* and *l'Apres-midi* were composed by Debussy. In Francis Steegmuller's *Cocteau* (Atlantic Little-Brown, 1970; p. 81), the playwright recalls that Nijinsky's choreography for *Jeux* was as outrageous an exposure of Diaghilev's fantasy about having sexual relations with two men simultaneously—although females replace males in the ballet—as was then possible.

21. William H. Gerdts, "The Square Format and Proto-Modernism in American Painting," in press, *Arts Magazine.*

White on White: From Tonalism to Monochromism

White on White, a Suprematist canvas painted by Kazimir Malevich, is ranked among the few radical position works in modern art. In the context of the ensuing argument, it will be shown to mediate two kinds of Symbolism, the synaesthetic tonalism of the late 19th century and the utopian monochromism of our own age. *White on White* may be understood as concerning two kinds of whites or an adumbration of its own capsulation into total monochronism. The result of the latter option for subsequent art is immense, its reductiveness speaking for the image of social perfection which the Russian Revolution was to have brought about. In Malevich, all this is symbolized; as such, the picture is not about itself. By contrast, recent monochromatic usage, say, in the work of American and European Minimalists, stands for nothing outside of itself. The gulf appears without bridge. Yet within this disparity lies a virtually endless selection of 20th century works which, in some way, approaches either extreme.[1]

Clue to the meaning of the break between such contradictory views can be gained if we examine some of the theoretical groundwork out of which Malevich grew, and in many respects, Mondrian as well. It is a commonplace to compare our Minimalist positions with the achievements of these artists. It is more subtle to indicate that both these men, and the movements they represent, Suprematism and de Stijl, had in great measure absorbed the tonalist thought endemic in the Symbolist position of the latter part of the 19th century through the early 20th. In this connection the achievements of an America expatriate painter—James McNeill Whistler—cannot be underestimated.

Whistler did not paint monochromatic works; rather he regarded his works as striking monochromatic notes. Through this attitude, the *Symphonies,* the *Nocturnes* were imbued with a musical pitch which previously had no existence as *pictorial value.* These major coloristic thrusts, despite the descriptive roles they played (fog, crepuscules, fireworks) also approximated, in the artist's mind, the private emotion inherent in the musical experience or aural episode. Whistler's views were confirmed, probably instigated, by two friends (one English, the other French), Albert Moore and Henri Fantin-Latour. The

former's indolent, draped nudes appeared to have no didactic end, no other purpose than to be themselves. The latter, like Whistler, had broken from the sensationist-based art of Impression in the 1870s, largely because of his trust in the confluency of music and painting. At that time, the Impressionists at last were able to assert themselves as independent of Courbet and Manet; Whistler and Fantin-Latour had in turn broken with the group with which they once had formed a common front during the 1860s. Neither Whistler nor Fantin-Latour was to appear at any of the eight Impressionist exhibitions held intermittently between 1874-1886 because they were unable to break faith with the new values they felt were now essential to their art. While Whistler began a long series of *Symphonies, Nocturnes, Caprices, Fantasies*—an opera of Chopin-derived nomenclature—Fantin-Latour had begun his "serious" painting, not the flower pieces on which his wide esteem is based, but the fustian evocations of scenes from Wagner, his idol, and shortly the idol of the Symbolists as well. It is curious that Whistler's aesthetic intransigeance was probably theoretically based, since his biographers record that he had a "tin ear." Unlike Fantin-Latour, a melomane, Whistler was unmusical in the ordinary sense of the word.

Perhaps the most famous of the early tonalist work is the first *Symphony in White,* one of the several portraits of Whistler's Irish mistress Jo Heffernan. It dominated the central entranceway of the historic *Salon des Réfusés* of 1863 and was regarded in its way as scandalous as Manet's *Déjeuner sur l'herbe,* which was shown at the same exhibition. Naturally the work drew adverse comment. It was novel on many levels, not the least being that Whistler, in advance of Degas, was conscious of the possibility of transposing Eastern graphic values into Western pictorial conventions. Jo's beauty reflects Whistler's admiration for the courtesan prints of Utamaro, a fact which cannot have failed to characterize in part the nature of his relationship with Miss Heffernan who, in the painting, dominates the polar bear on which she stands. It is more to our point that these multiple levels of idea are presented in terms of vari-tinted patches of warmer and cooler white, played off against Jo's russet hair and the yellowish passages of brushy polar bear fur: the image imbued with the controlling emotion of a single color—a musical tone or "hue," so to speak.

Later French painting, that of the Nabis and Intimists particularly, would take these views for granted. One of the celebrated canvases of Nabis-Intimist painting is Vuillard's *Symphony in Red* (the connectedness to tonalism is an important feature of Intimist art). Picasso, at twenty newly arrived in Paris, explicitly allied himself with the modernity of Nabis painting. Influenced by Toulouse-Lautrec, he painted *The Blue Studio,* a work of tonalist attitude which, by 1903, will have expanded to govern an entire production—"the Blue Period"—to be followed shortly thereafter by the "Rose Period." Gauguin, the chief Nabis mentor-as-hero, had noted in a South Sea manuscript, *Diverse Choses* (1896-1897) that "Color, being itself enigmatic in the sensations which it gives us, can logically be employed only enigmatically. One does not use color to

draw but always to give the musical sensations which flow from itself, from its own nature, from its mysterious and enigmatic interior force..." At this late date, it is perhaps egregious to note that the first premise of Maurice Denis' *Definition de néo-traditionisme* runs that "A picture... before being a battle horse, a nude woman, or some anecdote... is essentially a plane surface covered with colors assembled in a certain order..." Whistler's "certain order" had been synaesthetic tonalism.

In the period just prior to the discovery of Cubism, then, the monochromatic work existed if not literally then at least theoretically. For some, and this still included Picasso before 1907, the attachment to tonalism was expressive of delicacy and modernism of taste, themselves demonstrations that the artist embodied the moral superiority Baudelaire had codified as the signal quality of the dandy.

Since Whistler's nominal defeat of Ruskin at the libel trial over the *Nocturne in Black and Gold* (1877), tonalism came to be held in reverence by the young "moderns" of the day. Even black and white (Manet had regarded them to be as colorful as spectrum color) were regarded as possessing sensuous appeal, additionally valorizing these extremities of the gray scale beyond the prestige they enjoyed throughout the history of religions as the representative symbols of either the presence or absence of divine numinousness—of good and evil.

As it must appear that I am stacking arguments with regard to tonalist postulates, a few examples are in order. In a misunderstood work, Huysman's masterpiece *À Rebours* (1884)—aimed at demonstrating that the elaborate ritualization of senses inherent in aestheticism leads to a sterile death in life—we find Jean des Esseintes newly installed in his house in Fontenay (today, ironically a Paris suburb of bourgeois villas) winning the reputation of an eccentric, for among other things, having given a "funeral feast in celebration of the most unmentionable of personal calamities" (a passing bout of impotence) at which the entire meal, décor and service were arrangements in black. Not incidentally, Whistler's portrait of Lord Leyland, who had commissioned the famous Peacock Room, is in its effect (though not titled this way) a *Symphony in Black* or a black on black canvas, the Lord's evening clothes joining as one unit with the black background.

By contrast, in *Un Coup de dés,* the most hermetic poem of Symbolism's chief poet and theorist, Mallarmé, we find the meaning of the poem is built into, so to speak, the blank spaces of the spare typography. The whites of the page for Mallarmé specifically elaborated upon the meaning of the words. The poet said, in an explanation of the work published in a transient review called *Cosmopolis,* that "the whites of the printed page in fact assume importance, make the first impression; the versification requires this, as ordinarily, silence around a lyric work... I do not transgress this measure, merely disperse it."[2]

Another seemingly transient example from the late 19th century is telling. It was thought that one of the listed number of lithographs for the ninth and last

volume of *L'Estampe originale* (ninety-five commissioned works during 1893-1895), published by *Le Journal des artistes,* an organization dedicated to the dissemination of artistic lithography, was missing until it was recognized that the blind embossing which formed the tailpiece of the collection was, in fact, "an inkless intaglio print"[3] depicting a nude woman seen from the rear, a work executed by Alexandre Charpentier. It has been assumed that a print required an inked surface during its execution but Charpentier, the greatest of the *medaillonistes,* simply projected a sculptural attitude with regard to the graphic problem, viewing the ensuing *repoussoir* quite sufficient in itself to justify its existence as a legitimate print.

Similarly, this time in connection with popular advertising, the French biscuit concern, Lefevre-Utile, as a means of stimulating interest in its product, published a succession of biographies and caricatural portraits by Cappiello of the leading figures of the turn of the century, actors and actresses, called *Les Contemporains célèbres.* Eventually the collection was bound together between wooden covers (1904). Set into the front was the likeness of the "divine" Sarah pressed into an artificial ivorine substance and designed by one of the chief decorators of the period, Alphonse Mucha, who, in this way, also employed a white graphic piece modulated by the incidental flow of light across a relief surface.

Such experiments, either in abstruse literature or popular to the point of crass commercialism, are important because they establish models for the uncolored intaglio print, which by our mid-century had become a "modernistic" cliché—the print without ink—despite enormous differences in style and intention between the art of *La Belle Epoque* and the one of our reductivist abstract vernacular.

In drawing lines between the Symbolist work and the monochromatic print I am simply asserting that the latter is more an heir to tonalist aestheticism than its practitioners would admit, or perhaps are aware, reasonably assuming that the intaglio print responds to its own inherent technique and systems of order. Perhaps. Clearly, the colorless print takes on patterns of reductivist abstraction (the tradition begins before the First World War) such as modular sequences or checkerboard grids, but until the advent of Minimalism in the mid-1960s, these achievements were employed in *recherché* ways, the very trickiness of their optical appeal alluding to a delicacy of taste rather than the controlling principles of the utopian abstraction we find in Malevich or his disciples.

Certainly, this is not the whole story. My reservations are centered around the optical end to which the intaglio print (or drawing) is often sacrificed, an end connected to the refinements of aestheticizing tonalism. I refer to the kind of prints (or drawings) favored by *Group Zero,* or those gimmicky experiments of the *Group de Recherche Visuelle.* It continues, for me at least, in the visual gymnastics of Vasarely's work, for example. Risking overstatement, I am inclined to believe that all optically oriented achievements of 20th century art

(this includes the work of figures like Vasarely, Bridget Riley, and Richard Anuskiewicz) are a kind of tonalist aestheticism.

It was against the aesthetic tradition that Malevich was at last brought to Suprematism, even though his compatriot and, during the Revolutionary years 1918-1922, his rival, Kandinsky, still is in part indebted to the aesthetic baggage inherent in tonalism, which Kandinsky regarded as the expression of "the spiritual in art." Owing to the notion of sound-color equivalence in the Secession center, Munich, where Kandinsky lived, the Russian painter continued to project into his Expressionism a heavy rationale of musical inference. "Even in this painting" (*The Old City,* an evocation of Moscow that Kandinsky painted shortly after his arrival in Munich in 1905), "I was really chasing after a particular hour... the sun melts all Moscow into one spot, which like a mad tuba, sets one's whole... soul vibrating. No, this red unity is not the loveliest hour! It is only the final note of the symphony which brings every color to its greatest intensity, which lets, indeed forces, all Moscow to resound like the *fff* of a giant orchestra. Pink, lavender, yellow, white, blue, pistachio green, flame red houses, churches each an independent song... raging green grass, the deep murmuring trees, or the snow, singing with a thousand voices, or the allegretto of the bare branches, or the red, still silent ring of the Kremlin walls, and above, towering over all like a cry of triumph, like a hallelujah forgetful of itself, the long, white delicately earnest line of the Ivan Veliky Bell tower..."[4]

This euphoric passage, one of hundreds of "purple patches" in Kandinsky's large body of tractarian writing, clearly illustrates the cast of mind of numerous artists, even great ones, in the period of the discovery of abstraction, an event which occurred in various European centers immediately prior to the First World War. For sure, this discovery came about in many cases because certain artists thought that their abstractions were, so to speak, "pictures of something," that "something" being the order of music, or more loosely expressed, the order of sound. Aural parallels (they are Kupka's as well) provided a theoretical base from which many made the imaginative leap to abstraction. Even radical reformulations of nature, such as we find in Hermetic Cubism (1909-1912) still meant, for Picasso and Braque, an art that was naturally transcriptive. They believed (despite the axiomatic radicalism of their work) as did most men of their time, that pictures had to remain in some sense "naturalistic," however tenuous the naturalism, since wholly abstract forms (especially the forms of planar geometry which was the basis of most "non-objective" abstraction) were forms incapable of arousing sensations of empathy. One simply could not project an emotion into the image of a square, or the square induce an emotion in its turn—or so it was thought.

It was, in fact, the close veering to full abstraction inherent in Hermetic Cubism which precipitated the writing of *Du Cubisme* (1912) by Gleizes and Metzinger. Threatened by a Cubist achievement which went beyond simple analytical postulates, these painters aimed at preserving an art of objective

reality as begun in the naturalist precepts of Courbet—an art, however, simplified by the planes, strong tonal contrasts and quasi-geometrical elementarism, the "cubic" of Cézanne. Obviously, Picasso and Braque in 1909–1912 only retained a fluctuating network of edges, but remotely relating to the edges of planes, and which seemed illuminated as if from within the painting. This is the opposite of illusionistically depicted planes, seemingly lit from without, like sculpture, which marked the first Analytical phase of Cubism in which Gleizes and Metzinger were still working. They appear to argue for a progressive art: "Let the picture imitate nothing and let it present nakedly its *raison d'être*" only to deny this bold credo with the cautionary note:"Nevertheless, let us admit that the reminiscence of natural forms cannot be absolutely banished; not as yet at all events. Art cannot be raised all at once to the level of pure effusion."[5] How wrong they were in this early attempt at a history of Cubism. It was an error shared by the English as well.

Among the apologists for a new art based on primitive models and geometrical simplification was the English critic and philosopher T.E. Hulme, spokesman of the "London Group" which included, among others, David Bomberg, C.R.W. Nevinson, Wyndham Lewis, Gaudier-Brzeska and, at the beginning of his career, Jacob Epstein. Hulme, who died at the age of thirty-four in 1917, noted with Futuristic admiration for the machine, that the new art was going to express "a desire for austerity and bareness, a striving toward structure... away from the messiness and confusion of natural things..."[6] New art, like the drawing of an engineer, is that in which "the lines are clear, the curves all geometrical and the colour, laid on to show the shape of a cylinder for example, gradated absolutely mechanically."[7] But T.E. Hulme falters too, for like Gleizes and Metzinger, he clings to the idea which Malevich would render superfluous: "If form has no dramatic or human interest," he wrote, "then it is obviously stupid for the human to be interested in it."[8] He aphorizes this idea, when he quips that "a perfect cube looks stable in comparison with the flux of appearance, but one might be pardoned if one felt no particular interest in the eternity of a cube."[9]

Malevich changed all this. One *could* empathize with a cube, the spatial projection of a square, because in its presence one felt "a pure emotion"; "The square = feeling, the white space = the void beyond this feeling."[10] Malevich was describing the first Suprematist composition of 1912, a black square pencilled upon a white field, an act so extreme that one still marvels at its willfulness. Malevich imagined the possibility of an empathic relationship with non-dramatic, non-representational form. He insisted that not only could emotion be experienced *vis-à-vis* abstract forms, but that the emotions implicit in these forms were higher and better than the emotions invested in the forms of a naturalistically depictive art. In the midst of the turbulent enthusiasm for modernism in pre-revolutionary Moscow, and having passed through Folkloric

Primitivism and Analytical Cubism, Malevich in a "desperate attempt to free art from the ballast of objectivity" created Suprematism.

Apart from only momentary abstruseness, Malevich's ideas are easily grasped. They are bound to the dream of the utopian society which the Revolution was going to bring forth when a classless society had been instituted, free at last of the depredations of capitalism and the hypocrisies of organized religion. For such a new society a new art was demanded. Its vocabulary was to be that of Suprematism and ultimately Constructivism, a later evolution. But Lenin was indifferent to and Stalin opposed to the proposals of Suprematism which were regarded as neither programmatically nor didactically useful. The artistic taste of Lenin and Stalin had not evolved from the vapid distillations of bourgeois art which, vivified with a touch of Impressionism, had been the goal of Russian art since the mid-nineteenth century. With the advent of the cultural freeze, felt from the early 1920s on, Socialist Realism at length became the doctrinaire art of the Soviet Union and Suprematism was denounced as counter-revolutionary and bourgeois revisionist in intention. Still, Suprematist ideals dissembled within the art of El Lissitsky's *Unovis* group until in the Stalinist period various Soviet committees on fine arts had destroyed what was the single most advanced art of our century, more advanced in my view than that of Mondrian and Van Doesburg which, despite the many features they share in common, is after all, an extenuated Neo-Platonism.

The conclusions to be drawn by Malevich's actions were carried out by his disciples, who, in the period of cultural freeze, chose to leave Russia, most frequently for Germany, where (notably at the Bauhaus) they were able to transform Malevich's utopian theories into the practical, utilitarian ends to which the Bauhaus was dedicated. Malevich himself, in 1927, made a short visit to the school, carrying with him the Russian manuscript of *The Non-Objective World,* one of the great treatises on art. The work was translated into German and published by the press of the Bauhaus. The historical side of *The Non-Objective World* deals in part with the discovery of Suprematism, that "wasteland" or so the public thought, but for Malevich, a "desert...filled with the spirit of non-objective sensation which pervades everything."[11]

Lissitsky, Malevich's chief follower, converted from the folklorism of Chagall to the revolutionary art of Suprematism, drew the chief inferences of the *White on White.* Locating the roots of Suprematism in peasant patterns and crafts—the geometrical idiom of the Russian devotional icon is equally important—Lissitsky remarked that "Suprematism...did not wish to remain merely a decorative style, so it continued on the road toward the *annihilation of painting.* It seems to have begun to appreciate the relative lack of colour in the town in comparison to the village. This idea found expression in the final creation of the Suprematists and in 1918 Malevich exhibited a white canvas on which a plane was indicated with another white colour. By forsaking the

colourful and going over the colourless aspect, the Suprematists concentrated their attention on arranging the flat geometric planes which were to serve as ground plans for further spatial construction."[12]

These remarks were prepared for a lecture on *New Russian Art,* a large exhibition of Soviet art held in Berlin in 1922 which Lissitsky had organized. The theoretical interchangeability from one species to another, from painting to sculpture to architecture, is inherent in the morphology of elemental geometry. Malevich himself had made attempts at complex architectural monuments— *Arkitektona*—having concluded his essay on Suprematism with the observation that "a plastic feeling rendered on canvas can be carried over into space."[13] In Suprematism, architecture and sculpture coalesced into a single mode of presentation, the chief reason that Suprematist art seems so like American Minimalism of the mid-1960s. In our style the preeminent sculptural mode encloses an architectural aspiration as well.

Earlier, I underlined a phrase in Lissitsky's explanation of the *White on White,* the expression "the annihilation of art." Literally this is an impossibility. Certainly, if the Dadaists could not annihilate art then the Suprematists or the members of *Unovis* could hardly achieve this end.[14]

What I think is meant by this phase concerns the rejection of an art of individualized painting in which brushstrokes are personalized gestures and color a vehicle of sensibility. Malevich had reduced Suprematism to an art of squares and the color white; Lissitsky, who adopted the red squares as the special symbol of his *Unovis* group, to black, white and red; Mondrian and Van Doesburg to black, white and the three primaries. What we see then is that the art of the intellectual ambitions surrounding the Russian Revolution and the European *débâcle* of the First World War is one to which the act of visual reduction is central, in which the fewer the number of elements the greater the social implication. "Less is more" is a Bauhaus catchphrase. The drift towards the reductive mode means an element by element abandoning of those particular parts of painting which are expressive of outmoded individualized sensibility.

Reductivism leads directly to the monochromatic propositions of Yves Klein and Piero Manzoni in the late 1950s and early 1960s as well as the monochromism inherent in the Minimalist position of the 1960s. To take Klein as an example, at first, his work appeared to be unacceptable as art because it possessed an insufficiency of pictorial elements. In Malevich's *White on White* at least the square had been tipped, affording a constantly shifting reading of the field surrounding the square. Moreover, Malevich uses two kinds of white and the tipped square is demarcated by a still visible pencil line. In short, many visual activities remain evident, despite the reduced mode.

By contrast, Klein or Manzoni present an image in which no elements interact with one another. There is only the single colored plane. At length, the viewer concedes that the figure is the total image itself—and, by implication, that the ground becomes the surface on which the picture is displayed. This shift of

the ground onto the surrounding environment is one of the most important possibilities which painting took at the end of the Fifties. It is to be seen in a Jasper Johns *Flag* or *Number Painting* as well as in the constellation of slashed canvases in the work of Lucio Fontana of the same moment. Ultimately the implications of this evolution lead to our time, perhaps beyond. Our works sprawl across floors, lean against walls, depend from ceilings, rest in layered slabs one upon the other. Theoretical reductivism may, at length, lead us (if we are not already there) to an art which has no physical embodiment at all but which exists either as an imagined prospect or which is so insubstantial or so grandiose as to only be shown to exist through ancillary recording devices—the film, the photograph, the tape recording, the videotape or even the journal entry. We are probably at this stage in the present-day Conceptualist movement, an important connection to draw since Suprematism has been used almost exclusively to "justify" the earlier Minimalist episode. It is also important to note that much of the current Conceptual movement which grows out of Minimalism receives theoretical clues from Suprematism as well, clues such as we see in the wholly white chambers of Mel Bochner. Like Suprematism, Conceptualism is an art in which theory and doctrine equivocate with making as the primary artistic end. For the Conceptualist, objectification in some kind of sensuously determinable experience is a closed issue, one that already has been left behind.

At this point, we must admit that the reductivist process is not the closed machine of history that my earlier argument might suggest. Many stylistic threads inform the reductivist mode—not the least being Dadaism and dadaistically-inspired gestures of monochromatic appearance. Robert Rauschenberg's lost white paintings would be cases in point. And, granting that certain aspects of Dadaism emphasized a fundamentalist examination of base *materiel*—I think of the rejected substances of Schwitter's *Merz* collages—then certain Dadaist inferences can be drawn from some of the ultimate expressions of our own art, Robert Ryman's wall paintings and Sol LeWitt's wall drawings.

But the *annihilation of art* means, above all else, the rejection of sensibility and idiosyncratic personality, "sublime" ambitions central to the Field Expressionists—Clyfford Still, Barnett Newman, Mark Rothko and Ad Reinhardt. Although linked to the Dadaist tradition, Yves Klein can be understood in this light as well. "I am for a sort of depersonalization in art," he wrote. "The artist who creates should no longer do so for the sake of signing his work, but as an honest citizen of the immeasurable space of sensitivity, he should create always from his awareness that he exists, in a state of profound illumination, as does all the universe, but which we neither see nor feel, closed in the psychological world of our inherited optics."[15] The tone is close to that of Clyfford Still, who, in order to realize an art of total otherness, was first obliged to overthrow the "self-appointed spokesmen and self-styled intellectuals who with the lust of immaturity for leadership invoked all the gods of apology and hung them around our necks with compulsive and sadistic fervor. Hegel, Kierkegaard,

Cézanne, Freud, Picasso, Kandinsky, Plato, Marx, Aquinas, Spengler, Einstein, Bell, Croce, Monet... the list grows monotonous. But the ultimate irony—the Armory Show of 1913—had dumped upon us the combined and sterile conclusions of Western European decadence."[16]

In monochromism, "the longed-for tranquility of an absolute order," as Malevich described Suprematism, had been found. As it was for Klein, the monochrome represented the ineluctable here and now in which, through Klein International Blue, or Rose, or Gold, the artist could "experience a feeling of complete identification with space," an ether in which he was "truly free."

Notes

1. In the comparatively recent monochromes of Yves Klein and Piero Manzoni, or Robert Rauschenberg's White Paintings, the two attitudes are bound together mediated through Dadaist inferences.

2. I cannot dilate upon the implications of Mallarmé's work here. English translations of many of Mallarmé's critical articles occur in *Mallarmé, Selected Prose Poems, Essays and Letters,* translated by Bradford Cook, (Baltimore: Johns Hopkins University Press, 1962). Daisy Aldan, the poet, prepared an English edition of *Un Coup de dés,* preceded by a translation of the Cosmopolis essay, from which I quoted the opening lines. Further implications of Mallarmé's artistic gamble are indicated in my essay "Against Order: Poetical Sources of Chance Art," *Against Order: Art and Chance* (Philadelphia: University of Pennsylvania, Institute of Contemporary Art, 1970).

3. Donna Stein and Donald Karshan, *L'Estampe Originale, A Catalogue Raissonné* (New York: The Museum of Graphic Art, 1970), p. 7.

4. Vassily Kandinsky, "Reminiscences," *Modern Artists on Art,* ed. Robert Herbert, (New Jersey: Prentice-Hall, 1964), pp. 19-24, pp. 22-23.

5. Albert Gleizes and Jean Metzinger, "Cubism," *Modern Artists on Art,* Op. Cit., p. 7.

6. T.E. Hulme, *Speculations, Essays on Humanism and the Philosophy of Art,* (New York, 1960), p. 96.

7. Ibid., p. 97.

8. T.E. Hulme, "Modern Art IV, Mr. David Bomberg's Show," *The New Age,* vol. 15, No. 10, 7/9/14, pp. 230-232, p. 231.

9. T.E. Hulme, *Speculations,* Op. Cit., pp. 106-107.

10. Kasimir Malevich, "Suprematism," *Modern Artists on Art,* Op. Cit., pp. 92-102, p. 96.

11. Ibid., p. 94.

12. El Lissitsky, "New Russian Art" Sophie Lissitsky-Kuppers, *El Lissitsky* (Greenwich, Connecticut: New York Graphic Society, 1968), p. 335.

13. Kasimir Malevich, Op. Cit., p. 102.

14. The very name Lissitsky used to designate his abstract compositions, "Proun," indicates the degree to which the Suprematist and Constructivist successors were dedicated to the preservation of art. It is an acronym formed of "pro"—for—and "Unovis"—the new art: hence "Proun" equals "for the new art."

15.　Yves Klein, "The Monochrome Adventure," Yves Klein, exhibition catalogue. Trans. Lane Dunlop (New York: The Jewish Museum, Jan. 12-Mar. 12, 1967), p. 35.

16.　Clyfford Still, from a letter to Director, Gordon Smith, Jan. 1, 1959, in connection with an exhibition, *Paintings by Clyfford Still* (Buffalo, New York: Buffalo Fine Arts Academy, Albright-Knox Art Gallery, Nov. 5-Dec. 13, 1959).

The Furniture Paradigm

Throughout the 19th century, the distinction between artisan and artist originally formulated by the medieval guilds still obtained. Artisans were those workers whose occupations required artistic skills but were devoid of the humanist and philosophic content which, in the Renaissance, could elevate the artisan to the status of an artist. By the modern period, the separation between artisan and artist persisted until the Handicrafts Movement had assimilated numerous socialistic ideals. This later 19th-century trend encouraged a reintegration of artist and artisan into a single person who would be a contributing citizen of the new industrialized society.

But I run ahead too quickly. This essay is devoted not to furniture, a product of the artisan, but to an investigation of the ways in which the forms of furniture have meaning for 20th-century pictorial and sculptural consciousness, the ways in which modern artistic consciousness has been stamped by notions of furniture. The issue is elusive.

First, there are those real pieces of utilitarian furniture made just as furniture that, owing to certain historical pressures, appear to us as works of art. Then there are those pieces of furniture that somehow have been absorbed into, or transformed into, works of art. In the 1920s and '30s, the Surrealist Movement had a pervasive effect on the creation of metaphorical furniture as works of art. There is also, finally, that kind of abstraction that takes certain of its premises or formal properties from furniture—its horizontal thrust and floor-bound character, primarily—without incorporating furniture's utilitarian character. It is a kind of abstract furniture; it is art.

To the modern sensibility, real furniture achieves transcendence when ornament is integrated with function, when function itself generates ornament, not when ornament is merely a decorative appliqué. It is hardly surprising, therefore, that the furniture in the 20th century that has achieved the status of art largely comes from the 1920s. By that time, machinist-idealist aesthetic and a pragmatic approach to structure were deeply etched upon the artist's psyche. The new consciousness of these artists was greatly influenced by the Bauhaus and Bauhaus-linked doctrine and by the Russian Constructivists, Tatlin, Malevich, and early Soviet ideology whose impact on Bauhaus thought and practice was

considerable. With that great German art school, our epoch witnessed its most convincing instance of a parity between artist and designer.

Out of this milieu, certain literal pieces of furniture; although for the most part devoid of any consciously sought-for transcendence, achieved a certain identity as art, a certain classic status. It is clear that pieces of furniture are invested with such transcendence whether or not the designer had this ambition in mind. Take, for example, Rietveld's *De Stijl* chairs, Mies's *Barcelona Chair*, Breurer's cantilevered dining chair and *Wassily Chair*, Le Corbusier's various chaises longues, and, of a later, post-Surrealist type, Charles Eames's biomorphic plywood chairs of the 1940s, to cite but a few.

Unlike these classic pieces of furniture, however, Max Ernst's *The Cage Bed* of 1974 was a piece of furniture intentionally made as art through the application of a diverse Surrealist iconography derived from the mind unhinged by madness, hallucination, drugs or sleep. In which case, a bed would be a natural choice in the first place. As a type of furniture, however, the bed may be from the outset incapable of transcendence because it suggests a profane rather than a sacred use—a wedding with the carnal. A table, by contrast, for all its associations with everyday dining, nonetheless suggests the sacred meal as well, and thus it can function as a surrogate altar.

While those examples of machinist-inspired furniture that attained the status of art were being designed, Art Deco designers of furniture sought to reaffirm the separation that had arisen between artist and artisan. A Ruhlmann, say, or a Süe et Mare or a Follot revived the vocabulary of the 18th-century *ébénistes* and *menuisiers,* the great cabinetmakers and joiners of that century. In order to satisfy the longings of a bourgeoisie eager for the old luxuries of the aristocracy after the privations of the Great War, these designers took their inspiration from the past. They drew upon the Rococo and, in their designs, transformed many of its motifs through an application of the idioms of Cubism and Futurism. Their historical eclecticism dates this furniture, while it is precisely the absence of historical eclecticism which renders classic the Bauhaus-inspired furniture.

Thus far we have only considered autonomous pieces of furniture, but what is one to make of the chair, for instance, in Robert Rauschenberg's combine-painting *Pilgrim* of 1960, or, for that matter, groups of furniture in works of Edward Kienholz? Although its creation was based on an expressionist use of Dadaist and Constructivist principles, the chair in *Pilgrim* indicates that the work is, above all else, a "painting for sitting," just as Rauschenberg's *Bed* of 1955 is a "painting for sleeping." *Bed* is a painting he made as simply and as literally as one makes a bed. Making a bed a painting was a deliberate act on Rauschenberg's part, a Dadaistic conceit that not only undermines the conventional separation of art into painting and sculpture, but deaestheticizes the whole notion of art itself. To use furniture in this way maintains the expressionistic collage-into-assemblage tradition realized by Kurt Schwitters's constructions of the 1930s. This use may indicate that the artist's interest in furniture was only partial. In

works of this kind, furniture may be seen as interesting—interesting, yes, but no more so than any other element within the assemblage. Rauschenberg repeatedly demonstrates this ancillary interest in furniture, not only in his *Pilgrim,* but in the plain wooden chairs he used as stage props for Merce Cunningham's 1958 dance *Antic Meet* and his own *Sant' Agnese* of 1973. Not the Platonic ideal of chairness, but rather the absolute interchangeability of objects—any objects—is emphasized in his work.

I suppose the parent conundrum to all of this is posed by Marcel Duchamp's *Bicycle Wheel,* a readymade of 1913. Both halves of the work are meant for sitting: a stool, a bicycle. But in fusing these halves, all utilitarian aspects are denied. The stool may no longer be sat upon, nor can one mount the bicycle, for were the wheel placed on the floor, the legs of the stool would get in the way. Instead, *Bicycle Wheel* contrasts two opposites: static stool, active wheel. In so doing, the piece infers the cryptic and mystical binary contrasts, the para-religious fusion of opposites, that mark Duchamp's entire work from 1912 until his death in 1968.

There are many works of art in the 20th century that, loosely speaking, conform to the outward appearance of furniture. Such works—they are mostly sculpture—have been especially marked by the Surrealist sensibility of the 1930s. During that decade, metaphor, metamorphosis, anthropomorphism, eroticism, associative accumulation, deliberate clashes between the real and the dream, between anticipation and reality, and the priority of three-dimensionality over two were all marked in doctrinaire Surrealist practice. In the metamorphosed dream-furniture of Surrealism and its very broad suite, an inanimate, utilitarian piece of furniture such as a chair or a table is presented as a metaphor for the human form in such a way that it undermines, even denies, the usefulness of furniture. Surrealist furniture is essentially metaphorical, not utilitarian.

Anthropomorphism is a characteristic of surrealistically intentioned sculpture. Those figures in which one can quite literally sit, literally find oneself in the lap of something, reassert the anthropomorphic character of the chair, possessing as it does legs, seat, back, and even at times a sense of a waist. Often a chair has arms and often a headlike part, say for a pillow or antimacassar, or a place for sculptured ornament. All these bodily parts, added to the symmetrical and vertical character of a chair, render it the piece of furniture most susceptible to anthropomorphic meaning. A chair is considerably different in nature from a table which is non-anthropomorphic insofar as it does not stress verticality. Tables, in contrast to chairs, assert the horizontality of the ground rather than the verticality of the human. Due to its horizontal assertions the table is not easily recognized or invested with anthropomorphic content, despite the fact that it possesses legs. When, in fact, the table seems to take on life, it is usually in the form of a four-legged animal rather than a human being.[1]

In about 1936 Salvador Dali created a pseudo-18th-century tabouret which was supported by elegant cabriole legs and by a V rising from the back of the seat like a pair of giant arms ready to grab the sitter. Kurt Seligmann's now lost

Ultrameuble of about 1938 was also modeled in part on the human form. Its four legs were the legs of a woman, with white stockings encasing thighs and calves. They were, in fact, the disembodied legs of mannequins, shod in high-heeled slippers. Our fascination with both these pieces derives from the clash between our expectations or preconceptions—a piece of furniture should be inorganic— and the artist's conception—furniture in human form.

Meret Oppenheim's *Untitled* object of 1936, familiarly called the Fur-lined Teacup, exemplifies the sly sensual allusions embodied in the Surrealist tradition. Here a cup and saucer and a teaspoon—cold, inorganic objects industrially fabricated of ceramic and metal—seem to be sprouting an organic substance, hair. There is a clash here between sensory appeal and physical substance, a clash indispensable to Surrealism, and it is rendered particularly distressing because a teaspoon and a cup are, in daily use, drawn to the mouth for sipping and tasting. A disturbing eroticism, a prime ambition self-consciously sought by the Surrealist artist—is here intensified as it evokes, through the convergence of hair and ceramic or hair and metal, a range of oral-genital associations wholly unanticipated by the viewer.

Our perception of the anthropomorphic quality of a piece of sculpture is distorted by exaggerations of scale. A chair that is too large or too small for the human form violates our sense of fit proportion. Who is it that dwells in the room of Magritte's *Personal Values* of 1952? Who sleeps in the doll's bed and uses the giant's comb?

Magritte's fascination with the miniature is taken up by Michael Hurson in his recent balsa-wood chambers, such as *Basement of 1973.* Joel Shapiro's miniature furniture at first glance would seem to share this interest. The archetypes of miniatures are in his work—the tiny chair, the Monopoly hotel. At the same time, however, Shapiro is exploring the idea of scale to discover the degree to which such archetypes are able to "hold the floor" or express weight, to know their material quiddity and to consider questions of scale in the abstract.

On the other end of the scale, Robert Morris's enlarged furniture in *Hearing* of 1972 is also surrealistic, for his emphasis on scale here affects the spectator more powerfully than does his pronounced interest in radical politics, also evident in this piece. Similarly, though skewed by a concurrent interest in abstraction, Ned Smyth's outsized piece *The Bed* of 1975 also shares the Surrealists' interest in furniture archetypes and extremes of scale.

The Surrealists in the 1930s tripped or liberated the unconscious by the kind of surprising contrast found in Seligmann's chair, Oppenheim's Fur-lined Teacup, and Magritte's *Personal Values.* So too did Dali in his portrait of the movie star, *Mae West* of about 1934 for which he used a striking technique: the superimposition of one kind of image on another, each with its own separate range of associations. Dali called this technique the Paranoiac Critical Method. In this portrait, Dali superimposed the heavily made-up features of the film star upon the image of an interior so that Mae West's snub nose became a fireplace,

her lashed eyes the pictures on the wall, her tousled hair curtains drawn aside, and her full lips a sofa. After the discoveries of that painting, Dali, in 1936, designed a notorious settee in the shape of the bowing of Mae West's lips and upholstered it in satin in the period's most fashionable color, Elsa Schiaparelli's Shocking Pink.

Dali's 1936 lip-shaped settee, although designed as a piece of furniture, nevertheless set a precedent for the dissolution of rigid boundaries between painting and sculpture to create a continuum from the one to the other. This same continuum marks much anti-formalist American art today. Seligmann's *Ultrameuble* also achieved notoriety when it was exhibited in the epochal 1938 International Exhibition of Surrealism held in Paris. This exhibition marked a radical change in emphasis, on a broad front, from painting to sculpture, the Surrealist "poetical object." Painting's necessary illusionism is, after all, of less immediate power and effect than the actual, the tangible reality of sculpture.

There is a broad range of contemporary oneiric furniture that developed from the tradition of the Surrealist poetical object. Owing to a renewed interest in Surrealist metamorphoses, contemporary manifestations of the tradition abound. Lucas Samaras's *Chair Transformations* of 1969-70 are among the most famous recent examples. Here Samaras ignores furniture's usual utilitarian character, presenting instead chairs made of flowers or of needles; chairs not rectilinear, nor tectonically based on a vertical-horizontal scheme, but chairs formed by acute isometric angles or by curving interlaces.

Surrealism also introduced into art the notion of associative accumulation. Once more it is Dali who offers a prototype in a work such as his *Tray of Objects* of 1936. Here Dali has amassed an array of fetishistic, talismanic, and other objects derived by association that form a private and autobiographical mythology. By displaying objects as though on a store counter, the artist creates an ambiguous set of ambient free associations, rather like the free associations of psychoanalysis. Each association is emotionally colored by the character of the individual elements selected by the artist and by the effect of the various combinations of objects that may happen to attract the spectator's attention.

In the 1960s associative accumulation was evident in the Funk explosion felt throughout Californian art and seen in the regional centers of the country. In these regional centers, a range of expressionist sculptural furniture developed that was based largely on the handicraft tradition transformed through a variety of contemporary phenomena such as rock music, dope culture, the underground press, or Eastern gnoses. The regional artists incorporated these newer elements in their art in order to attack the theoretical underpinnings of an East Coast art establishment which they considered doctrinaire. Whether or not such an establishment actually existed is a moot point.

To the degree that it was internalized and private and, therefore, authentic, the Funk synthesis was valuable in that it could vie with, even supplant the contemporaneous Constructivist abstraction of East Coast art, which the

regional artist rejected as a generalist, centrist, international style. Furthermore, working in a private, rather than a common idiom allowed the Funk artists to pursue their own psyches, which were, in turn, manifested in their work at their most peculiar, most idiosyncratic. Individuality—the hallmark of the modern ethos—is thereby maintained.

The Surrealist hegemony, for all the bogus art it may have spawned, did initiate in the 1930s an important revision and expansion of the artist's notion of what sculpture could be: it could be soft, it could be fetishistic, it could be privately mythological, eccentric in substance, compulsive in methodology. As Dali himself pointed out, "The ideas of Dada and Surrealism are currently in the process of being repeated monotonously. Soft watches have produced innumerable soft objects. And readymades cover the globe."[2]

Although the Surrealist tradition is an important component of 20th-century sculpture, of even greater moment are the deep philosophical implications that furniture held out for sculpture. Throughout history, sculpture has been that tangible object which, while assuming myriad forms, mimetically assumed the vertical position of the human being on the horizontal plane of the earth. The mathematical symbol for perpendicular, an inverted **T**, could serve very well as an abstract sign for the class, sculpture. The *emburgeoisement* of art, especially in the rapid pace from the Renaissance to the present, further conventionalized this essential vertical character of sculpture by replacing, so to speak, the horizontal bar in the sign for perpendicular with the convention of the base, the socle, an aestheticized metaphor for "the rest of the world." Upon this new horizontal the vertical element was set. The base further served, by convention, to signify that that which was set upon it was sculpture. The base has served in sculpture the same function as the frame in painting: they are conventions informing the viewer that the flat illusion within the frame is a picture, the object on the base a sculpture. It is a convention that isolates and aestheticizes the artist's work.

In the 20th century this time-honored, ingrained convention has been subject to a concerted assault. By now the picture has either lost its frame or become the frame. The picture has been transformed into, or may assert its continuity with the universe. Similarly, sculpture has lost its base, and with this loss, it too has grown continuous with the universe.

From the late sixties onward, this continuity between the art object and the world has often been encountered in an abbreviation which, in one mode of expression is painting, in another is sculpture. At times, the work of art may have the form of both painting and sculpture at the very same instant. To a great extent, the cause for this radical revision in our sensibility dates back to Picasso's Cubist evolution. In his 1908 to 1910 Analytic Cubism, Picasso's paintings were based on techniques borrowed from sculpture, while in his 1912 to 1914 Synthetic Cubism, his sculpture was based on techniques derived from his own painting. This interchange between painting and sculpture was a turning point

in art, for no longer do we have two distinct classes: painting, sculpture. Modernism's most taxing challenge is to determine the limits of painting's interchange with sculpture—either to accept the recurrent collapse of these two classes into one or to assert their profound separation.

An absorption of the essential abstract feature of furniture permitted sculpture in the 20th century to relinquish, at least partly, its primordial presentation as a vertical monolith. For, in contrast to that archetype, furniture is floor-bound and horizontally thrusted. Devoid of its functional or utilitarian role, furniture may be viewed as a horizontal abstraction, reiterative of the horizon, a kind of dais. Modern sculpture today has taken over that elementary condition of floor-bound horizontality from furniture.[3]

This sculpture archetype was first explored by Brancusi. When he chose to work in the floor-bound horizontal, Brancusi attributed furniturelike characteristics to his sculpture, as in the long oblong *Bench* of 1917, or the *Table of Silence* of 1938 at Tirgu-Jiu, Rumania. The *Bench* saw many revisions; it later appeared as the chamfered seat in the cylindrical wooden benches for the park at Tirgu-Jiu, just as the *Table of Silence* had appeared earlier in his stone work as the table in *Leda* of 1925.

Brancusi was able to make the imaginative leap from vertical to horizontal sculpture through the grafting of the lost sacerdotal role of the priest upon the artist at work within a secular society, a society that from the outset acceded this free-floating role to its new priest, the artist. Brancusi's art is para-religious; it is a crypto-religion expressed through an archetypal sculpture that questioned sexuality, procreation, fecundation. In that sense, Brancusi's *Table of Silence* established a ritual site, all the more affirmatively alluded to by the twelve stools set about it—the Apostles? the months? the hours?

The *Table of Silence's* connection to a sacred arena is implicit, if not explicit. Its shape is reminiscent of the circular Aztec tables of human sacrifice incised with cosmic calendars. Like this Mesoamerican model, the *Table* becomes the *mensa* or altar, the site of religious blood mysteries or transubstantive feasts.

That Brancusi's imaginative self-presentation as a sacerdotal artist in a secular society may have allowed him to evoke such sacred uses in furniture in no way means that his descendents are obliged to preserve that identity. A few do, most don't. On the one hand, it is clear that the use of horizontal furniture as a metaphor derives from Brancusi; on the other, it is equally clear that artists today, with rare exception, reject the priestlike role in favor of the worker-role. It is not the maintenance of the role that is important, but rather the establishment of a new sculptural type for which the adoption of that role was once necessary. The role has been discarded but the type remains, and an art in the form of abstract sculpture based on the furniture paradigm came into being.

Notes

This essay is called "The Furniture Paradigm" in appreciation of Joseph Masheck's "The Carpet Paradigm: Critical Prolegomena to a Theory of Flatness," *Arts Magazine* (September 1976): 82–107. Here Masheck reconstructs the fluctuations toward illusionistic and non-illusionistic ornament in the decorative arts of the 19th century prior to a distinct modernist consciousness. It is that latter awareness upon which a formalist system in modern art is based. Masheck indicates that the oscillation between stereometric illusionism and planometric composition—the hallmark of early modernism—was evidenced in decorative-art theories in the 19th century. Since furniture falls in the province of the decorative arts, Masheck's study, with its numerous references to sources, serves as a syllabus to this essay. Masheck's "The Carpet Paradigm" followed his essay "Embalmed Object: Design at the Modern," *Artforum* (February 1975): 49–55, in which, in an appendix important for understanding the metaphor of the chair in modern art titled "Art As Rest and Rehabilitation," he develops ideas connected with Matisse's famous dictum—"Ce dont je rêve, c'est un art d'équilibre, de pureté, de tranquilité, sans sujet inquiétant ou préoccupant, qui soit pour travailleur cérébral...un calmant cérébral, quelque chose d'analogue à un bon fauteuil qui le délasse de ses fatigues physiques."

1. Scott Burton has said: "A table is not anthropomorphic. It's just a vertical against a horizontal. But a chair is anthropomorphic." (See Robert Pincus-Witten, "Scott Burton: Conceptual Performance as Sculpture," *Arts Magazine* (September 1976): 114. I acknowledge with gratitude the insights into the role of furniture in art I have gained from Scott Burton, whose ideas are of special interest since furniture plays so great a role in his art.

2. Quoted by Pierre Cabanne, *Dialogues with Marcel Duchamp*, ed. Robert Motherwell, trans. Ron Padgett (New York: Viking Press, 1971), p. 13.

3. The sculpture of Donald Judd and Carl Andre instantly come to mind, and to some extent, so too do works of Richard Serra, Robert Morris, Barry Le Va, and the continuing work of Robert Grosvenor, Richard Nonas, Kent Floeter, and Jackie Ferrara. Were one to examine the production of these artists, one would discover that in the late sixties each one worked, even if unwittingly, at creating a furniture-related archetype—a floor-bound, oblong solid, placed in the shared space with the spectator, and equal to, but not mimetic of the spectator. A concise statement of the link between a contemporary abstract sculptor and Brancusi is the following: "I began to make art seriously in 1958 as a sculptor cutting wood after the inspiration of Brancusi." Carl Andre, in "Statements by Sculptors," *Art Journal,* 35:2 (Winter 1975/76): 126.

Against Order: Poetical Sources of Chance Art

I

How to increase your talent and stimulate various inventions...Look at walls splashed with a number of stains, or stones of various mixed colors. If you have to invent some scene, you can see there resemblances to a number of landscapes, adorned with mountains, rivers, rocks, trees, great plains, valleys and hills, in various ways. Also you can see various battles, and lively postures of strange figures, expressions on faces, costumes and an infinite number of things, which you can reduce to good integrated form. This happens on such walls and varicolored stones, (which act) like the sound of bells, in whose pealing you can find every name and word that you can imagine.

Do not despise my opinion, when I remind you that it should not be hard for you to stop sometimes and look into the stains of walls, or ashes of a fire, or clouds, or mud or like places, in which, if you consider them well, you may find really marvellous ideas. The mind of the painter is stimulated to new discoveries, the composition of battles of animals and men, various compositions of landscapes and monstrous things, such as devils and similar things, which may bring you honor, because by indistinct things the mind is stimulated to new inventions.

Leonardo da Vinci, *The Artist's Course of Study*[1]

Against Order is an essay concerned with the options adopted by artists in response to a society based on materialistic predicates. For the European urban classes of the 19th century, culture might have been described as industrial, technological, imperialist, capitalist, scientific, militaristic—the modern world, in fact. Certain mid-century painters waxed nostalgic over the lost constancy and timelessness of an abandoned agrarian cycle—Barbizon. Some answered the utopian promises of uplift, social perfectibility and Positivism (which pre-eminent political theorists and philosophers such as Proudhon, Fourier, Comte and Marx promised to the proletariat) through an analogous transcription of primary sensory data—Realism, Impressionism. In the eyes of still other artists, largely poets, Courbet and Manet, and ultimately, the Impressionists were regarded as having addressed themselves to an abatement of spirituality which was thought to be the necessary counterpart of a materialist culture. They took the Realists and Impressionists to task for an assumed empiricism, lapse of

ideality, gross focus, rejection of imagination, for an art of only the tangible and the possible, for the loss of moral excellence and the ascendance of the *pompier* and the *bourgeois*. Symbolism would be the stylistic susceptibility to emerge from this intensely felt, if specious, argument.

As a corollary, arbitrary and imaginative methods began to be adopted as a means of liberating a shackled idealism. For the last generation of the 19th century, the arbitary, the fortuitous—sheer chance itself—seemed a desirable means of realizing an art of free and pure spirit which even admired forbears and mentors—the Realists and Impressionists—supposedly had sacrificed to what was viewed as base sensationism.

As for officially sanctioned art, this had long been indentured to a closed and immutable organization of obvious structural rules—the academic *ordonnances* whose very name refers to decorous and proper composition but which really means the *laws* of balance, closure, symmetry, and hierarchy. Retrograde apologists derived arguments from those of the 17th century French Academicians, pointing to the ideal landscapes of Poussin and the abstract, circular, oval organizations of Raphael's Madonna and figure groups as the essential models. Poussin and Raphael obtained, via Ingres, but the materialism of the 19th century reduced their seemingly divine prestige to empty rituals, cold rules and copybook diagrams, ultimately robbing them of the vitality and aperture they once seemed to have possessed.

It was against this doubly bankrupt heritage—a merely sensationist progressive school and the ritualized laws of a reactionary one—that hazard and chance arts were inaugurated.

What is equally certain is that these new, spiritual "disorders" quickly became their own kind of writ, their own established order. This is especially true in the present century since our stylistic jell and codification is set at a furious rate owing to the influence of the mass media and the value we place on novelty.

Our methods against order have achieved an almost phenomenological succinctness. The found object, the ready-made, the assemblage, for example, are forms whose appearances derive from the degree of alteration the artist imposes upon elements taken as they are found either in nature, or more probably, amidst the detritus of industrialized society. Duchamp's *Bottle-Rack* is perhaps the single most famous example of this bestowing of artistic identity through an act of sheer volition. Schwitter's *Merz* collages, composed of torn tram tickets and tobacco packagings, relate to this idea as do Rauschenberg's *Assemblages* from the late '50s and early '60s. In these large works Abstract Expressionist passages of flung and sprawled paint intercept intuitively discovered material from so-called real life—rubber tires, abandoned signposts, ropes, cables and hoses, not to mention scruffy taxidermy.

Similar to the absoluteness of the Dadaistic ready-made are the *Images Arranged According to the Laws of Chance,* Arp's collages of about 1917, which he claimed had been determined by the free fall of torn elements upon paper

grounds. In part, these served as the historical models for divergent sorts of American scatter pieces of about 1968, in which several painter-sculptors assumed the floor to be an environmental site, distributing all manner of organic and inorganic substance into controlled or less controlled environmental situations which determined in turn the precepts of the mammothly scaled examples of ecologically-based art of the present moment. This persuasion is well represented here in the work of Keith Sonnier, Bruce Nauman, Robert Morris and Robert Smithson.

Perhaps the bridge from Dadaistic nihilism to these environmentally organized episodes—technological, ecological and sheerly coloristic—may have been the Futurist-like Theatre of Happening as well as the allover usage of Abstract Expressionism. While the final image of the Abstract Expressionist procedure was displayed upon the wall, the arena of its creation took place upon the floor, and this process of flinging, dripping, and painting within an *anti-vertical* context cannot be minimized in terms of understanding our own art. The procedure adumbrated our environmental attitudes which opt for parietal experience and break with the tradition of viewer-object contemplation which derives from the early Renaissance easel picture.

The compositional premises of the significant art which developed at the end of the last decade are often aleatory, and if episodic at all, reject a narrative focus for the kind of incident that one finds in the actual experience of nature rather than in its depiction. In theory this would be opposed to the structuring which marked Minimalist practice of the mid-60s. Curiously, most of the exponents of present day pictorialized sculpture, evolved from this position, possibly because Minimalist-serial structure permitted a random placement within the grid or the module. Perhaps too, the serial structure permitted a rudimentary ordering upon which or into which the highly optical and charged amorphousness of the newer field painting could be hung or tossed.

In all, the high value the Surrealist placed on the processes of the unconscious and the pre-conscious cannot be underplayed in assessing the groups to which I refer. Stream of consciousness games and verbal free associations such as are found in the Exquisite Corpses, the pure automatism itself of a wide sector of Surrealism as well as current Surrealist distillates are difficult to overstress. Even the opposition Surrealist camp, headed, at length, by the retrograde Dali, with his Paranoid-Critical Method and his hand-painted dream photographs, cannot be dismissed in the context of contemporary art as he, too, like the pure Automatists, aspired to the liberation of free psychic energy which resulted from the seemingly arbitrary juxtaposition of elements of differing spheres of human activity. And that all the Surrealists adopted the language of classical political and economic class distinctions as they appeared in Marx and then connected these points of reference to a frank acceptance of the dicta of psychiatry, psychology, psycho-sexuality, Rorschach, Freudianism, and Jungian archetypes, is essential to the understanding of all contemporary American and European art. The

evolutions diagrammed in Marxist dialectics became the "historical" model for the "sequence of modern styles." The automatic mechanics of High Surrealism set the pattern for the drip and calligraphic flourish of Abstract Expressionist gesture painting. We are still part of this evolution. The pronounced blurring and thick surfaces of later field painting, the limpness and softness of later Pop manifestations primed by Claes Oldenburg, the widespread "anti-form" sensibility and the most topical "with-it" evasions of language and bald information art can be easily traced to the utopian ideals of High Surrealism.

It is patent that an account of each of these techniques, methods or styles would transform this introductory note into a college tome. I will instead address myself to the introduction of this desire for "disorder" as it occurs in poetical episodes of influential authors of the later 19th and early 20th centuries.

II

A faun, dozing of a sultry and brilliant noon, possesses two nymphs in reverie or reflection. Leon Bakst's roan-dappling of Nijinsky's skin-tight leotard applied fresh and direct to the dancer's costume each performance, the purposeful shambling of the choreography which made for "natural" rather than conventional dance patterns, the dancer's sensual, Eurasian bearing, the yearning distention of Debussy's music (1894), all served to definitively fit the erotically surcharged imagery of Mallarmé's eclogue in the public's mind. Diaghilev presented *L'Après-midi d'un faune* during the triumphant 1912 Paris season of his Russian Ballet.[2]

In 1894, while at work on *Un Coup de dés jamais n'abolira le hazard*, Mallarmé answered Jules Huret's enquiry into literary evolution, but his stricture on poetry, perhaps the most famous proscription we have of the Symbolist movement, are nonetheless applicable to *L'Après-midi d'un faune:*

> To *name* an object is to suppress three-fourths of the enjoyment of the poem which consists of the pleasure of comprehending little by little; to *suggest* it, that is the dream. It is the perfect utilization of this mystery that constitutes symbolism: to evoke an object bit by bit in order to show a mood or, conversely, to choose an object and to extract a mood from it by a series of decipherings.[3]

L'Après-midi d'un faune has remained so enigmatically pricking that its publication in its final form in 1876,[4] is understood to mark the first great date of Symbolism.[5] Whether this is so is a moot question although its relationship to the churning activity in the arts and letters of the late 19th century which we call the Symbolist movement is central and critical. At length this sensitivity circumvents Cubism, at least the heroic, analytical part of Cubism, to postulate certain features of the Dadaist and Surrealist styles.

In Dadaism, premium value is placed on personal eccentricity and an abusive debunking of convention. Eventually this leads to a non-art or anti-art

position in which the accidental and nihilistic is esteemed. Nothing in Mallarmé's personality can be argued as coincidental with these characteristics. He was civil, restrained, intellectual, and in the acute expression of these qualities, aristocratic. His writing is distinguished for its hard-cut, precious syntax. Though all equivocation, there is nothing accidental in his art.

Mallarmé's intentions in *L'Après-midi d'un faune* are of another order from those associated with Dadaism, the nihilistic attitudes of which Mallarmé would have rejected could he have known them. Nonetheless he had recourse to a poetic technique which is unexpected and fruitful for the subsequent Dadaist movement. Mallarmé liberates the relationship between the first and second elements of a metaphor. The sequence normally diagramed as A=B=C=D is purified to a cryptic collapse, A=D. This procedure, for example, may be seen at the poem's beginning in the confounding of the faun's very molecular existence and his natural environment. The faun argues himself as a being separate from nature on evidence that he is at length able to piece together out of fragmented memories. Through an intellective process he extricates a human essence out of elements of undifferentiated nature, the metaphor of his animal component.

More important in our connection is that Mallarmé, as early as 1876, makes use of a free typography, but timidly, of course, when compared, for example, to the typography of his last work, *Un Coup de dés jamais n'abolira le hazard* (1897). In *L'Après-midi d'un faune* he had discovered the method— typographical differentiation as the code to the deciphering of the poetic message. Let us compare at random lines 28-29,

Tacite sous les fleurs d'étincelles, CONTEZ
"Que je coupais ici les creux roseaux domptés

with lines 66-67,

O nymphes, regonflons des SOUVENIRS divers.
"Mon oeil, trouant les joncs, dardait chaque encolure

In both cases a conventional series of roman letters set in majuscules and minuscules, each containing a fully capitalized word, is followed by a line of italic type preceded by a quotation mark. The reader understands that the italic passages recount the ambiguous memories of the faun since it is uncertain whether the events have ever really taken place or ever will take place. These interior monologues are separated by passages of roman face which recount the faun's struggle for self-recognition. The capitalized words, *CONTEZ* and *SOUVENIRS*, hinge the parts of the poem together even though the events may have taken place at different times. *CONTEZ*, tell what? *des SOUVENIRS*, memories, the logically binding word *des* having been suppressed. Mallarmé is beginning to experiment with the laws of syntax, out of which Marinetti will

fashion the poetical anarchy of his *Technical Manifesto of Futurist Literature* (1912).

Curiously enough, Mallarmé's visual sensitivity is most flagrant in his most secret poem, *Un Coup de dés jamais n'abolira le hasard,* the logical meaning of which is still openly disputed.[6] Apart from certain fundamental interpretive premises[7] I will not attempt to decode this poem. I only suggest that its interpretation may be amplified if the literary historian approaches it also from the visual standpoint.

In 1897 the poem appeared in the review *Cosmopolis* with a prefacing note from which the following passage is taken:

> The "whites" [of the printed page] in fact, assume importance, make the first impression; the versification requires this, as ordinarily, silence around a lyric work or one of few feet which placed in the center, occupies approximately a third of the page: I do not transgress this measure, merely disperse it. Each time an image in and of itself ends or returns, accepting the succession of others, the page intervenes, and here as always, as it is not a question of regular sonorous beats or verse—rather of prismatic subdivisions of the Idea the instant it appears and while their concurrence lasts, in some exact spiritual "mise-en-scène," the text imposes itself in variable places, near or far from the concealed conductor thread, in proportion to the verisimilitude.[8]

If this extraordinary synthesis of space and notion were not proof enough, we also know that Mallarmé made particular associations with the shapes of letters as well as with their sounds. "The whole of *Les Mots anglais*," an etymological study of the English language made by Mallarmé in 1877, "is dedicated to the notion that letters convey something of the meaning of the words they compose."[9] For example, Mallarmé felt that the male principle is most cogently expressed in the "i" which also represented light for him while "u" represented darkness. "O" corresponded to the female principle.

With this in mind we can turn to *Un Coup de dés jamais n'abolira le hasard* in which the title and cardinal notion—a toss of dice will never abolish chance— is embodied in the poem's text itself, acting thereby as argument and appellation. The title and main idea as well as the subordinate notions are set in varying sizes of Caslon roman face and, as in the case of *L'Après-midi d'un faune,* the variation in pica size supplies clues as to the ways in which the metaphorical and logical elements are to be read. But Mallarmé's pictography is distinguished from conventional 19th century examples in a most important respect: it is not representational. Lewis Carroll ended the mouse's tale in *Alice in Wonderland* (1865) with an image-pun of a mouse's tail trailing off the page which conveys the diminuendo of his voice while depicting an amusing portion of his mouse anatomy. In short, Carroll's pictography reenforced the meaning of the words through a punning image. Carroll's pictography is representational whereas Mallarmé's is non-representational and gongoristic, evocative rather than depictive.

At first, the meaning of the title of *Un Coup de dés jamais n'abolira le hasard* conveys the strong impression that chance or hazard is a life-constituent which is always with us, to which we are ever subject and from which we are never free. This view, of course, sustains and conforms to the Dadaistic character of many works in the present exhibition, insofar as many of them allude to and betray a method of chance and accident. Yet, on second thought, the poem's central contention that a toss of dice will never abolish chance suggests nonetheless that chance may be abolished, only not through the means of chance.

What then? The answer to this riddle may be perceived in the model given by Mallarmé himself, in perfect art, and in a life lived as if it were perfect art. A poet such as Robert de Montesquiou-Fezensac (model of Huysmans's des Esseintes), a close friend of Mallarmé and notorious for the exquisiteness of his taste—in life as in all of his literary activities—gives us still another, more vivid example of a life lived as art.

Last, what is peculiarly distressing is the blatant obviousness of a contention irksomely cast in a ponderous obfuscation. After all, it is perfectly clear that a toss of dice could, in fact, never abolish chance. It does mean, however, that chance is a central obsession, probably not only to Mallarmé, but to the entire frame of reference in which he worked.

While we may take exception to the poem on such ground as has been suggested, its message certainly was more easily accessible to Mallarmé's intimates. The great graphic artist Odilon Redon, in a late suite of lithographs, the *Planches d'essai* of 1900, (executed three years after Mallarmé's poem was written), turns to the image of dice, an almost unique use of the motif in his production. Still, all may not have been so lucid, as André Mellerio, the first historian of the Idealist-Symbolist revival and Redon's chief biographer and cataloguer, makes this observation with regard to the print in question: a female profile looks at "an amalgam of confused objects."[10] The image of the dice was unclear to him.

Mallarmé's painstaking typography affirms the poetic notion that the artist is a creator in total control over a world of his own making. Typographically speaking, mankind is redeemed from the minimum predictability of life—its chanciness—through the maximum order of art. Perhaps this is the final meaning of the poem. Still one has to admit that the abstract pattern of double pages, which echo the facing page arrangements Mallarmé so much admired in Hokusai, are contingencies of the appreciation lavished on Japanese art by advanced taste in the later 19th century. A year before Mallarmé published his poem, Charpentier brought out a study on *Hokusaï, L-Art japonais au xviiie siècle* by Edmond de Goncourt, whose celebrated *grenier* vied with Mallarmé's bourgeois apartment as the leading intellectual salon of the day. That Mallarmé's last major work should be an enquiry into the role of chance—and which Mallarmé ultimately admits has dominion over man even though the poem itself

is seemingly a denial—cannot ever be minimized when it is a subject taken by Symbolism's most influential poet and critic. It was to Mallarmé that Gauguin wrote on his return from his first Tahitian voyage, asking whether he had "yet resumed his Tuesdays as he was anxious to tell him a little bit about his journey." The period offers other examples of the paradox of a sensibility attuned to formal perfection as well as to the potential of chance. The Swedish playwright August Strindberg, also a recipient of several important letters from Gauguin, had been familiar to French audiences since 1887 when Zola wrote an introduction to his play *The Father.* At the same time Antoine founded the *Théâtre Libre* for which Strindberg wrote several plays including *Miss Julie,* which we take to be a model—along with those of Ibsen—of the so-called Naturalist drama. Gradually, as in so many other cases, most strikingly that of Huysmans, these more realistic works gave way to a literature of greater psychological and symbolic attentuation such as we find in *The Dream Play* of 1902.

In 1894 the *Revue de revues* published an essay of Strindberg's called *Du Hasard dans la production artistique.*[11] The attitude expressed in this essay may be described as an open-faced avowal of the possibilities of chance when compared with that of Mallarmé's cryptic introversion.

Strindberg gives numerous examples of the transformation of chance into art. In Malaya the natives bore holes into bamboo trees for the wind to play. Weavers create patterns by the use of kaleidoscopes. While visiting the artist's community at Marlotte, a summering colony to which many of the *Indépendants* repaired, Strindberg discovered a "painting" in a panel smeared with palette scrapings—reminding one of Leonardo's precept that the mind of the artist may be aroused through examining "walls splashed with a number of stains..." Strindberg observed that "...the assemblage aroused a charming medley of consciousness and unconsciousness. This is natural art because the artist is working like capricious nature, without a determined goal."[12] After all attempts along orthodox lines had failed, Strindberg devised a suitable musical theme for *Simoun,* a play set in an Algerian locale, based on the chance strumming of a guitar. A musician acquaintance fixed the strings of his piano without rhyme or reason, prepared it in the manner of John Cage, so to speak. He then proceeded to play the *Pathétique Sonata* of Beethoven, "...and it was an incredible pleasure to hear this war-horse become young again."[13] Dissatisfied with the figure of a supplicant he had been modelling in clay, Strindberg smashed it with his fist and, after a few retouches and adjustments, the work became a "perfect" statuette of a little boy in tears.[14] Based on these perceptions Strindberg inaugurated a theory of automatic art.

The esthetic self-awareness epitomized by the poems of Mallarmé will be given up in the early part of the 20th century for a more robust expressiveness at the hands of the Cubist and Futurist. Symbolist gongorism will be replaced by powerful Futurist pictographs associated with a basic reform of language. For the

Cubist writer such reform will be subservient to the search for literary equivalents to the pictorial experience discovered by the Cubist painter. Striking examples flood the pages of Guillaume Apollinaire and Blaise Cendrars. As in a newspaper column pasted to a Cubist collage, a full passage from the adventures of a French nickel-mystery hero is quoted in the fifteenth poem of Cendrars's *Dix-neuf poèmes élastiques,* called "Fantômas" (1914). There is no question of logical comprehension. It exists visually, as color, shape, texture:

> Il y a aussi une jolie page
> "...vous vous imaginiez Monsieur Barzum, que j'allais
> "tranquillement vous permettre de ruiner mes projets.
> "de livrer ma fille à la justice, vous aviez pensé cela?...
> "allons! sous votre apparence d'homme intelligent, vous
> "n'étiez qu'un imbécile..."
> *Vol. 21, le Train perdu,* p. 367.[15]

A succession of roman faces form the opening line. There are five lines of which the left-hand margin forms a nearly vertical column of quotation marks. The open and close quotation marks are succeeded and preceded by three periods. The final line is printed in italics and it contains majuscule and minuscule letters as well as five arabic numerals. Cendrars has not merely quoted a section of popular fiction, he has extended citation to its apotheosis—the transformation of a footnote into poetry. This passage may be regarded as a parallel to those passages in Cubist collages which incorporate fragments of newspaper, calling cards or wallpaper. The wilful isolation and anti-logical context of the quotation, transform the passage into ready-made literature, prefabricated poetry, related to the detached character of Marcel Duchamp's *Bottle-Rack* of the same year.

Compared to the Futurist poet, the Cubist poet tends to a poetry of silence, of the meditative. The analogy between such work and the "meditative" still lifes of Picasso and Braque, which are often described as "poetic," is easily grasped. In the same way the still lifes of Juan Gris are often spoken of as "metaphorical," that is, the shape of the book is to the shape of the table as the shape of the table is to the shape of the mountain. The relationship between plastic forms can be characterized analogically in terms of literature, as a sequence of metaphorical elements, $A=B=C=D$. If the Cubist may be said to be meditative in his poetry, the Futurist by contrast may be described as captivated by sound. He is interested in sonority, in the cacaphonic, the noisy. The fact that Futurist poetry was frequently written to be declaimed publicly, to exhort brother Futurists into action, may account for the audial and onomatopoetic tendency of Futurist pictography. Not incidentally, the Futurist saw his art as violently opposed to that of the Cubist.

Marinetti's strong pictographic onomatopoeia is patent in his poem "Le soir, couchée dans son lit, elle relisait la lettre de son artilleur au front," published in 1919, although born of theories expressed in 1912. Similarly, permutations of

"Long Live the Army" and "Long Live the King" are interspliced with machine-gun crackings and siren screams in Carlo Carra's free-word-painting, *Patriotic Celebration* of 1914. In Italy the siren wails "HUHUHUHUHUHUHUHU" while in France it goes "Hou ou" as we see from the sound-image that Apollinaire renders in his sun-burst calligramme, "Te souviens-tu." Carrà celebrated Maréchal Joffre's hard-won battle of the Marne in a gouache collage, *Pursuit* of 1914. The following year he included the work in *Guerrapittura,* a cosmic intercalation of the sights and sounds of warfare. This consummates Carrà's Futurist activity and, retired to Ferrara from the front, he retreats (in association with Giorgio de Chirico) to an evocative hermeticism of pure form which he called "Metaphysical." Marinetti also celebrated Joffre's victory in his words-in-liberty poem called "Après la Marne, Joffre visita le front en auto."

These Futurist pictographic poems are related to the theory of words-in-liberty expressed by Marinetti in 1912. [16] His proscriptions are known as the *Technical Manifesto of Futurist Literature* and constitute one of the most remarkable linguistic documents of the century. As has been noted, Marinetti's dicta recall ideas that Mallarmé had incorporated earlier within his writing, but the anti-intellectual position of the *Manifesto* relates it as well to the emotional spontaneity then being explored in northern European Expressionist tendencies. Last, it presages the imminent anti-cultural stance of Dadaism.

Marinetti proposes a systematic destruction of syntax through the use of nouns discovered on the spur of the moment—automatically, so to speak—and through the exclusive use of the infinitive form of the verb. Adjectives and adverbs are to be expunged. Owing to aerial speed we can now compress analogies and digest ideas without analogical phrases. Therefore, such logical conventions as "such as" and "like" will be suppressed leaving only the substantive and its mate. Marinetti proposes "man-torpedoer" and "woman-road," among others. Punctuation is to be abolished. The flow of language is to be indicated by mathematical or musical signs. Analogies are to be extreme in order to purify language of clichés and commonplaces. Images are to be dispersed with a maximum of disorder. The first person singular is to be destroyed, that is, human psychology. However, "the landscape of odors which a dog perceives" or "to listen to motors and to reproduce their discourse" is interesting as they are expressions of a "lyrical obsession with matter." This leads to an "intuitive physiology of matter" and ultimately to the "wireless imagination." (Had not Mallarmé anticipated the Futurists when he referred to the "concealed conductor thread" ("fil conducteur latent") in his preface to *Un Coup de dés jamais n'abolira le hasard?*) Futurist literature will attempt to suppress "all the first terms of our analogies and present only the uninterrupted succession of second terms." Comprehension is given up: "To be understood is not necessary. We are, in fact, outmoded when we express fragments of Futurist sensibility with the means of traditional syntax and intellective processes." The new literature must

obstinately persist in being ugly. Intelligence is to be replaced by intuition, "...divine intuition, native to the Latin races."

The Cubists, of course, disputed the "wireless imagination" that Marinetti claimed for Futurism. Blaise Cendrar's poem "Crépitements" (1913), opens with "Les arcencielesques dissonnances de la Tour dans sa télégraphie sans fil" which contains at least three allusions. The Tower, capital "T," refers to the Eiffel Tower and to its representation in the painting of Robert Delaunay from about 1910 on. "Arcencielesques" describes Delaunay's method of dividing colors into spectrums of light, which marks his work from 1912 on, the method that Apollinaire called "Orphist" in his *Méditations esthétiques, Les Peintres cubistes* of 1913. "Télégraphie sans fil" is the wireless radio wave and electrical impulse, the most modern form of communication, a kind of magical transfer through technology. Like Marinetti's uncrippled, uninterrupted flow of second metaphorical elements of words-in-liberty, Cendrars's "télégraphie sans fil," too, becomes a form of anti-intellectual premise at whose core lies a savage and sexual intuition. Guillaume Apollinaire includes a representational image of telegraph wires in his calligramme "Voyage." The concise, cogent image parallels Marinetti's polyglot rhetoric and Cendrars' metaphors.

In the context of these notes, Cendrars, perhaps more than Apollinaire, continued the Mallarmé-like gongorism of visual changes as a clue to meaning. Apollinaire retains the Lewis Carroll tradition of the representational pictogram, the most famous example of which is the calligramme "Il pleut." In this poem the words are set like raindrops trailing down a windowpane. In no sense do I mean this as a negative criticism for, in terms of their emotional power, the *Calligrammes* appear to have had a greater appeal to a far wider public than the poetry of Marinetti or Cendrars. This situation may change however, since the frenetic and disordering postulates of much contemporary artistic experience corresponds more closely to the spontaneity of Futurist rather than Cubist emotionality.

It may seem that these descriptions of Cubist and Futurist literary episodes only fuzzily coincide with chance esthetic.[17] Certainly, the relationship between attitudes toward chance and fortuitousness in the Symbolist period are easily collated with similar points of view in Dadaism. But the relationship between Dadaism and the Cubist-Futurist fluctuations I have been describing only appears to be tendentious. It is certainly not easily grasped. We have been examining the dross, so to speak, of these movements. The issue will be clearer if we indicated what Dadaism neglected to share with Cubism or Futurism. Remarkably, Dadaism entirely refused a highly conceptualized representation of time and space. By this I mean that highly conceptualized representations of these human modes of measure tend to present images which may more easily be described as "timeless" and "spaceless" than highly perceptualized representations which convey strong impressions of instant and location. It is

this aspect, above all, and not mere pictographic effects which affords Cubism and Futurism their essential form and power. Still, the specialized graphic tradition begun in Symbolism and continued under Cubism and Futurism is swallowed whole by Dadaism: the "cryptographic" style of Mallarmé, the "calligrammatic" styles of Apollinaire and Cendrars, and the "pictogrammatic" style of Marinetti, if I now may be permitted to describe them in these ways. These ways, in fact, have become the routes whereby we have arrived at the many diverse options open to chance art in the present day.

Notes

1. Leonardo da Vinci, *The Artist's Course of Study, Selections from Notebooks of Leonardo da Vinci,* (Oxford University Press, 1953), ed. with commentary by I.A. Richter, p. 182.

2. See Serge Leonidovich Grigoriev, *The Diaghilev Ballet, 1909-1929* (London: Penguin Books, 1960), first pub. 1953; and Romola Nijinsky, *Nijinsky* (London: Penguin Books, 1960), first publ. 1933.

3. Jules Huret, *Enquête sur l'évolution littéraire* (Paris: Charpentier, 1894), p. 60; translation taken from John Rewald, *Post-Impressionism* (New York, 1956); pp. 483-484.

4. See Henri Mondor, *Histoire d'un faune* (Paris: Gallimard, 1948). Prof. Mondor is also one of the respected biographers of the poet. See his *Vie de Mallarmé* (Paris: Gallimard, 1941-42). For a remarkable study of Mallarmé's poetry see Emilie Noulet, *L'Oeuvre poétique de Mallarmé* (Paris: Droz, 1940).

5. Exhibition catalogue, *Cinquantenaire du symbolisme* (Paris: Bibliotheque Nationale, 1936), p. 1.

6. See Robert Greer Cohn, *Mallarmé's Un Coup de dés: an Exegesis* (New Haven: Yale French Studies Publication, 1949).

7. Particularly the idea of the artist's domination over his microcosmos of art, expressed throughout Wallace Fowlie, *Mallarmé* (Chicago: University of Chicago Press, 1953).

8. An English translation is scarcely possible although a useful working version appears in Daisy Aldan's translation of *Un Coup de dés jamais n'abolira le hasard* (New York, 1956). n.p., see Preface from which the translation is taken.

9. R.G. Cohn, *Un Coup de dés,* p. 35. See esp. the chapter, "The Significance of Letters," pp. 35-38, and Appendix 2, pp. 118-22.

10. André Mellerio, *Odilon Redon* (Paris, 1913), reprint New York, Da Capo, 1963, p. 124.

11. Republished in *Quadrum,* 10 (1961): 5-10, with an accompanying essay by Gören Söderström.

12. Ibid., p. 6.

13. Ibid.

14. Curiously the terra-cotta and reverie figures by the Italian Symbolist Sculptor Achille d'Orsi seem to be similar to this example given in Strindberg's essay. However, I only know d'Orsi's work through reproduction, and therefore, I prefer to let this issue remain conjectural. Strindberg was also a painter of merit whose work was exhibited at the Council of Europe Exhibition, *Les Sources du xxe siècle, Les Arts en Europe de 1884 à 1914,* held at the Musèe Nationale d'Art Moderne, Paris in 1962. See catalogue, entry nos. 692-95.

15. See Blaise Cendrars, *Poésies complètes,* intro. by Jacques-Henry Lévesque (Paris: Donoël, 1944), p. 122.

16. F. T. Marinetti, *Les Mots en liberté futuristes* (Milano: Edizioni Futuriste de "Poesia," 1919).

Man Ray: The Homonymic Pun and American Vernacular

Before a critique of this first (and tardy) Man Ray retrospective in New York[1] it is useful to propose an abbreviated chronological scheme. Roughly speaking Man Ray's career may be broken into three main phases. The first runs to about 1915 when Man Ray establishes his lifelong friendship with Marcel Duchamp. The painting of this early phase is marked by the then-fashionable modernist options, Expressionism and Cubism, with generally unimpressive results. In the directness of his stylistic adaptations, however, these paintings reveal the bedrock attitude upon which Man Ray will subsequently build a career. In 1913, he and his first wife Adon Lacroix, joined by the poet Alfred Kreymborg, were living simply in a kind of artists' commune in Ridgefield, New Jersey. An odd bibliographic souvenir of these early happy days are the issues of *The Ridgefield Gazook* of 1915, punning anarchic reviews which portend the scarcely transient New York Dada broadsides, *The Blindman* and *Rongwrong* of 1917. These magazines are marked far more by Duchamp's tentative adoption of American ways than by Man Ray's rawer ebullience. While a knowledge of Man Ray's work only partially assists our understanding of Duchamp's art, the contrast between the two is essential to a grasp of Man Ray's work. Duchamp's mind was both aristocratic and encyclopedic; Man Ray's art derives from vernacular culture and a concomitant journeyman outlook.

Man Ray's friendship with Duchamp ushers in the long second phase of his career which extends from the period of America's still neutral role in the First World War to the moments prior to the occupation of Paris by the Nazis in 1940. Despite the transatlantic and international character of Dadaism after the First World War, it is in the period 1915–17 that New York Dadaism, as distinct from European manifestations of the style, is formed with a character that each of its particular contributors—notably Marcel Duchamp, Man Ray and Francis Picabia—will differently inflect. Despite peculiar emphases, their signal collective achievement will be the legitimization of the Mechanomorph—the machine as a human being—as a profound and complex element of modernist iconography.

Man Ray's last phase is marked by his return to the United States, to Hollywood, where he remains for the duration of the war, and again his return to Paris in 1951, where he has lived ever since. This still-continuing period coincides with the recent recognition of the importance of New York Dadaism and, as a function of this awareness, the prestige accruing to Man Ray's work, corroborated by the reissue in editions—as were several of Duchamp's early works—of many of the objects and photographs of his second phase.

New York Dada counted among its own only a few artists, those already mentioned, and in varying degrees of allegiance, some members of the Stieglitz and Arensberg circles such as Marius De Zayas, Paul Haviland, Arthur Dove, John Covert, and Morton Schamberg. By contrast, European Dada encompassed a broader range of painters and poets, most of whom were later absorbed into the Surrealist movement. Ernst and Arp are prime examples of this smooth transition, as opposed to Schwitters or Tzara who never really joined the Surrealists. Man Ray and Kurt Schwitters appear similar in their attitudes toward the vitality of brute matter, their rejection of a hierarchic attitude toward materials, and in their direct, simple methodologies. Man Ray was stauncher in these attitudes than the Hanoverian. After all, Schwitters's greatest work, the now-destroyed first *Merzbau* of 1924–37, was titled the *Cathedral of Erotic Misery*. Man Ray's use of materials precludes even the vestigial talismanic undertones still evoked by certain organic substances in Schwitters's range of material which included, among other elements, a stuffed guinea pig and human urine.

The attitudes of the New York Dada group, many here in exile during the First World War, stem largely from Symbolism, from the self-referential and conscious elitism of Mallarmé and Raymond Roussel. European Dada, emerging in Zurich in 1916, some three years later than the American manifestations, is socially oriented, and ultimately derives from Marx and French utopian political theorists as well as Italian Futurist activism. It confounds, as does so much of the history of modern art, modernist expressionism with social change. The New York Dadaists cared far less about society in general, and made "inside art" that appealed rather to members of their own set. Of the big three of New York Dada, only Man Ray was native born (in Philadelphia in 1890). Duchamp came from the provincial French intellectual bourgeoisie, though finally he became a naturalized American; Picabia was also an international figure—French bred, of wealthy Cuban origin.

Until recently Man Ray has tended to run third in this hierarchy. New critical interests, particularly in film and photography—that is, in nonmanual esthetic techniques—while not dislodging Duchamp from his preeminence, have forced a situation wherein Man Ray now rivals if not supplants Picabia as the second figure of New York Dada. Certainly Man Ray's work is a far more unified achievement than is Picabia's, whose expressionist, automatist and quasi-

representational last phase—perhaps most everything after 1926—is of doubtful interest.

But to say that Man Ray's work is a unified achievement is to recognize that it assumes an essentially disjunctive production. His work has unity because all of it is consciously disunified. This passage from *Self Portrait* (1963), Man Ray's autobiography, illustrates what I mean:

> ... I wasn't as interested in painting itself as in the development of ideas, and had resorted to the graphic arts as the most direct presentation of them; each new approach demanded its particular technique which had to be invented on the spot. Whatever the variations and contradictions, one or rather two motives directed my efforts; the pursuit of liberty, and the pursuit of pleasure. I was terrribly afraid of being recognized by a fixed style to which I would be obliged to adhere. Painting would become a bore. Wasn't it sufficient that I signed my name to all my works, as had so many other painters who had also varied their styles through the years?

At first Man Ray wanted to be a painter, and throughout his autobiography, despite occasional *pro forma* disclaimers, he promotes the notion of the primacy of painting in his career. He is mistaken in this equivocation because to be a painter in the sense that the word is commonly used is to be fundamentally committed to the notion of a continual and consistent evolution of the manual act of painting. In this sense a painter may get better. It is clear from examining this broad survey that includes some 68 oil paintings from all periods that Man Ray's painting, which he intermittently deserted and resumed, never can be said to improve, and much of it as "painting" is downright poor.

Like Duchamp and Picabia, Man Ray's early painting synthesizes a range of Cubist, Futurist, Impressionist and Expressionist options. Painting as an activity engaging brush, paint, principles of illusionism, manual dexterity, and style is perhaps at last competently realized in Man Ray's two 1940 portraits of the Marquis de Sade. Even here the diffidence of touch suggests an awkward imitation of the more successful stony illusionism of Magritte while reviving motifs from Giorgio de Chirico's 1910–20 paintings. In fact, de Chirico lurks behind much of Man Ray's painting, most obviously in the oppressive series of *Shakespearian Equations* (1948), abstract portraits of geometrical and algebraic formulas. Apart from Man Ray's obvious debt to de Chirico (they are as awkwardly painted versions of de Chirico as those de Chirico himself was—and is—painting in the manner of his early work), there is in these later paintings, perhaps, a certain awareness of the mathematically linked sculpture of Gabo and Pevsner from the late '30s on.

Another illusionistic painting, *A l'heure de l'observatoire—les amoureux* of 1932-34, with its celebrated image of the lips of Lee Miller, later Lady Penrose (early seen as Fate in Cocteau's *Blood of a Poet*), levitated over the horizon of the landscape, still looks like an awkwardly executed Magritte. Man Ray's most successful painting as "painting" is of course *The Rope Dancer Accompanies*

Herself With Her Shadows (1916). Apart from its near one-to-one relationship to Duchamp's *The Bride Stripped Bare by Her Bachelors, Even* (1915–23), Man Ray succeeds here because there is no illusionism to conquer. *The Rope Dancer* interlocks flat templatelike shapes—the *Shadows*—similar to garmentcutters' patterns. These shapes parallel the sociological referents of Duchamp's *Cemetery of Uniforms and Liveries* (1914) which became in turn the *Nine Malic Molds* (1914-15). Such patternlike shapes may also be more inherently natural to the American vernacular tradition from which I believe Man Ray derives.

If I have an unenthusiastic view of Man Ray as a painter, at least in conventional terms, then why am I interested in his work? Unexpectedly, Man Ray's work is a function of American folk art—I mean his work connects up to the pragmatic here-and-now eccentricity of tinkering, carpentry, and the independent journeyman. As an illusionistic painter Man Ray is at best an aspiring naïf. Since his painting cannot "improve" beyond a certain point, what remains as interesting in his work is his self-reliant openness to media other than paint which allow him instantaneous but nonmanual results, for example the sheerly happy Rayographs, the air-brush silhouettes, and the capricious spontaneity of many of the objects, Man Ray's term for what Duchamp called Readymades.

In a sense the objects defer to Duchamp, but at times they have an abrupt immediacy that is unthinkable in the latter. Just as Man Ray's hand cannot be said to have developed beyond a certain point, so too does his gift for the pun—the central organizing principle of Duchamp's art—aim for a certain middle level, not bad, not good, not outrageous or dull, just *there*. You can look at a career in painting and in some sense measure the idea of manual evolution; but it is hard to look at a career and say that the punning has evolved. It's not part of our normal experience to regard art in terms of its linguistic correlations, and even less to draw a critical evaluation from the formal and linguistic overlap. That, however, is what I'm trying to do.

Let's take Man Ray's famous blue bread, the *Pain Peint* of 1960. In French, the word for bread, *pain,* and for painted, *peint,* sound alike so that illogically one is making an odd brief sound that duplicates itself, a sound that could mean "bread bread" or "painted painted." Logically, the homonyms mean "painted bread," that is a loaf of French bread painted blue. In itself a loaf of French bread, a *baguette,* painted blue may be strange, but its relationship to homonymic punning makes it that much more arresting. It may be that Man Ray's sensitivity to the sameness of sounds in *Pain Peint* was clued by the common French usage *train-train,* our "humdrum," the daily routine events of life. The referents of *Pain Peint* to Christ are underscored by substance and color—bread as the transubstantive body of Christ, blue the color of heaven. Originally women masquerading as nuns on roller skates purveyed the blue breads. Man Ray's point (as in so many of Buñuel's films) is comedically anticlerical rather than pious or religious. We have Dali's breads for that. (*Pain Peint* may also relate to Gino

Severini's famous lost Futurist canvas *The "Pan Pan" at the Monico* (1911), a title which is not pronounced quite the same as *Pain Peint,* but which is not that dissimilar either; Futurism is a central source of Dadaism.)

Man Ray's punning, incidentally, demands no more than high school French. It is direct and unsubtle, the joshing of a person who speaks a second language nicely. The situation is reversed in Duchamp's case. His elaborate punning is that of an arch intellectual supremely at ease in the written and auditory elements of a mother tongue. His English efforts are modest indeed.

Following Duchamp's lead, Man Ray exploited his own name as a source for art in *Main Ray* (1935).[2] In this object, an articulated mannikin hand holds a ball. Man Ray's first name corresponds to the French word for hand *(main).* The *ray* in the title is ambiguous unless the pun is incomplete. The object might more properly be titled *Main Rayé,* "striped" or "grooved hand," insofar as the grooves in the articulated hand suggest, as it were, stripes.

Another object of 1956/71 is titled the *Ballet Français,* which means "French ballet," but which sounds like it means "French broom" *(balai français).* Like *Pain Peint,* what's interesting is not the object itself, a mounted and painted bronze broom, but the linguistic correlatives which connect the notion of sweeping gestures with a choreographic idea, and conversely deflate balletic pretensions into something homely. Much of the meaning of the works, then, lies not in the objects themselves but in the overlay between language and object that they embody.

Still, as language-object puns, Man Ray's later works are tepid or thin compared to his high punning of the 1920s when his connections to Duchamp were strongest. A major work from this period is the 1924 photograph of Kiki of Montparnasse (a celebrated model and friend of artists), called *Violon d'Ingres.* In this photograph, Kiki is seen from the rear, and the scroll-shaped apertures of a violin are marked across her back. *Violon d'Ingres* in French literally means "Ingres's violin." Idiomatically it means a hobby (a "dada" or "hobby horse" if you like), so committed was the 19th-century painter to playing the violin. Kiki's headdress refers back to the turbaned odalisques of Ingres's paintings—and, seen from the rear as she is, *The Valpinçon Bather* of 1808 is almost specifically alluded to. In Man Ray's photograph these levels of information absorb one another and are capped by the similarity of shape between the curvature of a female back and the scalloped shape of a violin. *(Violon d'Ingres,* with its minimal indication of the cleft of the buttocks, seems to have been the model for Man Ray's more abstract and Weston-like photograph of 1930, the erotic *La Prière.* The kneeling figure in this photograph may refer to the praying communicant idea subsumed in Duchamp's late etching of *The Bride Stripped Bare.)* The odalisque, the harem inmate passively attending the attentions of her master, further enriches the erotic level of *Violon d'Ingres.* Man Ray has literally transformed her into the "sounding box" of that fascination—a notion reasonably linked to the American slang term for vagina, a "box." She was both

instrument and object of sexual attraction. Surely this last link is not foreign to Man Ray's love of women as erotic icons, a sexism guilelessly disclosed throughout the autobiography.

This discussion is not intended to promote the doctrinaire position that there is a fixed content to Man Ray's objects—that to explicate their linguistic and formal interchanges somehow explains their ability to capture our interest. These are separate questions. With the tightly clamped stack of metal called *New York* (1917-66), for example, one is at best dealing with a set of loose conundrums; the disparity, for instance, between an organic clue (a wood clamp) and an inert one (the citified, Art Deco layers of metal which infer the gleaming stylishness of later Constructivism). The object also puns with a novelistic cliché, that is, "a city in the clutches of...." Because of the multivalent clues in Man Ray's objects, one cannot claim that their fascination lies exclusively in language/form overlaps. We return to the old riddle. Is there an intrinsic formal value to these objects (in fact to *any* object) which is tangible and invisible but impervious to exegesis, or are these objects interesting because they function in larger iconographic or esthetic systems? I suspect the latter, but am forced to let the riddle stand in abeyance. In fact the problem is so deep-rooted in criticism as to be almost an academic question.

Man Ray's photographs are more like objects in that they display a directness that gives them a presence lacking in his paintings. This is because he didn't have to paint them. The brush is an infelicitous tool for Man Ray. He is more at ease with the implements of shop and darkroom, with pottering around. The French would say he was *un bricoleur;* we, a jack-of-all-trades. Man Ray's eminence as a 20th-century photographer is linked to the fact that for him portrait photography is an instantaneous and mechanical act rather than a manual task. Apart from a rare and arch period mannerism such as solarization, Man Ray's portrait photographs (of Tzara, Duchamp, Breton, Brancusi, Braque, Tanguy, Ernst, and dozens of other equally celebrated sitters) are marvelously unpretentious. This point is real when one compares Man Ray's photographs with the arty ones taken by Cecil Beaton, Horst P. Horst or Hoyningen-Huene of many of these same sitters.

This retrospective has claimed for Man Ray a particularly American inflection in the Dada movement. His bluntness is all the more striking as his work embraces one of the most convoluted art movements of our century. Man Ray establishes Dadaism's naïve pole; Duchamp its sophisticated one. The unforeseen irony in this is that Man Ray engages issues that are larger than his art; Duchamp, issues that are smaller.

Notes

1. The major American overview was held in 1966 at the Los Angeles County Museum of Art. The present show is redress for knickerbocker neglect. The exhibition was organized for the New

York Cultural Center by director Mario Amaya and Sir Roland Penrose in honor of Man Ray's 85th birthday. Both the prestige of the artist and ambitiousness of the selection—356 items in all—indicate that this retrospective ought to have been undertaken by a more economically favored institution. Owing to its uncertain finances, the Cultural Center is forced to function rather like a *Kunsthalle;* thus it shows a broad range of work. (While this retrospective was hanging, for example, one could also study the important and sadly overlooked Bouguereau exhibition organized by Robert Isaacson.) Despite its economic burdens, the Cultural Center at the moment is perhaps our most interesting museum. The Man Ray retrospective was accompanied by a thin catalogue—there was just no money. Still, the artist was handsomely served by William Copley's admiring and helpful essay. *Man Ray Inventor/Painter/Poet,* The New York Cultural Center, 48 pages, heavily illustrated and with a checklist of paintings, watercolors, drawings, objects, collages, photographs, books, aerographs, Rayographs, solarizations, $2.50.

2. It is egregious to note again that Marcel Duchamp derived the character of the Bride from the first three letters of his first name *(MARieé)* and the Bachelors from the last three letters *(CELibataires)* with staggering results for subsequent art. Similarly, his collected writings were published in 1958 under the title *Marchand du Sel,* a transposition of the four syllables of his name and a pun meaning "the salt seller" (and "the salt cellar", i.e., the container of salt), which, through an exiguous argument may be alchemically referential. Again the writings of Rrose Sélavy, i.e., Marcel Duchamp, published in 1939, is a collection of exquisite and often elaborate puns amassed during a lifetime.

Prospect

Learning to Write (Cy Twombly)

One theme stands out in the sparse criticism devoted to the development of Cy Twombly's painting—namely, that it is at once intimately connected with the physical act of handwriting, yet more elevated and esthetic than mere script. Painting, for Twombly, is regarded as a special category of calligraphy. To accept Twombly's painting as art means that one must recognize it as surrogate graffiti—that is, mock telephone booth or toilet scrawl. Many of these contentions I accept but with a serious difference. In place of the notion of "estheticizing" or "elevation" let me propose writing "pure and simple" (at least insofar as the latest work is concerned). One might say that the feverish poetry of late adolescence which we all wrote and which Twombly too meted out in reams (fortunately, he feels, destroyed) now has been replaced by a manuscript which, in common parlance, is no longer called a poem but a picture.

The ramifications of this view are considerable. Until the mid-1960s, Pierre Restany's lyrical summation that Twombly's pictures were about "poetry, reporting, sexual flaunting, automatic writing, affirmation of self and self-denial also,"[1] by virture of its graphism, still held true. This is no longer the case and handwriting has become for Twombly the means of beginning again, of erasing the Baroque culmination of the painting of the early 1960s. At present, beautiful writing has been submerged within a Jasper Johns-like gray field. Put bluntly, it has been drowned in a schoolmaster's blackboard. It has been reduced to rudimentary exercise—baleful, laconically dull gestures, reiterated over and over again in a kind of backwoods rote (the visual correspondence to Twombly's hesitant drawl?). Again and again Twombly seems to be writing "I will not whisper in class anymore," generating simply visual organizations of curling registers and parallel spiraling zones one above the other. In this sense, Twombly's last pictures are his most fully and consciously achieved desensitizations. They entirely revoke the esthetic viewpoint held earlier. They indicate the beginning of a new period for him. Elementary visual activity equals the physical act of writing. This is corroborated in other ways too. Paint, for example, is rejected as the means of recording gestural traces—rather paint is used to create the "feel" of a ground, that is, it is employed as a "pile up" of dusty and erased surface. The thing drawn (and erased and redrawn and erased and

redrawn, ad infinitum), that is the thing written and rewritten, is delineated out of a material which masquerades as chalk (actually a wax crayon), the binder of which breaks down during the writing to fuse in part with the house-painter's gray paint and to dryly adhere to the grainy surface of the canvas. The result looks for all the world like a blackboard scrawled over during the height of the Palmer Method craze.

There is some leeway of course in this closed metaphor. No longer is the thing drawn a fantastic self-generating elaboration of letters, words, phrases and regressive images as was the case until the mid-sixties, but it may now be a final and brutally incisive figure like the untitled "Square," set down foursquarely, as if by a concentrating child.

The development from the calligraphic graffiti to bald matter-of-fact writing (and "counting") is one which covers almost fifteen years. As early as 1954, Twombly had painted pictures in graffiti-like motifs. These pictures, resembling wall scrawls, heavily scoured indecisions, made up of blotchy, pencilled-in areas and evocative surface flakings, were composed according to a fine feeling for weight—by contrasting precarious constellations against each other and/or blank tactile surfaces. Twombly admits to "mainly having a feeling for paper rather than for paint," that is, for wall surface as distinguished from the thing, if any, depicted. Gillo Dorfles wrote perceptively that "Vast white spaces which are almost always off-center, are the voids which for Twombly have the power of color and matter and are, actually, the 'fullest' part of the picture."[2] A pictorial conception which plays with the weights of voids against pencil scrawls and heightened by indecisive brushstrokes covertly speaks of a derivation from Paul Klee and overtly aligns itself with the then prevailing Abstract Expressionist idiom—although the externalization of aggressive emotions germane to that style are in Twombly rejected for obscure urges and ambiguous options. It is significant that at that moment, 1954-55, Twombly had made the acquaintance of Robert Rauschenberg—the first real artist of his own age that Twombly came to know well. Rauschenberg, too, was painting black and white pictures using numerical configurations resembling children's games as imagery—again bespeaking the widely unacknowledged streak of Klee in these developments nominally associated with the de Kooning and Kline of the late 1940s. On Rauschenberg's advice Twombly spent two summers and a winter at Black Mountain College, which brought him into contact with several distinguished artists, among others, Robert Motherwell, Franz Kline, and somewhat oddly, Ben Shahn—all of whose work, even the last named, is echoed in Twombly's early production.

The first are sensible in the reduction of the image to black and white, the impassioned attitude of the painting, and a composition based on gestural structure. As far as Shahn is concerned, he is still visible in a love for elegant flourish, a visual breeding which Twombly has since been at pains to discourage and which in the most recent painting is finally expunged. Shahn's gouaches of

the late 1930s often depict broad, painstakingly diversified surfaces, brick slum walls, dreary expanses of handball court concrete, which are, in slight measure, the naturalistic models for the gritty plaster-like surfaces, the walls of Twombly's paintings throughout the early sixties.

At this point, Twombly was called into the army and was assigned, tellingly enough, to Cryptology. "I was a little too vague for that," Twombly recalls, but codework permitted him to stay stateside within reach of New York City where he kept up his valuable artistic associations. While still in the army, Twombly recalls that he often drew at night, with lights out, performing a kind of meandering and imprecise graphology for which he would shortly be esteemed.

On his discharge Twombly undertook long periods of travel throughout Europe, particularly in Italy and North Africa, where he remembers his most placid and happy moments as those when he painted in brilliantly white empty rooms overlooking the sea. During this period he began to exhibit. His first one man exhibition was held in 1955 at the old Stable Gallery, although he had already shown jointly with Rauschenberg at Kootz, an exhibition arranged through the good offices of Robert Motherwell. In January of 1955, incidentally, Rauschenberg also exhibited independently at Egan and was already demonstrating his radical revisions of Abstract Expressionism so that at this distance one hesitates to still join their names as adherents to a single cause.

Fortunately, the late Frank O'Hara reviewed Twombly's exhibition and reported that "A bird seems to have passed through the impasto with cream colored screams and bitter claw marks. His [Twombly's] admirably esoteric information, every wash or line struggling for survival, particularizes the sentiment."[3] "Struggling for survival" I find especially affecting.

At about this time, 1955-56, the earlier, more consciously composed abstract canvasses were replaced by compositions of all over graffiti. Still, their affiliation with the prevailing spatial concepts of Abstract Expressionism remained clear. Instead of informally balanced affairs of linear incision, smudges and blank surfaces, that is compositions contained upon the picture plane and retaining points of reference to the perimeter, the picture now became a machine for spatial expansion. The graffiti was dispersed equally over the whole surface. This scribble of mutant writing created inchoate fragments of line and shape sections cut off casually at their perimeter, which posited movements beyond the arbitrary vertical and horizontal edges. There was no reluctance to pass beyond the perimeter, no doubling back of fearful gestures at the edge as one even finds in Pollock. Such compositions would have had the compromising effect of thickening the ground along the edge, of creating conventionally accepted frames of space (as for example, the white paper "collars" retained in water color practice). In short, these pictures nonchalantly "expanded" beyond their edges. But, despite the continuous expansion out from the perimeter in all directions, there was very little sense of expansion *into* depth (annihilated by the wall metaphor in Twombly's painting), or out *from* the surface in an engulfing

experience (rejected because of Twombly's virtually anti-coloristic painting). Instead, the graphic experience tended to superimpose automatic flame-like shapes piled one upon the other, which associates these pictures with the vegetal and organic draughtsmanship of de Kooning and Gorky.

Shortly thereafter, from about 1956-57 on, Twombly began to reject the principle of superimposition, the pile-up of grass-written transparent words and alphabet fractures. Once again the canvas grew empty. The automatic gestures was replaced by recognizable clues of a regressive imagery related to primitive scrawls and graffiti. Whole readable phrases, sentences even, were now discernable. This legibility also held for representational conventions, often of a sexual or erotic primitivism, like idiotic lavatory doodles, pictograms of sexual organs, male and female, whimsical diagrams rejected as quickly as they were realized. These pictures grew like the walls of a privy ornamented by erotomanes or cheating students who left the answers behind for their buddies. These images were once more haphazardly composed, ordered by Twombly's sure taste which cancelled out the weights against the images, the smudge against the crusty patch and peel. In short, a whole vocabulary of fanciful imagery lying about the periphery of the concrete, was brought into play: drips, text, automatic scribble, patterns, words, allusions, criss-crossings, checker-boards, pencillings-in. This kind of painting takes its clue from collage as well as from walls.

The heart of this work was secured in Twombly's sense of an elegance and a naturally facile draughtsmanship. Fearing slickness, he drew as if with his left hand. To avoid striking the surface straight-on, he drew in oblique and contorted angles, punitively disciplining his linear seductiveness. Compare, when in a public telephone booth next, those doodles made straight-on to those made alongside in the cramped space, and perhaps this observation will be clearer.

In 1957, Twombly settled definitively in Rome. He married and began to raise a family. He exhibited regularly in the leading Italian galleries devoted to contemporary art. His pictures, already large, grew apace with a preoccupation with the Baroque richness of his new environment. Desultory excusions in poetry, myth, and history became evident in terms of literary allusions. The pictographic unravelling of his pictures was profoundly altered by the sweeping planes and space of the Baroque construct. He began to abstractly mimic the *tableaux vivants* of Lanfranco and Pietro de Cortona. This Baroque pageantry would continue until the mid 1960s. Its tenacity is significant because it represented a masterful solution to the dilemma of Abstract Expressionism during the advent of Pop. The easy solution, but the suicidal one, would have been the adjustment of Abstract Expressionist values to Pop imagery. Insulated by the Italian environment Twombly continued to develop his work along lines responsive to great, decorative schema.

In this light, my initial contentions regarding Twombly's present work makes of it something even more considerable and heroic. With it, Twombly casts down all that was grandiose in his mature style, rejecting a lush manner for

simple and stringent exercises. Instead of the Italian 17th century, Twombly has set up as his unconscious model the climax of 1912. Twombly has descended from the heights of a mature realized art to the elemental beginnings. After the capitulation of a vast style, Twombly has learned to write again.

Notes

1. "Son graphisme est poésie, reportage, geste furtif, défoulement sexuel, écriture automatique, affirmation de soi, et refus aussi." Pierre Restany, Exhibition Catalog, Galerie J., Paris, 15 Nov., 1961. Republished in Ex. Cat., *Sculture di Nevelson, Dipinti di Twombly*, (Torino: Associzione Arti Figurative, 19 gennaio, 1962; ex. cat. Galleria La Tartafuga, Roma, 6 marzo, 1963.)

2. Gillo Dorfles, "Written Images of Cy Twombly," *Metro 6*, 1962, p. 65.

3. Frank O'Hara, "Reviews and Previews," *Art News*, Jan. 1955, p. 46.

Cy Twombly

Unlike his generational compeers—Johns and Rauschenberg—Twombly's work derives more immediately from models of minor art. Even when their model was a regional figure—as in the development of Rauschenberg out of Schwitters—Rauschenberg freed himself from the past in ways that elude Twombly in his attachment to earlier masters, earlier art, and the esthetic notion of art. This toughens matters. There is as yet no helpful means other than stylistic analysis to transform what appears at the outset to be a damning attitude into a receptive view. The mechanic employed here will, I hope, clarify Twombly's attachments and allegiances while it underscores the irony of a means ill-suited to its subject.

Formalist tools and their lack of existential edge are, at present, in well-earned disrepute. Still the problem remains one of employing formalist methods, if only to demonstrate the paradox that Twombly's art has gained in its present stature precisely to the degree that it is illuminated by an art—epistemic abstraction—from which formalist analysis has openly and avowedly exempted itself.

Twombly and the Critics

A particular theme stands in relief in Cy Twombly's work—its intimate connection with the physical act of handwriting, yet one presumably more elevated and esthetic than mere script. He has always been recognized as a painter whose imagery is informed by calligraphy—beautiful writing. When Twombly's work of 1967 was shown, a new critical voice greeted these balder efforts in a way quite different from earlier discussions that focused on mere calligraphy. Max Kozloff observed that these pictures were

> ... like blackboards, perversely ap[ing] the anarchic scrawls of children—scribbles so unrelated to Surrealist automatism or Expressionist "action," that they ward off any attempt to think of them as valorous under pressure. Without an inherent tone of struggle, or pretense of evoking the unconscious, his calligraphy assumes that it was nothing other than what it was.[1]

In the work Kozloff discussed, the drawing and the erasure—the "writing" and the "rewriting"—was delineated by a material that masqueraded as chalk

(actually a wax crayon), the binder of which broke down in its fusion with housepainter's gray paint, and that drily adhered to the grainy surface of the canvas. I was struck by this Johns-like shift to a gray field as well, and referred to these works as "the means of beginning again, of erasing the Baroque culmination of the painting of the early 1960s... bluntly, it [the painter's calligraphy] has been drowned in a schoolmaster's blackboard."[2]

This view persists. Kenneth Baker, writing in 1972, assumed as a matter of course that Twombly's recent paintings were indeed blackboards. "A Twombly is only a blackboard insofar as it is a painting, but its claim to being a painting, that is to certain kind of meaning, is based on the illusion it gives of being a marked-up piece of slate."[3]

How did this situation come about? Until the mid-1960s, Pierre Restany's early summation, that Twombly's pictures were about "poetry, reporting, sexual flaunting, automatic writing, affirmation of self, and self-denial also," still obtained.[4] Twombly's development from a sensibility-based calligraphy endemic to Abstract Expressionism to a frank matter-of-fact writing and counting is one which covers almost 15 years. This tradition, it seems to me, is born in Paul Klee and persists transformed in Hanne Darboven. Twombly mediates.

Twombly and the Epistemic Abstractionists

Drawing is the means par excellence by which ideas are made manifest. Yet Twombly, always aware that his art is not one of idea but of visual effect, came to resent the very means by which his art exposes him. His art is not about ideas, but mindlessness. Therefore, what Twombly engenders is not drawing, but the drawing away of drawing. It is a kind of hand-hating drawing, one which denies rather than affirms. Its most signal manifestation is the scrawl, born of ennui, self-gratifying, registers of loops which characterize much of the recent work.

The introduction of conceptual schemata—geometrical figures, numbers, cribbings from Leonardo's notebooks and studies, landscape allusions, the imagery of blackboard and of writing—ironically underscores the conceptual shortfall of Twombly's work. In a still unresolved dilemma, Twombly lacks—or perfects as a function of his Abstract Expressionist inheritance—the very systemic framework which these new symbols are intended to demonstrate. It is a paradox of contemporary art that the current epistemology grants revived interest to Twombly's painting even though the nature of his art remains committed to seemingly undermined values of pictorial sensibility.

The advent and ascendancy of an intellectually-based abstraction in current painting—one outside of Twombly's purview—forces Twombly's work to be seen obliquely. Epistemic abstraction emphasizes diagrams, the graph, modular and serial structure, delineations made against measuring devices and templates; it employs the universals of mathematics and linguistics, it signifies its art-relatedness through studio referents of pencils, chalk, paper, and blackboards.

Suddenly, the Expressionist calligraphic tradition of Twombly's painting changes meaning—it is viewed as germane to the conceptual. The irony of this is that, while Twombly remains preeminently an artist of Expressionist taste, recent access to his work is fashioned from a public grasp immediately allied to systems of knowledge almost fundamentally opposed to the kinds of awareness occasioned by the central premises of Expressionist painting. Twombly's career, which might have been superseded with the advent of epistemic abstraction, has in fact been vivified in precisely the degree that his works are liable to be misread and misapprehended.

Ben Shahn, Futurism and Mural Imagery

On Robert Rauschenberg's advice, Twombly spent two summers and a winter at Black Mountain College, sojourns that brought him into contact with several artists of note, among others Robert Motherwell, Franz Kline, and oddly, Ben Shahn, all of whose work, expecially the last, is echoed in the blurred and expressive line of Twombly's early productions.

The Abstract Expressionists—notably Kline and de Kooning—are sensible in Twombly's preference for black-and-white painting, rhetorical scale, and composition based on gestural structure. Obviously Mark Tobey and Bradley Walker Tomlin, the central calligraphers of Abstract Expressionism, must be remembered in this connection too. But Shahn is especially pertinent, providing the clearest model of painting enamored of linear retentiveness, arid gesture, and a compulsive graphism. Twombly's commitment to taste as an end in itself fortifies these qualities.

Shahn's gouaches of the 1930s frequently depict painstakingly diversified brick slum walls and dreary expanses of handball court concrete. These are perhaps the natural models for the gritty plasterlike surfaces of Twombly's painting through the early '60s.

Shahn's urban mural imagery can be traced to an Italian iconographic antecedent. Beginning before the turn of the century, and culminating in his 1902 painting *Bankrupt,* Giacomo Balla had adopted this subject matter as a function of a proto-Futurist here-and-now actuality as distinct from the escapist idealizations and estheticisms of the Italian Symbolist movement from which Futurism so largely derives. Moreover, this iconography appropriated as an end a sense of solidarity with the working class. While this aspect of Balla was noted in 1961 when The Museum of Modern Art mounted the first broad overview of Futurism in recent times, in all likelihood it did not figure as a conscious source for Twombly's street pictograms. Nor for that matter could Robert Brassaï's mid-1930s photographs of the same imagery.

The point however is not to establish precedents for Twombly's use of graffiti as imagery, but rather to indicate what is compelling about it—namely, its vagrant existence as visual experience, as art (if you like), but as an art devoid

of the cultural ratifications conventionally assigned to art, an art then that falls outside of the academic precincts to which art is generally designated, an art akin to Jean Dubuffet's *art autre.*

Graffiti occur not in places of art, but in places of private use—in toilets, phone booths, in the subways, and in the grimy stalls of cheap restaurants. Graffiti are sociological referents. When they become the imagery of art—at least to an artist of Mallarméan proclivities—a curious reversal occurs. Instead of the anticipated expression of solidarity with class—as one finds in Balla, Brassai, and Shahn—in Twombly, the use of graffiti as imagery expresses the artist's sense of disconnection from class. In this context, such an imagery implies not the *déclassé*—the un- or disclassed person—but classlessness of a-classness—the art and artist "without place." Oddly, the actual graffiti of Twombly have, for the most part, no linked place on the surface. They have no specific moorings. They are mannered, nuanced gestures, relating to edge rather than to surface.

Twombly's use of graffiti as imagery does not overtly question the distinctions of Western social and economic theory. Ironically, it underscores only one Marxist idea, namely, that the liberal bourgeois artist is dangerous because freed of class consciousness.

Twombly and Mallarmé

Twombly has drawn and painted graffitilike pictures from the early 1950s on. These works—wall scrawls, scoured indecisions, blotchy penciled-in areas, and evocative surface flakings—are composed and decomposed according to a nice feeling for weight—precarious surfaces contrasted one against the other and/or against blank yet tactile passages.

Twombly admits to "mainly having a feeling for paper rather than for paint," that is, for surface or ground as distinct from the figure, if any, depicted. Gillo Dorfles rightly perceived that "Vast white spaces which are almost always off-center, are the voids which for Twombly have the power of colour and matter and are, actually, the 'fullest' part of the picture."[5]

This "visuality" stems from Mallarmé. In, for example, *Un Coup de dés,* the most hermetic poem of Symbolism's chief poet and theorist, the meaning of the poet's final work is enlarged by the very blankness of the poem's sparse typography. For Mallarmé, the unprinted elements and passages of the page specifically elaborate verbal meaning. Mallarmé said, by way of explanation of the work published in a transient review called *Cosmopolis,* that "the whites of the printed page in fact assume importance, make the first impression; the versification requires this. . . . "[6] If "a toss of dice will not abolish chance"—the central premise of *Un Coup de dés*—then what will? The answer, it appears, is in a life lived as if it were art. The esthetization of life that marks Mallarmé's circle persists in the manner and sensibility of Twombly.

A pictorial inflection of the weights of voids played against penciled scrawls and heightened by diffident and indecisive strokings covertly reveals a derivation in Paul Klee; overtly it aligns itself with an Abstract Expressionist idiom. Still, the unsublimated aggressiveness germane to that style is in Twombly rendered ambiguous by obscure urges and options, which are, in some evasive sense, literary and Surrealist.

In the early '50s, Twombly was called into the army and assigned to the study and deciphering of codes. "I was a little too vague for that," Twombly recalls, but cryptology allowed him to remain stateside within reach of New York City where he maintained valuable artistic associations. Still in the army, Twombly drew at night, without light, sharpening the meandering graphism for which he would shortly be esteemed. After his discharge, Twombly traveled throughout Europe, particularly Italy and North Africa, where he remembers his most placid and happy moments as those when he painted in brilliantly white empty rooms overlooking the sea.

This decor, this Mallarméan nothingness, prefigures the locus of recent epistemic abstraction. The "clean well-lighted" place is the American nirvana. This decor extends a corridor from the perfect cubic space of say, the Ducal Palace in Urbino through the late paintings of white rooms by Edward Hopper to Robert Irwin's satorilike environments.

Twombly and the Baroque

In 1957, Twombly had settled definitively in Rome. He married and began to raise a family. His palatial surroundings became a celebrated installation, and his personal collection of Classical artifacts, contemporary art, and esoterica of all kinds was widely illustrated in the fashion-conscious press. He exhibited regularly in leading Italian and American galleries even though his work veered away from an American mainstream then well-committed to a Pop consciousness, and on the verge of the intense abstract reductiveness of Minimalism. While the fascination with an iconography of the commonplace took hold in the United States during the early '60s, Twombly, working in Rome, altered the Expressionist idiom of his paintings to conform to the Baroque richness of his new environment. His pictures, already large, grew even larger with an intensified awareness of poetry, myth, history—Venus and Mars, Triumph of Galatea—primed in terms of the Italian 17th-century decoration which surrounded him.

The pictogrammatic unraveling of his pictures was profoundly altered by the sweep of the Baroque spatial construct and mythological references. Twombly adopted the poses of the *tableaux vivants* of, say, Guido Reni and Pietro da Cortona. This pageantry continued until the middle of the 1960s. Its tenacity is significant not only in terms of the moment-to-moment evolution of

an artist's work, but because it represented a solution to the abhorrence of vulgarity, a problem I believe central to the artist's psyche, and posed during the ascendency of Pop. The clearest resolution would have been the adjustment of Abstract Expressionist painterly values to Pop iconography—the conjunction, for example, made in the mid-1950s by Larry Rivers, Rauschenberg, and, to a lesser degree, by Jasper Johns.

Twombly's position had affiliated itself at the beginning of his career with Rauschenberg. However, by 1967 it became apparent that Twombly's affiliations more readily attached themselves to Johns. This has been the evolution of Twombly's work; after capitulating to the Baroque, his art seemingly revives elementary values. The grandiloquent and mock heroic of the 17th century now has been replaced by a leaner and severer understatement.

Twombly and Rauschenberg: Graffiti and the Common Object

Significantly, Twombly had made the acquaintance of Robert Rauschenberg in the early '50s, the first peer artist Twombly came to know well. Already admired for the so-called white paintings of 1952—bare stretched canvases hung in connection with a Cunningham-Cage dance concert at Black Mountain College—Rauschenberg, too, was at the time experimenting with black-and-white painting, and employing an imagery derived partly from children's games and numerical configurations. Again this bespeaks the widely unacknowledged influence of Paul Klee in these two artists.

Twombly's early major exhibition of wall-scale graffiti-covered canvases was held in 1955 at the Stable Gallery. The premises were in New York's West Side midtown area; a large loftlike space strangely similar to a SoHo gallery today, but one totally unlike the smaller, more fashionable galleries of the period, such as Sam Kootz's on Madison Avenue, where Twombly had just shown jointly with Rauschenberg in an exhibition arranged through the good offices of Robert Motherwell. In January of 1955, Rauschenberg also had exhibited independently at the Egan Gallery, then on 57th Street, showing works that radically confronted the prevailing Abstract Expressionist mode with a popular iconography suggested by street detritus and common objects.

These revisions point to a new way eventually designated Pop art. Still, the scribblings and wall graffiti which formed the image of Twombly's large paintings at the Stable show may have played the same role in his paintings that the intrusions of common objects and found material played in Rauschenberg's earliest Combines. It remains a question of interpretive emphasis.

Graffiti and Abstract Expressionist Allover

By 1955 Twombly was using the wall graffiti as a means of generating Abstract Expressionist allover. However, instead of using informally balanced affairs of linear incisions, smudges, and scoured blank surfaces, that is, compositions

retaining points of reference to the perimeter and delineated upon the picture's surface, the picture became a device for peripheral expansion. The graffiti were dispersed equally over the whole—the Abstract Expressionist allover preserved. A scrawl of mutant writing generated inchoate fragments of line, arcs, and shape sections excised at the perimeters, inducing thereby a sense of movement beyond the arbitrary vertical and horizontal cuts of the edges. There was no reluctance to pass beyond the perimeter, no doubling back of the gesture at the edge, such as one finds in the "heroic" period of Pollock (1947-51) when the allover was first exploited as an end in itself. Such tentative gestures at the edge of the canvas would have occasioned the compromised effect of a "thickened" ground—one that would have created the sense of conventionally accepted "frames" of space such as one finds, for example, in the white paper "collars" retained in watercolor practice. In short, Twombly's pictures of the mid '50s nonchalantly "expanded" beyond their edges.

But, despite the sense of a continuous expansion *out* from the perimeter in all directions, there was little sense of expansion *into* depth or *out* from the surface. These latter constrictions derive from the pervasive wall metaphor in Twombly's painting. Twombly's graphism can, like palimpsests, scrawl one upon the other but they expand little in or out—they grow but they do not breathe.

Twombly as Anticolorist

The wall metaphor is probably a function of the same metaphor as explored in the work of Kline—his *Shenandoah Wall,* for example; or possibly even of Hans Hofmann's paintings after 1950. Hofmann's "pushed and pulled" scoured works, employing rectangles of brilliant color, have the effect of annihilating space rather than inducing spatial readings. Moreover, such a heightened sense of expansion is impossible to virtually anticoloristic painting such as Twombly's. This indicates that Twombly—despite his affiliations with Abstract Expressionism in the '50s—worked outside the stream that fed field painting or "Post-Painterly Abstraction."

This means that, unlike the issues of optical expansion inherent to color field painting, Twombly's work rejects the spatial world of late Monet, a consciousness of which enters American painting at that time and which provides the springboard for the very type of formal analysis that I here use to discuss Twombly.

Instead of the formal and spatial concerns derived from late Monet, and the last phase of Pollock's career, Twombly remains closer to a Surrealist graphic experience, one which tended to superimpose automatic flamelike shapes—that is, closer to the vegetal and organic self-elaborations of de Kooning and Gorky. The latter's influence particularly cannot be minimized, especially those drawings from the last years of Gorky's life, circa 1945-47.

The Rejection of Surrealist Automation

From about 1956-57 on, Twombly began to reject the principle of superimposition, the pileup of grass-written transparent words and alphabet fractures. His canvas grew larger and emptier, the automatic gesture replaced by recognizable clues of a regressive imagery related to primitve scrawls and graffiti. Readable phrases, sentences even, were somethimes discernible. Often of a sexual or erotic archaism, like lavatory doodles, such pictograms of male and female sexual organs and whimsical diagrams were scrambled as quickly as they were actualized. The pictures grew like privy walls. These images were once more haphazardly ordered by Twombly's taste, canceling out weight against image, smudge against crust, patch against peel. A vocabulary of fanciful markings was brought into play: drips, texts, automatic scribbles, patterns, words, allusions, crisscrossing, checkerboards, pencilings-in. The heart of this work was secured in Twombly's sense of elegance and facile draftsmanship. Fearing slickness, he drew as if with his left hand. To avoid striking the surface face on, his pencils were held in oblique and contorted angles, a method that hopefully disciplined linear seductiveness and facility. Compare, when in a public telephone booth or toilet next, those doodles and inscriptions made straight on with those made alongside them in a cramped and lateral space, and perhaps this observation will be clearer. It is still the heart of Twombly's problem.

Notes

1. *Artforum,* December 1967.

2. "Learning to Write," *Cy Twombly, Paintings and Drawings,* Milwaukee Art Center, 1968. The other reference catalogue is *Cy Twombly, Bilder, 1953-1972* Kunsthalle, Bern, April-June 1973, with an introduction by Carlo Huber. A handsome picture book, *Cy Twombly, Zeichnungen* 1953-1972, Propyläen Verlag, Berlin, 1973, has just been published with a prefatory essay by Heiner Bastian.

3. *Artforum,* April, 1972.

4. "Son graphisme est poésie, reportage, geste furtif, défoulement sexuel, écriture automatique, affirmation de soi, et refus aussi." Pierre Restany, *Exhibition Catalogue,* Galerie, J., Paris, 15 November 1961.

5. Gillo Dorfles, "Written Images of Cy Twombly," *Metro 6,* 1962, pp. 63-71.

6. Most recently, Heiner Bastian also made passing reference to Mallarmé as a means of gaining access to the spatial properties of Twombly's work. Mallarmé's question, "What wing can be held?" is seen by Bastian to be the ambiguous model for Twombly's "line as distance and time between two spaces ("...hier sind die Linien Distanz und Zeit zwischen zwei Räumen,..."), p. 14.

Ryman, Marden, Manzoni: Theory, Sensibility, Mediation

There are several figures at work today who in their general abstract-reductivist drift, preference for a geometric format and use of monochromatic surface, can be seen to derive from the achievements of Malevich and of Mondrian, or in terms of a more immediate model, from Agnes Martin before she ceased painting in the late '60s. The problem today is less one of securing an abstract morphology—this is a given—than one of clearly focusing on those features of concern to the nominal act of painting. In this respect the Robert Ryman retrospective at the Guggenheim Museum reveals a desire to deal with the separate options germane to painting and clarify an approach to art which denies that the *act* of painting is *in itself* significant. Conversely, the recent exhibition of Brice Marden's paintings at the Bykert Gallery suggests that, no matter how reduced in visual incident, painting remains an esthetic preoccupation. Ryman is interested in painting as theory and one is therefore tempted to say that he is not interested in painting at all. Marden, on the other hand, is interested in painting as the expression of sensibility and as a result, he is committed to maintaining an inherited tradition. Both artists have concentrated their issues so closely, however, that they can be viewed as the opposing faces of a problematical region of discourse.

It is largely because Ryman's pictures stop short of committing themselves as paintings that we have had to wait for his retrospective to appreciate the nature of his accomplishment. In his one-man shows, we were presented with individualized tentatives, the cumulative effect of which remained an elusive quantity. Seen chronologically, in the context of a retrospective, Ryman's special particularities reveal a consistent theoretical position. By contrast, our awareness of Marden's theoretical position would not be enlarged by viewing his work in chronological sequence, as the central option—sensibility painting—has been observable in his work since the mid-60s, when he first absorbed the properties implicit in Jasper Johns's use of encaustic.

Nonetheless, Ryman's work accepts certain traditional issues; for him art still remains an expression of the painting support, of paint itself, and of

manipulation with that substance. Above all, he places an unusual burden on the intellective processes. It is in preconceptualization as it affects the previous three constituents that Ryman is able to realize his art. The argument of a typical painting may be stated as follows: a surfacing of the canvas with three layers of white paint. A canvas with merely two layers is, in the context of the theorem, an "unfinished" work, although the visual impression is identical to a three-layered work. Only prior knowledge of the argument permits us to understand its relative state of incompletion. Similarly, a painting may be understood to be a manual activity implicating hand, tool, and pigment. Ryman may determine as an art of preexecutive choice the kind of brushstrokes to be employed: strokes of certain lengths, strokes which are a function of how long the paint stays in the bristles (the duration of time wherein pigment is exhausted), and strokes in consonant directions. These decisions remove the brushstrokes from esthetic graphicism, from calligraphy, from sensibility. Though liberated from sensibility, however, the strokes still remain within a definition of what might reasonably constitute the act of painting. By contrast, Marden's brushstrokes are a function of praxis; they rely on the very experience of painting. Before anything else his strokes are artistic gestures, despite the reductive orientation of his work.

These distinctions are not absolute. There are Mardens which, granting their general monochromism, are built up through several layers of dexterously handled paint that appears affiliated to a sharp degree of preconceptualization. The paintings in this vein which I most appreciate are some works of three years ago in which a small area at the bottom of the canvas is left uncoated to form a spattered and spotted band. The band serves as a record of the slow buildup of layers leading to the generally understated grade of monochrome, either olive, slate, or claylike in coloration. The spotting denotes that the monochrome was arrived at slowly; it leads to a soft and diffident surface of closely modulated values and thicknesses, a technique clearly in debt to the gray and green coloration of Jasper Johns's paintings of 1955. It is worth noting that Ryman's earliest mature work dating from 1958-59, also recently exhibited at the John Weber Gallery, obviously derives from the same source (as well as Rauschenberg from 1949) and deals in fact with many of the issues central to Marden's current painting.

Likewise, in the most recent Rymans there are indications that sensibility is not an absolutely foreign condition. If it may be perceived that the most recent Mardens are moving from sensibility into theory (e.g., polyptychs of joined canvases or binary and tripartite compositions), so too the most recent Rymans suggest a transposition away from theory back into sensibility. For instance, the largest works in the Guggenheim Museum exhibition, the *Surface Veils,* three recent 12 foot square white paintings, indicate that a kind of soft Rothko-like field is emerging. This inflection may result from a scaling-up process; Ryman's preferred sizes are those in which the actions are natural to a free arm gesture and no more, although the actions selected may in fact be quite small and

therefore enacted within small formats. The new large paintings appear to be transpositions of small white studies executed on surfaces of a dry plastic fiber. The smaller compositions are executed with consonant strokes moving in one direction to meet strokes moving in another. In enlarging such visual propositions the surface of the canvas does not correspond to the surface of the plastic. The character of the paint, as well, has lost its correspondence to the dry white of the study and the tool proportion—large tool compared to small tool— seems in some measure "off." In negotiating the discrepant relations, something of a sensibility-like intonation reemerges.

At this point it is less startling to note the antithetical positions from which these two artists work. What is more extraordinary is that there have been previous attempts to mediate sensibility and theory in the context of monochromism, a mediation affected not in an abstract-reductivist vernacular but within the context of the revived Dadaist postulates of the 1950s.

For Americans the obvious connection would be Rauschenberg's *White Paintings* of 1951. Though lost, their existence is well-documented. Marden's close connection with Rauschenberg makes it impossible for him not to be aware of the works, but no doubt he would have known of them even were he not a personal friend of the artist. A European parallel to the Rauschenberg option is exemplified in the retrospective exhibition of the Italian artist Piero Manzoni recently held at the Sonnabend Gallery, New York. The artist died in 1963 at the age of 30. Like Yves Klein, Manzoni arrived at monochromism—his paintings are white, Klein's are blue—in the late 1950s. Neither Manzoni's paintings, nor Rauschenberg's *White Paintings* for that matter, were statements about abstraction. The Rauschenbergs were screens which registered the shadows of spectators. Hence they functioned as isolated rectangles of environment. Said another way, they could be understood as unadorned stage flats related to the theoretical aspects of music and dance as evolved at that time by the artist's colleagues, John Cage and Merce Cunningham. Conversely, Manzoni's monochromes, smaller in size, are compositions of an eccentric sensibility. By their resolute willfulness they resisted the monopoly of senescent European versions of Abstract Expressionism—*l'art informel* or *tachisme*—which dominated progressive European taste in the '50s in much the same way as the gestural aspect of Abstract Expressionism dominated the same period in this country.

By isolating the constituent features of art—color, line, or its sacred conventions such as base or frame—Manzoni broke away from this discredited modernism. Therefore the white monochromes of Manzoni must not be viewed as a body of images excluded from his other production, but as a parallel say, to the meter-long brushstrokes rolled up in tubes, or the elaborate joke representing *The Base of the World,* 1961. By isolating constituent features of art Manzoni paraded what he thought to be the *essential futility* of art-as-sensibility, a consciousness which finally led him to autograph human bodies, can his

excrement, and sell his signature to other artists to sign upon their own work. Intriguing in Manzoni's neo-Dadaist position is that his isolation of esthetic constituents, on the one hand, functions in a way parallel to Ryman's preconceptual art and, on the other, postulates the validity of art through iconoclastic activity, an attitude that paradoxically reasserts the value of sensibility. Thus Manzoni's Dadaism mediates otherwise antithetical extremes.

Manzoni is now out of the picture. He is interesting as an historical figure against which our problems are afforded definition. Nor is Ryman's or Marden's approach to art the central critical issue today. The current problem is our sense of the virtually de-energized condition of painting, an apprehension perhaps so overwhelming that even our finest painters—and sculptors as well—can only confront it through oblique asseveration. Certainly Marden, who is after all a traditional painter, surely recognizes that a static attitude can only serve to neutralize his art. Ryman, in turn, must be aware that he represents an essay at painting from an abandoned context. While still admissible as a curious paradox, the internal contradictions of Ryman's posture will in the end be a vitiating factor. But the end, of course, cannot be predicted. It may lead anew to what appears to be a pessimistic nihilism—but which in fact is an activist critique of culture—similar to the one adopted by Manzoni. Though there is nothing to replace painting except in fact what painting itself becomes, I nevertheless think that Ryman and Marden both measure from differing and mutually approaching ends the profound malaise into which painting has fallen. Their achievement therefore is no longer a function of the kinds of painting they do; it resides in the fact that they continue to paint.

Fining It Down: Don Judd at Castelli

One's critical opinions about recent American sculpture are almost entirely divorced from issues of pleasure and likeability although some of the artists are more immediately sensuous in their appeals than others. Whatever it is that makes the work of this group who are important seem important, it is clearly a function of an unswerving commitment to difficulty—at least insofar as Judd and Andre are concerned. The others—Morris, Sonnier, Serra—for all that is intractable in their work, waver by moments on the margin of an affable pictorialism, and it is this fact alone which may make Judd and Andre, to the exclusion of all other American sculpture of which I am aware, the dominant figures of the later '60s. They saw the period's hardest problem most clearly— how to deal with, in fact, how to protect, the solidity, the tangibility of the "recognizable" formal vocabulary of Cubism and Constructivism while reforming and renewing the spectator's sense of relationship to this legacy. To do so they were obliged to eschew all that was topical, disarming, and petty although Judd's continued feeling for lyrical color, *matières nobles,* and tinted plastics, especially evident in the recent reissuings of earlier work, may be the single element in his production which still threatens to subvert the otherwise magnificently therapeutic ambitions I have attributed to his trying enterprise.

The present installations, one at the Warehouse, one at the Castelli Gallery proper, are exceptionally difficult. It would be tempting, for example, to insist that the reissuing of earlier sculpture relates to Judd's fascination with an elemental primacy of material. To do so would link him falsely with, say, Robert Morris whose pictorial display of the substantive properties of materials has become marked in the period 1968-70. And yet, how different is Judd from Morris. The latter is involved in process, accident, nature, and even, one might say, in a narrative focus, each episode of his mammoth accumulations being permitted to have its own moment. Not so with the Judds. The reissuings seem to me to be much more concerned with refinement—I mean refinement as a kind of self-testing—in the same way that a Brancusi polished brass is more refined than the same subject carved in wood or stone. One could point to the late *Mlle. Poganys,* the *Torso of a Young Boy* or the *Blond Negress* for apposite comparisons. The employment of polished brass in each instance emphasized a

svelteness, an elegance and a pictorialism which the others, for all their strength and genius, lacked.

The problem of the use of polished brass, not only in the recent reissuings of older pieces but in the major new works themselves, is particularly acute and suggestive because, if anything, it still deals with the long memory of colorism in Judd's work. Among the most complex problems caused by the use of polished brass is the apparent absence of solidity—the sense of liquidity—it induces. I expect that Judd's fascination with this substance is based on the pictorial excitement that such a material causes in forms that are otherwise so solid seeming, so sculptural. There are views, for example, of the polished brass box, in which the recessed top is simply denied, appears flush with the sides. There are other views in which the sides appear translucent rather than reflective, as if one saw the floor *through* the side rather than reflected *off* it. Such illusions permit a massive form to exist in two spheres of being, in pictorial space as well as in sculptural space. Paradoxically, this pictorial illusionism may serve, at length, to intensify the sense of the solidity of the work.

This quixotic experience is even further exaggerated by the pictorial complexity of the major piece in the Castelli Gallery proper, which lacks even fewer devices to make its *raison d'être* clear. If the most peculiar passage of the untitled brass box is its recessed upper surface and inner rim, then its corresponding passage in the galvanized metal piece is manifested in the elements having been pulled in from the gallery wall. What I am trying to get at is that there is a kind of relationship between works and that the rim of the brass piece is a variant expression of the passage between the actual wall of the gallery and the actual wall of the galvanized metal. It may be an almost hermetic statement to the effect that the artist is not merely interested in the subdivision of a surface, of a wall and, by extension, as there are three walls in question, the subdivision of an environment, but in something infinitely more delicate—the desire to find the least sculptural method and at the same time the most highly pictorial one which would effect this otherwise easily achieved end, which would have been to have run the galvanized metal flush against the plaster surface to begin with. If this is so, then perhaps what Judd is up to is to combine both pictorial and sculptural experience into a single instant—itself hardly remarkable since the whole decade of the '60s is marked by this aspiration—but to do so while employing the least amount of given material possible.

In this respect, Judd has been particularly coercive of the spectator, forcing him into altered relationships with an elemental, at moments brutalist, formal vocabulary. Andre may attack the problem of surface and quiddity, Serra that of process, juncture and reconstructibility, but Judd is more oblique in his intentions. He engages the spectator without in fact permitting the participation to spend itself. Open ended boxes, for example, are placed too low to crawl through while polished surfaces and glossy plastic linings also thwart the sensate body appeals they are making. Similarly, blunt and environmental situations, like

the present galvanized wainscoting along the walls of the Castelli Gallery, not to speak of the earlier racked partitioned shelves or the stacked pieces, also frustrate participation while it dampens all environmental experience as might be glanced or reflected off the surfaces. The snow crystal surface of the galvanized metal still speaks of the attraction Judd feels for lyrical color. After all, he began as a painter. It also points again to the often casual and coloristic surfaces of geometrically based minimal sensibility—something I have already attempted to point out in the surfaces of Ryman's earlier painting.

The device of attraction/frustration—readers of philosophy will point to Merleau-Ponty as essential in this connection—seems to me to be motivated by a deep need to protect and reinvent the integrity of the Cubist and Constructivist vernacular at the moment when the great tradition of the Cubist monolith is most particularly assailed by the decorative appeals of technological intermedia. What Judd, and Andre too, block with their intransigent barricades, is the notion that dreary Rauschenberg-Cage kid stuff should pass for high art. I think that ultimately Judd and Andre are going to fail in this ambition—if it is their ambition—but in their failure, should it come to this, they will have created the most important work of the late '60s.

Michael Hall: Construction, Not Constructivism

Michael Hall has lived just about everywhere in the United States—urban, suburban, rural—long sojourns on the West Coast, in the South, in the Midwest—big city, small town. He has lived in these places never as tourist, but as long-term resident. It matters. In each he has mined its local characteristics; each remains vividly imbedded in his sculpture.

For the last seven or eight years, Hall has been a professor of sculpture at Cranbook Academy of Art in Michigan, or, as they say there, master of sculpture—there's one for painting, another for pottery, for weaving, architecture, and so on—following the workshop precepts of Cranbrook's original founders, the elder Saarinen and the sculptor Carl Milles. Under each of the nine masters is a group of graduate students, some hundred or so in all.

Hall and his wife Julie (an authority on American crafts) now live with their two children in the original Milles house. No one more than Hall appreciates the irony of this situation. He is so totally nuanced a person that the meaning of each of Cranbrook's "cubo-deco" frets, each nordic Bacchante, each flawlessly designed and executed idealistic signifier, is fully esteemed by him. Yet he recognizes that his role, if it is to be efficacious, is that of agent provocateur: *he must instill values in his students that will eventually demolish Cranbrook or transform it into what it has so largely become, a kind of monastic ideal perhaps best preserved, even were it possible, beneath a glass bell. In serving these ends, he ironically will have been faithful to the aspirations of its founding fathers.*

Since so much of my conversation with Hall was contrasted against this now nationally designated landmark, these 300 perfect acres, I could not have failed to register my impressions of the place with my impressions of the artist, each one throwing the other—assuming for the moment that they are really at odds—into simultaneously higher, more dramatic effect.

I

Michael Hall's earliest sculptures, ones that he still has photographic record of, correspond in time to his California adolescence. Raised north of Pasadena in a severe and ungenerous Methodism (his parents both teachers), Hall executed his first works in 1956 when he was 15. They were "tikis" done for the decor of local restaurants—"tikis" freely based on ethnographic prints he found in the local library. He carved them from palm tree trunks which he attacked with a chain saw. Thus, from the outset the "macho heroism" implicit (one now must certainly note) in the American constructivist tradition since the Second World War, was preserved intact.

Hall's first works then were not western—they were Trader Vic "tikis" influenced by Oceanic and other kinds of primitive imagery, such as Bakota carving. In all the enthusiasm of this work he was evincing his sensitivity to a vernacular stream that would lead to surprising results in his subsequent career—for example, his support of American folk art and his receptivity to the regional landscape.

While Hall was still an impressionable adolescent, the famous Dan Budnik photograph of David Smith standing like Proteus amid his sculpture in the fields of Bolton Landing was published in *Life* magazine. Hall was instantaneously transformed. Here was to be his model—very much as Smith became the model, one could say, for practically every American entering sculpture at that time.

In 1960, Hall went to the University of North Carolina at Chapel Hill, addressing himself to the sculptor Robert Howard, a former student of Ossip Zadkine at La Grande Chaumière in Paris, still one more sculptor turned constructivist in the train of David Smith. Howard was a good influence, compassionate and understanding. At the time, Howard's most famous student was Edward Higgins, who had left Chapel Hill six years prior to Hall's arrival. This was the heyday of the first group of sculptors in the Leo Castelli stable— Bontecou, Chamberlain, Rauschenberg, Scarpitta, and Higgins—the last named advised Hall to come to New York City—counsel pondered and rejected.

In North Carolina, Hall recapitulated the history of American sculpture from 1945 on. His most ambitious work was a biomorphic abstraction in cast stone—an extremely hard plaster filled with colored aggregate spread upon an armature. It occupied his entire student effort, combining a monstrous Roszak-like imagery with the surrealist residues seen in the West Coast Clyfford Stills of the 1940s.

By 1962, Hall had moved on to Seattle, to the University of Washington, there maintaining his synthetic constructivist stance, amalgamating a host of sources, including Higgins, who had by then become a kind of counselor and friend. While in the Pacific Northwest he saw the *Zigs* of David Smith for the first time. He says: "The stuff I was doing and what I was seeing were at odds with one another."

The trajectory from Carolina to Washington had been broken by a stopover at the University of Iowa at Iowa City. There Hall saw the great ceramic works by Peter Voulkos, such as *Black Jar*. Hall was so stirred and amazed by Voulkos' ceramics that in 1964 he went back to California hopeful of gaining access to the artist's studio.

For nearly a year he saw Peter Voulkos almost daily, offering him assistance from fine welding to the menial chores like sweeping-up. Voulkos by then had moved from his ambitious ceramics to a kind of heroic metal sculpture. He was surrounded by an array of sycophants freeloading on his elaborate meals and liquor. Hall, by contrast, helped where he could and, at last, was taken into the sculptor's intimacy. Voulkos' hope was to inflate crafts to such a high degree of aesthetic achievement that the essential and fundamental breach between the arts and crafts would be healed—or so Voulkos thought—through the very obliteration of the democratic/elitist distinctions that separate the crafts and the arts. Thus Voulkos would move over into sculpture at the same rung of the ladder that he had reached as a pioneer in ceramics and ceramic sculpture. I ask: "Did Voulkos really believe in the democratic cant that crafts people say they believe in?" Hall: "I don't know. I doubt it."

Hall remembers the '60s, California north and south, Los Angeles, Bay Area, Berkeley, a failed first marriage, supporting himself as a rock musician, the drug scene, Ken Kesey, and the like. The stay in California affected Hall's work (like that of so many others), in that it allowed him to pick up the technique-ridden color-wizardry of the California Fetish Finishers. Hall was drawn to high polish, either of aluminum or bronze, of various combinations of metal and plastic synthetics.

Eventually, Hall's travels led him to Kentucky. He continued to work in the sprayed, high finish surfaces endemic to California taste. The heroic models remained those of Smith and now, through direct contact, Voulkos. The material became even more polished and high-colored—fiber glass, bronze, lacquered surfaces, polished aluminum and the like—a successful synthesis easily assimilated to the constructivist tradition.

In 1968 Hall was a natural for inclusion in the Whitney Biennial of that year, an event that represented a radical coming of age for the artist. There he understood that he was not meant to represent a tendency in himself, but rather, in a certain sense, he was selected to ratify or flesh out a pre-existing one. For Hall, two dates count particularly: 1968, the Whitney coming of age, when he lost faith in a slick and acceptable style much in debt to California constructivism, and 1969, the inauguration of the *Gates*, a kind of constructivism inflected by strong regionalist imagery. They are, in a certain sense, the recto and verso of the same event.

The important 1968 Whitney Biennial, devoted to sculpture, had been expressly democratic, its selection committee funded and empowered to find "the best" sculpture throughout the United States. It was a "best" that often

papered the house, reinforcing traditions, but also revealing a new counter-formalist sensibility in the work of say Eva Hesse, early Richard Serra, and Robert Smithson.

In 1968 Hall was included as well in another important exhibition in Chicago that had the similar effect of further disassociating him from his peers. Hall ironically refers to most of the group who showed there as a "pantheon of not-quites." Continuing to work in fiber glass, he nevertheless showed an important early work called *Moon Pie* named after a popular junk food with a characteristic scalloped edge.

Moon Pie, its 12-foot archway marking regular mathematical undulations, is still rather Voulkos-like in effect. It signals the end of the period of the "successful object" and the beginning of what I will call a "mid-career" style, one that, for Hall, is marked by specific regional intonation and an iconography of arch or gate. (*Moon Pie,* with its somewhat Pop technological cast, is now set up on the grounds of Cranbrook. So distressing is it to the conservative Milles-formed taste of the community, it is frequently vandalized.)

At the time (1968), the influence of David Smith asserted itself visibly into the vocabularly of Hall's work, traceable most particularly to Smith's *Primo Piano I.* Cued by that work, Hall understood that "it was possible to make a two-sided sculpture." Through the planar aspect of Smith's sculpture, Hall was able, he thought, to address the kinds of problems visible in contemporaneous formalist abstraction (for example, in the work of Kenneth Noland)—that is, high art problems such as "frontality."

In 1968 as well, Hall came into working relations with Mark di Suvero. My personal feelings about di Suvero are mixed—the Franz Kline gesture, the slovenly pictorial model from the first generation of abstract expressionist painting, tends to repel me. Yet, unquestionably, when Di Suvero hits it—and 1968 may well be his greatest year, there's *For Lady Day,* or *Chimes,* or the great work set up in High Park in Toronto—one recognizes his complete autonomy from the populist attitudinizing that goes so far in undermining his authentic achievement.

We are now in the Kentucky phase of Hall's work (1966-70). The settling in is long, the experience southern though just diagonally below the Midwest. At this time Michael and Julie Hall are overwhelmed by the traditions of regional and naive sculpture. In Kentucky, for example, they discover the work of the woodcarver Edgar Tolson whose carvings have been so much sponsored by them, both as collectors and historian-critics of folk art.

As Hall explains: "I have two fathers—David Smith and Edgar Tolson. There is no way to overestimate Tolson in my career." Surely Tolson is about "The American Thing." To his students, Hall poses the following conundrum: "Speaking of 1930," he says, "there was Carl Milles, there was Tolson, there was John Flannagan." What do his students make of this startlingly disparate list? Milles may represent academized idealism, a metaphor for Cranbrook itself;

Tolson may be some Whitmanesque notion of America; and Flannagan an example of the sculptor emerging in the latter tradition of individualistic resourcefulness—a surrogate for Hall himself or they, themselves.

II

The year 1969 marks the emergence of the *Gates,* and a "mid-career" style. The term is egregious. Hall is a young sculptor with a lifetime of work ahead of him. When, in the venerableness of age, Hall's career is examined anew, what today can be seen as work falling into three distinct phases, will be seen to be all of a piece.

The *Gates* invoke the flat midwestern landscape. It is a certain kind of landscape metaphor—but it is not about trees or luminous meteorological effects or expressive responses to season or temperature. Hall is stirred by the outcroppings of industrial structures on the flat farmland; the wall relationships of barn and silo engage him; and more—the billboards, the derricks, the vans, the watertowers, the unexpected coming into view of the sign, the stock pen, the pasture boundary—all manner of industrial, farm, and dairy buildings. But in all of this simile, rarely does the art of the "mid-career" style call art itself to mind. By contrast, take Anthony Caro. His landscape metaphor is informed almost entirely by art—by David Smith, the generalized abstract reductivism of the 1920s and '30s in Europe, and the female-as-landscape as in the work of Henry Moore. In Hall (as well as others) the metaphor is that of the American region, a far more local source, far less informed by cosmopolitan and historical cross-currents. It is a form of regionalism, albeit abstract and constructivist.

Rick Mayer, who helps Hall build his public-scale works, says that Hall calls himself "the sculptor of Interstate 75." We're driving in Rick's van to visit *Tiburon* at Wright State University in Ohio. Mayer's memory is borne out by the number of sculptures that Hall has made revealing the regional metaphor and, if not only that, then bearing the names as well of midwestern burgs—*Ashtabula* and so on. (*Tiburon,* incidentally, gets its name—Spanish for shark—from a Bay Area town out past Sausalito.)

The *Gates* came into being at the moment when the credibility of centrist constructivism was at a low ebb in America, its idiom having been reduced to sheer academism in the suite of David Smith to Tony Caro, to the Bennington School of sculptors, the latter surely a "pantheon of not-quites." This constructivist academy had been challenged, then superseded by contemporaneous pictorial/sculptural options of the late '60s—say the scale and process-oriented expressionism to be found in Richard Serra's lead tossings, Barry LeVa's scattered variegated felts, Lynda Benglis's colored latex and foam, Keith Sonnier's flocked latex, Robert Smithson's Sites and Non-Sites—in short, by a wide range of sculptural attitudes traceable to a refreshed interest in abstract expressionist gesture. I have called all of this and more "Post-Minimalism." Be

that as it may, it was an inauspicious time for constructivists, albeit regionalist constructivists, to debut, despite the sheer number of them who did.

That it has taken Hall a decade, at least, to impose his vision as viable is a function of the displacement of Constructivism by more conceptually-oriented attitudes contemporary with his evolution. And before Hall will readily be accepted at his true stature, two issues must abate. On the one hand, there is the pervasive vulgarity of the "Ecole de Bennington" to be subdued—all that esteem for sub-Caro types. They are the "bad faith" of Constructivism. Deprived of exposure to someone of Hall's stature, the public continues to accept for high centrist constructivism merely its fiat. The saturation of this taste by the knock-off, then, has squeezed out, in part, the chance for an authentic talent within this vein to impose itself, largely because the public that might support Hall is precisely the same that is happy to make do with the synthetic imitation.

That is one side of Hall's problem with his public; the other is isolation from the center: the persistent, pernicious, malformed, and malfunctioning constellation of sectarian culture—no public, no patronage, and the vacuum caused by neither public nor patronage.

Of course, Hall need not be entirely disaffiliated from certain expressionist/pictorial roots sensible in Post-Minimalism (though he is not a post-minimalist). Two broad reaches of the style of the *Gates,* one iconographic, the other chromatic, indicate that much of the germ of his work can be traced to abstract expressionist sources as well. Works like *Ashtabula* or *Bowling Green* (which despite its name—that of an Ohio town—is pink) are emblematic of the situation. "There is a lot of that kind of pink in the Midwest—overpasses, industrial structures—you know, red pigment, but after two or three years the colors leach out. The pink is that of 18th-century wooden weathervanes." (Hall is referring to a worn work shaped like a rooster in his collection of American primitive art. I am brought up short. This massive man, a handsome version of an ugly person, has so much sheer taste and such a formidable ease with language that there is scarcely an experience for which his speech would not find the proper word, his hand the right shape, his eye the right color.)

In these and other gate motif works, color corresponds to a "felt necessity." Hence it derives from the tradition of sensibility abstraction, the ultimate chromatic justification of which is beyond language's capacity to state. It lies in an absolute justice of taste; that certain shapes—in these cases, iconographically gates—demand just that pink.

While such decisions are surely arbitrary, they are paradoxically—for artists that is—distilled from the acuteness of an artist's unique sensibility, altered in measure by the very history of his or her own art. Here form and content are inseparable. Be that as it may, such color choices are ultimately arbitrary: while they may be said to "be right" or "feel right" there is no external system whereby such convictions or assertions can be validated or ratified, though, in time, they may be vindicated. I hinder Hall in no way in making this assertion as the entire

tradition of sensibility abstraction and of formalism, too, is called to question in this remark, not just Hall himself.

This beckoning forth of the whole problem of sensibility abstraction allows us to be surer of Hall's connection to the heroic generation of Abstract Expressionism, both in painting and sculpture. Hall has always been drawn to its scale, ambitiousness, bigness, heroism, toughness, what today we see as its crypto-sexist stylistic attributes—qualities Hall conjures in such phrases as "romantic jeopardy," or "win big, lose big."

<div align="center">III</div>

Perhaps I overstress a regionalist model for Hall—it certainly isn't the essential artist. That phase was, itself, transitional. Despite all the felicities of his earlier work, Hall's important sculpture comes after his "mid-career" style, comes after the *Gates*. While such work insures Hall a measure of local importance, it is far from being why Hall might be considered a significant sculptor. The reason I esteem Hall is locatable to the work following the *Gates*. The year 1972 sees the beginning of this important contribution.

Sundance, the first important work by my standards after *Moon Pie,* was completed in 1973 in Grand Rapids, Michigan for a plaza separating two office buildings. In *Sundance* we have the essential contribution at its most succinct: a right-scale architecture that does not relinquish its status as sculpture. "I want to make sculpture that can withstand urban clutter, or suburban clutter for that matter, or any other kind of buzz or interference." This will remain true of *Tiburon,* and of *Stockton, Brahma,* and *Drifter.*

Not that all of the structural features of the *Gates* are abandoned. Clearly the neat sense of building remains, of seam, of joint, of plane; essential worker-like qualities of well-crafted execution remain. But, in the end, Hall gives us, above all else, right-scale architecture as sculpture.

The stylistic model for this contribution lies in the traditions and sensibilities of the '60s—in Minimalism itself (though Hall is not a minimalist). Characteristics of '60s Minimalism is a kind of sculpture that parades as architecture—a species collapse occasioned by the theoretical underpinnings of Minimalism.

The difference between the minimalist forms of the '60s and Hall's work of the '70s is that, in the former, architecture functions within a sculptural sensibility context. Thus minimalist sculpture invokes the scale model, not the built architectural effort. By contrast, Hall's work is sculpture that is a kind of architecture, built in the right scale, in full scale, in one-to-one.

If one thinks of central minimalist figures who have addressed sculpture— say Sol LeWitt or Robert Morris—we see that there is no scale, or rather, scant scale or fluctuating scale. Scale in LeWitt or Morris is a function of theory, forms or information ratifiable against external epistemologies, exterior pure

measurables; in that sense, they demonstrate true empirical facts. But they can be either large or small since their forms are functions of external ideas. Their sculpture is not about finding the right scale, but about style embodying a true ratification system and, as such, they have made an enormous contribution.

Hall's sculpture after the *Gates* is marked by a change in scale necessary to the absorption of an architectural consciousness that refutes sculpture's status as a constructed object. Only insofar as the minimalist sculptors also sought this, are there any points of similarity. But the tradition of the constructed object, even as it continues today, despite its manifest excellences, refused to come to grips with what had really taken place in the sculpture of the '60s. To maintain the *Gates* meant that Hall would simply roll on in the inertia of Picasso through David Smith—as have most all of the constructivists of conventional ilk.

In 1972, Hall took account of new issues occasioned by the analytical stresses of the '60s, issues that revoked the cubist hegemony. No longer could sculpture be a matter of cubist-derived scale or constructivist-derived scale, nor could it be an art of part-to-part comparison, graspable in a "pleasing" single glance. Sculpture in the late '60s began to see that Smith was the great contructivist swan song of Cubism. When that recognition hit home, Hall joined the ranks of Richard Serra, Carl Andre, Don Judd, and grew similar to aspects of di Suvero, of Michael Heizer and Robert Smithson and Robert Irwin.

Hall's best works are enormous walls of color that need to be experienced physically, behaviorally—works like *Cygnet* erected on Lakeshore Drive in Chicago, *Brahma* shown first in Chicago and later set up on a Cranbrook slope, and *Tiburon* at Wright State University. Hall's architectural sculpture, while perhaps invoking the architectural curtain walls traceable to the International Style of the period *entre les deux guerres,* rejects the overkill of the Malevich icon—a residual Suprematism present even, say, in Barnett Newman's rare sculptures, and because of Newman, tremendously influential today as a paradigm. All this absoluteness is underplayed in Hall's work as the result of slightly open seams, a sensibility-derived color, the occasionally organic surfaces (such as plywood and the like), the visibility of structure supports beneath (flanges, for example), a slight relief from the ground plane, and so on. Color choice is very important. Hall is drawn to gray, to leached or bleached hues. Naples-like yellows—certainly not the hard black/white or red/black or blue/black of suprematist graphics; Hall's physical and visual properties keep him from entering the essentially Malevich-like iconography that marks so much of today's best abstraction, a recalcitrance (perhaps) that still links him to a maintenance of sensibility painting.

Hall's most important contribution then is the revocation of a constructivist aesthetic, one that following the First World War came to embody little more than the big luxury object, in favor of a sculpture newly expressed as architecture, both in scale and imagery—wall, plane, roof, siding, balustrade, ramp, etc.—yet without giving up its essential sculptural recognizability.

What Hall (and the other sculptors I noted) points to is the very reassessment of the history of Constructivism. As a formula, Constructivism as a closed style can now be seen to equal Picasso through David Smith. While today there are other ways to perceive sculpture, such as sculpture as performance (Acconci, Burton), or sculpture as epistemic analysis (LeWitt, Bochner, Rockburne)—the young generation of sculptors who preserve the time-honored integrity of sculpture as bound to the physical manipulation of tangible forms can be said to have altered the sense of Constructivism back to its very latency, to construction itself. Thus, Hall, Serra, Heizer, Smithson, and even di Suvero at moments, need be regarded no longer as constructivists, but as constructionists. Within this development, the emphatic statement can be made of Michael Hall: Construction, not Constructivism.

The Disintegration of Minimalism: Five Pictorial Sculptors

More startling than the works in this exhibition may well be the possibility that the sensibility and the period which they record (1967-70) may be over. These artists are eminent representatives of a tendency called Pictorial Sculpture. This is perhaps a weak term, but it is preferable to Maximalist (that is, of Anti-Minimal persuasion), not only because the latter term is confusing, but also because these artists earlier passed through a Minimalist phase. This evolution was equally marked in their somewhat older confreres more immediately associated with Minimalism—Robert Morris, Robert Smithson, and Robert Ryman, among others, whose earlier work contributed to our conception of Minimalism and whose later work offers pertinent similarities in method and appearance to the work of the five artists exhibited here.

In my critical writing, I designated the sympathies of these artists towards a need for identifying sculpture in pictorial terms—particularly with regard to color and unusual substance.[1] The designation arose out of my description of Keith Sonnier's work through 1969 which recognized the artist's mood-filled and depleted range of color which he embodied in substances of great limpness. He also utilized, as did Alan Saret during the same period, granulated and atomized materials. This predisposition to coloristic solutions might be considered a parallel to the intentions of Second Generation Color Field painters during the years 1964-67. However, these painters—Olitski, Frankenthaler, Louis, Noland, and Stella—were attracted by a kind of up-key, high color, very different from the subdued intensities favored by the group we see here.

It is easier to understand the meaning of the work of the five "painter-sculptors" if we establish a generalized model of high sculptural aspiration in the period of 1964-67. The term used to designate the modernist position in sculpture at that time is Minimalism. In this mode, elemental geometrical forms dominate and are presented as isolated wholes or in multiples of non-variegated elements, such as are commonly found within serialized units. To employ seriality as a compositional basis means that scale disparities as a method of achieving visual interest do not exist; nor does "composition" for that matter,

since each element within a serial presentation remains constant, and adopts easily comprehensible patterns—horizontal sequence, vertical ones, grid formations, and variations of these arrangements.

Minimalism, at least in its sculptural state, is a presentation closed in upon itself, conserving its energies, making no reference outside of itself. In this respect, Minimalism, even when expressed in painting, is preeminently non-pictorial; said the other way, Minimalism is essentially a sculptural mode. Granting its abstract basis, Minimalism is an analytic mode of presentation considerably stronger in its effect when present in sculptural (or architectural) terms. And as a sculptural mode, it seems to me that its importance lies less in the kind of geometrical presentation it favored and more in the vocabulary of forms it defended and preserved—the integral Euclidean and solid Geometry of Analytical Cubism, those embodiments of "pure emotions" found in Suprematism and Constructivism (the intellectual styles of the Russian Revolution) and the spiritual diagrams of de Stijl.

However, by 1967, we see a concerted attack upon these properties made by a phalanx of young artists who expanded out from the analytic frame of reference of 1964-67 toward a synthetic one. The ultimate historical model is, of course, the evolution from Analytic Cubism to Synthetic Cubism, which is still the most important prototypic episode of the evolution we are dealing with, because then, as now, we first encounter an art of sculptural sensibility presented in pictorial terms—Analytic Cubism—followed by a pictorial experience presented in sculptural terms, Synthetic Cubism.

Accession III was first executed by Eva Hesse in 1967. In it, she was as aware of its sources in Minimalism as she was of its divergence from it. "That huge box I did in 1967, I called it *Accession*. I did it first in metal, then in fiberglass. On the outside, it takes the form of a square, and the outside is very, very clear. The inside, however, looks amazingly chaotic, although it's the same pieces of hose going through. It's the same thing, but as different as it could possibly be ..." (*Artforum*, May 1970, p. 60).

The difference was most clearly expressed in the eccentric interior, with its understated tactile and coloristic effect. Out of the extreme delicacy of her responses Hesse would very quickly be driven to reformulations of Minimalist sensibility along lines of heretofore unencountered textural and coloristic distinctions. What we observe in Hesse, as in many artists around her, is first, a dissatisfaction with Minimalist sensibility itself, and then its disintegration. This disaffection sought its own definitions in revived enthusiasm for color, although of dim range, a fascination with eccentric limpness, environmental groupings rather than static and isolated monoliths—gestural characteristics which speak for the importance that the morphology of Abstract Expressionism held and continues to hold for these artists. Think, for example, of the two worlds of form which Hesse's *Expanded Expansion* binds together. One, the serial presentation common to minimalism, the other the limp and gummy tactility of the rubberized gauze out of which it is made.

In writing regularly about these developments, I have often had occasion to point out the enormous prestige that Hesse's work had for her peers. The knowledge of her imminent death and then her sudden passing made it almost impossible to come to grips with the importance of her contribution. For those who imagine that her working career and production were too limited for us to properly esteem her work, I remind them that the mature careers of Van Gogh and Seurat were similarly compressed.

The coloristic aspects of Alan Saret and Keith Sonnier most closely approximate the issues I have discussed in connection with Hesse. What must always be kept in mind in dealing with these artists is the comparative unimportance that sculpture, conceived of as a fixed, monolithic thing, tied to a site or isolated upon a base, holds for these artists. Instead of the vertical monolith which duplicates the unconscious acceptance of the vertical human entity on the horizontal of the earth, the artists were attracted by low-lying, floor-tied works which were situated in environments such as the corner of a room, or were limply hung from whatever architectural projections as might be found in the studio—nails, door handles, moldings, and the like, a method of display which always subjected their forms to the tug of gravity. What is curiously strong in their work is not so much the look of having been dragged down by gravity, but the "landscape" of the other side, of the weight of air pushing down upon crumpled and tossed forms. Significantly, these solutions alter the tradition of Carl Andre, who in his role as colleague and teacher, had affirmed the choice for a Brancusi-like reiteration of the pure, horizontal plane. Andre's solutions are morphologically the same as the floor, they are dais. In the work of these artists, the floor is contrasted against the elements of their pictorial sculptures. Added to the environmental tendency was the new fascination with limp substances. Both Saret and Sonnier were attracted by flaccid, chaotic distributions. In certain Sonniers, compositions were set up through the use of string alone or gauze and powdered flocking which was sprinkled upon tacky rubber latex. In Saret's work, we see the use of ground chemicals poured into dune-like mounds of colored powders and set within the passageways between rooms; or piles of orange sheeting or delicate fields of diversely colored wire layers.

In addition to Abstract Expressionist usage, we must look to Claes Oldenburg's early soft sculpture for the formal sources important to these artists. While the crushed and crumpled vocabulary has remained the natural idiom of Saret, it has, in the work of Sonnier, been transformed into that of hard and dense substances such as glass, neon, and technological implements. From 1969 on, it became clear that for all his complex technological environments, Sonnier still dealt with a personal and lyrical use of color. Never a substitute for art, his technology was a function of the structuring of passages of murky and unpredictable light. Neon, glass, video tape reorders, and projectors are sources of color for Sonnier, not cop-outs to the Machine.

Richard Van Buren's craggy plastic reliefs deal with the offbeat, dim color favored by Saret and Sonnier. Initially drawn by allover organization whereby

small pools of plastic were spilled over lengths of synthetic fibers and then, when dry, hung pell-mell upon the wall, Van Buren now deals in fewer and much larger elements. The earlier work betrayed a preoccupation with Abstract Expressionist morphology. At present, Van Buren is grappling with something much harder—the figure/ground duality inherent in large relief units displayed upon a wall. The principal meaning of the earlier work derived from an intuitive understanding of the method of dripping and arranging erratic shapes. Now, the being *in it* of the execution has been replaced by the figure/ground problem that is inherent in this type of sculpture which exists as an extentuation of painting. What has happened is that the ground of the figure/ground duality has been replaced by the wall or environment and the figure has been set free. This echoes the collapse of the figure and ground into a single entity first achieved by the Minimalists.

While it would seem that Dorothea Rockburne's work is involved in eccentric substance and depleted colorism—crude oil on paper, powdered graphite on cardboard—the system of organization derives from mathematical Set Theory, but it is here displayed in terms of sheer artistic volition. The ordering comes from a simple set of operatives (themselves deriving from one aspect of Minimalist seriality), equal sub-division within any given whole. But once these subdivisions have been made, they are arranged with an effusive sensibility similar to the work of her colleagues. Mathematics functions here only as a means towards a coloristic end, as technology functions for Sonnier—or as elemental gut responses work for Van Buren or Saret.

Minimalism, shattered and ground fine, has become the grist and pigmentation of pictorial sculpture. The fields of second generation color painting have literally become fields—acreage, earth—and the ground of the figure/ground duality have literally become grounds—earth, desert, world. The episode of Pictorial Sculpture has brought us to the border of still another *Terrain Vague*, the future of American Art.

Note

1. See especially Robert Pincus-Witten, "Keith Sonnier: Materials and Pictorialism" *Artforum*, Oct. 1969, pp. 39-45.

The Seventies

In my mind's eye I scan the essays, reviews and catalogues that intersplice my "real" commitment—teaching—during the past decade. The essays were undertaken as acts of critical advocacy in an ambience that tended to formalist criticism and reductivist abstraction. My just-changing voice, as it were, while picking up on the formalist tone, rejected the kind of art it defined. My position was ambiguous to say the least, both supportive and sabotaging of Formalism.

Some "recap" is in order. About a decade ago, I began to write for the "sharpest" critical art magazine of the day. From an itinerant reviewer I rose to the upper reaches of the masthead, even unto Senior Editor—a hollow magnificence, as those who have borne such titles can attest. The pinched scholarly mode of my early writing reflected the general mandarin tone characteristic of critical writing of the sixties. The manner, often pompously inflated, was a function of a formalist methodology revitalized by Clement Greenberg during the 1940s and '50s, and ratified in the work of the younger Harvard critics of the '60s, notably Michael Fried. All personal reference, exposed personal reference that is, was covert in this machine of closed judgment. Privileged biographical details were omitted. This tone prevailed not only because formalist critics imposed apersonal, hermetic values on their writing, but because artists also insisted upon it. Formalism then, at its crudest, became an extenuated Wölfflin-like discussion of self-evident wholly tangible visual properties—form versus iconography or biography. The latter were denigrated as "literature" by Greenberg, as "theater" by Fried. Yet, I could not apply the desired tone to the art which it defended. I was indifferent to Noland, bored by the Bennington academy of David Smith/Tony Caro-derived Constructivism. I was inured to the Olitski-derived fat-fields of Poons and company. I felt alien to what Stella came to symbolize (though I have never abandoned a great admiration for his work). I got things rather muddled thinking that what I disliked was Minimalism, which certainly wasn't so, as developments around Judd and Andre, Bochner and Rockburne were to reveal. It's that there was something else in the air. Minimalism was moving somewhere else, and where it was going I came to call Post-Minimalism; before that, "anti-Minimalism." I postulated, as the central critical chore, the problem of how it was

that Minimalism seemed to be turning itself inside out, seemed to be becoming Post-Minimalism. I fretted as to why it was that Robert Morris, say, was turning into another kind of Robert Morris, or, perhaps more emblematic of the shift, why Robert Smithson was turning into another kind of Robert Smithson. In an intuitive way, I felt somehow that I was a function of that change, that I was meant somehow to be adopted by this moment as I was to adopt it.

There are many lacunae in my writing. Essays were often devoted to lesser figures. Major figures were set up as paper tigers, or given short shrift in asides or footnotes or in invidious comparisons, *mea maxima culpa*. But, by and large, the new major figures of the decade were seriously written of . . . Serra, Sonnier, Hesse, Bochner, Rockburne, LeWitt, Tuttle, and latterly, Ferrara, Winsor, Campus, and Burton.

After a certain time it was clear that the high formalist cult of impersonality had waned. By the end of the sixties, art defended by high formalist writing was no longer capable of seizing the imagination, well, my imagination. Stella and Olitski-derived painting, formalist art in general, had been challenged by a new set of imperatives tempered in the crucible of Viet Nam, and energized by the insurgency and success of the Women's Movement. Much of the art of the sixties, too much, stands inculpated, if seen as the objective correlative to, and a fitting decor for, the glossy glass and steel-enclosed corporate complexes that profited from the war. With Viet Nam, young American artists underwent as bitterly vivid an alienation from proscribed goals as, say, the Impressionists did when they lost faith in a set of imperial esthetic values at the time of the Franco-Prussian War. What the formalist sensibility would have considered eccentric processes and subjective embodiments—really, what the formalist could not even conceive of as art—were suddenly assimilated to emerging social and esthetic imperatives. Mind you, I am no Marxist—no more, say, than anyone else working today, though all of us have had our frames of reference altered by Marxist history and terminology. Unflappably, in true formalist fashion, I still believe that the history of art answers its own internal imperatives, although, unlike formalists, I recognize that certain of them may be linguistic, iconographic, temporal, and behavioral. I am no analyst and make no special brief for psychoanalysis, yet I see that art may serve therapeutic ends. While it is not therapy, it may reveal an internal psychological struggle, bare the traces of angst-filled crises, perhaps fit into patterns of Freudian interpretation or Jungian archetypal collectivity, is surely a function of education—yet I do not believe art is therapy, analysis, or scholarship.

In our society, a more recent emphasis, then, was one which stood in almost direct opposition to what had previously preceded—a true formalist would feel this corroborated formalist thinking through negative definition—the same only opposite; yet it is not. Much of the art I am drawn to is manifested in the blatant exposure of artistic persona and psyche, a formal autobiography or biography in which the artists perform, as it were, an esthetic strip-tease, divesting

themselves of protective coloration, layer by layer. Such an autobiographical and confessional art stands in greatest possible contrast to earlier formalist values. Despite the seeming reversal of these values during this decade, an essential constancy persists—living personality—hallmark of modern art, is maintained, although no longer manifested through facture, that is, individuality of touch, but through an unrepentant, prideful, even autobiographical, confession of those areas of human activity in which artists are uniquely personal.

The years 1966-70 mark a watershed in American art. The years ending the sixties, by and large derived their options from a still earlier style, Minimalism. Minimalist forms reflect a geometric abstract style based on "pre-executive inner necessity." What the phrase means is the rigorous external geometry of Minimalism attempts to be congruent with the logic of style, a logic concluded even before the paintings were started, the sculptures made. Of course it's obvious that to think through an argument is not the same thing as to make something; the actual doing of things enforces myriad formal interventions and discontinuities on engaging real matter. Such encounters constantly shift and redirect the act of making; thus where painting or sculpting may lead can never be where the argument had gone.

Numerous paths radiate from Minimalism's stylistic nexus. Some maintain the fixed reduced geometry necessary to the style, while others move off in directions seemingly at odds with the mother style.

A simple comparison between 1880 and 1890; during that decade there developed in parallel avenues (though one might think of them as osmotic laminations), the classical Divisionism of Seurat, the proto-Cubist ambiguities of Cezanne, the Symbolism of Gauguin, the Expressionist options of Van Gogh. These trends—Divisionism, proto-Cubism, Symbolism and Expressionism— huddle together beneath the blanket term Post-Impressionism. Some are easy to see as derived from Impressionism, others less immediately so; yet all derive from the formal riddles conjured by Impressionism. So it is with Post-Minimalism; certain aspects that are readily seen to derive from Minimalism's essentially reductive and analytical character, others less immediately so. The term, then, is useful in a broad way, the way the term Post-Impressionism is useful—an "ism" covering a multitude of stylistic possibilities preceded and postulated by an apparent parent style. Post-Minimalism in its variety compares to Minimalism as Post-Impressionism does to Impressionism. ◊

The first phase of Post-Minimalism is marked by an expressionistic revival of painterly issues. This was occasioned by the reaction to the taciturn ungenerous inexpressivity and absence of chromatic appeal typical of Minimalism. Equally striking was the application of this expressionistic painterliness not only to painting, but to sculpture. Such manifestations may be said to mark a revival of gestural Abstract-Expressionist attitudes after a long hiatus during the 1950s-60s. This expressive painterliness was accompanied by a refreshed focus on personality and colorism and on a highly eccentric,

dematerialized or scattered form. These are features, say, of the work of Eva Hesse, Lynda Benglis, or early Barry LeVa and Keith Sonnier. Often the very eccentricity of the substances they used were a means whereby the artists could be identified, a "signature" substance as it were. Such is the case with Serra's lead, Sonnier's neon, Benglis's foam, LeVa's felt.

The new style's relationship to women's consciousness cannot be overly stressed; so many of its formal attitudes and properties, not to cite its exemplars, derived from methods and substances that hitherto had been sexistically tagged female or feminine, whether or not the work had, in fact, been made by a woman. Its paradigm, Eva Hesse.

This early phase peaked in 1968-70, and I called it the "pictorial/sculptural" phase. I noted its emphasis on the making process, a process so emphatic as to be seen as the primary content of the work itself—hence the term "process art." When this occurred, as it did say in the lead tossings of Richard Serra, or in the *Drawings That Make Themselves* by Dorothea Rockburne, to cite but two examples, much of the virtual content of the art became that of the spectator's intellectual re-creation of the actions used by the artist to make the work in the first place.

The nerve center of Minimalism was its attachment to the "pre-executive," the intellectual. This rationalistic strain was maintained and generated an even more sharply honed up-front intensification of the theoretical and analytical bases of art. In certain instances such theories lead to making visible or tangible forms whose primary content maintained parity with an analytical logic, be it linguistic, mathematical, or philosophical. Sol LeWitt and Mel Bochner are noteworthy examples. In others, theory appeared to usurp the visual form to become, as it were, the formal embodiment itself. Here art—I mean the visual or tangible construct—and language grew interchangeable.

The great creation of Post-Minimalism was the adumbration of new methods of composition—ones no longer based in the Realist's mirror of nature or the Expressionist's empathetic distortion, or the Surrealist's gestural automatism, but ones that took their principles from the information-based theories of knowledge, theories "out there," in the world, from epistemology.

Thus, there emerged around 1970 an information-oriented abstraction, one that loosely honored say, mathematical set theory, zero-to-nine formulas, or Fibonacci series, "Golden Sections," or spectrum-based color sequences or contingent theoretical systems emphasizing red-yellow-blue primaries—this, rather than a sensibility-based choice of color. In this the work of Sol LeWitt, early Robert Smithson, Mel Bochner and Dorothea Rockburne are exemplary, although still earlier, Jasper Johns and Ellsworth Kelly formed bridges between the Abstract Expressionist generation and the Post-Minimalists. Mondrian, Malevich, and Barnett Newman were newly reassessed.

The epistemological trend was paralleled by a widespread invocation of the role of language either in terms of its own science—linguistics—or, somewhat

later, as a kind of poetic or loosely applied grammatical metaphor. The stress on the role of language triggered wide reaches of the conceptual movement, a name by which the broad front of the art of the early seventies is now known. Aspects of the conceptual movement addressed art wholly as a function of a linguistic system, replete with philosophical and political ramifications. By now this tendency has splintered into subsequent evolutions drawn to neo-Marxist critiques of capitalist culture or to extremely individualistic confrontations between work and image. The typology most often encountered today might be described as an extended, captioned photograph.

The epistemological examination of pure platonic knowledge continues apace; however, work produced as a function of an affiliation to such closed systems is surely, by this moment, less the question of urgency it once was. First, theory was honored; then it was honored in the breach. Honor in the breach, especially in terms of its broadfront appeal today, indicates the waning power of a purely theoretically-based art. Then again honor in the breach is itself an update of a Romantic theory of art.

The rejection of epistemology was met from the very first, from 1968 on, in terms of a revival of Dada principles first broadcast in New York City by Duchamp, Picabia, and Man Ray around 1915. Unwittingly paraphrasing New York Dada's ontological concerns, many aspects of Post-Minimalism emphasized temporality and a theatrical cult of manneristic personality, in which artists themselves became the malleable raw material of their own art, as well as their own myths and products. A reinvigoration of temporal and theatrical issues led to the development of the conceptual theater, body art and the like, as seen in later Benglis, Chris Burden, Dennis Oppenheim, and Vito Acconci.

An extremely reduced scheme of the last decade can be read as: 1) the advent of pictorial sculpture; 2) the emergence of an abstract, information-based epistemology; and 3) its counterpoises, body art and conceptual theater.

The reader who has hung in there this far must wonder, "Well, what of the Realists and Photo-Realists?" Perhaps this is not the place to once more deny them (as I have done repeatedly during the last ten years). To paraphrase an odious class-indicting adage—the Realists, like the poor, are always with us. Representationalist art, as with all work that is unaware of the existence of modernist history (e.g., naïve art, fetishistic art), or uses modernist history for the most immediate political gains in the art world (e.g., Pop-derived *Brilliant!* Ultrarealism or esoteric history painting), must be judged according to its individual merits. It is clear that while a Pearlstein may not be found wanting, his myriad imitators—all those MFA expressionist representationalists—have a way of blinding us to Realism's merits. But as much could be said for the imitators of Morris Louis or Jules Olitski or, for that matter, of those of Rockburne or Bochner. My attitude toward Realist art is one that is altered in each circumstance in which I meet it. But for the most part representational Expressionism is duplicity on all counts; sheer self-delusion, the result of merely inadequate

technical gifts. Most representational Expressionists cannot draw (I mean in the conservative sense to which they volubly pretend). They justify and rationalize their inept recordings of the visual world as expressionistic or emotionalistic communication. They are not communicating—except collusively: I'll admit your therapy as art on condition that you admit mine. By contrast, for the Post-Pop Realist, nature is not even a consideration since nature for that kind of painter has been replaced by technology—the exact photographic image. Nature is not even looked at—rather, it is the glossy magazine photo in lieu of nature that is studied. Such a painter, or sculptor, derives from the media fixations germane to Pop art. Like anybody else I too am brought up short by sheer manual virtuosity. For the larger part, virtuosity is itself the essential content of this kind of art. Looking at photographs is better.

Through sheer frustration I've come to the following: ignore the Realists—they'll win anyway; and for a very important and depressing reason—the appreciation of contemporary art is intimately locked into a knowledge of contemporary art. And most people do not know it or want to know it for an elaborate range of reasons and ruses. Realism provides a time-honored vehicle for the maintenance of painting and sculpture conducted in the absence or rejection of the history of modern art. Thus we have disenfranchised know-nothings and privileged know-nothings. Disenfranchised ignorance is tragic, and our society must go far to ameliorate or rectify social evils. But willful ignorance stemming from privilege is inexcusable.

Despite a polemic hardheadedness, I see that a wholly theoretical argument is a weak one; it refuses to discourse with the real world, with the pragmatic. So it too must die of its own ideological overkill.

In the long view, no one can truly say what it is that artists do—except perhaps that they "make art." The "Seventies" has pointed up, perhaps more than any other modernist decade, that an artist offers up visual alternatives to the prevailing organizational modes. If this is so, then above all else, beyond objects, beyond ideas even, the great creation of the artist is to enforce or impose within the current scheme of things a range of alternative organizational premises. Some of them are by now time-honored, venerable: the Cubist "grid," the Surrealist's automatism, the Dadaist "mechanomorph," the Abstract Expressionist's "gesture" or "drip," or, more latterly, "stain" or "field" and so on.

From a certain angle, these achievements are systems of ordering visual (and tactile) information. The most venerable method for ordering such information—and ratifying it as correct—derived from placing art in an ancillary dependency to nature—art was nature's mirror seen through a temperament. Despite wide variations in the application of that attitude, it prevailed for some seven hundred years. I can see why there would be so widespread a proscription—though after so long a life, the attitude has grown stale, even if, at its inception in the 13th century, it was a violently fresh issue for Europe. After all, seven centuries is ample time to change an ideological premise into an

academic prejudice. And, having proved useful for so long, why abandon it? From a certain viewpoint, it informed the profile of western culture in a way that perhaps no other figment of esthetic ideology has.

My abhorrence of Expressionist Reality is modified by a profound esteem for its achievements. Still mightn't one entertain, if even for a short while, that, as the Realist's tree on the canvas is right because it looks like the tree in nature, so too is the abstractionist's configuration right because it is borne out by correctly pure information. The Realist's tree is "illustratively" right, the abstractionist image "demonstratively" right; the former "represents," the latter "presents."

Insofar as both Realist and Abstractionist require a "thing out there in the world" (no matter how different these things are, the one material, the other conceptual), there are similarities between them, an area of overlap. And more, they are ideologically similar within the confines of this overlap—this need for ratification by that "thing out there." Thus, in rejecting the Realists out of hand, I must be ready to disavow the Abstractionists. Still, there is a vast difference between seven centuries of ingrained practice and indurated uncritical acceptance. Those values accruing to the art I admire are scarcely a decade old. The sheer cultural advantages unthinkingly allocated to the Realists allow me the luxury of abrasive overstatement.

The recent decade of American and European art has opened a field seemingly without convention or classifiable standards. On the one hand this latitude encourages the maintenance of a great and continuing modernist episode; on the other it has become a source of terror provoking, even among an art community which ought to know better, a staggeringly conservative backlash. In a certain sense, the resurgence of conservative painting and sculpture that marks so much of the past decade testifies to the sheer creative power of progressive artists during the period.

The Neustein Essay

I

From a certain vantage, the great creations of modernist visual order are the "cubist grid" and "surrealist automatism"; this assertion is made in the face of the fact that there have been hundreds of thousands of artists during the 20th century. The period 1912-14 marks the codification of the "cubist grid" in Picasso's collages and constructed paintings; 1924 stamps itself on modernist history as the date of the writing of the First Surrealist Manifesto, the earliest proposal of an art based securely on automatic principles.

Nineteen sixty-eight is such a date. At that time it became clear that a new 1968 method of visual order and ratification had come into being—one I call "epistemic abstraction". Despite its fearful name its principle is easy to grasp; the term comes from the word "epistemology"—the science of knowledge. Just as the Realist ratified his work to be correct through a comparison between the thing in nature and its illusionistic counterpart in art, so too does the "epistemic abstractionist" possess a system of ratification; only the comparison takes place not between Nature and Art, but between certain absolute ideas and Art. These x "epistemic ideas" are as concrete and ratifiable as empirical knowledge gained from sensory stimuli.

What ideas are as true as things in the real world? Here are some. On recognizing them, the reader will quickly add others of a like type from his own fund of knowledge: A to Z, the alphabet analyzed into its syntactical components. In Hebrew it would be "from *Alef* to *Tav*." Another would be 0 to 9, or any rational sequence of numbers, or their correct permutation, such as 2, 4, 6, 8 or 3, 6, 9, 12 etc. In terms of color, Red, Yellow, Blue, is a ratifiable epistemology as they are a correct subset of the color White. Spectrum sequences from infra-red to ultra-violet, or any section thereof, are correct as they may be ratified in terms of their sequence in a physical analysis of light. Complementary relationships too—red/green, orange/blue, violet/yellow—are epistemologically correct, and so on. I am not talking about colors as a function of sensibility. When sensibility becomes the overriding issue there can be no system of ratification. Sensibility art possesses no argument other than the artist's feeling that such or so is the right

color to use; but this conviction can never be demonstrated as true or correct—it is wholly arbitrary—though, in the end, the artist may be vindicated in his color choice insofar as it may be "liked" or "admired," may "feel pleasing"—and in the case of great painting, say, even exalting. Even then, art made in a sensibility context is really a kind of narcissistic collusion between artist and public, a wholly subjective episode.

By 1968, the exploitation of sensibility in art, be it in terms of color, gesture, composition, even of the world of moral affections, simply had been used up as a means of engaging young artists. They no longer cared whether a subjective and random activity was valid for them or a public for that matter. Sensibility art had died and a system free of arbitrary content emerged wherein ratifiable data would be the central issue.

This eruption of epistemic abstraction appeared with special emphasis in two places and contemporaneously—New York City and Jerusalem. Joshua Neustein assumed legitimate position beside such notable epistemologists as Mel Bochner, Dorothea Rockburne, Sol LeWitt, to name but a few of the New York group. As Rockburne has made Golden Mean Ratios or folded sheets of carbon paper her signature, or as Bochner has made an examination of the Pythagorian 3, 4, 5 and the triangle, square, pentagon his signature, so has Neustein made the structural interrelationships between the Fold, the Tear, and the Cut, the basic concern of his epistemology. These linear surrogates are his signature.

What are some of the issues encoded in Neustein's folds, tears and cuts? They are simple: two halves make a whole, or to halve a half is to make quarters and so on. Folds, tears, and cuts embody absolute and impersonal sequences. That the tear in Neustein is a function of an expressive action, paralleling the painterly gesture of an earlier visual type, is of incidental concern although it allows Neustein a double access of appreciation—the recognition both of an intellectual structure and that of a vestigial expressionist bias. Of course, this "expressionist bias" is itself an intellectual referent signifying the species Painting. (The latter aspect has always seemed to me to be the most potentially risky feature of Neustein's work. Still, it may be necessary if only to have aided in the embodiment of its epistemic aspects. More recent evolutions seem to indicate that this expressive character may yet serve to resolve the growing dilemma surrounding the epistemic movement itself.)

Other aspects of Neustein's content would be, say, the designation of front and back, of recto and verso and, by extension, of ventral and dorsal. To tear a sheet, or to cut it in half and then reverse one of the halves from front to back demonstrates that a whole sheet not only comprises two halves, but that it also comprises a front and a back. All this is eminently obvious. Yet, it often requires rehearsal, especially at this early stage of public support since the public's anticipations are not geared toward the recognition of systems, but toward the narcissistic encounter with sensibility experiences.

Neustein rightly regards these latter episodes as a kind of mystification— one he takes to be a form of indulgent bourgeois sentiment. In the absence of

specific knowledge, the public imbues art with a factitious content—the notion, say, that art embodies transcendent experiences, or that it expresses in some way, a state of soul. Such attitudes are not demonstrable. While they may be acts of faith, there is no proof that these acts of faith are warranted, or even desirable.

Let us go further. Supposing the front and back of this Neustein I am inventing—although a work like *Gneiss Dermis* easily serves as example—were further orchestrated, say, by the fact that while the front was kept white, the back was painted or sprayed black. Then, the permutation of part to whole, of recto to verso, would be even more visually embodied. Such strategies characterize *Installation I.*

In Neustein's permutations the entire syntax of species recognition is brought into play; for example, were such sheets arrayed upon the wall, they would partake more greatly of signifiers indicating the species Painting; were such sheets spread upon the floor, they would all the more easily signify the species Sculpture. Through such a simple identification process, Neustein indicates that the diagnostic profile of the species is a function of location, of context. In so doing he need not resort to earlier and by now debased conventions such as the frame (for painting) or the base (for sculpture). In Neustein's work position signifies species: the parietal = Painting, the dais = Sculpture. If species is identified through location, then the art thing in itself is neither painting nor sculpture, but a polymorph of some kind, since its meaning as species is contextually inspired.

Still another gradient of information exists between the fold, the tear and the cut. Often the fold is less severe in its effect as it is the least discretionary of Neustein's linear effects; while identifying sectors, the fold still holds them together. When the fold is used one easily sees, for example, how two halves bind together, function continuously or in terms of an overlap. The tear still maintains a strongly visual connection between sections—even if they are separated one from the other—since the serrated edge, the teeth of the tear as it were, can be seen in terms of interlock or intermesh with comparative ease. The cut totally severs the two sections and, free of such pronounced self-referential indices as the fold or tear possess, the cut allows for other, perhaps broader ranges of referential comparison—color for example, or location, or modularity, or texture, etc. A work like *Hinge Removed* deals with this problem.

So far, nothing has been said about "liking" Neustein's work, since "liking" it has relatively little importance at this early moment, though at some future date perhaps, "liking" it will seem all there is to grasping the work. "Liking" is a function of sensibility, a quality replaced in epistemic abstraction by "getting" it, through the understanding or resolution of a certain range of intellectual gambits. Eventually, when this art is sufficiently familiar, grasping the argument will be replaced by the sense that the work has come to exemplify a closed period or style that the spectator may accept or reject out of hand.

For the artists associated with the style, this has in fact happened. And it is very troubling. The bias toward an international epistemology peaked by 1972. In a certain sense the style now rolls on in its own inertia, even while it continues

to attract many new adherents. But its electrifying moment has passed and in the work of the new exponent, one senses a certain lassitude, or a didactic scholasticism.

I hope the reader is not surprised by this assertion; equally surprising ones can be made of any of the celebrated *isms* or *ologies* of the 20th century. What is surprising, for example, is not so much the advent of Fauvism but that Fauvism, at least for Matisse, only lasted for two years, 1904-6; similarly, the Analytic Cubist style lasted, in Picasso's work, for only one year, 1908 into 1909. The examples are legion: New York Dada peaked in 1915; Pop-Art, 1958-62. I supply these dates at random to indicate not that epistemic abstraction is over but to underscore the extraordinary vitality it possessed—if one considers that its high expression lasted for four years at least.

This change is discernible in the resurgence of earlier values, primarily those of sensibility. This may owe not only to the evolutionary fate of style itself (though there is that element) as much as to the frustration felt by the original formulators on encountering ten years of incomprehension, the constant return to ground zero on engaging the public. In the end it often seems easier to dissemble, to adopt consensus values of sentiment and mystification.

To grasp an argument is never the same as grasping the art. We do not know what the art of art is. No one does. It is unquantifiable, beyond language's capacity to state. At best, these descriptions point in the general direction of where the art is to be found. Artists make art. Critics make arguments. Historians reconstruct contexts, the interrelationship between art and arguments.

II

In 1975, I was asked to observe the tenth anniversary proceedings of the Israel Museum in Jerusalem. I recorded the impressions of my visit, including in them an account of Neustein's position as I understood it at that time:

> Neustein through the long afternoon confirmed the strong moral influence exerted by the *Ofakim Hadashim* particularly Zaritsky and Arie Aroch, whose small pictures reveal private pictograms linked to the earthbound sources of Judaism . . . It was Aroch who first noted, for the artists, the parity between folding and drawing. Neustein continues this idea adjudicating between cut and fold as a graphic set. Neustein's earliest mature work reveals the influence of American figurative expressionism, one partly derived from Rivers and Diebenkorn. Since 1968 . . . an awareness of external abstract systems whole unto themselves came to challenge the prevailing expressionist cast of his work. Thus his work allows a double access: a lingering painterliness embodied within an analytical armature. His preferred surfaces are sprayed, torn, crumpled, slashed, revealing methods and processes that run counter to the rational systems and analytical procedures equally revealed in the turbulent drawings. . . .
>
> Ironically, Neustein is anything but the natural colorist his works suggest he ought to be. The aggressive tenor of his attack is of interest almost because it underscores the innate circumvention of a coloristic gift—one rare enough anywhere—and for the most part, I mean internationally, foreign, even anathematic, to the larger nature of contemporary reductivist abstraction. . . .

Neustein, for all the rational systems of his torn drawings, has never relinquished, has stubbornly maintained the "psychological" status of painter, one whose *sine qua non* is the manipulation of paint, hence of a matter and substance which now serves as a proxy for colour. It is not so much that he is a painter *manqué;* rather it is a question of a drawing per se manifested as paint *manqué.* These are positive, not negative qualities in his work.

This essay affords me the opportunity of somewhat expanding a biographic and interpretative account of Neustein's life.

Neustein, born in 1940 in the Danzig Corridor, first was displaced by the Germans, then the Russians. He spent part of his early childhood in Siberia where his father had been sent to cut wood as a forced laborer. Subsequent uprooting followed—Warsaw, Austria, escape from the Eastern zone to the West, Israel, at last New York City where his parents definitively settled in Brooklyn. Neustein established himself permanently in Jerusalem on returning there in 1964. Biographical details are rather chilly; imagination and propriety shrink from discussing the painful situations such data infers.

A curious dilemma: language. There is no longer a mother tongue at home—or to say it better, there are too many languages, all poorly spoken, in accents and inflections differing from the way the natives speak; even in the first stable environment that Neustein knew, there was anxiety. In a fundamental way, the artist even as a child, was forced to seriously focus on the language problem—what language do I speak? In which language do I think? Neustein imagines he spoke Polish until he was seven. He recalls a lapsus, an infantile breakdown when he took to bed and from which he arose only to speak English. Of course, this is a screened memory, mythologized in family lore.

Still, of all disciplines, that of language has accrued to it a striking and rapidly evolving science—linguistics. This represents another central source of Neustein's epistemology. (Of course, the dynamics of linguistics are far more complex than Neustein's visual permutations. Neustein's structures of thought are much closer to a grammar of a grammatic than a linguistic.) For example, if wall equals Painting and floor equals Sculpture, then Painting and Sculpture equal prepositions—that is location of actions : to, at, in, on, by, from ... situational contexts characteristic of Neustein's work. While engaging issues of quantitative permutation Neustein's work does not derive from the numerical frame of reference. It functions in a more complex verbal terrain. The *Greek Tortoise* for example, while engaging an infinite halving process is primarily fascinated by the dramatic paradox inherent to the limit concept.

Similarly, to tear, to fold, to cut, to locate, to paint, to spray, to gouge, to mark (while surely surrogates for pictorial gestures held at bay) exist as linguistic parallels, basic verb forms. They stand in as simple a parity to language as they do to art activities. Their very status (at once grammatically forthright and yet visually ambiguous) allows for the transposition of pictorial acts into constructivist ones; to cut, to fold, to tear, etc. are all activities germane to

Constructivism itself. Thus language confounded with sheer artistic will, allows for the merging of painting and sculpture into the single entities so characteristic of epistemic abstraction. It even provides criteria for the initial judgment of the work.

Though raised in New York City, Neustein can hardly be said to have been much exposed to its cosmopolitan diversions. He underwent a rigorous orthodox education surviving on the street through sheer physical dexterity and urban savvy. A kind of tight cockiness still characterizes his demeanor. The effects of this stringent education fundamentally inflect a vital attachment to abstract concepts.

The central fact of Jewish art—usually honored in the breach—is that it is abstract. The myriad modifications of so-called "Jewish art"—often representational—indicate local or temporal compromises with powerful external stylistic pressures. The source of this drift toward abstraction is by now so well known as to require but the briefest rehearsal. The two strains of Judaism, Eastern and Western, are deeply aniconic, result of a scrupulous application of the second commandment, the Mosaic injunction against graven imagery. The impact of this staggering proscription was heightened and aggravated by a later commitment, not so much to learning itself, but to an idealization of the book. The book, in such an extenuated sense, serves to hoard a mass of signs within which the indescribable and unnamable, the ultimate abstraction, may be encoded (or decoded). The cipher processes necessary to this cryptography are not necessarily semantic; they are just as often syntactic, examining verbal identity through letters, letter fragments—crossing the t, dotting the i—spaces, punctuation, diacritical markings of all kinds, calligraphy, typography, orthography, through an obsessive and indefatigable recognition of systems in which logical narrative, day-to-day common sense, may in the end play but little more than an ancillary role. Unbridled scholasticism explodes pragmatic sense through a commentary piled upon commentary and, in a more specifically mystical Jewish context, through the application of hermetic, gemmatraic, and kabbalistic interpretations—methods that drive out virtually all empirical sense from language, replacing reasonable meaning with inscrutable metaphors and processes.

Be all of it as it may, one need not look to such elaborate impositions and interpretations to explain Neustein's art—though I think at least a passing awareness of them is necessary. There are quite simple anecdotal details in which one might indulge exemplary speculations: Neustein recalls for example how, as a Yeshiva student, he endlessly doodled and drew on the margins of his Torah Commentaries. Discovered at this desecration, Neustein was punished by being forced to erase these markings in an attempt to return the pages back to their pristine sanctity. One sees in this situation a certain sensitization toward the

tactile experience of drawing itself, let alone to the sheerly physical properties of paper—its fiber, pulp and strand. And the anecdote establishes a paradigm as telling as the perhaps more elegant model of Robert Rauschenberg's erasure—as an act of art—of a drawing by Willem de Kooning.

And that the epistemic abstractionists use paper bluntly and unapologetically as the essential material, that they are tuned into the most direct exploitation of paper's physical properties, also adds a certain prestige to an otherwise commonplace childhood memory. The ascendence of paper as the substance of greatest authority is accompanied by an appreciation of many other of its features—its absence of aesthetic pretentiousness, its ordinariness, its cheapness, its ubiquitousness, its signification of studio and art life, and so on. Mostly, paper's connections to drawing, one as a natural consequence of the other, is maintained : paper and pencil, paper and pen, they go together like hand in glove.

If one feature marks epistemic abstraction above all others, it is an indifference to conventional painting and sculpture and a preference for, indeed a reliance on, the act of drawing itself. Since painting and sculpture exist anyway, as we have seen, as functions of location exist "prepositionally" within the epistemic grammar, there is little need to paint or sculpt in the first place. Besides, all that busy work, all that hand-wrist diddling, that little hairy stick technology, all get in the way—or so it seemed during the headier days of the movement. The important behavioral concept-piece, *Picture Plane* (it exists as a photographic documentation), deals with these very problems—a parable of painting's seductive content without the trappings of painting itself: frame, canvas, oil paint, the sheer theatricality of painting.

Worse, color confuses matters—it dredges up emotions, ambiguous ranges of human experience that the application of a rigorous ratification system—a kind of visual mortification—sought to obviate, adjured, in the first place. Color, mother of painting, simply confused things, kept on pulling one back into the sludge of sensibility. It had to go. It went—however not without leaving a certain residue in Neustein's work—sprayed surfaces, for example and often as not, the unstable and blotchy color of paper itself, a fading array of whites, beiges, tans, matte yellows, pinks of all kinds, blotted blues and greens depending on the kind of paper he used.

Drawing is as well, the meeting place, the crossroads of painting and sculpture—and architecture too; as such drawings is the crucible of all the visual arts. The pronounced emphasis on drawing in epistemic abstraction rendered painting and sculpture virtually superfluous, as they are, encompassed by the act of drawing in the first place.

At length breaking away from paternal sectarianism, Neustein completed his baccalaureate degree in the history of ideas and philosophy at the City College

of New York; he played competition chess and answered his first conscious stirrings of an awareness of art. He enrolled in the Art Students League and at the Pratt Institute, respectable art schools in New York.

His early painting is inflected by American Abstract Expressionist values of the 1950s and '60s; and even more by the Ofakim Hadashim. The similarities of Neustein's early painting to the slick amenities of Larry Rivers for example cannot fail to be noted by an American-trained eye. These qualities of facture were pleasing to the Israeli daily press when Neustein exhibited at the Bertha Urdang Gallery, Jerusalem, 1966, his first exhibition.

Neustein's early virtuosity fitted in all too well with the scene: it emphatically corresponded to the nervous graphism that mars even the superior painters of the Ofakim Hadashim. It even mars an occasional work by Zaritsky, Streichman, and Mairovich, Neustein's uncle, the brother of his mother. One is tempted to make much of this, though surely Neustein's great love of painting stems from a deep admiration for his uncle and his work.

Neustein, withal admiring of the achievements of Ofakim Hadashim and in whose succession he regards himself, is not without an objectivity towards them as well. He recognizes that the lyrical nervous stitching, so characteristic of their work has the effect of "frenchifying" their art. This feature underscores the already markedly French aspirations of dated Israeli culture.

By the mid-1950s, the Ofakim Hadashim had taken on abstraction and worked it back to pre-Impressionism, to the sheer unravelling of light. The reason, according to Neustein, that they were painting backwards, owes to the absence of a critical underpinning, a critical language that surfaces at the same time that new visual values emerge, a failure of the scene, as lacking today—he feels—as it was in the 1950s. Thus the painters of Ofakim Hadashim, granting their quality, kept sliding back to the good old cliché: "Go back to Nature". In short, theirs was an early consciousness of abstraction. This stands in vivid contrast to Neustein and his peers who replace the adversary status of nature with that of the accruing history of abstraction itself. In the former abstraction is always in doubt; in the latter its existence is never doubted.

Used to a highly partisan critical arena my assertions take on a polemical edge. In contrast, Neustein seeks to assure Israeli continuity, not to succumb to notions of an aggrandizing American Oedipal fixation. In the one there is the desire to ford generations: in the other, succession is assured through a ritual slaughter of the father. Neustein feels little need of undercutting his forbears, nor even to undermine the institutional meanings or conventional attributions of their painting. His work is dialectically enriched by their own continued vitality, against which his modifications are that much more sharply honed.

In a prescient way, the expressive latency of Neustein's work—held in abeyance so that epistemic abstraction could answer its own emergence—asserts itself once more. A kind of encysting process is at hand: to break the enterprise is far less an issue, than to assure continuity and wholeness.

In many ways an attempt to heal this break is being widely felt throughout the entire art world—a broadfront reassertion of sensibility values would seem to show this. After all the slogans and the street fighting, art remains additive. It is not a question of painting ever having been dead—such an excess characterizes early expedients—but of painting coming to grips with the messages of the new style; as the new style must come to grips with a consciousness of its own altering state.

Blasted Allegories! The Photography of John Baldessari

No question of a negative arose in the very earliest photographs. The photogenic drawings of Fox Talbot directly result on a chemically salted sheet exposed to light; or, in the case of Daguerre, the fixing of a light-engendered image took place on a more complex chemical membrane. But with the development of the negative/positive print—Fox Talbot in England, Bayard in France, and the great generation of so-called "primitive" calotype photographers in England, Scotland, and France—the similarity of photography to the graphic tradition was instantly manifest. The woodblock, the copper-plate engraving, the soft- or hard-ground plates of etching, and the stones of lithography all tacitly assume the presence of a negative master image of which the print is the positive reverse. This tradition of master/negative and slave/positive is maintained in photography.

As the appreciation of the graphic print became a function of connoisseurship, so did the photographic print; and in the degree that the latter did so, it became yet another graphic manifestation quite properly perused for all manner of connoisseur desirables—strength of image, quality of paper, tonal depth, clarity of impression, state of impression, marginalia, and on and on and on—a whole baggage, in short, to which (among others) Baldessari's photographs give the old heave-ho, that is, cast into wry and humorous doubt.

As he says, "I just want to challenge the boundaries set up by each convention. The irony comes through as a by-product. I don't consciously set out to be ironic. And I have enough appreciation of the traditions to preserve them. But I don't consciously work for beauty."[1]

What has been lost in perceiving the photograph as an object of the connoisseur's delectation and pedantry is the sheerly existential uniqueness of the photograph itself. Paradoxically, the advent of a contemporary photography no longer predicated in the image reversal of the negative sheet—the Polaroid print or the diapositive slide—has gone far to liberate photography from the tainted appreciation germane to graphic connoisseurship. Instead, it has reconnected the contemporary photograph to that short original moment in the

nineteenth century when the positive image existed alone, independent of a master negative.

This odd perception was facilitated by the strong conceptual basis of the arts in the late 1960s and early 1970s. With Conceptual Art, as this broad front was loosely termed, the photograph was valued for "its ubiquitous normalcy, its ordinariness, its 'transparency,' when compared to the high pretensions of painting. The Conceptual Movement, at least for a brief moment, allowed us to make art without pretension; especially if we turned to photography. And for the same reasons and at the same time, many artists turned to typographic print and to text. It was everywhere and it was detached from esthetic pretensions."

"The real reason I got deeply interested in photography was my sense of dissatisfaction with what I was seeing. I wanted to break down the rules of photography—the conventions. I discovered I was more of a 'thinking' person than a 'working' person. Photography allowed me to register my ideas more rapidly than painting them. They grew out of a sense of urgency. If you're stranded on a desert island and a plane flew over, you wouldn't write 'HELP' in Old English script."

During the heyday of Pictorial Photography (the two decades bracketing the turn of the century), the photographer, in order to distinguish himself from the amateur (the lay photographer unleashed on the world by the success of George Eastman's Kodak), emphasized connoisseur values. This was achieved through making photographs as "artistic" (as "art-like," that is) as possible. The result of this attitude was the Photographer as Artist. The recent Conceptual Mode reversed these priorities and instead we came to value the Artist as Photographer, but with the following caution: the newer photographic image is to be appreciated (at least for the time being) for the properties neither Pictorial nor Documentary. (The latter quality especially has been the essential condition, the very spine of photography from its inception, a condition that Pictorialism strove to mitigate.)

As Baldessari notes, "Most painters have a malleable sense of the world. If you want a yellow tree here, you put it here; but a photographer is more hidebound. He's hamstrung by the real world of objects. Photographers are hung up in the documentary. And the laboratories play up to this.They won't print the edges of the negative, say. It comes back cropped, or color-corrected; or negative scratches will be filled in." That artists will freely use commercial laboratories is itself a further testimony to the erosion of the tradition of the connoisseur. "We're back to Andy Warhol calling the studio 'factory' and our, by now, whole tradition of post-studio art."

What then *is* valued in conceptual photography, in a mode so resistant to the Pictorial and Documentary values? Certainly structures, say, based on abstract rationalist systems—0 through 9, red, yellow, blue, etc. Think of Baldessari's movie *Six Colorful Inside Jobs* (1977); basically it's a film about a fellow painting a room each day. The color sequence is coded to the prismatic

spectrum—Monday is red, Tuesday is orange, Wednesday is yellow. Do I have to go on? "And it gets rid of relational painting," Baldessari notes, "while insisting on the ordinariness of the task of painting itself."

But Baldessari's conceptual photographs are predicated on more than informational or epistemic ploys; few artists are as instructed in or as sensitive to the sheer history of his medium as Baldessari. He regards himself as "an artist whose stock and trade is art history;" and he is marked by distanced, ambivalent feelings regarding this history. "It's love/hate all the way." Grasping this ambivalence is central to understanding the artist's intentions. Despite obvious manifestations of information-structure, his work is closely linked to an imagery or a methodology derived from Symbolist, Dadaist, and Surrealist concerns. Hence a perverse teasing animates Baldessari's photography as it develops an iconography and a methodology derived from Symbolism, mother of Dada and Surrealism.

Ironically, Symbolism as a style profoundly marked Pictorialism and its concomitant connoisseurship. Baldessari, then, maintains properties germane to the photography of the turn-of-the-century without engaging the conventional modes of perception applied to the photographs of that time, most obviously connoisseurship itself.

"You know, in a photographer's darkroom there's a trash bin—and in it gets thrown all the bad gradations of tone; or the prints are all spotted, or all black, or blurry. But I could like them because in the end it's all a visual sign system." That's the epistemic side of Baldessari's thinking arguing against connoisseurship. But then he counters, "What photographer would stand to have a finger-print on his photograph? A painter could conceivably allow it."

Beyond this, matters will be clearer if we look at certain characteristic photographs of the *Pathetic Fallacy Series* (1975). A "pathetic fallacy" is a literary term or figure of speech devised by John Ruskin (as Baldessari writes in his own notes on the series) to project an animate condition, the attribution of human emotions, say, into inanimate objects.[2] The pathetic fallacy is also applicable to concrete things in the world, such as Baldessari's *Wistful Chair* or states of abstraction such as colors. Think of Baldessari's *Stoic Peach,* or *Suspicious Pink; Resigned Yellow.* "I didn't use 'Angry Red,'" he says. "It's just too obvious." But things are not so simple as this. In *Wistful Chair* a woman's face is surprinted upon the image of a chair seat. The chair by itself is an image utterly sanctioned in modern iconography ranging, say, through a repeated expressionist use in the work of Robert Rauschenberg or, more informationally in Joseph Kosuth's conceptual work *One and Three Chairs* (1965).

To invoke these noteworthy sanctions (not to mention the innumerable appearances of the image of a chair in photography) addresses but only a partial aspect of Baldessari's image. After all, it is not the chair that matters here but that the chair is fused with an image of a face. The Surrealists, especially, long made use of the conjunction of the face in a taboo location—here, in the very seat of a

chair, suggesting through this placement an inescapable oral-genital association—as does, for example, Meret Oppenheim's far more celebrated "Fur Lined Tea Cup," or *Object* (1936), to call it by its correct name.

"On the one hand, I like the deceptive simplicity of the exact information of things—like a chair—but, on the other, I want the ambiguous multiple-entendre to be there too—metaphor and allegory—as in the *Blasted Allegories* series (1978).[3] Basically things are what they are. But then they are something else too." Which is, at its most terse, a working definition of Symbolism.

The source of this face-in-chair motif is easily traced back to the iconography of the disembodied head rampant throughout Symbolism, especially those that appear to float in Redon's lithographic illustrations of Moreau's many *Apparitions of the Head of John the Baptist to Salome* "You know, Robert," says John, "I just realized now that I never thought of the parts of my body as going together. I saw them as separate. Maybe it's because I'm so tall. I have to use willpower to glue them together."

The Symbolist use of the motif of the disembodied head, while alluding to castration as it does, is more exactly intended to provide a sign of the mental function, of thought or of thinking itself. As such, the connection between Baldessari's *Pathetic Fallacy Series* and the mental processes invoked by Symbolist imagery is clear.

Baldessari's use of a Symbolist/Surrealist tradition perhaps will be more easily understood if we examine the set of photographs called *Cigar Smoke to Match Clouds That Are Different (By Sight—Side View)* (1972-73),[4] from a series of that title. The images themselves were selected from the most successful shots of a single roll of film—successful in that the smoke the artist is exhaling most approximates the shade of the clouds in the photographs affixed to the wall directly behind the artist.

So many elements function in this work as almost to beggar iconographic analysis; among them are the images of the artist smoking, the smoke/cloud resemblances, and the pervasive blue color of the shots themselves. Not least, in this simple list is the seemingly farfetched, negligent character of the experiment itself—a scientist task free of a priori goals—akin to those "experiments" made by Marcel Duchamp in 1913 when he dropped a one meter length of thread from a one meter height, thereby creating the template profiles of a new set of rulers. In altering the rulers' straight edge to conform to that of the thread's curve—repeating it three times—as in a controlled experiment—Duchamp rendered the rulers useless, as they no longer measured the shortest distance between two points. Then he proceeded to use them in demarcating the position of the "Capillary Tubes," a pictorial element of "The Large Glass" (*The Bride Stripped Bare by Her Bachelors, Even)* [1915-1923]). Need one add that Baldessari has reconstructed this event photographically as part of his *Strobe Series/Futurist* (1975), a series sometimes devoted to the reconstruction of famous "decisive moments" in the history of art.

I don't want to get wrapped up in Duchampiana, except to say that Duchamp and his New York Dada colleagues, Man Ray and Picabia, cast the longest shadows across the Symbolist/Surrealist tradition of 20th century art; that Baldessari in the *Cigar Smoke*...series shows himself smoking a cigar is itself an index of his personal sense of connection to Duchamp, who often was photographed while smoking a pipe. Man Ray's untitled photograph of a cigarette lighter (1920) is also helpful in this connection. Man Ray's name is engraved on that lighter showing that his image is intended to be understood as a mechanomorphic self-portrait, of which there are so many in the history of Dadaism. The most famous of all perhaps is Picabia's 1915 portrait of Stieglitz as a camera, bellows limp and truck brake in gear.

Man Ray's photograph of 1935, *Ce qui nous manque à tous (What We All Lack)*,[5] records the image of a clay pipe from the bowl of which emerges a soap bubble. The work takes its name from the handwritten inscription on the pipe shaft. Where the art is in this work—whether in this "object of affection," one Man Ray created to be photographed, or in the very photograph itself—is one issue. Another issue addresses the fragile clay pipe, an object often viewed as precious, replete with talismatic esthetic pretensions as is repeatedly shown in constructions made by Joseph Cornell that utilize real clay pipes, or in paintings by the Surrealists, notably Pierre Roy, that depict them.

It is easy to see why two iconographic traditions should fuse: both smoke and bubble are elements of extraordinary impermanence, lighter than air, near transparent and long associated with otherworldliness—a "pipe dream"—and resistant to the materialistic coarseness of a Positivist here and now. Smoke or bubble have long been considered symbolic of spirit or idea as alternative to state of matter. Take Thomas Couture's *Boy Blowing Bubbles* (1859), for example. In this painting by Manet's teacher, the bubble symbolizes the poetic visions of a future poet laureate. These are alluded to by the laurel crown hanging on the wall behind the pensive boy.

The association of the bubble—that thing of iridescent fragility with esthetic and untainted beauty, purity itself (think of Baldessari's 1966-68 canvas, *Pure Beauty*)—was so conventional a signal or trigger by the end of the century that it plays a central role in the iconography of Pictorialist photography. One finds it, say, in Clarence White's *The Crystal Globe* (1903) or the collaborative Steiglitz/White *Experiments* of 1909, and on and on. At length this estheticism became so pervasive as to force a shift in class affiliations—moving from the high iconography of the Pictorialist artistic aristocracy to the blue silver ball of the middle class front lawn, the spinning mirrored globe of the depression ballroom, and finally to the Deco Revival discotheque. And, as Baldessari agrees, the return to Pictorialism and to Allegory is a chief component of immediately contemporary sensibility today. Blasted Allegories!

Not only was Steiglitz susceptible to the use of such arch-imagery as the bubble as a means of introducing "abstract" content into his work (content, that

is, about "idea" and not "matter"), so too would he be drawn by that other great symbol of the mental—clouds. It is not for nothing that Baldessari attempts to make his smoke rings duplicate the shape of clouds—as these transient entities form the basis of Steiglitz's most protracted series of photographs. Steiglitz, mind you, does not call his cloud photographs "photographs of clouds;" rather they are called *Equivalences,* drawing to them through this nomenclature the clichéd status of symbolist imagery itself.

"Equivalences" were, in the Pictorialist/Symbolist mode, indications of spiritual or abstract "states of soul." The term, a catchphrase of the period (as "Simultaneity" or "Fourth Dimension" were for the Cubo-Futurist period that followed), was shot through with vague extrapolations—synesthesia especially, an "incorrect" sensory response called up by a disparate stimulation, such as when one speaks of seeing colors upon hearing music. Synesthetic equivalences are conventionally traced to Baudelaire's "Correspondences" and back beyond them to the spiritual visions of the Illuminati of the 18th century.

Perhaps the only thing, then, remotely fresh about these Pictorial/Symbolist clichés is that, through indirection, they provided a clue toward grasping a more modern meaning of abstract with which we have replaced the earlier meaning of the word as indicating something "not material." If anything, our meaning of abstract is entirely materialistic, rejecting as it does the dualism of spirit versus matter. Admittedly there is a lot of hangover sentimental talk about spirit, but it is virtually meaningless in our secular culture.

Last, the Symbolist affections of Baldessari are almost mechanistically referred to through the use of pervasive blue in these photographs; for, if nothing else, blue continues to appeal—across the monochromatic blue canvases of Miro at the moment of his most committed Surrealist adherence to the realm of unutterable perfection first called up by Mallarmé's gasp, *"... L'azur, l'azur, l'azur, l'azur."*[6]

Baldessari's photographs preserve other less immediately obvious connections to Surrealism. After all, Baldessari is in these photographs shown smoking; and, as Man Ray's bubble pipe bore an inscription, so too is the most disquieting Surrealist assertion of all—*ceci n'est pas une pipe* (this is not a pipe)—also an inscription, one written by Magritte below his celebrated image of a pipe (1928-29).

"If it is not a pipe, then what is it?" is the usual response asked of this image.

"It's a *picture* of a pipe!" Or,

"It's neither the real thing nor an illusion of reality; it's a Freudian symbol!" Such standard replies are now seen to gloss the question.[7]

Magritte himself warns us against any factitious simplicity in the interpretation of his work. He does not call his painting "A Picture of a Pipe" or "This Is Not a Pipe;" rather the work, known in several versions, bears high flown titles, among them *La Trahison des images—The Treachery of Images.* I take it the treacherous was much on Baldessari's mind when he undertook the

Embed Series (1974). Baldessari tells us some of his intentions with regard to this series. Sparked by a concern for "the hidden persuaders" used in advertising or in national propaganda, Baldessari's *Embed Series* deals with

> the embedding of words, and occasional images, within the photographic image. A variety of means were employed—airbrushing, brush, double-exposure, etc.... Various levels of invisibility were explored, from obvious to near invisible. At best, this embedded information can possibly be perceived on a subliminal level rather than on a conscious one. At the least, this device offers a method of literally wedding words with images without the dualism of text adjoining image. Another motivation was to test the idea of subliminal motivation. Can I really get one to believe the messages I have hidden about *imagining, dreaming, fantasy, wish,* and *hope?*[8] (my italics)

A characteristic work from the *Embed Series* is called *Rose; Orange (Death)* (1974). At first glance the image of a sliced orange abuts that of a rose. On scrupulous examination, the viewer at last makes out that the artist has picked-out the word "death" through the use of skillful airbrush highlighting. He did so through connecting the shimmering highlights of the citric sacs of the fruit placed just right of the center and near the rind. In a similar way, the folds of the rose petals near the flower's center tuck and frill into spelling out the word "death."

Apart from the obvious injunction that calls to mind an ever-vigilant presence of death in the life of the senses, the *memento mori*—the central lesson taught by the still life tradition of the 17th century—Baldessari also reminds us through the use of the subliminal word "death" that his *Rose; Orange (Death)* (these entities which are also colors) is perhaps the most treacherous or perfidious image of all. And Magritte is honored in so doing.

One last mechanism remains to be pointed out as a means of understanding that Baldessari's photographs employ the indices of Surrealism. Frequently Baldessari will create happenstantial continuities, arbitrary similarities in shape and scale in quite different photographs as a means of affecting or assuring formal continuity and logical cohesion as we glance from one photograph to another. Many of Baldessari's series exhibit this trait—*Violent Space Series* (1976), for example.

Nowhere is this property clearer than in the collage of commercially produced pictures postcards of a touristic island allure. Palm trees found in differing glossies are here pasted together on purely chance similarities of trunk girth. In one, we see a South Sea girl, in another a figure climbs a tree claiming coconuts, and in still a third perches a sweet koala bear. All this palmy slope emerges from a wind instrument played by a supreme musician. (The collage itself refers to the "conceptual musician" Charlemagne Palestine.)

The preeminent model for the system of chance structure derives from the Surrealist game of the "Exquisite Corpse" *(Le Cadavre exquis)*. The circumstances surrounding the creation of the chance poem *Le Cadavre exquis*

boira le vin nouveau are now part of the modernist myth: each element in that sentence was contributed by players unaware of the word that had preceded their own single word contribution. From this attempt to disclose a new method of inventing form based in chance, the Surrealists branched out, first replacing some words with pictorial representations (as in a rebus) and then affecting a wholly continuous set of visual increments made by the artist/players ignorant of the appearance of the section that had preceded their own contribution. These, too, were called Exquisite Corpses, perhaps even more aptly than the early poems as they were fully visual. It is this Exquisite Corpse structure that is maintained in the chance alignment of Baldessari's photographs.

So we see that while Baldessari's photographs in no way rehearse our ingrained response to the sign systems of connoisseurship or the documentary photograph, still, sign systems of a very special artistic tradition are maintained in his work. And because we recognize these traditions—if not their original manifestations, then certainly their infinitely varied development—we are thus able to recognize Baldessari's "inartistic" photographs as art.

So aware is Baldessari of this that one might almost describe his effort as being a wry or rueful commentary on the sheerly poignant myth on art or art history itself. Indeed it is the central concern of his *Ingres and Other Parables* (1971), those sad, shaggy-dog stories about art and the artist's frustrated longing for fame.

The recognition that Baldessari's work is preeminently an ironic commentary on art also announces his continuity with Pop Art's cold diffidence. Think, for example, of Lichtenstein's many parodies of modern masters. But in addition to all this there is as well Baldessari's own very special quirky detachment.

And to have said all of this is still not to have said where the art in Baldessari's work is—as if one could. For it would be wrong to infer from this essay that iconography confers the status of art. This is manifestly incorrect. But it is equally egregious to be left holding a bag of tautological formulae—that art is made by artists and that he or she who makes art is an artist. And yet, what else is there? That, too, is a vexing lesson to be drawn from Baldessari's riddles, as it is, I suppose, one of the chief conundrums posed by the Surrealist tradition itself.

Notes

1. All quotations unless noted otherwise transcribed by the author from conversation with the artist on October 22, 1980, New York City.

2. It is helpful to note in this connection that the definition of Pathetic Fallacy also serves as a good working definition for the mechanomorph, the greatest intellectual creation of the New York Dadaists—Marcel Duchamp, Francis Picabia, and Man Ray.

3. Baldessari's sensitivity to Nathaniel Hawthorne's irritated cry of frustration (rich with multiple meaning)—"Blasted Allegories!"—is also revelatory. The name of this body of work . . .

is meant to describe the use of allegory/metaphor as a damnable process, a curse: blasted allegories!! An allegory is a useful device in the rich meanings it can generate, but its very blessings are a curse in the multiplicity of meanings that can be generated, thus the possibility of confusion. An allegory can mean so many things—it can mean anything and nothing. So, if one elects to use allegory as a working method, one is often prompted to curse. But the phrase can also mean "exploded," pieces and bits of meaning floating in the air, their transient syntax providing new ideas. [From the artist's notes for a catalog to be published for his forthcoming exhibition at the Stedelijk van Abbemuseum, Eindhoven, Netherlands, scheduled to open May 15, 1981.]

4. This work explores issues similar to those examined in *Cigar Smoke to Match Clouds That Are Different (By Memory—Front View)* (1972-73). In this set of photographs, the cloud images instead of being appended to the wall are affixed to the artist's brow or forehead, thereby even more clearly asserting the mental and ideological affections germane to the artist's Symbolist-derived intentions and imagery.

5. The simple error in French is troubling: *ce qui* means "who"; *ce que,* "what." Man Ray wrote "ce qui" here, as well as in several variants of the work made during 1935-36. Yet, the English title is always translated as *What We All Lack.* Man Ray's most assiduous student, Arturo Schwarz glosses this slip by noting that the artist's "knowledge of French was imperfect." Schwarz also reproduces Man Ray's 1964 reconstruction of a 1935-36 variant in which the error is corrected. See Arturo Schwarz, *Man Ray, The Rigour of Imagination* (Rizzoli, New York, 1977), p. 370.

6. It goes without saying that this most famous Symbolist utterance resonates within the blue fields of Miro's painting at the moment of his most declared Surrealist affiliations. In this sense, *L'azur* permeates the blue of Miro's work called *Peinture* (1925) (that is, "painting itself"), a blue monochrome interrupted by only the most vestigial elements—a near invisible line along the center to identify horizon and a speck of star in the upper left-hand corner to indicate sky. Baldessari may be futher drawn to this Surrealist purview in so far as certain Miro works of 1924 depict smokers. While dilating on the obvious phallic/masculine connections of smoking, one is reminded of Guillaume Apollinaire's calligram *Fumées* or *Smoke* (1914). In that ideogram a figure is typographically depicted as holding aloft a lit cigar, the upward drift for the words for "cigar smoke" being freely typeset to illustrate the rising fumes. See Margit Rowell and Rosalind Krauss, *Joan Miro: Magnetic Fields,* (Solomon R. Guggenheim Foundation, New York, 1972), p. 90.

7. The degree to which these are rudimentary responses can be measured if one turns to such elaborate iconographic interpretations as those provided by the following: Joseph Masheck, "The Imagism of Magritte," *Artforum,* May 1974, pp. 54-58; or, Andre Blavier, *"Ceci n'est pas une pipe," Contribution Furtive à l'étude d'un tableau de René Magritte* (René Magritte Foundation, Brussels, 1973).

8. From the artist's notes (see note 3).

Keith Haring: The Cross Against the Rod

Keith Haring is one of that handful of artists who has received international recognition so quickly as to make it seem that his is an art with no past and consequently, no future, an art emblematic of the now. Obviously, seeming and being differ. Of the future one can only guess, but this essay, at least, will show in part that appearances to the contrary, a strong awareness of the past is at play in Haring's work. And consequently, the future too.

Among the causes of this sense of sudden apparition is the enthusiastic reaction of a network of pilot galleries so influential to the formation of avant-garde sensibility, American and European galleries ranging far afield, from Soho to Los Angeles, from Amsterdam to Naples. The impression promoted by this distribution network—a few artists really, handled by an even smaller number of galleries—was reinforced by several international exhibitions of immense prestige, notably Dokumenta 7, held this year in Kassel or Diego Cortez's contrast between European and American "Pressure to Paint," (as he called it), held early this summer in New York (1982).

This coincidence reified a tendency of considerable impact, what might be called the interface between two extraordinary urban episodes. Neither alone maintains a primary commitment to art (though that they address questions of art is beyond doubt). Together they form an extremely volatile synthesis of compelling import: the history of the clubs plus that of the graffiti writers. And Haring may be seen as its most exemplary figure.

Haring, now 24, is a lean sprinter-like fellow, endearing in the way of young animals; only with spectacles. He stems from Kutztown, Pennsylvania, an almost-hangover middle American town in the heart of Pennsylvania Dutch country. Though standing far to the left of the fundamentalism which permeates the blue-collar town, Haring nonetheless appreciated the qualities of enduring stability with which the surrounding Amish and Mennonite farmers endowed it. Still he felt obliged to dissemble. Accommodation obtained through his sixteenth year. The ease of his cartooning, his mastery over Mickey Mouse and comic strip imagery of all kinds, afforded him a distinct cachet and place of privilege through high school. But between sixteen and eighteen there grew a sense of stress and so began his American wanderlust, hitch-hiking across country to settle at last in Pittsburgh.

Two results of importance are traceable to this phase—his first one-man show at the Pittsburgh Center for the Arts, of abstract drawings as it happened; and his amazed response to the Pierre Alechinsky Retrospective mounted at the Carnegie Institute in 1977.

Haring's enthusiasm flew in the face of the "advanced taste" of the period when Alechinsky, in certain measure, and his CoBrA cohorts (Asger Jorn, Karel Appel, etc.) beyond question, were rejected out of hand for the unrepentant expressionist bias of their paintings. The late Seventies was responsive to the postures of Conceptualism, a mode that, when not dominated by linguistic structure, was still drawn to a compromised halfway house, Sensibility Minimalism.

Alechinsky sanctioned, for Haring, an abstract painting the essence of which stemmed from the graphic arts, and from an automatic orientation too, comprising of a multitude of seemingly self-generating little shapes—like those, in fact, that Haring was then painting. But believable. Authentic. Necessary— existential qualities driven from a critical vocabulary then devoted to empirical and measurable properties. While Alechinsky was the grand discovery, Dubuffet remained the household word again quite despite the fact that, at the moment, "informed sensibility" relegated the French painter to the nadir of his consequence.

Haring's prescient response corresponds to the public view today and scarcely five years have elapsed. In short, Alechinsky provided Haring with the model for "an art of painting in a state of heightened awareness." What seems so peculiar is the degree of art information, here as throughout his still short career, that Haring availed himself of (as did several other artists), despite the libel that they function in a world of cultural and visual illiteracy, if not even in one of express anti-intellectualism. Without stretching arguments, if anything the exact opposite is constantly seen to be true.

Apart from Alechinsky and a momentary flirtation with video, Haring derived scant horizon from Pittsburgh. Still Pennsylvania, for all that—the Kutztown youth, the Pittsburgh post-adolescence—emotionally informs Haring's life and art even to the iconographic. A simple example. The atomic silos that figure in the present-day narratives refer to events at Three Mile Island. It was while visiting home in 1979, but only fifty miles away from these atomic reactors, that the duplicitous comedy of errors attendant upon "melt- down" (a term whose meaning technologically-minded artists such as Haring knew full well) was played out. Mobilized into action, Haring participated in the first anti-nuclear rally held in Washington, D.C., hard upon the gross neglect of that episode. After all, the protesters from Kutztown, Harrisburg, Pittsburgh were the citizens most immediately exposed to radioactive fallout. Haring's No Nuke sentiment enlarges a Pennsylvanian consciousness that extends the horror of local radiation to one of global vaporization.

Of course, that's not what his art is about—you mustn't be fooled, unless you choose to think it is. The autobiographical always informs imagery but what imagery means as art can never be said. So that, if Haring's art has an iconographic affiliation, he is no more a culprit in this than, say Rosenquist or even Picasso.

Anyway, Haring quickly recognized that Pittsburgh offered too small a scope—even less for his art than for the imperatives of his private life. And so he came to New York. Here the complex transiency of the clubs come into play. Ostensibly places for music and dancing, their histories still are rooted in the more liberated politics of the late Sixties. The West Side bars promoted, say, the more S and M side of things, with their moustached clones and back rooms; the East Village stressed rather more the imaginative hyperbole of drag queen and TV. (How could Haring, an erstwhile video-artist and incipient graffitist fail to miss the coincidence of initial between TV (television) and TV (transvestite)?

Today this militancy is far less topical (perhaps) than the simple fact of just being able to dance and to find a like-minded community. It is hardly surprising then that advanced social views drew advanced art into its milieu, and as the clubs answered a need for music it also provided exhibition space—as it continues to invite into its precincts progressive art of all kinds. Haring's exhibition history is punctuated not only with gallery references but with "club dates."

With Pittsburgh behind him Haring enrolled at the School of Visual Arts, the pretext for moving to New York—while the life of the clubs and an attendant sense of exhilarated liberation also played a compelling role. As a sophomore Haring studied what was called "semiotics." His souvenirs of the class are quite droll as his "semiology" largely consisted of storyboards dealing with overt sexual imagery. Class reactions were ambivalent—enthusiastic over his illustrative skill of a kind, say, formulated by the Barbera/Flintstone tradition (on which his peers, like him, had nourished); but, despite their amazement at Haring's skills, his classmates remained silent in the face of the overt content of these easy and skillful drawings. They loved the drawings; they didn't know what to "do." The "semiotic" consisted of the burlesque.

Real courage came from a reading of Robert Henri's *The Art Spirit* with its appeal to Whitman-like daring and a strong nationalistic, anti-academic stance. This revelation prepared Haring for the discovery of the graffiti writers whose art synthesized (for Haring) Henri's sense of pioneering self-sufficiency with a personal belief in a mode of existential awareness—Alechinsky. "To be inside a subway car covered with tags was beautiful! I arrived in N.Y. during a great period, when people were doing whole subway cars. I was aware of great artists. Like Lee. They worked in large scale; in short amounts of time; in bright colors. Those things demand to live. They're uplifting."

It is difficult for a gradualist progressive to admit of some of the critical reception surrounding the graffiti writers. Much of the enthusiasm strikes me to

be yet another facet of a colonization through exaggerated receptivity born of liberal guilt. To invoke the Allover of Abstract Expressionism as the visual precursor of this urban experience strikes me as duplicitous and manipulative.

Even Haring is aware of this tension. Characteristically, when he began to participate in the thrilling subversion of subway graffiti, his caution, even his classicism, was strongly inflected. First, the subway panel on which he draws is hardly the car. This panel is often in a kind of limbo, covered with black paper as it awaits a fresh advertisement. Thus, the convention of the picture, its "sign," the framed panel, is present from the outset. This black paper surface (reproducing as it does the schoolroom blackboard) is peculiarly sympathetic to Haring. And more, there's something integral and agreeable to the subtle pressure of the chalk in Haring's hand as he attacks that matte surface. It is startling to note that these studious and intimate drawings are made in a noisy often threatening environment.

The graphic directness and diagrammatic simplicity of Haring's composition further demonstrates his venerable classicist predisposition going as far back, if you will, to the schematic registration of Archaic Greek vase painting. But such justification is almost as pretentious as the sociologue's invocation of Abstract Expressionism for the graffiti writers.

Haring dates the threatened quality of the current subway style to the crackdown of the MTA (Metropolitan Transit Authority) on the graffiti writers. "Once Mayor Koch," he says, "began to respond to resentment against the graffiti by having subway cars scrubbed clean overnight, many of the great writers were driven out"—to be supplanted, he suggests, by amateurs gratified only by the evident thrill of risk.

Still it is important to Haring that his work is appreciated by the graffiti writers who respect him as an artist. I wonder about Haring's continued fostering of his mythology in the context of the subway; or to create alternative visual environments (exhibitions) in the context of the clubs. In short, there are many gestures of a fugitive character (the recent giving away of twenty thousand posters, say) that seem arbitrary and based on a need to maintain the good graces of a community from which he may be growing.

Still, for all this "possibility," the sudden emergence of Haring dates to his show at Club 57 on the Lower East Side at the end of the summer of 1980. At the beginning of the season he was also a participant in the now legendary Times Square Art Show, an event that went far to defeat the hegemony of Abstract Formalism and the Conceptual. But Haring's contribution to that show, a word piece, was rather lost in the vivifying grunge. After procrastinating, Haring found himself with but a four-day time lead before the scheduled show at the club. A friend loaned him the use of a large studio space and in a kind of fever of anxiety and exultation he called upon his confirmed skills of a jigsaw-like abstraction and of cartooning.

Stapling sixteen pieces of oak tag to the floor and working them all in series of latex and paint spray, Haring produced a body of generative work. Some of it was still abstract but several drawings first exposed the narrative iconographic elements that he continues to elaborate.

In a way one can even tell the story of this continuous narrative—Haring can—though what it means as a story is less definable, is ambiguous, functioning rather in a domain open to analysis. Indeed the danger of Haring's narrative is the ease with which the myth appears to be decipherable. It really isn't.

"The Flying Saucer appeared, zapping animals in a field, transferring some extraterrestrial force to the animal world. From the animal, the Flying Saucer zapped faceless humans."

The narrative is impressive partly because Haring regards the imagery as a kind of sentence in which grammatical elements may substitute one for the other at will, a kind of abstraction that he sees as based on his "semiotics."

This body of work generates from within its own continuing adventure. "The four-legged animal, cows, pigs, sheep, become the dogs. The Flying Saucer remains as a symbol for energy and the pyramid is added," reflecting popular fascination with that form as a source of mystical energy. "What has happened is that these animals have been zapped. They become energy sources. Then the kid happened" (the famous Radiant Child as the poet Rene Ricard dubbed him [*Artforum,* Sept., 1981]). "Maybe the kid is radiating energy that had been zapped down to earth by the Flying Saucer."

In reality the baby and the dog as separate motifs had been used by Haring as a kind of cartoon signature when he was out making street drawings. The baby and the dog became his tags.

Then follows a Baroque elaboration. "The crawling baby is trailed by animals. The baby faces the dog. I could draw anything. There was a levitating black figure getting energy from an unknown source. A white figure holds a no-energy stick and stabs the black figure. The black figure falls down. The white figure fucks him. The energy rays are transferred to the white figure. I saw this as the white rip-off of black culture."

"Then comes the man with the hole in his stomach. The dog jumping through the hole happened on the day John Lennon was murdered. It's about that. Stairs started going up and coming down. Stairs became a pyramid with a glowing rod at the top. The cross gets introduced. It's the cross against the rod." And on and on.

The elaborate narrative develops with image specific to event; for example, the man with the six arms, a recent iconographic figment, is locateable to the Falkland Crisis; the cross and the rod, to the advent of Solidarity and the search for independent action in Poland and the Pope's visit there.

Despite Haring's blunt and forthright descriptions, schema verging on the pornographic never appear in the subway. The underground is Haring's

laboratory for a diversified body of work—drawings on paper, paintings on tarps (industrial tarpaulins), painted objects, statues, murals, etc., as well as the subway drawings themselves.

By and large, Haring's ideas are thought through clearly, for about a week or so. When each image is absolutely explicit there follows a kind of lightning dash to record the notion. Of course, there are many times when the artist acts on impulse, improvising on the spot. A fresh advertising placard is found and in a moment the image is set down. The drawing might be up a few days, perhaps a few weeks. And so a new picaresque image is put forth in the world—but never explicitly sexual ones. "Kids like the drawings a lot and I don't want to endanger that."

The most recent work, in particular that done on "tarps" and found objects sometimes has an aggressive elaboration of surface resembling the busy nervousness of certain Abstract Expressionist Allover. The visual mosaic-inlay may honor the *horror vacui* said to function within so-called primitive ornamentation. Emptiness according to this theory signifies space and thus, it is argued, "the primitive mind," ill at ease in the natural world, elected to cancel out, to eliminate so naturalistic and scientific an index of experience. Haring acknowledges the theory, reminding one also that the aggressive surface nervousness refers back to the abstract work he painted in Pittsburgh. He recognizes too that the graphism of much of the present work is inappropriate to the subway style, one calling for legibility and clarity.

Equally pertinent in the present work is Haring's desire to devaluate a presumed superiority of individualistic drawing on paper or canvas over other kinds of cultural artifacts, considering all surface as having equal worth. Some recent work has even been executed jointly with a "fifteen-year-old kid named Angel whose tag is LA 2." They have collaborated on vases, pillars, paintings, as well as the notorious garden figure of Venus on the half-shell shown recently at Wave Hill in the Bronx.

After all is said and done perhaps this biographical take is wrong, a kind of selective fiction. Groups of "chosen" episodes, sequences of events, force an intentionist reading. In Haring's case—Kutztown, Pittsburgh, Alechinsky, New York, Robert Henri, the clubs, the graffiti-writers, etc.—argue for causal logic as if they all hanged together like stones on a string. But in the end, the question arises, Why these elements and not others? Would not other choices have made for a tighter case? Is it that one is after all drawing up a legal brief? Or are all elements ultimately arbitrary? The answer in art is perhaps yes. A biographical reading tends to reduce import, cripple meaning, hobble work in its essential condition as art.

Haring is young, eminently idealistic and truthful to a fault—as is manifest in any of his phrases. His loyalty, unbending, laudable for sure, also conveys this minimizing effect. Clearly art is a cipher tied to immediate circumstance, *pro tem*

aspirations and local pressure of all kinds. But these conditions must not be confused with the art—they only serve as signposts, guides to where the art is.

In the degree that Haring's art is isolated from its inspiring social ethos, other properties become evident—properties both clearer of perception but all the more difficult to articulate—art properties. To tie Haring's art only to a specific social view is to read his art in terms far smaller than it actually is. What of Haring's sense of scale (in fact, vast)? ambition (overarching)? graphic values (virtuoso)? and painterly ones (fluent)? What of gamble, risk and ingenuity (profligate)? These qualities and a hundred more may in the end be keener spurs to Haring's art than a programmatic biography, which only describes a spur to action.

Jedd Garet: Nature as Artifice

The problem: to use a slangy vernacular within an art historical argument. While my discussion of Jedd Garet may begin with a batter-dipped, deep fat fried, radar range of reference, the meaning of his work as art can only be as high art. One may begin with Bullwinkle but one ends with Baudelaire.

Garet's art is about art in precisely the same way that all art is about high art and not just about sociology—though the latter's high profile obtrudes in discussing this new development. All that will fade as the work is isolated from its animating frame of reference through the passage of time.

While Garet was formed on Disneyland and sit-com TV, the lingua franca of much of today's art, the Disneylander is unlikely to appreciate what Garet does, as art that is. Nor does Disneyland intend to promote art values—not expressly, (though it may). Nor does it ever reify as art its own potent notions of style. Still, for sure it provides iconographic clues.

"Jocks vs. Freaks," Jedd Garet's phrase by way of characterizing his high school years. Of course he was on the Freaks side, despite his athletic build—the late druggy sixties hangover side, but, in the early seventies, conventionalized. Only light stuff, a couple of LSD trips, marijuana. Privileged teen nostalgia for the hairy politicized psychedelia of the sixties he had heard spoken of as a golden age—but in which he was too young to have participated; a perk of the upper middle class whose modes essentialize for the world—as they have since the ascendancy of the movies—glossy consumerist physicality.

Naturally, one cannot explain art, not that of Garet nor of anyone. Adduced meanings are useful only in the short term. They, and the discussion of the artist's life, are, in a certain sense, what people mean by the word hype. Hype is the discussion of everything other than the art of concern to the art. But, then again, of the art one can really say little. Medium? Dimension? Provenance? All that is museum registrar talk. Beauty or ugliness? They are assertions of conviction—puffery about transcendence. Formal significance tacitly assumes a set of historical terms—critical lists of modernist desiderata: abstract expressionism, gesture, field, allover, frontality, edge tension, reductivism, minimalism, post-minimalism, pluralism, post-modernism, maximalism, historical revisionism, and on and on. The more it changes, the more it stays the

same, and the argument says nothing about art. Even art historical niceties are a kind of hype. Still, for many, such statements may take the form of promotion of proscriptive theories of culture, generally Marxist, latterly semiotic, and on and on. Hence, for a moment at least, let us stay with the "hype." It used to be called biography.

Garet, now twenty-eight, was raised in California to a family of economic success and cultural aspirations. "Dad's a really attractive businessman," originally from the deep south and now a vice-president of U.S. Industries. The West Coast/East Coast dislocation of Garet's youth was occasioned by his father's employment—Laguna Beach where Jedd was raised, to New Canaan, Connecticut where he attended high school.

The New Canaan house was just down the street from Phillip Johnson's and, as a teenager, Garet would trespass on the architect's property, pressing his nose flat against the panes of the famous glass house. Once, the guest house door was ajar and Garet went in to investigate. These illegal entries were covered by a native nonchalance. He would call out to, whistle for, an invisible dog by way of signalling to the world that he belonged there.

There were early brushes with art. Dana Garrett, the artist's elder brother by two years (they spell the family name differently so as to differentiate between their careers) is also a painter of merit. He was always a provocative figure for his brother. The pervasive Warholianism that suffuses an entire generation was particularly manifest in Dana's New Canaan hobby. Like those who collect beer cans, Dana opted for Campbell Soup cans. "All that red was intensified by the dark blue he had painted his room."

Barboura Garet, Jedd's mother, is a painter in the California area. The mode of her work is decorative and abstract, dealing with simplified still-life motifs that may be likened to models in Richard Diebenkorn (also abstract and Californian) as well as revealing the influence of Milton Avery, not to mention Matisse.

Garet is indifferent both to the work of Diebenkorn and Avery as "painting that never can be offensive to anyone," an injunction that does not obtain to Matisse for whom Garet expresses admiration, especially of the so-called "failed" paintings (ca. 1912-17) when Matisse was struggling with Cubism.

Though primarily a businessman, Garet's father also provided a strong model. "He filled the house with Knoll furniture, he listened to great jazz, he dressed wonderfully. He also designed one of his office desks—which was this huge slab of wood—a flat floating plane invisibly anchored to the floor. That's just one example of his fastidiousness with regard to design and environment." And so, through the parental ambience, the atmosphere of Garet's youth was artistic.

Despite the art clues, Jedd was then far more the Californian athlete, an expert swimmer, as later he would become an expert skier, not olympic class obviously but still one with the physicality of it. For sure, something of the broad-

shouldered, wasp-waisted silhouette character of his "Minoan" imagery is informed by a transposed athletic logo. And, as part of this, an insistent note of 1930s-like nudism—the *novecentisti* palestra, a bright clean neo-classical sports arena, both Fascist and fashionable at one go. Mussolini's Rome; Hoyningen-Huene's and Horst's trim tanktop swimmers. The playing field of the fashion plate.

Garet's boyhood and early adolescence then was spent in an atmosphere of privileged and easy physicality. A child in the land of the lotus eaters, realization came without anguish. In his early teens he declared preference through an act of "political drag," the sporting of a pair of high unisex wedgies. The point is the use of clothes, as they were being exploited then, as a means of political expression, ultimately a semiotic key to the art form by which he was later drawn in his college years—that of the conceptual performance, which on the West Coast possesses a depth of meaning, a history, far beyond the transient moment it enjoyed here at the margin of the conceptual movement.

Earlier, when the family had moved to New Canaan where he finished high school, an art teacher, Bernice Hall, drew his nascent strands of consciousness together to form a single braid of purpose. "I became the cliché artist of my class. The art and literary magazine staff artist. Fortunately, at the time, at New Canaan High it wasn't cool to do sports."

Hall instituted a Saturday school that proved inspiring. As is rarely the case in high school teaching, Hall's pedagogy was independent of therapeutic intention, divorced from didactic application whereby art making becomes only a tool for psychological investigation. No such teacher's college mission attached to her work. "You were there only because you wanted to be there. And I was a high school art star. I made giant abstract paintings. The high school still owns one. It's hanging in somebody's office."

From high school, Garet went to the Rhode Island School of Design for two years, "Riz-dee" as the kids up on Benefit Street say. RISD enjoys a propinquitous siting beside Brown University. Together they dominate the beautiful hill above Providence, framed as it were by the longest row of colonial picket-fence and cottage—a kind of Litchfield, Connecticut transposed. At college he made notable contacts that would change the course of his life. Foremost among them was John Cheim, who in his turn became an instrumental figure at the Robert Miller Gallery, and who pressed for Garet's first show there in 1979.

Cheim remembers Garet's passage through RISD as an episode marked by sartorial obsession—"stomping about the hill in black boots," that kind of thing. Garet concurs. "I never took painting courses. I never learned how to paint a still life. I took no formal courses in painting an apple. I never painted a cube. I never even finished there."

Much of the power of the work shown at the first exhibition is involved with a kind of ironic flat-footed depiction of precisely such "lacking" primary

information: the balluster vase, simple cylinders, spheres and cubes all rendered bluntly, Gestalt diagrams of fifties do-it-yourself illusionism. It is a kind of illusionism as signifier, chunks of the elements of style as style itself. The pictures guy the simple forms of "how-to" still lifes. But the spheres, the cones, and the cubes also echo the *Toys of the Prince,* to cite but one of De Chirico's many still lifes of the Metaphysical Period.

At RISD, Garet continued to be drawn by the conceptual performance, inventing it out of art magazine information; "proposal art, a bale of hay with a light bulb stuck in it." You remember the typology—post-minimal performance, conceptual, process oriented, earth art—the descriptive phrases drift into memory. "I was copying what I saw in *Artforum.* Then I got to New York and I realized that if I wanted to get in it I couldn't copy it. So when all my fellow artists were going into the rock scene, becoming musicians, I became a painter. It was the Mudd Club scene, New Wave. I began to paint. I didn't go into rock music, but that's what the scene was about. Rock music was a focal point for creative energy so I listened to the music anyway. But I really don't like it. I prefer rhythm and blues. The Lounge Lizards, the Talking Heads—they're filled with artists." In the degree that one can determine the chronology of so osmotically nourished episodes as the Club Scene and the East Village phenomenon, the latter seems to have grown easily out of the former.

Even at this short remove, Garet's ascent appears vertiginous. On leaving RISD, he lived briefly in confined tenement quarters in the East Thirties off the swiftly developing East Village scene, though an active participant in it for all that. He was then a transient student at the School of Visual Arts.

While there, Garet met Fred Mueller, a former co-director of the Pace Gallery. Mueller exercised an immense influence on Garet. A noted connoisseur of oriental art and dealer of significant modern works, Mueller was in the uncommon position to promote young art. He opened his celebrated Gracie Square apartment to Garet—with its Shang bronzes, Ming furniture, its Arps and Samarases.

In the interim, Garet moved into his present loft space in an industrial building overlooking Forsythe Street just below Delancey. As part of the social utopianism of the 1930s, the WPA had ripped out a concourse of city blocks to provide light and air to a lower East Side, then still the enclave of the Russian Jews who escaped Imperial conscription and institutionalized anti-Semitism at the end of the century. This now legendary diaspora culture made uneasy truces with the Irish and Italian enclaves and the pockets of Baltic orthodoxy of the Eastern Church—Ukrainians, Estonians, Latvians, Poles. The latter group remains today, their tenement blocks gleaming in a lower East Side of decidedly Hispanic cast and old Jews. And with the surging of the East Village phenomenon, artists and incipient gentrification.

Garet's loft once looked out on greensward with stepped playgrounds, gardens and wading pools in Park Department red brick Georgian. Today all this

is asphalt, grafitti, dereliction (human and otherwise). Here slumber the wino and the psycho, the one atop his broken bottles, the other across her shopping bags. And here in her net undergarments the cheap prostitute gives service to cruising motorists stopping by for the job. As sordid as it all is the scene is no more lurid than the garbage and the grafitti merit. Indifferently Garet once watched a prostitute being taken, arms akimbo, against the thrust of the line of gathering clients.

Up and down the area: Tompkins Square, the East Village scene, the Fun Gallery, Patti Astor, Gracie Mansion, the New Math, Civilian Warfare, Nature Morte. The scene works as a feeder to the SoHo situation and young dealers are carving out a sector. They begin with the Untouchable but a machinery is put into motion that transforms detritus into treasure. The smallness of the scene is inescapable. The minute working space of old lower East Side railroad flat and the virtual impossibility of privacy enforces a celebration of communal exuberance, intensifying a myth of fraternity that leads to shared iconography— the East Village version of the *Köln Freiheit* group. There are Garet dilutants, Basquiat distillates, Kenny Scharf knockoffs, Barbara Krugerands and on and on. The work of art, independent of all other considerations, is at least this much: talisman of shared experience. As a thing in itself it tends to be decried. It becomes art, insofar as lip service is paid, only in the degree that it invokes a novel sense of community. Certainly this is true of the beginnings of all new styles.

This communal thing argues against personalistic theory, and forces a factitious bonhomie. Increments of bad faith are flaring up especially between the East Village graffitists who tend to emerge from Black and Hispanic catchments—and the cool imagists who tend to be white, deracinated middle class. But at the beginning, since what was to be was so unknown, a broad based symbiotic truce obtained between all parties. But individuation, fed by the emergence of particular young artists, is in the air. And with it acrimony. Still, for the moment, the mix assures easy access of one artist to another, an availability that guarantees a shared iconography and reifies the pretense of a "mindless absence of theory"—which is, of course, not the case. No art is free of a theory of art but the present "anti-intellectualism" paraphrases conventional Romantic notions of inspiration and anti-academism, and sets no one above anyone else— in principle that is, and the democratic forms are observed (often in the breach); and too, such an attitude consciously overturns the protocols of high art that were once avowed, even embraced, under Minimalism's sway.

All this devalues verbalization (at least in theory) quite as it promotes a false theory of hedonistic pleasure. "It's pure joy for me, I don't have to think," as if pure joy demanded no thought. It erases, in theory, distinctions between artists as to success, class, race, though all those distinctions are there, if for the moment, temporarily glossed. Naturally, much of this occurs because economically it had

to. Even these slum alternatives, these non-biodegradable blossoms, are very expensive to come by.

Do not be misled. That my discussion embeds Garet in the East Village is true—he is in it but not absolutely of it. In many ways his work is antithetical to the communal aspirations of the area, not least in terms of its cooly rendered Italianate iconography. When Garet first showed, the critic Stuart Morgan trillingly quipped "Plinths Charming" by way of title for his New York chronicle sent to the London-based magazine *Art Scribe* (November 1979). Garet's work, enthusiastically received, welcomed even, at the time of two New York shows (Robert Miller 1979) and a first London exhibition (Felicity Samuels, 1979) slaked a parched thirst for an image-making that paralleled a referentiality found in the work of the so-called Three C's, Cucchi, Chia, Clemente. These painters of the same postwar generation, (Clemente, born in 1952, Garet in 1955) emerged into international prominence at the same time as Garet. In short, the moment was propitious for the Italianate, coincident with an enormous revisionist machinery favoring late De Chirico the first time and catapulting the work of his less well-known brother Alberto Savinio into considerable esteem.

On a certain level then, the achievement of the three C's may be seen as reasonable, to be expected. For a decade and more European artists have chafed under the pretentions of the American claim of privileged priority in the modernist agenda, an organic sequence broken in Europe by the advent of Fascism and its temporary triumphs, but miraculously transposed here at the time, and preserved intact.

As such, the Italians of the late '70s naturally allied with the young German painters of the period—if only on a pro tem basis. The latter, even earlier, had opted for an unabashed Expressionism. Their move was seen as the means of bridging broken German modernism as well as the lever to unseat an inimical American modernism. New German Expressionism is also at odds with the poetical image-making of the Italians whose resurrection of a national Italianism was achieved through a refreshed appeal to classical image and myth. This revival inadvertently provided an iconographic screen upon which to project Garet's imagery and which momentarily seemed convergent with it.

How much more extraordinary then is Garet's achievement for, compared with the Italians, he may be said to have created his Italianism ex-nihilo, out of nothing, as he was working, unlike they, in a word bereft of their own freshly embraced tradition.

Still, vestigial late surrealist classicism had never been fully abandoned in the United States where it was cryonically preserved in the factitious studio prop classicism of '40s and '50s movies and advertising as well as the lurid stage lighting we associate with these manifestations. By the early '70s all this had become paradigmatic to the gay coding of the contemporary homo-erotic stance.

For all the *Goyescas* about it, Garet's loft affects considerable elegance. Once glossy white, its glare is now toned down by black enamel. The floor, once blazing

green, has softened to a kind of chartreuse Day-glo stain. It was here that Garet joined forces with the incipient club scene.

Eric Mitchell, "premiere New Wave filmmaker" shot *Underground U.S.A.,* the milieu's most characteristic flick, in Garet's loft. Hence his credit title as Set Decorator. He did create the decor for the film, three paintings of the how-to stripe vase and one grand costume, Patti Astor's wired cone garment (like an inverted lamp shade) for the lurid ending.

The story line tells of a society girl—shades of Edie—who came to New York to make it big, to become an Underground Star. All this perpetuates the myths let alone the lingo of the Golden Years of the Silver Factory. A frame of reference to popular culture, the East Village Vulgate, reaffirms roots of this mode in Pop Art. Patti's suicide is enacted in a wire lampshade dress. The frank black/white inversions and inside/outside reversals—formally minimalist in character—echo in the Garet canvas stretched over '50s shadow boxes to be seen in the film frame directly behind her.

Arch Connelly, a painter of hayseed charm, said, "The cone is the shape of the eighties." Connelly's friendship with Jedd and Dana dates back to their California days.

"My larger pond is San Francisco where I was able to concentrate on clothes and drugs and take on the full-time job of GOING OUT. Mostly I attended but usually gave PARTIES. I met a few thousand people, including Dana Garrett and his brother Jedd Garet both of whom I just loved. I've put on shows, 'theatricals' with and for my friends (the Cockettes, the Angels of Light and Warped Floors), mostly making the stage decorations but having a few walk-on parts too." (From *Bio,* The Fun Gallery, New York City.)

Connelly's work uses artificial gems, pearls and jewelry mixed with lava-lava Cypress Gardens driftwood shapes which in their way echo much of Garet's tropical indulgences and formal stratagems.

Anyway, Connelly said, "This cone is the shape of the Eighties," an interesting throw-away line. Not only is the cone a motif central to Garet's painting, it may also correspond to the "ideal masculine wedge," shoulder to waist of Garet's Hollywood Moderne torsos. Then too, as a shape it mediates the strength of Cezanne's dictum, the Bauhaus costuming of Oskar Schlemmer's Triadic Ballet, the elegance of precisionist calla lilies to the labor intensive, pre-pret engineered garments of Charles James.

Needless to say, gallery sensibility, for decades far more alert and experimental than critical and curatorial receptivity, has already erected bridges to this group.

So complete was the heightened sense of communal activity in the East Village that for a while it seemed that life without it was kind of narcolepsy. Garet was addicted to the "fun" of his work, by which he meant "painting without a break for three days." To sustain that kind of intensity he turned to the artificial paradises, as Baudelaire called them, because they allowed for the

experience of the simulacrum of fun. And fun was this driving compulsion to honor a task called making paintings.

While there is no specific iconography exclusive to this episode, certain titles allude to it, Breathing Water, say. Here the allusion is made by the assertion that one is breathing something unnatural, quite as one sniffs a drug. Then again among the prime cultural distinctions we make is that art equals the "otherness" of "not nature." Hence, for us, art is not natural, it is artificial. Thus language allows for, if we let Breathing Water stand for an entire production, a paean in praise of the artificial, the not natural—that is, art itself. The metonym derives from Baudelaire.

Garet at the time of his first one-person show felt that his work was coding homo-erotic signs, "putting them on the line in the art world." To his surprise, they were never mentioned, in print anyway, except say in the stray allusion made by Kay Larson in a paragraph (*The Village Voice,* 17 Sept. 1979) that spoke to his sculptures, "like objects for a transvestite's prop room." This is hardly the case except that something of the fictive drama of such a locale corresponds to the vitality of Garet's art.

Still, to insist upon specific meaning is to traduce the generalist intention of Garet's paintings as well as to over-specify his imagery. For though he admits to "a focus on elements of style that is sort of gay, these things are not necessarily homosexual." As he says, "there is nothing specific, yet it is there." Of the paintings of men, (there are scarcely any of women), he notes that "they are not sex phantoms. They are idealized and generalized. They are rendered without genitals. They are streamlined." Occasionally the figure is a fragment, a torso with neither hands nor feet, though Garet tends to avoid such depictions as it points to "frailty and vulnerability, where I aim for refined idealization." Perhaps a rare iconographic model for this fragmentation is the solarized male nude photograph by Man Ray dating to the early 1930s (a virtually unique subject for the artist).

Buoyed by euphoria and a sense of community Garet's first exhibition proved exhilarating, as did the second. His drawing was untroubled and schematic—ebony pencil on raw canvas mostly from thumbnail sketches or just the barest ideas. At first all this happened felicitiously. Few pictures gave trouble, though acrylic allows for easy correction. Now, in distinction to his early insouciance, Garet begins to worry about "how to paint," though he has not given up his schematic working procedure—with its unrepentant reliance on the blending brush, that wide fanned tool of the commercial illustrator. "It's real easy. I was thrilled when I discovered it. It made it easy to avoid expressionism with its reliance on rendering. I've done little painting without a linear blend. I put one color down next to another. Then I go over them with blending brushes. Each color gets a blending. It's really important to have a time limit. It's like an egg timer. I do a lot of masking, unless I do a lot of paintings at one time, which I don't. I don't like that. I like to keep one painting in mind at a time."

Garet's assertions of ease are disingenuous, the Pavlov-like responses natural to a generation said to brook no delayed gratification. That Garet takes this tack as a matter of course in no way means that his work really is easy to the eye. He may mean easy to make; never easy as art. There is much in his work that resists the eye, that is indigestible, so as to throw his assertions of ease into considerable doubt: blunt broad surface, high-key Mannerist color, for example, Chartreuse, cerise, iridescences of acidulated cordial distillations. An earlier Abstract Expressionist model for this kind of color is found in the paintings of Bradley Walker Tomlin or William Baziotes, themselves no strangers to Mannerism.

Of Garet's discrepant disjunctive scale comparisons, big to small in flattened ironed-out diagonal corridors of space, Parmigianino's, *Madonna With A Long Neck* (studied in Horst Janson's college text illustration) is an avowed model, as is De Chirico. The professed creed is at great variance with the visual evidence.

Garet's growing awareness of a need for visual indigestibility—as a means of eluding modish acceptance and typecasting—is reflected in the far more complex compositions of late, as well as the often unapologetic appearance of correction and pentimenti—the use of drawn or pastel passages over the painted canvas.

Now genres are fused—landscape and abstraction, say. In three years we have moved from happy-bad-taste De Chirico to the perhaps more intellectually rigid constructivist fusions found in Prampolini—that is, we have moved from a Metaphysical School model to a kind of figurative abstraction that signifies later Futurist developments in the early phases of Italian Fascist Utopianism of the 1930s, the *novencentisti*.

"La femme est naturelle, c'est-á-dire abominable." Woman is natural, hence abominable. Though the phraseology is abhorrent to the artist—let alone modern ears generally, Baudelaire's *Mon Coeur mis à nu* (My Heart Stripped Bare), essentialized a venerable prejudice. Its ramifications were stretched when he attached them to his notion of the Dandy. For, not only is woman natural and abominable she is "toujours vulgaire, c'est-á-dire le contraire du dandy," she is always vulgar, that is to say the opposite of the dandy. In his essay "Le Dandy," forebear of Susan Sontag's "Notes on Camp," Baudelaire tells us that dandyism, "the last flourish of heroism," is "before all else, the ardent need to make something original of oneself but within the limits of acceptability." Dandyism combines "the pleasure of stunning others with the proud satisfaction of never being stunned oneself."

Owing to Baudelaire's sexist aphorism, the possibility of perverseness and ambiguity is fused to modernism's most salient argument—the continuity of formal significance with the condition of absolute novelty. More, that that which is new may be perceived as that which is most like art. Yet if art is artificial and nature natural and if woman is "natural and abominable," then, if one persists in the syllogism, art is male and laudable—not necessarily homo-erotic, but not

necessarily homophobic either. Still, that is how academic defenders would have us read it. We learned, say, during the heavy critical support of Abstract Expressionism, that art was sexist and anti-gay. Similarly, that André Breton's sexism obtained in the defense of early Surrealism, is a perception derived from the adventitious misreadings afforded by Baudelaire's two doctrinal texts of modernism. Still, from these texts we can locate the ongoing and acrimonious struggle between taste and art, taste as art, style and art, style as art, the heroism of taste versus the brawn of art. From here also derives the curious high incidence of a politicized homo-erotic and the emergence of the new.

My point is not to endorse what is correctly condemned today as a sexist tenet. Still, in invoking Baudelaire, I would like to stress those heady paradoxes as still obtaining—but very freshly—in Garet's painting.

Garet's critical susceptibilities are keen. His work derives from an almost manifesto-like purism. Of his intentions (while recognizing that intentions realized do not necessarily make for art), Garet says, "no words, no natural elements, nothing natural, including the figures. They were statues, not people. And no natural colors, no earth colors. Well of course, everything is found in nature, but I wanted it, nature that is, to be artificial. It's not that nature is hard to do, it's that it's against the rules. I broke down all my rules—one by one."

Entry

Form. & Q.M.

Random Notes on Painting from a Critic's Daybook

12 January 1973

The critical part of the artist's mind—the part different from the mindless "doing" of things, the "systems" part, not the "process" part—is much more acutely formed today than before. This results in a terrible frustration as every "process" move is near-instantaneously understood in all its ramifications. Such awareness leads the artist to a terrible despair, to a dark cave from which he/she must emerge having rediscovered art. Painting/sculpture must express this rediscovery, this beginning anew.

This is very different from Formalism's "ten flavor" art in which the artist *QUARK FLAVORS* changes nothing of the given existence of an ideal category, say painting or sculpture, except the balance or relationships between the flavors.

17 March 1974

An odd idea: the source of the typology of sculpture is *structure* or *support,* of painting, *the mark.* Therefore, sculpture that plays with support, with variations in structure, is inherently uninteresting because it is tautological. Similarly, painting that plays with variations in marking is uninteresting because it elaborates only the essential premise of painting, the mark. For sculpture to become interesting it must address itself to the mark; for painting to become interesting it must resolve the problem of the support. In short, the painter and the sculptor must exchange identities and methods so that painting and sculpture may continue to flourish. Painting addressed to the mark, the gesture, facture, is over... and sculpture addressed to the structure, the support, construction, is equally passé. I don't know if this is true. *BUT IT'S A WONDERFUL IDEA.*

Epistemic abstraction contains an integral flaw—it must always lessen; it is marked by its reductive character—always, always, one less element, one less

issue. Ultimately, if I am right, epistemic abstraction leads to *Nothing; nothing is the ineluctable result of abstract reductivism.* This problem is resolved in two ways: 1) One perceives that a *theory* of abstract reductivism is not the same as the *practice* of abstract reductivism. Thus, the technological solution of abstract reductivism, the way an artist manifests his/her art, circumvents and short circuits the ineluctable conclusions of abstract reductivism. The hand maintains and preserves what the mind destroys. It is rather like the physics of white light. Reduced to its spectrum components, theoretically it can be recomposed into white light; in practice, with paint I mean, however high their purity, colored paints never recompose back into white because of the impurity still inherent in the materials. *Practice* maintains what theory *culminates.*

2) Many artists are fearful of the power of theory. Dimly they recognize that *the dialectic of abstraction leads to nothing.* Thus they revert to figuration and iconography as a means of staving off the ultimate *nothingness* of abstraction. I think that this contributes much to a resurgence of representational art... the fear and anxiety of artists who perceive the inevitable wasting away of form inherent to abstraction.

Or 3) The dialectic abstraction leads to pure visual information, pure data which is, in itself, *beautiful* in that this *information* is *new,* or *newly perceived* to be a proper content of art.

21 May 1974

Theories of abstraction: In abstract reductivism, the ineluctable condition is Nothingness. Nothingness is eluded by practical issues centered on component abstract visual elements—line, shape, surface, hue, texture, systemic structure, touch, figure, illusionism, even iconography... When all the component issues corroborate one another, when there is no discord, the abstraction is beautiful— although in an odd way, empty and repetitive. The choice then for the abstract artist is to either fall off the edge—into *le néant*—or to become "beautiful." Immense numbers of practical ruses and asseverations enter into painting so as to elude these polarities—the most dramatic curative or purgative is to adopt another species type. After "falling off the edge" (having achieved *Nothing*), or after having achieved the *Beautiful,* facility in execution engages the moral obligation of a species curative: painting cured becomes sculpture; sculpture cured becomes painting.

All elements of reductive abstraction pre-exist ideally in the mind and are tacitly assumed to exist prior to their manifestation as form.

2 February 1974

Possibilities: systemic conceptual activity is no more or less interesting than representationalism in that they both have an external means by which the

"rightness" or "correctness" can be measured—conceptual work against a closed intellectual system, the representational image against nature. Perhaps then 1) the emergence of a narrative conceptual style has arisen to undermine the tyranny of an external system, and 2) it may be, after all, that the expressionists are right, in that their work depends in no way on a corroborating system, something external to the work, but only upon the "belief" (therefore mystical) of the importance of the inspired and uniquely beautiful accident.

9 February 1974

In the '60s, the autonomy of the species type "painting" and "sculpture" held. By the end of the decade, hierachy of species and hierarchy of materials central to preservation of the species type was first questioned through the introduction of "eccentric" and "signature substances." This led to a focus on pictorial sculpture and process articulation. In turn the vital expression is now a function of the introduction of issues of temporality without giving the species identity of painting and sculpture over to pure performance. Still, to introduce temporality, not be theatre or performance, and still be painting and sculpture: this now seems to be the central issue of advanced art. Is it possible?

24 March 1974

A real problem: representational painters, working directly from nature, tend to rationalize as positive achievements their inept recordings of sensory data—their distortions and spatial ineptitudes. They do this partly out of fear of being accused of taking cues from photography. The result is "expressionist communication." The sad thing is that this is self-delusory and leads to the perpetuation of the very ineptitudes they are dedicated to overcoming.

Still representational painting after nature is a mode by which a humanist and academic species—painting—is preserved. After all is said and done, it seems important in elementary Western cultural terms, to preserve painting (and of course sculpture too) *for themselves.* This feeling (admittedly a nostalgic one) may be part of my disaffection for Technology in itself, and too for my growing disinterest in painting and sculpture that does not proclaim its species identity—or at least that confuses itself through admixtures of technology and/or temporality.

16 October 1974

Painterly painting—even so-called painterly abstraction—addresses figuration. Painterly abstraction is shot through with lost or absent figuration. Linear painting is not about painting at all but about analysis and surface: It addresses issues of the draughtsperson. And drawing, for us, is the meeting place of painting and sculpture or painting and architecture. But it is not about painting.

26 October 1974

Expressionist painting is about figuration, even when abstract. Bizarrely the hardest problem for a figurative painter is "the idea" of a painting. Otherwise nature becomes merely pretextual—and the underlying rationale of representationalism fails. "Pretextual" figuration reveals an indifference and insensitivity to nature that abstractionists would never accede to.

9 November 1974

Students immolated in the sacrifice to the past are destroyed by history. It is as stupid to be consecrated to Titian as it is to Warhol.

21 December 1974

Convinced of the fatuity of illusionism in painting—illusionism seems as inculpated as any other cultural manifestation of 19th century, e.g. technological utopianism, imperialism, nationalism, etc., etc. To be committed to illusionism surely goes hand in hand with the idea of painting as a métier, a skill or trade that produces a product, the well-painted picture. This alone ought to render illusionism superfluous, yet it hasn't.

16 March 1975

What is preserved in abstract reductivist painting is a diagnostic profile reduced to small numbers of elements—shape, surface, support, color, touch. These are five representative components that might be viewed as necessary to the preservation of painting. While such elements may be shown as necessary to painting's preservation the belief in only these elements and not in others is impervious to analysis. Why just *these* elements? Thus the ultimate elements of painting's diagnostic profile represent acts of faith, mystical confidences. (Since 1968 certain painters have driven out support, preferring to work directly on the wall rather than on canvas, board or paper. Similarly, other painters have objectified the stroke as a free element in space, transforming color, gesture and touch into the components of a "pictorial sculpture," into an object.)

Why is it desirable to preserve painting in the first place? This question is too worrisome, too imbricated in culture. It assumes painting as a *summum bonum* whose ultimate value is demonstrable only as an act of faith. It too is impervious to analysis.

Entries

30 May 1975

Art-Rite's painting issue came out with a sly "dumb" Ryman cover and some random notes on painting from my journal. The piece amuses me and spurs me on. The basic impulse of painting is to deny or cancel space (although most would say to create the illusion of space), of sculpture to affirm space and, in so doing, to affirm time. Thus, sculpture is always narrative as it shows relationships that exist between real elements; and since it occupies three dimensions, it is always real. Painting, occupying only two, is always unreal (though its status as an object is real).

Representationalism more properly falls within the province of sculpture owing to sculpture's innate narrativeness. Hence, sculpture is more acceptably and more inherently figurative than painting. There may be something in this suite of abstract concepts but they are unreadable, unwriteable, and unthinkable.

15 July 1975

The source of painting is the mark, the denial of space. The source of sculpture, the affirmation of relationships, hence, of space. The painter fears space; the sculptor welcomes it. Illusionism may be understood as a means of totemically conquering space by the painter who, dealing in the sculptor's currency, magically incorporates the sculptor's power.

Now, theories of art are honored in the breach; before, theories of art were honored. Honor in the breach is a theory of art.

13 February 1976

Even if the basic impulse of painting is to deny or forswear space, that that is what is frequently met as painting is hardly the case. There is an immense gulf between the motivations of an art-species and its externalization. This paradoxical dichotomy may be rooted in a guilty and anxious over-compensation

(manifested at its most extreme as representationalism) made by painters who by instants glimpse the primordial negativism animating their work.

28 September 1975

Each decade is marked by the young style of the late years of the preceding decade: '70s art is really '68; '80s art will be '78; '60s art is '58 and so on.

Possibility: a belief in the power of narrative is sufficient justification for representational art—if the "story" is sufficiently strong it doesn't matter how it is painted.

Sculpture differs from painting because it has no background to worry over; thus, the whole narrative is fixed within the object. The sculptural object is especially venerated as it serves a double function, as its own object and its own setting. In painting such intensity is dissipated as both objects and setting are depicted.

19 November 1975

Op art is abstraction for people who hate abstract art; it *does* something amusing—kitschy. Kitsch is art for people who hate art.

Representational painting is interesting coloristically when interesting colors appear in nature and then are copied

21 December 1975

Again and again inept spatial recording leads to the rationalizations and justifications of Expressionism. Poor spatial integration, the crushing and crumpling of the figure, fudged passages of point to point transcription, leads to: 1) its own kind of Expressionist taste and appearance and 2) is generally accompanied by a muddy insensitive palette. It seems the gift for correct proportional recording keys into a gift for fresh color. So much in Expressionism gets botched and labored, especially the setting down of the point to point examination, so that color suffers through painting and repainting.

11 January 1976

Since the antagonist of modern painting is illusionism, Abstract Expressionism can wing numerous maladdresses—ones that Expressionist representationalism can't. Error in representational art is all the more exposed, raw, and naked, since it is embodied illusionistically. Expressionist art aims at overload.

BYPASSING THE OBJECT

Just as conceptual art may be said to circumvent or defeat history through bypassing the object, personal mythological and fetishistic art does the same. The intuitions that guide this art, generally sexual and religious at the core, are impervious of analysis as are primitive arts of all cultures; such arts fall outside of history. Much work of this kind has been appearing of late, especially made by women, so locked into formerly cryptosexist methodologies and iconographies is this art. Mouths and teeth play an important iconographic role here partly because the mouth is the public counter-part to the secret vagina: mouth = vagina; tongue = clitoris (= penis?).

29 November 1975

Assuming that painting and sculpture have "normative profiles," an exaggeration of a single element in a diagnostic profile forces or pushes the species to transform into its opposite—painting into sculpture, sculpture into painting.

All right, all right, agreed: the major achievement in art has been transcriptive of human imagery, thus leading to a hierarchy of genres—figure composition over landscape, landscape over still life, etc., etc. But, even granting this impossible-to-staunch prejudice in favor of art as a mirror of nature, there still is no reason to assume that our generation must do it, must persist in making representational art. The acknowledgment of one kind of superiority over another in art does not entail a production keyed into this admission. Abstract artists are perfectly able to recognize the pretended superiority of illusion over abstraction, of representation over presentation, without for a moment wanting to produce an illusionistic art. A parallel may be seen in Mannerism: after Leonardo, Raphael, and Michelangelo, a subsequent generation fully cognizant that they would never achieve such titanic results never tried to, never wanted to, aiming instead at an art of species exaggeration. In short, for certain generations—it would seem ours too—after a grudging acknowledgment of the superiority of academic hierarchies, the question still remains: so what?

The bent saw that with enough dedication a student can conquer illusionism just isn't so—witness the mounds of ineffective visual distortion "justified" by the Expressionist ethos. But that these trivial realists could be, with no trouble—just a design course or two—competent abstractionists is an equally absurd assumption. The realist must be brainless and all hands. The abstractionist must be all brains; hands maybe. The likelihood is that the manual deficiencies of a weak representationalism is coupled with an equally mediocre mind. In short, poor representational art, poor abstraction.

2 November 1975

The ineffable shifts in feeling that make for recent stylistic succession. First, there was the rejection of sensibility-based illusionism in favor of a new organizing principle based not upon what is seen (as filtered through sensibility) but on what is known: a composition corroborated by true structures of logic— binary comparisons, zero through nine, circle-square-triangle relationships, set theories, etc. After logical structure as a basis for composition, what happened was that the same kind of disinterest the artist once felt toward nature as the compositional model emerged to falter this development; neither external nature nor external logic were able to command the artist's impulses toward creation. This had a triple effect: a) it sent the artist to pure sensibility abstraction free of any external system of corroboration—e.g., Tuttle, Renouf, Pozzi, Twombly, etc; or b) to an art rather more ethnic and or pure imagery—all the manifestations of post-Pop realism linked to a media-based image of nature; or c) to internalize the art process so that in rejecting sensibility or illusionism the artist fell back on the self, the ego, the "I." Clues existed (Morris's *I-Box,* Nauman, etc.), but, in part, the most acutely new mode is an autobiographical conceptualism—Acconci, Benglis, James Collins, etc. However, this art, if it is art, will appear to have been short-lived, largely because of the transient theatrical nature of these efforts which tend not to be embodied in whole separate objects (but rather in things that are part object, part experience) so there is little "art residue," art fallout. The clear distinctions into ideological camps which mark our moment will tend to denigrate to effacement manifestations of this kind of experience.

29 June 1975

After a confining regime of bedrest and antibiotics I went stir crazy. Tossing aside good sense, went down to Soho and visited with Jan Groover. Her new loft has a fine darkroom and a high view over the slant in Sixth Avenue below Canal Street in a Beaux-Arts factory building with a pressed-in classical facade. Groover's color photographs are more interesting to me than ever. Their scale is larger, color crisp and impressive.

I have the feeling it's easier at this moment to look at photographs rather than at paintings, at least the Media makes us think so. The degree of cultural conditioning necessary to absorb painting's information appears suddenly more demanding and specialized—requiring even an acculturation similar, to, say, the appreciation of *lieder* or the French art song. By contrast, the paths of receptivity to seeing a photograph are more in tune with the broad range of pressures that forms the contemporary outlook. Perhaps the seriality of Groover's photographs are not so much a lingering concern with Minimalist structure, but rather, a way to block the sheer facility of seeing, a tactic that forces the viewer to perceive the

photograph in ways that hobble immediacy—thus making the viewer perceive new possibilities as to the nature of a photograph: seriality to defeat immediacy.

18 January 1976

Visiting Jan Groover during the installation of her photographs at Max Protetch's Gallery: still resist them because of a lingering view of photography as yet another form of graphics although the abstract information embedded in these photographs have little or nothing to do with photography as a technology, but derives instead from issues in painting and sculpture (which in turn are influenced by her photographs).

The photographs deal with a barely known photographic ambition—the suppression of the inherent spatial illusionism of camera reprography. Groover does this by waiting for anonymous inanimate urban things—walls, buildings, cars, trucks, streets and street stuff, shadows, and shapes—to align themselves, to line up along their edges so that the photograph reads as a puzzle of interlocked, flat templates. These colored images, often enough square, are set into serial sequences so that lateral, time-based information—shadow changes, front and side views, scale alterations—is recorded in regular divisions or, roughly speaking, in primary color changes (the rhetorical stuff of Minimalism found in nature)—further ironing and flattening the camera's purely, inescapably technical illusionism. Her photographs then are remarkable, but they remain for all that photography and, while able to rationally, I am hard pressed emotionally to fully divest myself of an academic and formalist argument favoring high species and unique objects. But, as photographs, hers more than any honor such argument without relinquishing one wit of their photographic state.

17 January 1976

To Gary Stephan's studio; an accessible Brooklyn Irishman. A strongly synthetic painter, Stephan is committed to elegances and refinements of an almost oriental flirtatiousness, surprising in his nagging, by moments hard, abstract taste. Irked by the implicit reduction to formula of all painting (from natural illusionism to more recent conventions like seriality), Stephan finds himself falling back on pure feeling, on the inner necessity of fine color (albeit an associative color) and of trued and faired shapes to "hold," to embody his convictions concerning authentic "space." He uses this word to express the sense one has before works that appear convincing as art. Stephan's para-associative colors and shapes cannot, in his case, be divorced from a finely tuned historical memory—Pompeiian reds, fresco surfaces, Lorenzetti-like colors, greens coppery, and reds mossy, blues cerulean, shapes blunted but easy, and the like. The frank aestheticism of this kind of visuality is the understructure whereby his belief and argument of the fatuity of formula-art is nourished. But it is double-edged and

works as much for as against his pictures. An attractive, intellectual painter, discovering, against his will—almost—pictures to be loved. His studio is at the extreme end of Canal Street directly over a methodone clinic—a splendid view of the true and fair West Side Highway overpass bridge.

17 January 1976

Yesterday to Pinchas Cohen-Gan's makeshift student's studio space at Columbia and the bathetic living quarters provided by the Columbia stipend. He is so far advanced over the students there (and most of the faculty too) that it's funny. Amazing work rejecting conceptualism as yet another closed period style, Cohen-Gan like several others had reverted to autobiography, not as conceptual theater, but rather as a kind of irony somehow reminiscent of, say, William Wegman (but not "joke art") or early Michael Hurson (but not expressionist illustration—not that knowledge of so specific a local source would even be open to him); or a kind of art that ricochets off heavy abstraction, neither one denting the other. Cohen-Gan's new figurative drawings recall early Walkowitz or Avery if you like, but only because his figures are so rudimentary and squashed. These "figurative circuits," as he calls a new suite, play with quasi-anonymous archetypal social and human situations—sitting at table, a group in a room, running in landscape, meditating while walking, a man with a pet—but the manifestation of these human activities is barely actualized so as to elude illustration (as it is commonly understood), illusionism, and specificities of any kind, physiognomic, geographic, or ideological.

Extremely ironic paintings and drawings on themes such as huge "field paintings" of colored canvas painted ineptly-on-purpose with makeshift wooden ramps set up against them so that the viewer may literally run up the ramp and jump into the field (which, of course, the viewer "literally" can't do); transcriptions of mathematical definitions played against balderdash illustrations, color tags dangling from them, visual addenda totally disconnected from the theorems; or paintings on touching, old linen from a defunct hostel, napkins and tablecloths spattered with huge blow-ups of the "figurative circuits"; cloth samples from schlock furniture showrooms painted over with small, colored rectangles. It is all so poor and abject and cramped. The canvases and clothes hang over cord lines in shared student studio space like so much mangled Steinberg-y laundry.

The output of Cohen-Gan in New York has been immense; and despite the grim bureaucratic crumminess he lives and works in here, I'm sure his stay has marked a big shift in his creative plateau—the abandoning of cryptic abstraction alone marks its significance in his career. Important to Cohen-Gan is a barely liminal, autobiographical memory (similar to perhaps the playlet archetypes of Boltanski, though he rejects this), a weird philosophical impatience with theory, and a sharp receptivity to shoddy, cheap substance. Though his whole work is

entirely indifferent to questions of painting, Cohen-Gan has an unexpected sense of color, not bright, nor strong, nor tonalistic, but downbeat, murky, and shrewdly crappy.

22 January 1976

To Kent Floeter's studio; top floor of a Broome Street loft building neatly got together for family life, his wife, a boy, a girl. Floeter, lean and craggy. Serious minded, in love with "tough" art, high criticism, with the naif and the intuitive still cracking through his racing enthusiasms. In the studio seven floors below; as if an open-ended corral, the rolled steel piece set up last year at Bykert—echoes in steel (as Nonas paraphrases in wood), aspects of Andre and Serra but differing from them in Floeter's attention to the cleanly cut chamfer and variant bipartite measurements.

On the wall the Upsom board drawings of a natural sculptor. The board with red lead primer drying into an almost palpably mat surface. While leaving systems behind, Floeter still retains the generalized rightness embodied in memories of regular subdivisions, dynamic symmetries, or golden mean ratios. The boards seem errantly sliced and form interlocked edges that function as line and as a means of shaping small acute triangles on the orange boards. These shapes—not quite leftovers—occasionally induce figure/ground readings (though this is clearly not their intention), black triangles dangling in orange atmospheres. Such vestiges of design effects more evocatively reveal a sense of their discovery, not of having emerged willy-nilly out of simple systems applications. The shapes are there because they *feel* best there; their rightness is linked to a sense for surface and for neat slice. The black of the triangles is too strong a contrast to the red lead, too insistent of a figure/ground tradition locked into graphics (perhaps a vestige of Al Held, a professorial Yale memory).

The orange/black interchange evokes Greek black figure vases as the cuts signify, were this simile to hold, the graffiti of the ancient terra-cottas. Apart from this passing old art reference, Floeter's red lead drawings relate, I think, to the material proxy you get in contemporary art of the kind most meaningful to him: read lead = Floeter; black paint stick = Serra; carbon paper = Rockburne; dry pigment = Bochner, etc. etc.

In this purview Floeter's red lead surfaces are not about color, least of all about fine shades of temperment, but a weight-anchored sculptor's visuality that, if color at all, equals white. But Floeter has worked no equivalency for the black triangles. Were my scheme to obtain they ought to be blue (carpenter's crayon?); thus red lead would equal white and blue would equal black. In so doing, Floeter's sense of cropped hyper-graphics would supersede the tradition of figure/ground dualities and approach the immanent visuality of a conceptual set, the orange/blue complement.

Entries: Vaulting Ambition

13 June 1982

In the small hours was still en route to Zurich for the festivities surrounding Bischofberger's Homage to Leo Castelli. Later, a delightful room in the Hotel Eden au Lac—a kind of turn-of-the-century villa. My room is at the corner with a terrace overlooking the lake, the far shore, the mountains. Luncheoned with David Salle and Janet Leonard. The Venice Biennale, they say, is *un four* with the main pavilions far from ready, the Robert Smithson survey a known quantity (for the American contingent at least), and a murky heat.

Exhilarated I walk to the Kunsthaus, a mixed bag with numerous masterpieces—Cézanne, Monet, Van Gogh, Picasso, early Giacometti, Mondrian, Brancusi, and the turn-of-the-century Swiss—Hodler and Rodo, for example, or Augusto Giacometti and Cuno Amiet; an amazing Tinguely retrospective and fine drawings by Enzo Cucchi. The excitement of a rich city that had been the home of Dada. Disaffected punky disco zombies down at lakeside in a surreptitious drug traffic. Spotty sun, drizzle, and cold.

14 June 1982

Continues heavy rain. The Dada pride of the city is reflected in its art, its Dada treasures—Janco, the minute Schadographs, and the Tinguely too, a kind of Dada bricolage, as Duchamp once characterized his own attitude.

June 15th in the a.m.

The tensions and paranoid anxieties of these last days evaporated during the toasts at Leo's dinner, a testimonial really (though hardly a roast) given him by a leading dealer of the younger European generation. A large number of museological peers came as well. The night historically marked a period, though all but a closed one, as Leo has adopted as his own many of the younger artists, too, including some Europeans. The social jockeying, of course, was blatant.

During the toasts, I made one lauding not the shrewed businessman but the kind and sweet one, aspects of Leo's personality I avoided commenting on, in my essay, for fear the catalogue would be seen as sheer puffery. Ileana Sonnabend recalled that it was sixteen years before at the opening of Bischofberger's first exhibition in 1965—a show of Pop Art much borrowed from her—that she first met Antonio Homem, now the director of her gallery, a crucial encounter for them both.

The present Bischofberger gallery is now in its fourth location, a handsome space on the Utoquai, large and white. The works looked fine though the Johns was a bit crushed by the weight of the Schnabel, "the best damn painting in the show," he unrepentantly notes. Perhaps. A grand international crowd appeared at the opening. Annina Nosei was there and Edit DeAk and Salome—a broad range of the new punky set intermingling with the extraordinary number of dealers. I tried, Dutch uncle, to caution Jean-Michel Basquiat from pissing away his new-earned bucks as there might not be so much of it always coming in. And he was quick to take umbrage.

Perhaps the most touching toast, enunciated in her gravelly French accent—difficult in English but surely hard for the Swiss/German-speaking crowd—was Toiny's. The second Mrs. Castelli reminded the guests that the toasts for Leo also obtained to Ileana, the first Mrs. Castelli, for she too had participated in Leo's brilliant 25-year quest—a flowering olive branch if ever one was proffered.

Guests were served in a Buren-like striped tent with a yodeling Apensell orchestra beating tunes out on zithers. Later, a final drink in the hotel bar. As we sat in a tight circle, the Mephistophelean German painter Salome lit upon Leo, whispering to him that Leo was the most attractive man there, that he knew he was a great lover, sexy for sure, because he once had a lover called Castelli (ergo, the Salome/Castelli show at Annina Nosei) and he wanted to give him a present, something that would make him feel good, by which, I assume, he meant some dope. The whole thing was eerie and unnerving. We were all a bit nonplussed. Leo, sitting in a chair, the arm of which I sat upon, huddled close so I could easily overhear the whispered exchange. The scene caused David Salle to note, after Salome had at last quit the group, that "there's just no telling appetites any more."

Leo in the armchair, possessed of a Hoffmanstahl-like resignation, reflected on the sumptuous outlay, the food, champagne, wine, servants, and music, enough to meet the needs of an annual budget of a poor canton, and wondered why, what it all meant, what will be next.

"There is a lot of Volpone in them," I said, as they measure out the spoils of an imaginarily divided Castelli-land. Leo murmured, "Yes, Volpone." "...But there's a lot of Gianni Schichi in you," I go on. In all, a wonderful evening with Leo stirred and many of us collecting autographs under the illustrations of the catalogue.

Paroxysms of anhedonia: Toiny was curious to know what Salome said to Leo. I recounted the phrases with as much vivacity as possible. Toiny: "I hope he said it into Leo's good ear." Toiny begins to take on mythic proportions.

By train from Zürich to Kassel. Awkward change in Frankfurt. Mistakenly took the short local train and suddenly found ourselves—David Salle, Janet Leonard, and Barbara Jakobson—rushing our luggage through crowded compartments to make the properly-destined car before decoupling. Then my characteristic German paranoia set in approaching hilarity and tears—the lowest point—as we idled in a local stop called Bürken—"so aptly named" guys David—at best a siding, an abandoned train car, some concrete industrial sheds, some pseudo-medieval buildings. Bleak. The basic existential stage set. "Imagine," David says, "five p.m. on a Friday in November here."

The hotel was a stupid kind of motel out at the edge of Kassel in a suburb called Wilhelmshöhe. Young *Kartoffelköpfe* everywhere. Documenta is Künstler Kamp. Later we meet up with the crowd in the heart of the city, a raw border town of exposed bluntness some twenty kilometers from the Eastern Zone. (After I discovered the park, the chateau, and the old town the next day, it mustered a certain charm.) We met up, as I was saying, in an Italian restaurant that every fifth year, for Documenta, sees a like vitality in its rooms—collegiate loud, collegiate dated, and collegiate snotty—the crassest being the Art and Language crowd, Michael Baldwin and Mel Ramsden doing a Mutt and Jeff collegiate aggressive Philosophy I number awaiting the clay-footed god "Joseph"—Kosuth, that is—slated for an epiphany, by their account, on the morrow. Anyway, when they caught the glitterati (as the columnists say) at "our table" (and how could they not, our tables were cheek by jowl)—d'Offay, Chia, Clemente, Van der Meij, Jakobson, Boone, Salle, Kiefer, artists, dealers, writers, husbands, wives, girlfriends, boyfriends—the Art and Language crowd fell into torrents of childish aggression by way of pantomiming "please note us." When they had pried my name from me ("Listen, just who are you, anyway?"), Baldwin actually explained, "Look, you bastard, I've just given you a compliment!" Ramsden, picking up on his dada, went on about how the journal was the death of criticism, but how he *nevertheless* had saved my article on Jim Collins "looking for his name." And *they* talk about the naked ambition and careerism of young painters as they mimic painting with teeth-held brushes. Didn't Andy once find a painter who held the brush in his asshole?

June 18th in the a.m.

Documenta turned round. Depressed from the night before, I walked up the mountain to Wilhelmshöhe, an astonishing schloss and park with lakes and gardens before it, a castle at its feet and above it, a terraced cascade of waterworks surmounted by a version of the Hercules Farnese. The schloss, once seat of the House of Hesse (whose fortunes were built on the sale of the stocky German

farm-hands, "Hessians," as fodder for the Hanover wars), houses the Gemäldegalerie and the antiquities. These collections are newly refurbished and constitute one of the singular museums with a brilliantly installed antiquities gallery. Beyond that, superb Rembrandts and old master galleries. A beautiful Simon Vouet *Death of Sophonisba* is contrasted with the Nicolas Regnier of the same subject.

The Documenta exhibition is a highly inflected contrast of highs and lows, so the effect of the exhibition is more greatly exhilarating than would appear in terms of its habitually heavy double catalogue. The incontestable *hors de concours* figure is Anselm Kiefer; Georg Baselitz makes a strong showing; and A. R. Penck is extraordinarily believable, too. Perhaps more nettlesome, though impressive for sure, is Robert Longo's relief of the *Battle of the Business Men.* Surprisingly, Barbara Kruger's phrases still make a strong showing, a last credible word-and-photographic artist in the gasps of the conceptual débâcle. Hans Haacke's compelling social documentation of Dr. Ludwig, the great collector of modern art, and the growth of his chocolate millions stands inculpated by the very same system he decries. At the lower right-hand corner of each sheet there is a copyright circle. Salle's work was sabotaged by an indifferent hanging, though the worst of the many assaults on the Americans—we all sensed a powerful doctrinaire anti-American stance—was borne by all the artists overwhelmed by Jonathan Borofsky's five giant hammerers in the Neue Galerie. Inside, huge marbles of France and Spain could not be removed, so large were they, making it seem as if Borofsky's shadow-play giants were in the process of forging these academic pieces. True, but they overwhelmed all the paintings on the walls about them, too. One felt that he had been "set up" by the exhibition's directors. Perhaps not.

Dinner with Ileana/Antonio/Nina Sundell after a confusion worthy of Feydeau about Madame Sonnabend's rooms. There were never quite enough— she had reserved several awaiting the Castelli party—because, it at last turned out, of the unannounced arrival of an extra Sonnabend, the Boston dealer of the same name (no relation). The confusion caused by his arrival was uncut Abbott and Costello: "Who's on first?"

At dinner a discussion of the new direction that art dealing is taking—in fact, a revival of the old. No longer, as in the Seventies or Sixties, will dealers so easily commit themselves to an artist regardless of what that artist may become; at least, that's my impression. Instead, in the degree feasible, the dealer will even seek purchase (if need be) only of a specific body of work, a body of work believed in. The other work may sink or swim within the artist's oeuvre. *L'Enseigne de Gersaint.*

We spoke of a certain kind of dealer who appears to be in competition with her artists. Nina noted that the competitive dealer's model is hardly the mother—no artist can bear the dealer/mother, but, in a funny way, the nanny (if even a frightfully fashionable one). Antonio, ever tonic, picked up the thread and

spoke of artists delighted by dealers who treated them indifferently but who seemed nice and unthreatening, if even falsely comforting, but who were not in competition with them: nannies.

19 June 1982

One last memory: *fou rire* with Ileana as we walked up from the Orangerie back to the Fredericianum in the center of town where the main exhibition is installed. The path, really a succession of staircases, was a bit difficult for Ileana to negotiate. "Perhaps there is a sign that points to a real path with no stairs. What does that sign say?"
—"Fick deine Oma."

13 March 1982

Animated lunch at Da Silvano with Ileana, Antonio, John Neff, and Christos Joachimides and Norman Rosenthal, the latter two curators who had pulled together the off-shifting and rerouting "New Spirit" show at the Royal Academy in London. They are now preparing a follow-up exhibition for Berlin to be called Zeitgeist. Fascinating young men. Joachimides is Greek, educated in an English school and now based in Berlin. Rosenthal comes of Bratislava forebears. His awareness of art history is noteworthy. As its secretary of exhibitions he has organized the current Caravaggio show for the Royal Academy as well as the Murillo show for the Prado. Despite their connections to past art they are formidable eclectic antennae of the new. Joachimides is all appetite and volubility marked by a grand girth; a kind of Peter Ustinov. Norman is leaner and smaller with a kind of embryonic charm to his expression. They make a fearful, brilliant team.

5 October 1982

The first consciousness of style is expressed as vaulting ambition, an o'erarching desire to be different—that is, to be new, as new as possible from an immediately preceding avant-garde. This process occurs no matter, even in the face of a recognition of possibly dubious social, moral, or ethical values, though after the sense of novelty has been shed this process may be perceived as highly moral, ethical, and therapeutic.

Style is at first perceived as art; then it is demoted to just style; then further demoted to oblivion whence it is rediscovered through processes of historical revisionism whereby style is resusitated as a function of advanced taste; whence it moves up again to the condition of style; whence once more it is perceived as art. So art begins as style. You don't have to explain to me how easily such a scheme

fits into market consciousness and the commodification of art, especialy today. Think of it, two styles—style as art and "just style." The term "advanced taste" signifies the union of urbane perquisites and Dandy Capitalism—so too is "historical revisionism," a pastime of privilege.

12 October 1982

Berlin: the recording of the name excites me, yet first impressions of the place suggest the city strikes a provincial note. Traveled here for Zeitgeist. The flight singularly uninteresting save for sheer numbers of tots, a regular children's crusade. Staying at the Bristol-Kempinski. The room put aside for me looked out over the old synagogue—pieced together from the remnants of the medieval synagogue. Just too difficult. I chose another that looked over Kurfürstendamm.

To the National Museum housed in a Mies building. A show of late Sixties, early Seventies "material" sculpture. If there is anything that has dated, it is the post-minimal distribution sculpture stuff—though for certain there are other kinds of masterpieces in the museum, the Beckmann *Siesta,* say, or certain charming Nazarene works. So much modern art was sold off as "degenerate" during the Hitler period, or destroyed, that the modern re-collections give a sparse impression.

David Salle thinks of the megalomania of the current crop of younger German artists (a function of the nurturing of a propensity for Wagnerian myth) as being quite beyond the merely outrageous and demanding petty myth-making of the current artists generally. He sees a real difference in intensity between them and the painters of the Pax Americana, of the Triumph of American Painting; he sees them as proponents of Tomorrow the Art World. Perhaps. I see the situation more as a marketing problem: a constrained number of artists handled by even fewer international dealers; and when the style has passed the work will be as dim as any post-minimalist proposition, that is, until the style is rediscovered. Even at the National Museum a lot of wretched Fifties art was beginning to look good again.

In the afternoon/evening things picked up. To Zeitgeist office and managed a visitor's one-shot pass to the exhibition in process of installation, easily the best contemporary art show I've ever seen, though disputations throughout. Somehow Norman and Christos managed to communicate their enthusiasm for the new work to the invited artists and most exceeded themselves. Those that didn't fell behind and looked weak. Much work was up though lots remained to be installed. The refurbishment of the old Kunstgewerbe Museum, now the Martin-Gropius-Bau (the architect-uncle of the famous Gropius), is far from complete, but it is a magnificent eclectic shell. Terra-cotta ornamentation, open Renaissance courtyard, and a glassed-in atrium draped in the exquisite folds of a napkin *baldacchino.* The fragmentary character of the site adds immensely not

only to the show but to the meaning of the mythical ambitions of the new art, especially the German. It seems that Immendorff comes from Fassbinder; Kiefer from Syberberg.

A first installation glance: the Marcus Lüpertz bronze variant of Rodin's Walking Man is an expressive Cubism; David Salle's double canvases, his finest; Immendorff, Chia, Cucchi are all beautiful. Baselitz, Schnabel, Kiefer not fully installed yet. Stella looked first-rate though his is the only abstract work in the show.

In the center of the court an immense mound of mud and clay of Joseph Beuys refers back to a 1948 nude female torso he worked on as an art student. The cracked clay of this piece, clotted on a warped armature with its old modeling stand, is there beside the mound. Beuys had saved everything. Regarding Beuys' long run of bad art—to have once been genial confers the patent always.

Michael Werner, the most côté dealer, notes that he doesn't like the silhouetted shadow cast by the Borofsky cut-out placed behind the glass ceiling, regarding it as "inaesthetic" and distracting from the Renaissance-like character of the two floors of work placed about the atrium. I referred to the silhouette as "revanchiste" for the Beuys megalo-mud gesture. Then again, one doesn't really even pay attention to the Beuys because of the scale of the setting though, of course, Beuys's work sanctions the new generation. In truth, Borofsky is a lucky late-Sixties Bostonian who keyed into the style shift and nowhere near the significance of the artists he is now shown with at Documenta or here at Zeitgeist, at least not by my reckoning.

The exhibition space is located at the edge of the Berlin Wall. The Museum had been heavily bombed during the Second World War so that the outside statuary, what is left of it, prefigures the temper of much of what is within— especially the work of Lüpertz. Further destruction ensued with some ill-considered underfunded urban renewal moves in the 1950s. A neglected outside placard chillingly announces that on this site once stood the torture chambers of the Gestapo. The graffitied wall was not so high that one could not see the temple portico of the old Prussian Academy on the other side. On our side of the wall Borofsky added his emblem to the graffiti, the running figure. In his exhibition space on the second floor a sculptured figure literally vaults from a window—but in the wrong direction—as it appears to be diving into the Eastern Zone.

The experience of seeing the installations incomplete, of the hanging itself, of David's fine pieces, of congratulating Norman and Christos, of meeting the sinister, leather-trousered, shorn-headed, earringed Lüpertz and Immendorff, add to the stimulation of the scene.

The German artists elaborate a ready-at-hand mythology inculcated since childhood, adding to it an expressionist scale and turbulent paint-handling fed by two sources. The scale is that of New York School action painting; the brushwork, and much of the imagery, that of Die Brücke. All this is magnified by the necessities of the allocated wall space. Most artists attempted to meet the 13-

feet-high-plus area, a size suggested by the organizers. What is peculiarly sad is that there is no New York institution that would undertake so formidable an exhibition. Only the Whitney, MoMA, or the Met could do it and their failures of nerve and information are coupled by a faint-hearted, wrong-headed, and uninformed curatorial staff caught up by petty problems of day-to-day procedure. Not to say that Christos and Norman aren't—but the situation they work in allows for a ruthlessness and a recklessness that their natural gifts answer.

Then again, while Europeans undertake the exhibitions of such scope, drawing thousands of visitors over months of hanging, their gallery life is scant and undernourished whereas we enjoy an active gallery life of fast change and repeated visits. So a certain balance is kept; indeed, taking into consideration marketplace factors, the balance still drifts in our favor.

I note that Immendorff comes from Fassbinder; Kiefer from Syberberg. David Salle, by contrast, implies an enormous iconography if not mythology through referential bits and pieces, snatches of motifs and visual quotations of all sorts. Yet his intention is to deny and cancel the very imputation of these hints and that's what all the cancellation, superimposition is about. He aims, for all its representationalism, at a kind of new figurative abstraction. Deracinated Iconography.

12 October 1982

Antonio's 43rd birthday passed simply, if being in Berlin can be said in itself to be a simple detail. It is not for me, certainly not with mother's 80th birthday hard upon me and the hotel being but a few blocks from the Wittenbergplatz or the Charlottenburg.

Berlin is better looking at night under neon and illuminated by plastic publicity signs. It is after all nearly totally a city created in the 1950s and all that that means in terms of the new urban design. I admit to a certain camp appreciation, even of that. Since it rains all the time the streets shimmer by night.

Down to Zeitgeist again. Julian's things were now being hung and one was amazed to see them in a room the dimensions of which actually greeted the scale of the vast plate paintings and those rare works about which I've withheld appreciation (that odd self-portrait-like Aorta picture) rise in my esteem in this beautiful room. *The Sea* with its charred log seems exquisite and refined in the space. So there is that gratification. David Salle and Julian Schnabel are certainly up there. Chia and Cucchi look equally strong. Clemente disappointed a trifle, Paladino, a great deal. Baselitz here took preeminence in the way that Kiefer did at Documenta. There's one Kiefer here that's of considerable interest, a memorial to an unknown artist. An interior made of a painted woodblock suggesting Speer and the Haus der Kunst was noteworthy. The second work containing three burnt planks (Nurenberg?) had been shown at Documenta.

Lunch: funny puns at the Kempinski Grill. Of a celebrated critic, Ileana says, "Let's use the word, a witch, who prophesies."
—"A Sibyl," I say, "but wrong."
—"An unSibyl witch," Antonio concludes.
So it was with us all day; light-hearted banter. After lunch to the restored Charlottenburg. The Egyptian collection with the disappointing painted plaster of Nefertete. Then across to the antique rooms, equally unprepossessing. Then to Charlottenburg itself. One had forgotten that on its waxed *faux marbre* and gold-leaf walls there hung *L'Enseigne de Gersaint* and a second version of the *Embarkation for the Isle of Cythera*. In the heart of bombed-out Berlin, the Wilhelmskirche—pseudo-German-Romanesque; Aachen is the source. It was built in 1894 to celebrate the Wilhelmine Succession. Cracked and fragmented mosaics owing to the Allied bombing of Berlin. San Vitale, this time—though both its mosaic and shape are the source for Aachen. In the academic Renaissance style of the late nineteenth century the mosaic works. The octagonal structure repeated for the steel frame modern counterpart to his horrendous reminder of the war. This heart of Germany is the most "post-modern" architectural unit I can think of.

David said an interesting thing. It is applicable to all of a certain type: "She found meaning, there had to be a meaning, in her being there, anywhere really, with someone else, anyone else."

13 October 1982

This morning to East Berlin with the Manilows. Louis is on the advisory council of the USIS—a bureau of which is open in East Berlin—which meant that he could arrange for a van for all of us. Antonio, holding a Portuguese passport, could not come this way that so eased border formalities, nor could Attilio Codognato who arrived last night from Venice. Perhaps Zeitgeist will go on to Palazzo Grassi.

The experience in part beautiful—the Shinkel Pergamon part—but, in the main, the Eastern Zone is chilling. The sun/rain formula worked well in the Shinkel-Insel with its astonishing palaces out to the very edge of the rivers. The Russians grabbed this grand historical part of Berlin running from the Brandenburg Gate down the Unter den Linden past the superb twin churches of Shinkel, one advanced in renovation, the other still dilapidated and burned out since the war. Full trees have now rooted in the roofs below the dome. The Shinkel complex is connected by a temple structure mounted by a Nike driving a chariot led by griffins. The Pergamon Museum, incorporating the East Asian, Iranian, and Islamic holdings, is newly restored and beautiful—though, of course, the glass ceiling is already dirty, the lamp glasses broken; walls begin to crack and bulbs have burned out. One knows it will rapidly deteriorate, just slip away, but

what a group of superb stones. The Gigantomachy is beautiful beyond dreaming with passages to take one's breath away.

During lunch with a correct USIS official (at the Zillestube, named after the popular illustrator) at one of the 1950s anywhere ferro-concrete hotels built on the already-dated showplace boulevard, one grasps the horizonlessness of the Eastern Sector. To see the West on television, the Western tourists, to have open exchanges across the border, but to be locked in is an oppression. The contrast here, where appearances are kept up, so far as they can be, is instantly perceived. Even Red border guards occasionally shoot one another, run to freedom, are tried by the West and receive light judgments. All this showplace banality is jammed with people. Salaries are paid and, in principle, all social needs are met. So the East Berlin "bourgeoisie," if one may use this term for an idealized proletariat, spend their money here. Our waiter (a twin to Jean-Patrice Marandel), after luncheon service, sadly ground an old crank organ by way of entertainment. Showcase youth as Shubert's *Der Leierman*.

As Zeitgeist concludes, its installation becomes, despite all excellence, less exciting. The working disorder disguised the weakness of so many (especially the "even younger" Germans) so that the strengths of the strong become that much more marked as did the weaknesses, even of the well-known, especially Sigmar Polke. Baselitz is the lion of this exhibition just as Kiefer had been at Documenta.

Antonio and I envision follow-up exhibitions for Zeitgeist: Weltschmerz, then Lebensraum. And for the next, Wanderlust. The final exhibition will be called Blitzkrieg.

Attilio is anguished. Should he arrange to take the exhibition to the Palazzo Grassi and how, under what terms, expectations? *Succès d'estime* or *succès de scandale?* The public there in Venice—blasé, uninformed—will dislike it under any circumstances, so why bother to prune away the unimportant material? Then, too, the pruning means a whole new exhibition.

15 October 1982

In the afternoon in the rain to the museum in Dahlem. Astounding. A hoard of Italian painting and sculpture, Rembrandt, early Netherlandish masters, not to speak of ethnographic treasures, so rich that one could hardly breathe, believe, or speak: Raphael, Piero, an Alberti portrait in bronze.

What has been fun these days apart from the fantasy of wealth occasioned by the hotel, the grill, the lunches and dinners, the infusions in the lobby, the taxis and all the smart people of Vanity Fair, what has been fun beyond all of that, has been the mangling and punning, all the polyglot little jokes (and they are little) we've all made.

Writing in bed, nearly three a.m. The opening went well despite the heavy rain. Most interesting was a long late conversation with Frank Stella, Barbara

Jakobson, Donald Sultan. When at last tired of Frank's arrogance, his inability to see anything good in any of the young artists, I defended Schnabel, Salle, Baselitz (hardly "young"), and the others. Frank believes the ultimate meaning of art is in its quiddity, in its sheerly self-evident excellence, its seriousness of purpose and sense of continuity with history—which he thinks is threatened "by all this."

For me Frank's defense seems just so much self-service. Sincerity is ultimately invisible and, as for the rest, on that level there can only be the matter of neurological stimuli, responses to which, if organized, can only be a continually changing set of conceptions ultimately called style. It is hard to imagine, well, for Frank to imagine, that we are in a moment when historical style itself is a proper art problem, the way flatness once was, or frontality for formalist painting, or definition was for conceptual art. As soon as the container changes we will lose that sense of fresh possibility and this style, whatever it is, new figuration, say, will be over.

At length Stella softened his stand, though he still felt the congestion in Schnabel's painting revealed too little a sense of space—but then he makes reliefs—and even he began to acknowledge a certain sympathy with the *envergure* of the younger artists. He questioned his presence at the exhibition and the American presence in the show, feeling the exhibition would not be especially different were they out. But are not Schnabel and Salle American? Or Borofsky, or Rothenberg? At one point Stella expostulated, "But Botticelli didn't think about style." Surely Botticelli was an artist obsessed with a stylistic late Gothic revival. His work explicitly turns its back on the logical unfolding of space in fifteenth-century painting in Florence. He is all about "style."

The Sandro Chia sculpture interests me as commentary on a kind of Italianism from the 1930s. In Chia's painting, perhaps, Pascin seems apposite. The sculpture is less neo-Gio Ponti, more neo-Richard Ginori.

10 October 1982

Visiting the Mary Boone Gallery. Julian Schnabel has been painting there for a month now by way of opening the season. All mystery and exigency. The exhibition reflects all the pent-up anxieties attendant upon "the second novel." Since Julian had a family obligation in Boston that day, he left word that I might visit. I found the installation in the spattered all-white gallery—even the floor— a sensation. Like all romantic effort the exhibition needs pruning. When the works work, when Julian is painting at the height of his powers, the works are glacially perfect; conversely, depths are abysmal. Things will sort themselves out quickly though. Schnabel remains one of the very few interesting painters I know. And the heights are there.

The Raft is a huge plate painting, crockery silvered over to represent the shimmer of water. A cast bronze Christmas tree (and how complex was the gating for that pour?) stands as proportionately high off the surface as Duchamp's

bottle cleaner from the background of his *Tu'm*. *The Raft* echoes with the violence of Géricault, as well as its realism, and the independent American-mindedness of Twain—Life on the Mississippi. Its single bronze tree invokes the three Christmas trees of Beuys's incarcerated Russian winters—as seen in *Snowfall*, the great work preserved in Basel.

The other relief painting is an untitled altar—a huge antlered bronze cross manacled to a painted backdrop. The work is too carbuncled. The imagery, such as it is, is indecipherable—intensifying the Carolingian book cover-like character of the work. Religious intention it has—what with a triptych-like composition and altarpiece organization. This is the part of Schnabel that exalts Michael Tracy: Schnabel as decorator. But sincerity is invisible.

Apart from these works, Schnabel is attempting a kind of fever-dream painting of liberated unself-consciousness, dredging paint and image together. By moments he attempts to keep color fresh (often unsuccessfully), as fresh as his desire to ride out his heated jet of inspiration. Colors go murky owing to frenzied revision—painting under fire—painting hovering just at the edge of respectability. It is a kind of dizzying aerial gymnastic, not so much as without a net below as wanting the very wire above—though this thread may be the disguised untrammeled verge-imagery itself.

16 July 1982

We had gone to the Trans Avanguardia exhibition at the Porta Metronia, a difficult-to-reach Roman arched wall. Between the arches makeshift cubicles of cloth and iron piping had been set up. They were all in a terrible state, having suffered from the inclemency of the Roman summer—violent rains and storms countered by extreme midday heat. They say that in Sicily water is available for only one and a half hours a day. Achille Bonito Oliva's Trans Avanguardia is essentially a promo for his Electa book of the same title. The LeWitts have cracked in the heat and it seems that the antlers have been dislodged from the Schnabel loaned by the Ludwig collection. Sperone, whom we saw in his quarters (ex cardinal e principe Albani) near San Carlo alla Quattro Fontana, had already withdrawn a Chia damaged by the violent temperature changes. Sperone also showed us new Chia and Paladino.

The difficulty of Rome as an art scene despite its importance as a capital is the smallness of its edges. Perhaps one work in ten, if even that, will enter Roman collections so that the larger body of recent important art would move into the world through American, German, and English dealers. That means the hegemony will be seen (when it is at last seen) as a patrimony outside of the country. Then the die-hard indurated pseudo-socialists will claim, "You see, American dollars have stripped us of our national heritage." Like what the French say of Cézanne, as so many of them are outside France: "Capitalism has robbed us."

The truth is, these pseudo-socialists never cared for nor wanted this work when it was new. They neglected it in the name of "Great Art," or "The People," or "Culture." "You like this Clemente, this Cucchi, this Paladino? Why, they can't even paint," is what one heard throughout Rome insofar as one had conversations about contemporary Italian art with purportedly informed people. As for the others, still more pseudo-romantic "risorgimimetic" art will do. But when at last the Italian artists are seen for what they are, as late De Chirico is now understood, or Savinio, or crazy late de Pisis, then will they crow, "We have been robbed by the capitalists." Such are the duplicitous demagogics of the pseudo-radicals.

23

Entries: Cutting Edges

10 February 1979

A slide talk on his remarkable sculpture by Richard Fleischner—who might pass for William Wegman's twin—the young site sculptor working in Rhode Island: the talk held at the Max Protetch Gallery. (Paula Cooper began this extra-artistic gallery function; she has for several years opened her space to dance and music. All that seems more natural in Soho than uptown. In Soho dance and music are more immediately grasped as somehow being part of the dialogue between painting and sculpture. Soho has had for years flourishing performance art centers such as the Kitchen, not to mention other less well-known alternative spaces.)

Fleischner clearly is a key figure in a school of sculptors including, say, Alice Aycock, Alice Adams, Mary Miss, George Trakas, Jackie Ferrara, not to mention figures working in the Midwest whom they may not know, say, Michael Hall or Ed Levine. Behind much of this work stands Robert Irwin and the heroic figure of Robert Smithson as well—the latter even more legendary for an untimely death. Oddly, there was no mention of Robert Morris—we were eating hamburgers after Fleischner's lecture—though he is part of this, too—and Michael Heizer was rejected as being a one-shot artist (untrue). There are many differences, of course, and, as a group, they are hardly cohesive. I wish, for example, that Fleischner thought less in "plan," more in "elevation." Or, at present, a certain "literary" excess in Aycock's work is off-putting. But for all that, these "constructionists" represent the cutting edge of the art of the late Seventies; they are its most seriously progressive group, the one least marked by petty M.F.A. amalgams, the least soft-centered trend. (Mel Bochner, it is reported, has had, as always, a last word on this "cutting edge": as once he coined the term "joke art" for certain aspects of the Conceptual movement, he is, I am told, speaking of the work of this group as "house art.")

24 February 1979

...Last night at the Kitchen: Eleanor Antin as Eleanora Antinova. Imagine an artistic Bronx girl come of age in the 1950s. She read Romola Nijinsky's

biography of her great husband and Karsavina's *Theater Street*. She is drawn to the arts and to the myth of modernism—Stravinsky, Diaghilev, the première of *Le Sacre du printemps*. All this, were it not enough, is later compounded by the provocations of the Feminist Movement (in which she plays a central role) and the Conceptual Movement (equally central—the *One Hundred Boots,* for example), not to mention the permutations possible to Feminism and Conceptualism combined. One begins to grasp the drift of Eleanor Antin's awkwardly strong balletic play *Before the Revolution.* In it she fully answers the need for a fervent honesty and integrity, purging, as it were, the already duplicitous overgrowths of a co-opted Feminist Movement. There are girlhood clues: cut-out dolls are now used to signify historical characters, the cut-outs' paper tabs replaced by literal clothespins to hold the wooden template garments to the stage figures.

All this and more is backcloth to Antin's essentially literary frame of mind; she is, after all, developing a complex performance as she did before in *The Angel of Mercy,* a play based on the life of Florence Nightingale (with a brilliant photographic analogue stylistically derived from the work of the great Victorian photographers, Roger Fenton, Hill and Adamson, Julia Margaret Cameron, etc.)

In *Before the Revolution* Antinova is made out to be a black dancer. At one point in the course of the play she addresses the audience commenting on her interlocutor's—Serge Diaghilev—so-called "dilettantism." Antinova recites the now-familiar litany of Diaghilev's great discoveries to countermand the charge: Nijinsky, Stravinsky, Karsavina, Bakst, Grigoriev, Pavlova, introducing into the list her own name. For an instant I was perplexed and, returning home, I checked the index in Grigoriev just to make sure that Antin's black Ballerina Assoluta had never really existed.

There are really many problems. As a playwright Antin is not good enough; as a performer not bad enough. There is a kind of amateurishness necessary to the success of the conceptual performance, necessary to bring it off with any flair or style. Antin's ambitious love of it all has the effect of demoting her work to a kind of embarrassing enthusiasm. Generally, the conceptual performance succeeds only when it is truly awful, for in that way the artist is disguised, covers his or her tracks. The truly awful in this kind of performance permits the artist to be taken seriously in a way that competency does not. Ironically, when the artist is obviously good and when the ambitions are obviously elevated (as they are in this instance), the conceptual performance fails.

3 March 1979

To the Dia Foundation underwriting of Robert Whitman's *Palisade* at the Hudson River Museum—hired buses through driving rain pass the slums of Yonkers. The performance trivial in the extreme, hence "just right." The sensibility was still that of Black Mountain, or Rauschenberg, of Abstract

Expressionism. A dark atrium was hung with a scrim that rose and lowered at expressive intervals. These gauzy screens had all manner of film, photographic slide, shadow and light, mirror-deflected beams projected on them. The images were largely those of floral close-ups, of roses and chrysanthemums. The "cast," like Noh players clearing the sets, hung about, not really aimlessly but in that mindless disaffected way deemed necessary to such performance—casting shadows, deploying gauzy swathes of cloth upon appropriately located lines to catch image and light.

Certain movements were striking, as when the balcony festoons were raised, partially obstructing the viewers' sight lines and then dropped back down again; or when the floor cloth (the painter's drop cloth?) was raised to the roof for illumination from below. The metaphor was sentimental and watery and, for all its liquidity and technology, the Merzbild cum Merzbau, i.e., the environmental collage, was its source.

3 March 1979

... A good idea that went awry, that of a "private symposium" comprising a broad swath of Photographic Conceptualists. It was probably organized for Morton Neumann, sweet selectively deaf dean of Chicago collectors, now in his seventies. Anyway, he was there. It was held in Roger Welch's large loft at Houston and the Bowery, with a big turnout, around two hundred, I guess, beer in the fridge for all. Seated at the long table were Mac Adams, Bill Beckley, Peter Hutchinson, Vito Acconci, Dennis Oppenheim, William Wegman, and Welch himself. (In a way, the grouping signaled a high point in the too-little appreciated careers of John and Susan Gibson. In an important way, they have given the last fifteen years to promoting this perhaps at present blunted edge of the vanguard. I wondered whether the assembly did not represent a certain desire to firm up what might be considered the slipping toe-hold of the photographic conceptualist movement in the current scene.)

The evening progressed; each of the artists spoke about the development of his work with Acconci making perhaps the most dramatic recitation. Welch seems to have most tellingly attached his conceptual ambitions with important social consideration, especially geriatric memory reconstruction. Beckley's ironic commentaries remain very striking. Oppenheim once more aggravated the ambiguous niche he occupies; is he really a megalo-genius or does he just seem that way—and, in the end, is there a difference? William Wegman read a funny autobiographical statement recalling the style of Jean Arp's Dada souvenirs. And I like Adams and Hutchinson both, the one for his evolution from photograph to the environmental display, the other for the scholarly lucidity of his enterprises. Unfortunately, the pleasant Richard Lorber as moderator didn't squelch a philistine—"I mean, what kind of elitist audience are you aiming at?—that kind of pushy audience member. The artists gave his hostile question serious

the creation of culture

consideration and then disliked themselves for doing so, growing sullen and embarrassed. A moment later, they unwittingly transposed their frustration onto Colette who, from the audience, noted that she did "store and window art to reach a wider public," but felt that the art community looked down at her for doing so. Her feelings were justified, but her complaint was unexamined; the dumb prig they answered.

10 March 1979

...An artist/critic colloquy organized by Donald Kuspit at the School of Visual Arts...the audience jammed to overflow in the school's black-walled auditorium. The panel members were Lucio Pozzi, Hilton Kramer, Donald Kuspit, Alex Katz, Alice Aycock, and Irving Sandler....The role of the critics came off pretty well: Aycock likes critics to tell her something about her work that she hadn't recognized.

Pozzi (by far the most profound if impractical): "Artists and critics are equal partners in the creation of culture"; and again, "When critical criteria are normative they foreclose options."

Katz: "Criticism is required reading," and, earlier on, "When your style changes, you have to change a lot of friends or you have to change back your style."

Hilton Kramer, implacably reasonable as always, spoke with unusual frankness of his loss of friendship with David Smith; as the latter waxed rich and famous, he came, as Hilton sees it, to regard human exchanges as a form of commercial barter. Kramer recalled his sense of affront when, late in his career, Smith asked him his fee after they had spent a day drinking together editing a statement Smith was writing for an exhibition catalogue. An overwrought student blurted from the floor, "Smear someone living," but the student was quite wrong in his take. If, in fact, Smith came to view his friendships as professional exchanges, then surely he was correct to offer a fee for what was in his eyes an afternoon's labor—despite Hilton's view of the matter, or the student's ejaculation. But I don't mean to be dense: of course Hilton's point was that he saw the editing not as a "job" but as an act of friendship.

...Siah Armajani's brilliant "reading rooms" opened at the Max Protetch Gallery. The gallery was jammed—had the public so quickly heard of the success of Fleischner's talk?—for Armajani's impassioned philosophical "explanation" of his work....Warming to his subject Armajani struck one, after a moment, as a muezzin calling the Jeffersonians to prayer. On one hand, the presentation was helpful and exciting; on the other, a bit ex post facto. Three important ideas of Siah's: place is identified by structure—a bridge, say, fording a river identifies by its sheer location the place where it was erected. "Neighborliness"—one thing just next to another seemingly without rhyme or reason, taste or premeditation.

The last idea: a man must have a house in order to be free. I begin to be troubled by the conflation of gallery and classroom.

Michael Hall and I talked of this at lunch yesterday. He thinks of pulling together a piece?, a catalogue?, a book?, an exhibition?, on the group he is calling the "Suprastructionists." I had been calling the style of the group he had in mind "Site-Specific Constructivism" and/or "Constructionism." It is already clear, though the general public might not have heard of Aycock, Trakas, Hall, Armajani, Ferrara, Fleischner, Adams, maybe even Tom Doyle, the artists surely are beginning to cool toward one another—I mean in stylistic terms. If individuation is not yet in full sway, then it is surely in the air.

...A good idea: the "Site-Specific Constructivists" require a metaphor, a sign system for the works to work:

Aycock: the medieval town
Hall: the Midwestern farm
Armajani: the Jeffersonian enlightenment
Stackhouse: the Amerind
Fleischner: New England Perfectionism
Doyle: the Union blue battlefield.

This stylistic nicety sparked by Hall looking at the depicted architecture in Poussin's paintings—not so much as architecture per se, but more as a range of signs invoking a lost classicism and the idea of the antique. It may even be that those sculptors in the new tendency whose work does not clearly reveal such metaphors may, in fact, be party to a different constructivist impulse, the "purer" ones maintaining the Minimalist legacy drawing upon the architectural models of Malevich.

11 March 1979

...With regard to the Site Specific problem: the metaphor or sign system is necessary (perhaps?), but what of the sculptors who betray none? Peter Berg perhaps, unless his metaphor is, in the end, that of the white-black squares of Malevich and Russian Constructivism generally. Jackie Ferrara, too, is caught here: what is her metaphor?—colonial domestic architecture—the Parson Capen hearth; or is it Carl Andre; or is it Meso-American stepped pyramids?

Yesterday a long drive with Peter Berg to the Williams College Museum where another version of his important installation at the Bertha Urdang Gallery (November 1977) was restretched across a circular vestibule below the museum's dome. The space was seemingly divided in half by a square punctured "windowed" wall. In fact, this wall was a narrow corridor, blocked by the "window" that in the new axis of the corridor was seen to be a cube. Thus, to negotiate the corridor, one had to either crawl below the cube or climb above it; in all, a difficult piece of negotiation owing to the narrowness of the channel. The "corridor" connected two wings of the museum.

22 March 1979

...Last night yet another panel, this one held at the refurbished Great Hall at Cooper Union. Donald Kuspit was burned during the course of the exchange, not because of what he was saying, which was just, but because of the inability of the general public to grasp his reasoned arguments, especially when couched in his professorial manner. The panel was there to discuss "Formalism." Our distance from the Sixties and early Seventies (when considerations of formalism were riveting) was marked by a succession of jejune questions from the Cooper Union Art School students.

—"What is this thing Formalism anyway?" Worse yet.

—"Who is this guy Greenberg you're all talking about?" If, after a decade, the kids simply don't know, why bother? During the course of the evening this in a nutshell was the course steered by Brian O'Doherty and Douglas Davis—a tack categorized as "nihilistic" by Kuspit. Douglas Davis asked a suite of questions obviously not covered by formalist values, rather as if they had never been posited before: What has Formalism to say about personality and biography? time as linear progression versus synchronicity? the experience of nature? the historical past as context? and so on.

Rudolf Baranik made a strong case regarding Formalist consciousness as a fundamental constituent of all art. This argument came from an historically informed sensibility. Cognizant that during Greenberg's sway Formalism had been equated with elitism, Baranik also dumped on Greenberg. That Greenberg's Formalism was "deterministic" (as Baranik asserted) is untrue as was O'Doherty's off the cuff opening remark that Greenberg's Formalism was "predictive." That artists grafted determinism onto Greenberg's argument or extrapolated predictability into its workings was not the author's failure, but that of the artists. And in so doing, it was they, not the critic, who were being predictive or deterministic. Their despair following the collapse of Formalist painting during recent years cannot be attributed to failures of the critic but to inadequacies of the artists. Greenberg, in determining the salient formal properties that mattered to him, had simply set up a smaller diagnostic profile than usual within the broad range of formalist possibilities (of which the broadest and truest was the one that Baranik and Kuspit insisted on, namely its character of rigorous self-examination). Any fool can see that to merely make a work that checks out against a master list of constituent visual or tactile properties can hardly guarantee the fabrication of important art or any kind of art really; and Greenberg would have been the first to say so. The most negligible of the artists we associate with Formalist art are precisely those who reduced Greenberg's observations into mere guidelines.

Kuspit and Baranik insisted on Formalism's continuous validity precisely in the degree that it continues to be preoccupied with a self-examining character, the auto-reflexive nature of art making. Unfortunately, those speakers were

preceded by Mimi Schapiro who trivialized and re-routed the argument toward a self-serving description of her recent work based on fan imagery. Discomfited by the inane avenue Schapiro brought to the discussion, Kuspit felt constrained to characterize it as such, noting among other things that fans were used not only in the negative sexist terms Schapiro correctly wants us to be aware of, but that fans were used to keep one cool as well. (I might add that from the 17th century on, fans had been used by men in the West as well as in the Orient in precisely the ambiguous terms of elegance and coquetry that were imposed by the patriarchal cultural values Schapiro rightly abhors.) What happened, of course, is that Kuspit's sound discussion was taken to be yet once more a patriarchal put-down by the volatile Feminists (both male and female) in the audience, especially as Kuspit's manner is aloof, and Schapiro is a major figure in the political evolution of Feminist consciousness in the arts. Dore Ashton also spoke nicely insofar as she quoted Blake and fortuitously Mies van der Rohe—but there was something perfunctory in her presentation that made one suspect that she could pull out Blake (if not Mies) no matter what the subject at hand. Kate Linker made for a Mannerist wraith of a moderator, beginning well—but the floor ran away from her.

3 April 1979

To Gary Stephan's West Canal Street studio. He showed me two dark paintings. I hadn't enjoyed painting, straight painting so much, in a long time. The format is generally that of a wideish rectangle, taller than the painter himself, or me for that matter; the image was dark and painstakingly brushed. The slightly mannered building of acrylic crust at the shape's edge, so characteristic of Stephan's recent work, is less marked in these new pictures. In a raking light the acrylic impasto made an almost x-ray effect, one the artist claims is permanent owing to the stability of the acrylic molecule. The image is strongly anthropomorphic—a kind of tallish "torso" with thin "arms," headless and legless, fills the rectangle almost to the edge. The darkest of the paintings and for me the most beautiful was the purplish-brown *Two Brothers*

8 April 1979

[I saw the "lighter" paintings at Stephan's opening. I thought the anthropomorphic archetype damaging—especially the one that has a kind of sutured gash up the "body." The dark paintings are the unexpected progeny of Morris Louis' *Bronze Veils;* the light ones derive from early Dubuffet.]

After a time we played with moving the paintings about, and in doing so a curious possibility emerged: the inversion of the anthropomorphic archetype (the torso) equals the still-life archetype and vice versa. The still life = figure. By

contrast the landscape archetype possesses no such volatile relativity since its inversion invokes itself. Hence, the archetype is tautological as the inversion of landscape = landscape.

Stephan, a deftly verbal painter, spoke of his new color range. Previously his paintings explored a lighter, more "sensitive" palette, last year's "brights," so to speak, which Stephan views as functioning within an "official Christian" color range. His current "black" paintings—one might call them that—deal with the "unofficial" dark colors of Christianity, this year's "dusties," as it were. Seeing these paintings leads one to suspect that, as there is something like real sculpture again in the work of the "Constructionists," there might be something like real painting again. I don't mean what is currently being called "New Image Painting" with its private icon emblematically set in the scale and space of Abstract Expressionism. No, not that (though I do like Robert Moskowitz's paintings very much). I mean a straighter abstract painting like Stephan's dark work.

23 February 1979

To Arthur Cohen's Chelsea loft to look at the large pastel drawings. Joel Shapiro told me about them. He may have responded to them because in such a large part they deal, as Shapiro's drawings do, with lovingly labored surfaces of a kind that one now sees as forming an almost autonomous school. Strange bedfellows: Johns, Bochner, Shapiro, Benni Efrat, Serra, Harry Kramer, Ellen Phelan, Arthur Cohen, et al.—no commonality of stylistic interest save that of a reliance on highly sensitized yet messy drawing.

Cohen's drawings are abstraction locatable to the model of the invented ground plan seen from high. This view in plan reverses Cohen's illusionistic sources for an earlier interest; his prior painting addressed ambitious illusionistic views into Italian Baroque dome structures: ceiling views bypassing the heavy cornices of Borromini's San Giovanni in Laterano. From this skillful illusionism Cohen has suddenly emerged an adept abstractionist.

Certain pastels indicate the intermediary simplification, a flattening and simplifying of shape that earlier had aspired to a virtuoso trompe l'oeil. In simplifying the image of these drawings Cohen called to mind certain Rothkos of a landscape archetype, Rothkos of an upper and lower zone. This intuition as to source becomes all the more pointed since Cohen works his pastels horizontally, drawing on an architectural drafting table. Thus, Cohen's "vertical" drawings are comprised of two horizontals one pinned above the other, direct appendage, no intermediary stretchers, no conventionalized frame. Cohen gave himself to the sheer process of drawing, to the gummy correction and rectification, to the stomp and drag of the kneaded eraser; shadows of original indecisions cling there, cleaned up as best they could be, so that in the end what does remain as the image might be described as a drawing of the least contradictory evidence. And it is very

good. A few racing architectural *aides-mémoires* remain—circumferences spinning behind one another—the last overlap is the final remaining illusionistic clue, one that now suggests the patterns of a child's electric train tracks, say, or a toy racing car track. But for all this, these strongly circular designs—Giotto's circle perfected, as it were, through the dogged practice of drawing the thing through making it. Drawing it as sculptor would draw it—though Cohen is not a sculptor—still invokes Cohen's earlier affection for Baroque architectural motif—the cartouche, the oeil-de-boeuf aperture typical of the Roman Baroque.

Mel and Dorothea: Rehearsing One's Coolness

I am not a writer. True, like many adolescents I went through a heady poet phase, but my pretentious high-school invocations of Eliot and e e cummings now only embarrass me. A real writer's gift for sustained dialogue I have not. Nor can I invent a plot line to save myself. But, for all that, I have been privileged to enjoy a professional and personal association with many artists and critics who deeply marked the cultural life of our time; and, in the degree that I was able, granting my feeble literary gifts, and the contemporaneous demands of a taxing academic life, I tried to record those events and experiences that comprised the day-to-day, week-to-week fall-out of that privilege. Perhaps for no more noble a reason than that I simply did not want to lose sight of the fact that, after all, I had been party or privy to them. For, in forgetting our lives, we lose them twice over—in time spent and in time forgotten.

Still, I had promised myself that I would not use my journal as a means of self-justifying rationalizations; instead, I wanted it to be a place where I would honestly record my impressions—even were the notations to reflect poorly on me; on a certain level, that several of these notations have been published out of time, as it were, already may have cast me in an unflattering light—one I own up to. Perhaps even too readily. So it goes.

I have long been a reader of journals. Trained in art history, I perhaps place an inordinate importance in them, more than another person might, simply because it is in the journal that, by and large, the most honest delineation of all manner of historical subjects is most mordantly etched. Gide, Renard, the Goncourts, Bashkirtseff, Saint-Simon, David d'Angers, Delacroix, Eva Hesse, Landucci, and on and on. I suppose I prefer the journal as a form of scholarly record, even those in which one suspects that the writer was driven wall-eyed between the event and future readership. I even prefer the journal form to that of the personal letter. Letters are addressed to recipients. In being thus broadcast, they are pitched to conform to the writer's image of the recipient. The journal, by contrast, comprises epistles to oneself. One need not dress for such a reading. The danger, of course, is that the writer may have too inflated a sense of the

historical role of the journal, and so may adjust the record from the outset, attempting in this manner to place him or herself in an especially favored light, having done so by way of gaining an affirmative judgment from a thus-primed tribunal of subsequent generations. Yes, there is that pitfall. On my behalf, I can only affirm that I tried to elude this deformation. I call up in mock defense my very guileless tone of self-esteem. Whatever else, it testifies to a certain frankness; if one is really attempting to engage the reader's partiality, little can be more alienating than to be heedlessly smug.

One of the most telling features of American art criticism following the Second World War, criticism that today is called Formalist criticism, is (it is widely believed) its wholly disengaged tone; such art criticism, if it really exists, dons the Emperor's clothes of art history where prevails the fairy tale of disinterested scholarship. The Formalist critic pretends that the art he or she writes about exists in a vacuum, was indeed even created in that refrigerated limbo; and this polite deception continues. But even the ubiquitousness of this view in Formalist criticism cannot gloss an inescapable truth: that the writing about art is as subject to personal and external pressures as is in fact the making of art.

But I have noted this many times and in many places, so that there is no need to begin these valedictory entries concerning Mel Bochner and Dorothea Rockburne with what must pass from the very outset as a formula of exculpation. That I would not have.

Let me introduce them as they are first met in Bernice Rose's *Drawing Now* catalogue for the Museum of Modern Art, 1976 (and as far as things go, these introductions are fairly warm):

DOROTHEA ROCKBURNE was born in 1934 in Verdun, Quebec, Canada. In 1956 she received a B.F.A. from Black Mountain College, N.C. She became an instructor of art history at the School of Visual Arts, New York, in 1970. In the same year she had her first one-woman show at Bykert Gallery, New York. In 1972 Rockburne was awarded a Guggenheim Fellowship. She became a U.S. citizen in 1974. She was induced in the Eight Contemporary Artists exhibition in 1974 at the Museum of Modern Art and has had numerous exhibitions both in Europe and the U.S. (p. 84)

MEL BOCHNER was born in 1940 in Pittsburgh, Pa. He received a B.F.A. from Carnegie Institute of Technology, Pittsburgh, where he was a student from 1958 to 1962. He graduated with a major in art and a minor in philosophy. In 1963 he was a philosophy major at Northwestern University, Evanston, Ill. In 1964 Bochner moved to New York, where he became friendly with Eva Hesse, Robert Smithson, Brice Marden, Sol LeWitt and Dorothea Rockburne. From 1965 to 1973 he taught at the

school of Visual Arts, New York. Bochner has written numerous articles on contemporary art. (p. 83)

By way of stark contrast, my entries record a far more personal, often intense interaction between two major artists, who, for several years, shared their personal lives as today they continue to share many aesthetic viewpoints. Their stature as artists is never in doubt, but their human qualities I came to see are as variable as the next man's or woman's, mine included. Of course, this is but a selection from far too many entries and references to be included in this piece. But I attach certain hopes to their publication: that a beautiful and influential style may be more fully illuminated by following the movements of two of its most genial practitioners; and to dispel to the general public interested in such matters any illusion regarding the art world, through reflections of its concomitant backbiting, jealousy, anxiety, disappointment, and endemic ingratitude. Mind you, I don't especially grieve over these human traits, the base to the most noble—one simply hopes that in the end the latter will prevail. I accept them philosophically as appertaining to all human enterprise, not just the feints and parries of the art world.

The publication of these entries, then, is cautionary. While debunking, if you will, the rather tedious mythical status that artists arrogate to themselves, indeed must, they reveal, for all that, the very basic human stress under which artists toil. In the end, of course, it is the art that remains (at least, that's how the sentimental pieties have it). Extraordinary, since art is an ultimately indigestible residue about which one can really say nothing valuable—nothing, that is, beyond the secretarial data germane to the machinery of information retrieval that historians have perfected as part and parcel of their trade—provenance, exhibition history, footnote references, publication data, etc. etc. But the art of art is utterly impervious of analysis.

What is sad in all this is not that these notes may record the alteration of friendship, even its loss—such affective histories are not particularly interesting in themselves—but that the period covered in these entries reflects a stylistic episode in American art now gone by, an episode fraught with wild hopes and sky-high optimism which, as of yet, has not come round again in the cyclic machinery of the times. But it will.

As regards the journal cuttings, many cuts have been made so as not to be fatiguing; while I may have been obsessed by the inspiring and genial connections that heated my subjects (sometime, early in the Seventies, I came almost to feel myself as "Bochner's Boswell"), the current reader, in all likelihood, will feel that my inadvertent record of these epic honings was in reality no more than a sharpening of aggravated differences without distinctions. The glaring two-year break between 1974 and 1976, say, is not one of diaristic abstinence but merely, in editorial terms, an act sparing the reader repetition

piled on repetition. A triple dot thus ... indicates their excision. After all, many things cannot yet be said publicly, if ever, either from our commonly shared sense of decorum or even from more practical considerations, such as the possibility of litigation. Attitudes of absolute certainty typical of the private journal are here modified to the status of "perhapses" and "may-haves." After all, though one feels sure of the motives of one's friends (or enemies too), such motives, for all that, remain attributed. In the end, one can never know why people behave the way they behave. There is behavior and a theory of behavior; they are not one and the same. Amendations for the purposes of clarification appear within brackets.

29 August 1970

...A telephone call from Mel Bochner. I plan to see him and Dorothea Rockburne next week.

8 September 1970

... All conversation is a kind of gossip. The so-called world of ideas depends on whom one is talking to.

15 November 1970

... Earlier in the week a visit to Dorothea Rockburne's studio on Chambers Street—blank white studio with a television set perpetually going without the sound. Is it a kind of naturalistic security ... in the face of the acute abstraction by which she is drawn? She, like Mel Bochner, and like Sol Le Witt, ... is working in "set theory," simple elements of cardboard, subdivided into neat and clear sub-units. These are carefully placed on long rolls of white paper, and casually painted over (apparently) with crude oil, 39¢ a jar, that is absorbed into the cardboard (shades of Morris Louis), bringing out the grain of the pulp (shades of Eva Hesse). The work never really dries, and will probably rot in ten years. [It hasn't.] But, since for Rockburne the sense of art is coterminate with the sense of Now, she is not unduly perplexed.

The units, though based on simple sets, are hung with comparative freedom, allowing for shape-to-shape comparisons utilizing the wall and floor in a subjective way that really has no parallel in her basic mathematical premises— thus disaffiliating her art from that of either LeWitt or Bochner.

I was touched by her quite personal style ... She comes from a Canadian working-class family, with a mother marked by a genteel ambitiousness. She was dissuaded from going to high school (by which term I take it she meant what we call "college"), which in Canada is state-supported. Instead she went to work, among other things, as a waitress. Always interested in art, she won a scholarship to a Canadian Royal Art School, attending classes at night. At length, from

various sources, she grew convinced that she ought to go to Black Mountain College, then still at its legendary apogee. There she came to know Rauschenberg, and, in recent years, has worked for him in various capacities. While at Black Mountain, she was attached to the mathematician Max Dehn, whose lectures were of capital importance to her. She says she still reads mathematical texts the way other people read novels—yet there is no sterile braininess in her manner...Dorothea, against harsh real world odds and by sheer dint of will, has begun to make it.

6 December 1970

...I went to Dorothea Rockburne's opening at the Bykert Gallery. The show was serenely perfect. Afterwards, many people adjourned to a noisy, smoky supper at Max's Kansas City [originally an artists' bar but now a rock club] to fête her success. Mel sat at Dorothea's right, I to her left, and on my left was Klaus Kertess [then Director of the now-defunct but historically important Bykert Gallery]...There were at least 20 others present as well—Van Buren, Marjorie Strider, David Prentice, Forrest Myers, many people. I think the evening was a great memory for Dorothea and I filched a champagne glass for her as a keepsake...[I wonder whether she still has it?]

13 February 1971

...A luncheon with Dorothea Rockburne and Mel Bochner. Mel way down, I think partly from a natural competitive envy, there is a strong interest in Dorothea's work now...Perhaps Ileana Sonnabend will show her in Paris. As to Mel, so far, nothing. Only one gallery, Dwan, can really show him—perhaps Leo Castelli, too, but neither has risen to the occasion. [Dwan: another historical gallery, also defunct, but at the time a stronghold of Minimalist persuasion; John Weber, now Rockburne's dealer, emerged from its staff. Bochner was represented there in a group show, Language IV, 2-25 June 1970, one of an influential series held between 1967-1970, with his now-celebrated work *Language Is Not Transparent,* a phrase written directly on the wall in paint and chalk.]

The Guggenheim International opened the night before, and granting the predisposition favoring Conceptualism, Mel's work was studiously exempted. Diane Waldman's catalogue makes no reference to him. He is obliged to use makeshift places of exhibition such as Jeffrey Lew's place [155 Greene Street in Soho], for want of any other, thinking that to avail himself of such opportunities may in the end make things only worse for him. ["Makeshift" was heedless of me. Though the place was a horror and still is, much extraordinary work has been exhibited there. Today we would call it an "alternative space."]...Oddly, talking of Dorothea's work, the term "Dorotheater" slipped out...

21 February 1971

...This week I put a bug in Michael Sonnabend's ear about the possibility of exhibiting Mel Bochner's work. Michael imagines I know something of the immediate scene, but is perhaps afraid that the *Measurements* of Bochner offer nothing tangible to sell. However, there really would be objects for Michael were he to open in Soho, as he says he will—enough to give Bochner an exhibition ranging from permutations of set-theory to diagrams of linguistic propositions. These are, in an objective sense, merchandisable works...

6 March 1971

...Mel will have a show next week in the Greene Street Experimental Gallery. He says his last work has been about exactness—measurements. Hence, the new work will be about "inexactness." ["10 Aspects of the Theory of Measurement." I reviewed it for *Artforum,* May 1971, pp. 75-76. I note this transient piece as it early points to an Italian architectural model for Bochner, one that in recent years has grown more visibly important for him: "...what is most interesting about Bochner's room occurs in the transposition of the feeling which, if felt at all, is usually experienced while moving through architecture, particularly Italian 15th-century architecture..."]

11 September 1971

Bayport [The Long Island town where my friend Leon Hecht and I once owned a cottage]...Mel and Dorothea here, despite rain. Dorothea spiritedly defended Barnett Newman: problems of "absorption," absence of reflective surface. She is not interested in the Newman of the "Sublime." Enthusiastic about Lawrence Weiner, who, according to her, is interested in objects as "nouns." She, by contrast, is interested in objects as "connective words": "and," "but," "by," etc. Mel, for his part, distinguished between Intelligent Artists (Newman) and Intellectual Artists (Reinhardt).

Dorothea spoke of her trip through the Inca domains of South America. It is not the huge dressed stone of Inca architecture that captured her interest, but the seams, the joinings between the stones—and the vast horizon all around, at which she was the center.

Mel had good news. Ileana Sonnabend will give him a Paris show. Dorothea will have a show at Bykert in fall.... They are at a breakthough moment...

17 September 1971

Bayport...Mel helped me further along into the conceptual problem by making an important distinction between an ontological and an epistemological

conceptualism. The first tends to be involved in the artist's theater of his own being—Nauman, Beuys, for example. The ontological conceptualist tends to be clearly in the debt of Dadaism. The epistemologist by contrast is interested in the essence of knowledge rather than the essence of being. Hence, he tends to make or do "information," theoretically-based things. Mel himself is a good example.... On the basis of this distinction, one can begin to make qualitative decisions in conceptual art, good or bad...or just plain "interesting."

2 October 1971

... Earlier in week Mel Bochner opening for "Projects" at MoMA. In the evening a little gathering arranged for Mel at Rauschenberg's Layfayette Street studio. Rauschenberg's friend Robert Peterson barbecued chicken. Mel, Dorothea, Sol LeWitt, the Sonnabends, the Konrad Fischers, Jenny Licht, Gilbert and George, many others. Mel's piece *Three Ideas and Seven Procedures* is complete unto itself—derived from Italian studies of lines in empty rooms and yet from Malevich's *White on White* as well. A thrilling day for him....[The work—numbers counted in contrary motion on masking tape applied to the wall—is described in my "Bochner at MoMA: Three Ideas and Seven Procedures," *Artforum,* December 1971, pp. 28-30.]

2 November 1971

...Spent morning with Dorothea Rockburne....She is impressive, firm, and hungry. Her new work, startlingly good, is premised in Boolian mathematics and Husserl; it deals with "Intersection," "Union," "Complementation." The index to Complementation run Entelechy, Cup of Grease, and Logos. The group breaks down into Disjunction, Substitution, and Synthesis. I don't much hold with this alternation between mathematics and visual experience, but Dorothea, mindful of her lessons at Black Mountain College, is captivated by what mathematicians called "the elegant and beautiful solution."

15 November 1971

Bochner, separated from Dorothea, is sacking out for a while at Rauschenberg's house on Lafayette Street...Bochner showed me new work. A grid of masking tape between bed and couch in room he is sleeping in. The tape measures out all directions open to each square of a grid in a counting sequence. The work is very dense, but, executed large on white floor and tipped into the Sonnabend Gallery where it will not parallel the walls, the grid would work. Its name: The Axiom of Exhaustion [shown Sonnabend, Paris, January 1972].

I was struck by the diagonal placement on the floor and that, in working out the model, the masking tape had been snapped rather than cut, leaving a kind of

jagged serration at the edge. The mystery of both these "expressive" un-Bochnerlike elements cleared when Mel told me how impressed he had been at the current Mondrian retrospective [Piet Mondrian. Centennial Exhibition, the Solomon R. Guggenheim Museum, 1971], especially Mondrian's unfinished *Victory Boogie-Woogie*—diagonally placed and snap-taped.

30 November 1971

Late. Leon and I just back from Dorothea's studio for dinner. Depressed. . . . Great sense of camaraderie. Strong frank evening. Suddenly, Dorothea closed in, going through material we had agreed upon—*her* article. When? Now! That I still admire her art after this hemming in surely tests my critical objectivity. . . , especially as she has thrown into doubt a lot of material that has appeared or is about to—not to mention Bochner's motives, an article about whom we saw today in a first hot-off-the-press December issue of *Artforum*. Have I been so ill-used? I suddenly feel an un-person. . . .

5 December 1971

. . . Consternation and sadness caused by Dorothea's actions. But it's the work that matters. Tuesday I will take John Coplans [then Editor of *Artforum*] down to the studio. I want to do a feature on one year's work by Dorothea accompanied by transcriptions of her journal pages. [It appeared as "Works and Statements," *Artforum*, March 1972, pp. 29-33 + cover.]

. . . Mel showed me a rough ball of masking tape covered with numbers: "My show at the Museum of Modern Art," he said.

13 January 1972

Dorothea's show ["Gradient and Fields," Bykert Gallery] is superb. . . quite without parallel. While there I learned that an interview with her and Jennifer Licht [then a curator at the Museum of Modern Art] had been planned for *Art and Artists* and is scheduled to coincide with publication of the *Artforum* portfolio. . . . In the light of dual publication both pieces strike me as little more than a well-orchestrated PR stunt. I told Klaus Kertess that should the Licht-Rockburne interview in *Art and Artists* appear in March, I would postpone the *Artforum* piece. . . . Eventually I called back and said that, whatever, Dorothea's work came first; the piece would still appear in *Artforum* as planned. Dorothea called the following morning quite overwrought. I asked why she hadn't told me that a piece for *Art and Artists* was scheduled? And more, why hadn't Jennifer's interview been offered to me—just out of good scholarship?

15 January 1972

...I mentioned the recent contretemps with Dorothea to Mel. He was not especially interested. He has broken with her, and resents having to listen to stories about her. The individuation process is now in full swing.

He told me that since his MoMA show, and the article, and the Paris show, and the New York show (both at Sonnabend), and the fact that he has reached the level of screening for a Guggenheim, he suddenly realizes that what he says and does has meaning as *history*.... Anyway, now that he is *there* (and he is fearful that he's only going to be *there*, how long? two years at most), he suddenly doesn't know what to do. When it didn't matter, he knew. He said, "The only thing that's holding me together is this mystical idea of the artist, me, the archempiricist!" He is leery of being in the position of suddenly being forced to answer the press of fame by "doing pieces," that is, by making prints, multiples, and the like. [He has, of course, made beautiful prints in the interim; so has Rockburne. See the exhibition catalogue *Prints: Bochner, LeWitt, Mangold, Marden, Renouf, Rockburne, Ryman* (Art Gallery of Ontario, December 1975-January 1976).]

...One ought to be chary of Dorothea—she so rarely says kind things about her friends. They always seem to fail her in some way. When will I? I found it terribly difficult to write about her today.... [At this time I began a long essay on Rockburne, but it was scrapped as will be seen in the next entry.]

22 January 1972

...Have spent the week largely preoccupied with editing the photographic and statement material of Dorothea. A certain over-meticulous nature on her part has made the editing arduous. Mel's essay on Dorothea ("A Note on Dorothea Rockburne") will open the portfolio, then Jennifer Licht's interview, and finally a rehearsal of two or three years of Dorothea's works. I abandoned my essay as being too biographical. I wrote about her in an overpersonalized way. "Robert," Dorothea protested, "you can't say that."...

Dorothea is so exacting during the editing session. She insisted upon repeated examination of Mel's piece, even after it had been agreed upon; and Jennifer's too. Each time a piece would be gone through, she insisted that scrapped excisions be reinstated and later formulations turned back into earlier expressions....

3 March 1972

...Mel talked about the *Seven Properties of Between*. The position of each composition is mapped on the gallery floor on the basis of their truth. The

"truer" propositions—ranging between specific, general, or tautological truths—parallel the walls. The "untruths" are placed diagonal to the wall. The unique proposition—Mel regards it as an act of faith—is the one that runs "if nothing is between A and B, they are identical." The proposition is false, unless A and B are cited as congruent. But Mel set it up as an isolated act of faith. Serra picked up on the specialness of the case by suggesting that Mel was "thumbing his nose" at other art—and Andre, in that whatever its location, the proposition was *manifestly* false.

Mel met Richard Tuttle at the latter's beautiful wire/shadow/pencil/line show [Projects: Museum of Modern Art]. Both had been preparing statements for this summer's *Documenta*. Tuttle gave Mel a muzzy-headed statement to read, then asked Mel what his statement was like—"I've written nothing." Tuttle replied, "Sometimes to say nothing is also a lie."

5 February 1972

...The *Seven Properties of Between* entirely denies the notion of a gallery context....

Washington's Birthday 1972

...Mel has found a new loft: Barnett Newman's old one—a huge, high-ceilinged place, two banks of floor-to-ceiling windows, overlooking White and Church Streets....

16 May 1972

Visited Mel in his new studio. Beautiful work. Systems of appending newspaper to the wall: relationships of stones to squares—empty, partially empty; permuted relations of numbers; counting exercises; elaborately drawn number sequences. Counting for Mel corresponds to those exercises in contour delineation and chiaroscuro that all types of tradition-bound artists rely on— from the most representational to the most abstract. Mel is one of the very few artists who has genuinely opened new territory—but he should not allow artists into his studio until the work is exhibited, as his proposals can be so easily knocked off....

29 October 1972

Certain things grow clearer: artists resent me as they refuse to allow a critic a role in the dialectic of contemporary history. They feel the same sentiment with regard to art historians, pretending that art historians are engaged in only a certain kind of decorous activity. For my part, I want only to be honest to what I

want to do—and not to what artists, or art historians for that matter, would have me do. I want to actively support an art that eludes definition, an art that is so bare that it is unclassifiable. Only Mel is moving in that direction, perhaps Dorothea.

To do what I want isolates me from both artists and art historians—both would have me institutionalize my zeal. In the balance is the obvious fact—I have become an alien.

4 January 1973

In Mel's studio—down, down—gray, depressed. Dorothea got to him. Main argument: my article ["Mel Bochner: The Constant as Variable," *Artforum*, December 1972, pp. 28-34 + cover] had robbed her of her achievement, her rightful place in art history—an art of set theory was hers, not Mel's. Perhaps; I had to strike out fifty lines on Dorothea at the outset, because both said they were tired of being known as "Mel-and-Dorothea."

As it stands, it took the publication of the article to learn that what was being referred to in terms of Set Theory was not arithmetic sets anyway, but rather Conceptual Sets, or Epistemic Sets. Errors, if any, in specific fact can be rectified.... the worst is the vindictiveness of it. I think Dorothea is simply jealous of the article, and used it to flail Mel... I told Mel, "Love is the strategies of sadomasochism." Remembering their separation, and division of possessions into separate studios, he said, "Objects are emotions."

I went to Dorothea. I first had to clear whether she was only transposing situations. When my Rauschenberg review ["Card Birds and Cardboards," *Artforum,* January 1972, p. 79] appeared, she was accused of feeding me history. Is she now accusing Mel in turn of feeding me history—as a means of exonerating herself from her own earlier charge? She claims not. Is she using me as a parental surrogate, transforming Mel into a sibling and jealously vying for my approval or demonstrations of affection? She claims not.... Anyway, no theory of behavior works; there is just behaving. Her claim that there has been a falsification of history is more serious, as well as her claim that her "ability to work has been endangered." She calls Mel a "political vandal," and insists that she "believes in art itself above all else." She claims...that *Measurements, Drawings, and Projects* of 1967-68 are in fact of a later date. Again, that the Catalogue of Plans of 1967-68 are of a later date.... She claims that she had written a letter to Mel from Brazil describing a line around the room: that letter and not *No Vantage Point* was the origin of the MoMA project.... As questions, they require only yes and no responses from him.

On the other hand, he is down—seems to need Dorothea, as she him. Even granting the allegations, the important thing is the viability of the relationship. But Dorothea is no longer satisfied or touched by Mel's contrition. Instead, she wants guilt to mobilize him. To what? An immediate denial in *Artforum.*

Certainly, if she were to make such claims in a letter to the Editor, this would signify nothing less than rupture with Mel. Is that really what she wants? I think not. And she is in an agony of indecision and double-mindedness. The dilemma remains unresolved.... Later, with Mel, I asked him about the matter. He was startled and said, "Is that what she accuses me of?"...

5 January 1973

... I asked Dorothea whether she was angered by Mel's "ingratitude." After all, when they met, there was supposedly a certain helplessness and floundering on Mel's part that Dorothea pulled him from. No.... She accuses Mel and me of having acted in "sexist concert." This is untrue, unless to be men itself inculpates us. If, in fact, she wishes to allege false dating against Mel, I invited her to do so. And I told her so. She backed down. The argument to which she retreats is always the therapeutic purity of art; to work, that is the cure. Romantic and posey? Yes. But what, after all these accusations, does it mean practically?

10 January 1973

Poor Dorothea. She is so frustrated.... She wants to have the record set straight, she says, as to who first developed an art of Set Theory. She feels so cheated, so ripped off by history. She who gave to the word "sets" the most logical, the most mathematical of meanings. But the letter is not forthcoming.

... Mel trying hard to remember the source of the pencil line around the room came up with Robert Whitman's show of a red laser beam shot around a chamber in the old Pace Gallery on West 57th Street. I forget the date of the show, about 1967. In retrospect, a remarkable achievement, that Whitman show. [Reviews, unfortunately not illustrated, were written by Gordon Brown, *Arts Magazine,* September-October 1967, p. 53, and Max Kozloff, *Artforum,* December 1967, p. 54. Some idea of the work may be grasped in the *Time* Magazine illustration, "Artist Whitman and Laser-Beam Projector," October 27, 1967, p. 64.]

21 January 1973

Mel and I ran into Clement Greenberg in a gallery on 57th Street. He was pleased to accept our invitation for a cup of coffee ... and it seemed that he didn't want to break away. It flattered us that he knew our work, as we surely knew his.... But, in the end, he was guarded and kept his distance. I was writing, for him, "premature art history." He went on about "quality," his code word for what he liked.... He still as yet could not "see" Mel's work. Johns, for him, was a "major minor figure." Poons was "major," although he admitted that Poons mostly ratified Olitski.... Clement kept on talking about the "autonomy" of his

experience, yet neither Mel nor I let him get away with it. Clem was too politically ardent in the 1930s to end up an aesthete now. Nor could he get away with the distinction he still insists on between painting, sculpture, and literature. He views Mel's work as being of the latter type, but we both quickly noted that Mel's work was fully visual. "Painting" and "sculpture" are now replaced by epistemological taxonomies—philosophy and mathematics, but that in no way obviates visuality on the one hand or tactility on the other. But all this worried Greenberg because, as he said, while he "liked to think," he didn't much like "the experience of thinking." But he conceded that should he give credence to Mel's work, "it would turn his head around." And he promised to visit the show.

27 January 1973

... The openings of Dorothea Rockburne, Sol LeWitt, and Mel Bochner, all in a day. It ought to have provoked a sense of elation throughout the art world, but instead has led to bruised unhappiness. Dorothea cut Bochner away from the party that was organized for her; Bochner, in turn, did not see her exhibition.... Dorothea's show: theatrically installed in a glaring, brilliant white gallery, floors and walls white and harshly lit—nonetheless beautiful. The carbon transfers and reversals of *The Drawings Which Make Themselves* are ingeniously worked out, a highly accomplished *visual* exhibition. Sol's show was the best I've seen of his. His basic set of vertical, horizontal, and diagonal lines was incremented one by one laterally on the walls of the Weber Gallery.... Mel's show naturally was difficult by two jumps beyond even this. *The Axiom of Indifference* was a system of inclusion and exclusion employing copper pennies.... Using the heads/tails aspects of pennies, the coin underscores the in and out aspects of the axiom: all in = heads; all out = tails. A mixed situation, some in, some out, = heads and tails... that was it. The effect is chilling and alienating, especially in the vast space of the Sonnabend Gallery.

William Seitz did a coarse, funny thing; he pitched pennies into the system, and only when Mel threatened him, did he back down. His comrade in this folly was Louis Finkelstein... Seitz went so far as to protest, saying that whoever he was, he (Bochner) was spoiling their pleasure in the work, that he knew the artist, and that was what the artist intended. Whereupon Mel introduced himself...

Greenberg appeared. He would not give an inch, though he did congratulate Mel upon a type of art he absolutely felt no contact with...

Ironically, we left the gallery as the bells tolled for the signing of the Vietnam "peace treaty," a rainy night. A pyrrhic peace. Like tonight, a pyrrhic victory for Dorothea. Is it? She will never accept her work with any certainty until Mel acknowledges it. And to have cut him from her celebration may have strengthened his resolve against her...

29 January 1973

Surely, the dramatic floodlit illumination of Dorothea's exhibition was intended to be seen as distinct as possible from Mel's, a theatricality counterpoised to Mel's understatement. He always tries to locate the situations a merest hair's breadth away from any given reality. There is no theatricality at all unless, of course, this perverse reversal of effects is itself theatrical. Certainly, that's another reason why something so commonplace as pennies were used.

9 May 1973

Language, it seems, is to Mel's work as "picture plane" and "frontality" were to Formalist painting. . . .

19 June 1973

Last night at Mel's studio. Problems begin to arise in his art. For the last four or five years, Mel has been sharpening an art in which the linguistic correlatives underscored and verified the visual information, and vice versa. The art lay somewhere in this interchange. In the last year or so, the absorption of this position by the art public has been rapid. By now, any bright master's candidate in the fine arts can do a knockoff of a Bochner. Thus fearful in part of falling into mere self-imitation, Mel has enlarged the bases of his art. Like Richard Serra, who has gone back to making recognizable sculpture—Constructivist sculpture, that is—Mel is now moving into what might be described as pure painting.

 Since February, . . . Mel has been working with color. The sketches are either worked up as finished drawing-painting on paper (gouache) or executed on large sheets of enameled paper pinned on the wall. The latter adumbrate final versions to be executed directly on the wall in enamel. The first drawings deal with "sets" of primary colors in altered sequences. The "breaks" are marked "and" or "or." The attachment to his earlier works is still evident. But, by May, the verbal connection had been dropped in favor of visual connections denoted by black masking tape on the wall that marked variant arrangements. Now the masking tape has also been abandoned as being too close in appearance to the earlier linguistic and mathematical sets. He is working with the idea of large "squares" (actually 34 x 36 inches) of primary colors plus black, white, and gray bars which echo and respond to one another across facing walls of large architectural installations; or even the corners and, most rarely, incorporating floors and ceilings. The relationships are now freed from a superposed system of language and mathematics, with the result that while they provide a strong impression of logical structure—e.g., inversion, variation, alteration, etc.—they are no longer truly logical. In short, they enter the realm of art mysticism—"the right feel," "the right weight," "the right sequence," that is, problems of sensibility and taste.

"I do not know what I am doing," Mel confesses. "I have only the confidence in the rightness of my intuition. After all, five years ago I was right to pursue the direction I did, against all odds or hope of understanding. Now I must pursue this."

I feel Mel has walked out on a long springboard, has come to the edge far earlier than we, and plunged. Will I? I don't know. I was drawn to an art which was wholly explainable, which was free of studio cant and art-mysticism. Yet the new work is "very beautiful," whatever that means, and we have been watching it grow from the first moment.... Leon remarked that the new work offers infinities of possibilities.... Instead of the narrow range Mel worked in, the new work seems to have too many variables—color, scale, architecture, permutations, mirroring, inversions, reversals—too many elements to enforce within a closed, solopsistic system.

Mel observed something interesting: when color "squares" are placed more-or-less at eye level, they are rather like straight painting. "When they are too high on the wall," he said, "they appear to be architectural. When they are placed too close to the floor, they appear to be too sculptural."... These works have in their drawing stage elements which remain tied perhaps too obviously to de Stijl.... And even something of Ellsworth Kelly, too. Of course, Kelly's work is so diverse that each artist creates Kelly anew to suit his own needs.

[On 25 July 1973, I gave a public lecture as part of the series "Problems in Criticism" at New York University. On rereading this address, given on the day of Robert Smithson's funeral and dedicated to his memory, I discover many passages that reflect my relationship with Mel and Dorothea at that time. Without wishing to publish this lengthy lecture at this late date, perhaps the following excerpt suffices to reveal the still-apostolic intensity of this reflection:

The recognition of the new must coexist with an intense empathy with the artist—so much so as to oblige the critic to adopt the artist's experience as a personal burden, a commonweal, a common cause if necessary. The critic imaginatively must be the artist. This is very difficult. The human exhaustion implicit in my view of the artist's life is often unbearable. The artist—the real artist—is in great measure defined by an existential aloneness. Accept it as you will, you must recognize that the artist is that person who unendingly drives him- or herself to individuate from the past—and after a moment that past comes to include his or her own efforts too.

This is entirely different from our conception of our labors. We view our lives as a field strewn with work to get done. Each problem—however many stages and negotiations it may entail—is in itself finite, achievable. Each chore is completed in turn, and anew we assume fresh responsibilities, each successive one defined very much in terms of the last one completed. By

contrast, *the artist repeats no chores*—he or she lives his or her life in a continuum of consciousness that in each instant clarifies and corrects the awareness that immediately preceded it. In this sense *the artist never finishes anything.* What we see as art is the strewn detritus, isolated objects, elements, and experiences of a life lived as a united quest—to somehow find the means to nourish the energy and consciousness to correctly realize the next instant in a continuum of consciousness. The real artist only has energy enough for this one obsesssion.

Clearly there are attachments, liaisons, friendships, unions of all kinds along the way. But the artist—unlike us—perceives that such attachments, whatever they may be, undermine and dissipate the energies required for the production of art. Therefore unions are at best only temporary. Inevitably they rupture—it must be so, or else the artist will cease to struggle through the consciousness necessary to achieve art. In gaining Society the artist loses Art. He or she merely becomes "artistic" or "arty." The "artistic" and the "arty" function as social cushions and buffers of art, but they represent the failure, the impotence of art.

The unions and attachments that destroy art are, as Cyril Connolly called them, "the enemies of promise." Since, however, pure existential aloneness is unendurable—the path to madness—the artist's life is thwarted by conflicted desires. It fluctuates between a need for society and a need for egoistical isolation. This then is no brief for artists as people—but one made in amazed appreciation for what artists are compelled to do— make art. Neither does it promote a Romantic idealist view of the artist. It is, in fact, a pragmatic assessment made on direct empirical examination.

Ironically, the artist does not want the critic as I have described him or her. Such a critic *impinges, drains, threatens, insinuates* him- or herself into the artist's life. Such a critic *socializes* the artist. Such a critic wants to be the artist. On the other hand, this is precisely the critic that the artist wants, for in a real way such a critic alleviates, if only momentarily, the isolation implicit to being an artist. This establishes a powerful interaction. Resolution may take three forms. The first two are negative: rupture or pander. Either the artist and the critic break or the critic is reduced to promotional propagandist.

Yet each party attempts to forestall this inevitable denouement, as it acknowledges either that the artist has become "artistic" or that the critic is "not an art critic"—that is, has become a journalist. The dynamic thus persists—the critic always in an inferior role since he or she vicariously lives, imaginatively reconstructs the artist's struggle without, in fact, experiencing the artist's real isolation. This is in fact the third resolution: in the degree that the conjunction holds between artist and critic, art continues—since in modern culture there is no art outside of the dual struggle.]

11 July 1974

...Mel involved with large wall drawings, the indications for which are made through perforated cartoons. "Sinopia," I said.—"That's the word I have been trying to think of for days."

10 August 1974

...Saw Dorothea—all uptight—about forthcoming group show at the Museum of Modern Art [*Eight Contemporary Artists,* October 1974-January 1975. Bochner, incidentally, was not one of the eight artists chosen by Jennifer Licht.] Mel and Dorothea work from strength to strength, still in lock-step, still in the grip of their renunciatory *Liebestod.* Mel working in drawings that deal with the unexpected shapes germane to superimposed and abutted triangles, squares, and pentagons. Dorothea is making "paintings" that explore superimposed shapes formed by incisions and scorings made in squares and the Golden Section rectangles generated by these squares. Mel is working in pastels; Dorothea in gesso and paint. Mel executes pastels on the walls and shows them on the floor; Dorothea executes works for the walls and shows them on the floor. Both suddenly are talking of "framing" works. Both are working out projects based on trips to Italy, made last year and this year to Siena and Assisi. Like Italian fresco cartoons, the models for Mel's wall works are pounced through perforated masters—"sinopia." The colors derive generally from fresco painting, the chalky colors especially of Piero della Francesca, whose works profoundly affected him in Arezzo this year. Dorothea shows me pictures of trecento and quattrocento altar paintings—Duccio's *Maestà,* for example—and speaks of the retable and framing "cuts" as models for the sets of "cuts" she now makes through her gessoed canvases.... Dorothea showed me her cryptic, oracular statement for the MoMA catalgoue and I corrected it with her, more perhaps from a sense of impish play than from any authentic scholarly consideration. I wanted somehow to show her new assistant—yet another perfect young artist-intellectual—that his goddess may have clay feet. I always feel that Dorothea gets her readings so confused—unlike Mel, who can assimilate and duplicate the content of his readings. He transmits, Dorothea translates. I noted that Max Kozloff wanted to cover the MoMA exhibition—he is anathema to Dorothea. Half an hour later she "idly" inquired whether Joe Masheck could do it. Surely she was thinking of Masheck's recent article in which he compared Robert Mangold's structures to Alberti church facades [Joseph Masheck, "A Humanist Geometry," *Artforum,* March 1974, pp. 39-43]. You see, historicism is the tag idea, like Mel's "sinopia."...They both want their Italian connection. I've written it for Mel, Masheck for Mangold; now Dorothea wants *her* Italian antecedents in print, too.... [To bring this historicist certification to the present moment, what does one make of Brice Marden's annexation of the 15th-century divine Fra Roberto

Carraciolo of Lecce, one of whose sermons provided the artist (it is maintained) with the inspiration for five new paintings "linked to the five states of the Virgin during the Annunciation." See Jean-Claude Lebensztejn, "From," the catalogue essay to *Brice Marden, Recent Paintings and Drawings* (New York, The Pace Gallery, September-October 1978). It would seem that all the initial figures of the old Bykert set—even the more nervously small-talking of them—are determined to have their Italian antecedents spelled out, no matter how taxing of one's credulity. And to have said this in no way countermands the truth of their assertions; then, again, it doesn't endorse it, either.]

10 October 1974

...*Eight Contemporary Artists* opened at MoMA. Dorothea carried the evening...Dorothea, who has a sense of occasion, was all turned out...Mel was her escort. She smiled and bowed, was fêted and happy....

21 June 1976

...Visited Dorothea in her new, vast studio in Grand Street. I thought the first rooms were "it," but in fact they were but half of the huge, *de rigueur* white space of a Soho loft, the module set by ornate pressed-tin Corinthian-capitaled columns. Dorothea has held on to much of her earlier work. Fine examples of each type—drawings which make themselves, the oil-stained drawings, a remarkable suite of white, buckled, and scored paper drawings that preceded the Golden Mean drawings. They reconstituted the surface in rearranged edges marked by graphite line and smudge; framed like beautiful white reliefs, they give a certain credence to Dorothea's claim that she is primarily a sculptor. The whole suite of kraft-paper studies for the Golden Mean paintings are there. Backs of paper are distinguished from the front by a layer of shellac as previously she had differentiated the front and back of the Golden Mean brown canvas by a layer of gesso. They are all there, neatly accessible...a reference collection for the artist's development. Now she is pressing in favor of color. The small kraft-paper pieces for the Golden Mean paintings are being executed in color on canvas—in small scale. Dorothea insists that that's what she was always working toward. The primacy of painting? Of color? "But I thought you were a sculptor?" The rational empiricism of Dorothea's work obviates and circumvents color, unless she is an actual colorist, which I fear she is not...what it comes down to is Dorothea's once more setting up the conditions of historical inevitability. Since her color is not keyed into a system, her justification comes from "Italian primitive painting"—Sassetta, Giovanni di Paolo, Duccio—the colors of whose work "most intensely express the shapes." The connections to drawing, to gesso, to a natural, rationalistic strain lead her rightly, after all, to stress her affinities to the Sienese.

...Like LeWitt, she too has made photographic mountings of snapshots of gridded things; Dorothea is mounting her color shots of things based on curves, especially the ogival arches of the fourteenth century, late Italian Gothic.... She is much out of circulation now, she says, because she stays home working with a mathematics tutor. "What kind of mathematics are you studying?" "The mathematics of curves." Thus, I suspect, is next season's work insinuated into the media. [I note with a certain sense of rue the October 1978 advertisement: "Dorothea Rockburne, Drawings: Structure and Curve."]

2 October 1976

...In a Greyhound bus traveling with Leon on our way down to Baltimore for Mel's opening at the Baltimore Museum of Art [*Mel Bochner: Number and Shape*, October-November 1976. Essay by Brenda Richardson].

3 October 1976

Back to New York, next A.M.... The exhibition exhilaratingly beautiful, with Mel's references to intonaco, sinopia, the whole fresco-Italian range quite in hand.... Dorothea made no appearance. A conspicuous absence. But, by the sheer powers of rationalization that both Mel and Dorothea possess, Mel seems to have glossed over the absence. She, it is said, was deep in thought, preparing for her forthcoming exhibition.... Mel's great achievement, despite all the staggering beauty of shape development in color (his is an exquisite sense of color), was in the location of artistic validation within numerical and linguistic systems.... A testimony to my feeling: one can make a measurement piece today (there's one in the exhibition) and convey no sense that the work is copied or violated in its spirit, though the idea dates to 1968. A measurement installation is believable as dated 1968-76. In contrast, one can't make a drawing in 1976 after the shape drawings of 1972 and still credibly attach a date of 1972-76 to it.

6 November 1976

...Went to Dorothea's show, indeed several times, and now feel sure that the repeatedly urged studio visit made in early summer was made in the hopes of my volunteering to write the catalogue accompanying the exhibition. Naomi Spector did [*Dorothea Rockburne: Working with the Golden Section*, 1974-76, New York, John Weber Gallery, October-November 1976]. The same hypnotic tone of uncritical praise, very *petite chapelle*, is marked throughout an essay, composed, I am sure, by fiat, from Dorothea herself, "from above." Mel did not appear at her opening...nor, rumor has it, did he appear at the champagne reception or dinner party for her which followed, perhaps to reciprocate in kind for her absence from his Baltimore opening...Finally, I decided that this final

step of Dorothea's descent into color is *un four.* Dorothea has no real sense of color, nor of surface—so labored is it. The works have been given names from Duccio-related subjects, derived from panels of the *Maestà;* again the Bochner/Rockburne invocation of Italian primitives as cultural ratification.

4 December 1976

Lunch yesterday with Mel. Mel notes that my new attitude toward criticism is echoed in much current writing, Mel said of my Entries, "It's just like Eckermann's conversations with Goethe."...Mel lent me a copy....Mel is so high-minded it's amazing. He regrets, as I did, in meeting with Dorothea back in May, the terrible breakdown of the sense of community. Mel misses Smithson terribly as a peer he can talk to. His individuation from Dorothea is clear and final. Richard Serra often seems to verge on the half-mad and is filled with himself. Mel wrongly thinks that there's no sense of community among the younger artists—the way there had been among Dorothea, Mel, Smithson, and Serra. They once felt allied to LeWitt...Judd was a hero, but not one of them, and Andre was one of them, but a villain.

20 February 1977

...Mel reluctant to admit that the stylistic focus has changed from a Formalist one to a more laid-back, untheoretical art, one I characterized as "Californian" whether or not it literally stems from California....Mel's point is less one of acknowledgement than of countenance: to grant that any of it may have some touch of quality, whether or not such a stylistic attitude represents a broad front shift in terms of contemporary history, is simply beyond him....

6 April 1977

...Mel talks of a different pacing—early on, fast ideas put out at a furious rate; now, slower ideas with much space between them worked deeply....

8 June 1977

Chinese luncheon with Mel. Reviewed our indifference to Noland, Olitski, High Formalism of the '60s—with the exception of Stella, who continues to fascinate. Mel said his paintings always "masked anger." He remembers Andre saying that Stella's work was born of desperation—at first a desperation with the work around him, and now a desperation with his own work....

11 September 1977

...Mel, it turns out, made two films in the Sixties: one is *Sixteen Views of Dorothea* and the other is *Walking a Straight Line in Grand Central Station*. Mel's judicious sanitization of his career edited out any mention of those efforts when we so carefully went through his early work together, that many years ago....

6 April 1978

...Richard Martin [Editor of *Arts Magazine*] tells me that Mel stopped by with a letter. Mel has written a suite of lapidary phrases whose meaning one does not quite grasp over the phone, though its tone is clear. It sounded like a statement from the floor, rather than a call for rectification or a query for information. But it all comes down to what Mel, and, by extension, many artists, consider the proper limits of critics and criticism to be. I am afraid his Olympian puritanism allows only for a very narrow bridge of discussion, and while I am happy to discuss matters within these boundaries, they are not necessarily the *only* boundaries I want to talk about things in. More, there is the tacit assumption that it is the artist alone who determines the bounds of the discussion—false. That art is creative, criticism uncreative—false. That artists may evolve, play hunches, while the critic may not—false.

In a certain sense, to make up an argument is what critics do. In making up the argument, they make up all but the primordial formal content of the art about which nothing useful, nothing beyond the merely tautological—that it *is*—may be said anyway. To make up an argument is as creative and hunch-playing an activity as making art....

Mel said something about jargon; for Mel, that is not throwing stones in a glass house; it is juggling boulders in the Crystal Palace.

He said something about gossip not being ideas. The contention simply will not bear scrutiny. He may be right, but he cannot prove that he's right. We do not read the Goncourts today for their novels and plays, but rather for their gabby journal. And what of Saint-Simon? It was Mel himself who lent me his copy of Eckermann's home life of the aged Goethe, Goethe *en pantoufles,* as it were. He claims I have no access to his mind or his thought. Perfectly true in an obvious sort of way. But it may also be claimed that the artist himself does not possess this access either. "To think" doesn't necessarily mean that one has access to the thought process, even one's own. It all comes down to the truism: despite the evident fruits of thought, we don't know what "thinking" is, or what "to think" means.

Anyway, what is awful in all of this is that Mel felt constrained to retaliate, ... which means that he is hurt, and I certainly don't want to hurt him. And I apologize for having injured him, if indeed I did. But my apology in no way

is a recantation for a belief in the creative autonomy of criticism. That I will not apologize for, nor would any apology be forthcoming because I happen to think Mel the finest artist of his generation. I would make the same apology to the least of artists, and in precisely the same terms.... [What this means in practical terms is that a work by Bochner today is still as "large" with regard to its art ideas as when the artist began to impose work on the world some ten years ago. And, despite the heightened coloration of my image of her throughout the above, I would claim the same for Dorothea Rockburne. Compare this, if you will, to the condition of those who may be said to occupy a second string in the style that I have been writing about. This latter group—still an elect body, mind you, when compared to the hordes massing at points even more peripheral to the center—is defined by the fact that what one receives from them as art is a form of signature—figments of a stabilized style the content of which has grown inert and, through its lazy frozen character, stands now as surrogate or proxy for what the artist once struggled toward. In this sense, the art of the second stringers is "smaller" than at the outset of their careers, condensed, as it were, so as to make it clear that whatever variations and deviations such as now occur, do so in a way that does not threaten or challenge any of the larger premises of the matrix style. They now make for distinctions without differences within what has come to be recognized—as much by artists as by public—as a stabilized, institutionally appropriate decorous activity, be it painting, sculpture, or what have you. The artist at this stage of abdication becomes a craftsperson and paintings become as pots.]

14 April 1978

Sourness: saw Mel at the corner of Spring and West Broadway. He averted his glance so as to pretend to have not seen me. And again, later in a gallery, our paths crossed, but he ducked out so as not to have to speak to me....

29 April 1978

...The exchange of letters appeared. [*Arts Magazine,* May 1978. Ironically, in a special issue devoted to Robert Smithson.]

28 July 1978

Whitney opening: Paul Cummings' show of drawings the Whitney has collected or received in the last five years. Crowd thinned by midsummer doldrums....Dorothea put me off, and Mel's bluff hail-fellow-well-met tone made even short-tether civility hard to carry off....On one hand, there is the tremendous flash of pleasure in recognizing them, and then all the rushing in of thwarted feelings....The worst of all is rehearsing one's coolness.

Index